THE SCENE: REPORTS ON POST-MODERN ART

CALVIN TOMKINS

REPORTS ON

THE VIKING PRESS
NEW YORK

POST-MODERN ART

First published in 1976 by The Viking Press
625 Madison Avenue, New York, N.Y. 10022
Published simultaneously in Canada by
The Macmillan Company of Canada Limited

LIBRARY OF CONGRESS CATALOGING IN PUBLICATION DATA
Tomkins, Calvin, 1925—
 The scene: reports on post-modern art.
 Includes index.
 CONTENTS: Moving with the flow.—Raggedy Andy.—The
skin of the stone.—EAT.—Maybe a quantum leap.—All
pockets open. [etc.]
 1. Arts, American. 2. Arts, Modern—20th century—
United States. 3. Avant-garde (Aesthetics) I. Title.
NX504.T64 700'.973 76-1863
ISBN 0-670-62035-1

Printed in U.S.A.

All of these essays except "Raggedy Andy"
originally appeared in *The New Yorker*.

a man collided with the moon
and the painters found other vocations:
they painted faces no longer,
but scars, intimations, signs . . .

—PABLO NERUDA, *Amores*

PREFACE

An art critic once scolded me for writing uncritically about contemporary artists. His tone was clearly territorial: If you can't bring some intellectual heavy artillery to bear on these imbeciles, he seemed to imply, then stay off the range. Being a reporter and not a critic, however, I tend to feel that what artists say or think—and certainly what they do—is a good deal more interesting than what contemporary art critics write about them.

Not much critical artillery is deployed, at any rate, in the following reports, all but one of which appeared originally in *The New Yorker* between 1970 and 1976. They are presented here more or less chronologically, except for the profile of Henry Geldzahler, written in 1972, which I have put first, because it covers in a general way the larger "scene" that formed the background for the period under review—the 1960s and early 1970s. Taken as a group, the pieces seem to have relatively little to do with painting and sculpture in any familiar sense. Painting and sculpture did not vanish from the scene during this period, of course; at the moment, in fact, the new photorealist painting is the hot ticket in a number of SoHo galleries, in more than a few museums here and abroad, and in the collections of the German buyers who currently dominate the American art market. But a lot of energy has been going, nevertheless, into activities of another order.

One current preoccupation is with theater. "Where do we go from here? Towards theater," John Cage wrote in 1957. Cage was referring to experimental music and musicians, but his forecast could have applied equally well to most of the artists discussed here—artists who have chosen to work with time as well as with space by making films and videotapes, or by involving themselves in dance and performance pieces of various kinds. Robert Wilson, a painter who found that he could realize the images in his head more fully on a stage than on canvas, has pushed the concept of an artist's theater further than anyone else. His work perhaps foreshadows a revival of the periodic urge toward the *Gesamtkunstwerk*, the marriage of all the arts in a grand

spectacle of sound and color and image and gesture, an ultimate mixing of media.

Some other recent trends have proved abortive, at least temporarily. The art-and-technology movement that generated such a lot of steam only a few years back has clanked to a dismal near-halt; the earth artists are hard put these days to find benefactors willing to finance their grandiose excavations. This could change. At the present writing, Christo is struggling to get clearance for his proposed eighteen-foot-high, twenty-four-mile-long *Running Fence* in northern California. Television, in the hands of Nam June Paik and other genial madmen, may yet become a technology hospitable to art. Meanwhile, a great many artists engage in a great many entirely different activities that are unrecorded here, some of which may turn out to have been well worth watching.

For several years there has been no dominant movement or style in contemporary art. Heavy-artillery (or large-bore) critics see a decline in the quality and seriousness of recent American art, a lowering of standards and a surrender to the gossipy tastes of a sensation-hungry, pseudo avant-garde audience. The situation is nevertheless a good deal freer than it was in the mid-1960s; when Pop or Minimal or Color-Field Painting took up most of the aesthetic oxygen, and it is also more difficult for artists; the young artist today has to make all the decisions for himself. Curiously, one no longer hears so much about the "crisis" of contemporary art—a critical cliché of the 1960s. Artists continue to work, and even to sell. A few dealers flourish, as always. Preoccupations change, but the scene remains lively.

Another persistent tendency in recent art has been for artists to try to make the viewer an active participant in their work. Through his own involvement, it is hoped, the viewer completes the process that the artist has set in motion (thereby circumventing the critic, whose anguish increases). The following reports are offered very much in this spirit. Ten years from now we may all be artists, and, as Warhol has said, everyone will be famous for fifteen minutes.

C.T.

CONTENTS

ILLUSTRATIONS

THE SCENE: REPORTS ON POST-MODERN ART

MOVING
WITH THE FLOW

It is not without irony that the Metropolitan Museum of Art chose to inaugurate its second century with the largest exhibition of modern American painting and sculpture ever assembled. For nearly a hundred years, the museum had never quite known what to do about the work of American artists living or recently dead. It did not even have a Department of Contemporary Arts until 1967, and then the total exhibition space allotted to it was one gallery; moreover, a good many established artists, critics, and dealers looked with grave mistrust upon Henry Geldzahler, the fledgling department's ebullient young curator, and it was clear from the outset that any major exhibition put on by Geldzahler was bound to become embroiled in controversy. While the uproar over Geldzahler's "New York Painting and Sculpture: 1940-1970" exceeded all expectations, it did at least serve to dramatize the Metropolitan's long-delayed plunge into the maelstrom of modern art.

It was an enormous show: 408 works of art by 43 artists, filling 35 galleries on the second floor—an exhibition space nearly twice as large as that of the entire Whitney Museum. Geldzahler, who said afterward that he had got just about everything he wanted from lenders in this country and abroad, actually performed a considerable feat of organization and installation under great pressure. His show had originally been scheduled to open a year later; the opening date was moved up to October 1969, when it became evident that the pre-Columbian exhibition called "Before Cortés," with which the Metropolitan had intended to open its year-long centennial celebrations, was running into delays. The selections were Geldzahler's alone—no consultants or committees were involved. In the ensuing controversy, however, the museum came in for at least as much criticism as Geldzahler. Although "New York Painting and Sculpture: 1940-1970" was rarely referred to in art circles as anything but "Henry's show," the formal title and the fact that it took place at the Metropolitan seemed to suggest that Geldzahler's choices would go down in art his-

tory as definitive for the period, and because Geldzahler's choices encompassed some notable omissions and inclusions, the shock waves could be felt long before the opening. Indignation and outrage resounded in the New York reviews. The *Times'* John Canaday called it "a booboo on a grand scale" and "an inadequately masked declaration of the museum's sponsorship of an esthetic-political-commercial power combine promoted by the museum's Achilles' heel, Henry Geldzahler." Hilton Kramer, the *Times'* regular art critic, decried it as a celebration of "fashionable taste" and accused Geldzahler of "moral and intellectual abdication" of his curatorial role. "Geldzahler's playground is what it is," Emily Genauer wrote in the *Post,* and she added that the Metropolitan's indulgence of Geldzahler was "a capricious course . . . without parallel in the annals of museum gamesmanship." Most of the critics focused their attention on the artists who had been left out, and ridiculed Geldzahler's definition, in the exhibition catalogue, of the guiding principle behind his selections: "the extent to which their work has commanded critical attention or significantly deflected the course of recent art." Quite a few artists were understandably bitter at being passed over as nondeflectors; if the show had been smaller, they might not have been so offended, but forty-three artists was a rather large number from which to be excluded.

There was a great deal of the usual art-world talk about nefarious plots to manipulate the art market (Canaday's "esthetic-political-commercial power combine"), and it was feared for a time that such well-established artists as Louise Nevelson, Larry Rivers, Tom Wesselmann, Jim Dine, Richard Poussette-Dart, and others would suffer a decline in price as a result of being left out—a fear that proved to be illusory. The exhibition was by no means universally disliked, however. John Richardson, the British critic, called it "the most stimulating and refreshing exhibition in recent years," and Thomas B. Hess, though generally critical in *Artnews,* went on to say that the works were beautifully displayed, and that if only the show had been called "Forty-three Americans" or something similarly unpretentious everyone would have been happy. The review that Geldzahler himself liked best was written by Philip Leider, the editor of *Artforum.* According to Leider, the show represented the point of view of someone who had entered the art world in 1960. Geldzahler, Leider wrote, "has been true—consistently and ruthlessly true—to his own experience," but, he added, his experience "has not been an experience of art . . . so much as an experience of the art world, of dealers and gal-

leries and museums and collectors and magazines and critics." Although this might appear to some people to cast doubt on Geldzahler as a judge of aesthetic quality, Leider concluded that the show, for all its eccentricities, was "an exhibition of American art of the past thirty years as beautiful as any we are ever likely to see again."

It was an interesting point. The art world that Leider referred to did not really come into being until the 1960s, and by 1970 it had ceased to exist; although many of the personalities remained, the spirit was different and the excitement had died down. In his introduction to "New York: The New Art Scene," Alan Solomon, a former director of the Jewish Museum and a prominent figure on the scene himself, described the 1960s *esprit* as being optimistic, open, experimental, and feverishly intense; artists felt free to question every previous assumption of the purpose and function of art, and this "anything goes" philosophy was actively encouraged not only by the artists' dealers and by half a dozen new and very active collectors but by a new and avidly enthusiastic public as well—what Hess and other critics have referred to as "the vanguard audience." The vanguard audience went to all the openings and to all the parties, some of which became social events of considerable magnitude. Now that it was generally accepted that great art could be produced in America after all (the triumph of Abstract Expressionism had gone relatively unnoticed until the mid-1950s), no one wanted to miss out on the latest developments. Important new work was being discovered every week, or so it seemed, and the real trick was to "get there before the dealer." Artists were no longer isolated creatures forging private myths; they inhabited and dominated an "art world"—visible stars in a gaudy million-dollar production with a supporting cast of . . . well, hundreds, anyway. The critics deplored the new scene, for the most part. Hess, a stanch champion of the pioneer generation of Abstract Expressionists, saw the vanguard audience as a historical parasite that "patronizes the new painting while attempting to contain and muffle its subversive content"; such an audience, he said, could destroy the integrity of the New York School, just as it had undermined the School of Paris in the previous decade.

What actually happened, however, was that the innovative artists escaped, as they usually do, into new regions, where even the most dedicated vanguardist found it difficult to follow. Several American artists of the 1970s went in for the complete rejection of the art object as such—a trend foreshadowed as early as 1912 in the work of Marcel Duchamp, who for many of his American admirers has been the

most influential artist of this century. Concurrently, the recent business recession has made American collectors nervous. Buying has fallen off sharply, the art market has become, to use the current term, "problematic," and the scene has lost a good part of its luster. In view of these developments, the timing of the Metropolitan's big show was extraordinarily fortunate. Because Geldzahler had limited his selections, as he said, "to artists whose distinctive styles emerged and were viewed before 1965," he did not have to deal with conceptual art, earth art, or any of the other inconvenient trends that have dispensed with the art object. Today, it is doubtful whether a comparable survey of recent art could be mounted at all. In spite of his omissions, moreover, Geldzahler's list of artists was essentially the same as the list for every other big group exhibition during the 1960s; his show as a whole was thus a clear reflection of the New York art world of this period, and Geldzahler himself, who did enter that world precisely in 1960 and became almost immediately one of its most visible activists, was certainly being true to his own experience in organizing it as he did. The show, in fact, could almost be seen as a valedictory to the decade.

The art world, of course, turned out in all its motley splendor for the opening. Geldzahler had seen to that. Everyone came—the artists, the artists' wives or widows, the girl friends and the boyfriends, the collectors, the critics, the dealers, the secretaries and assistants from the galleries, even some of the behind-the-scenes types, such as the three Lebron brothers, art handlers and shippers, who had stretched a good many of the canvases that hung on the walls. More than two thousand invitations were sent out, and then, when it was suddenly realized that the day set for the opening—October 15, 1969—coincided with the Moratorium Day demonstrations against the Vietnam war, more than two thousand telegrams were sent out, postponing the opening until October 18. Only two people turned up on the wrong night, but a good many more than two thousand crowded in on the eighteenth. The stately, black-tie world of the Metropolitan trustees found itself mingling with tribal swingers dressed as American Indians, frontiersmen, Cossacks, Restoration rakes, gypsies, houris, and creatures of purest fantasy. The see-through blouse achieved its apotheosis that night, and spectators lined up three-deep to observe the action on the dance floor—there was a rock band in one gallery and a dance orchestra in another, to say nothing of six strategically placed bars. Works of sculpture acquired festoons of empty plastic glasses, the reek of marijuana hung heavy in the air, and at one point

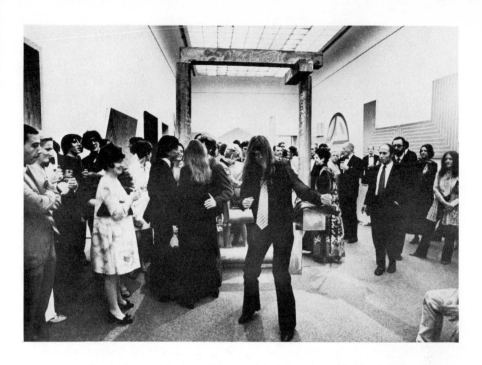

"HENRY'S OPENING," OCTOBER 18, 1969 (Courtesy The Metropolitan Museum of Art)

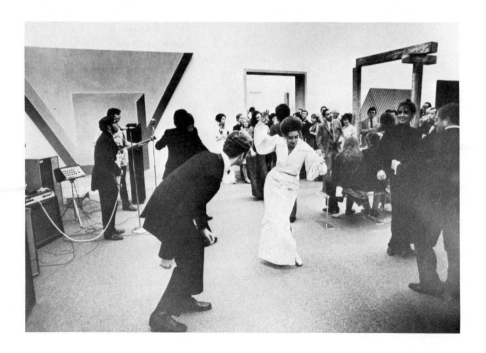

late in the evening, while the rock group blasted away in a room full of Frank Stella's paintings and David Smith's sculptures, a tall woman and a lame sculptor wrestled for fifteen minutes on the parquet floor, untroubled by guards, spectators, or a century of Metropolitan decorum. Exhilaration was everywhere, compounded of pride, chauvinism, and sheer visual delight. The New York School had wrested the mantle of artistic supremacy from Paris (as one was forever being reminded), and here was the visible proof of this historic victory: individual galleries devoted to the work of Jackson Pollock, Arshile Gorky, Barnett Newman, and the other giants of Abstract Expressionism (the general feeling was that Geldzahler, with his 1960s eye, had not really done justice to this heroic period in the 1940s and 1950s, but then who could?); the monumental abstractions of Mark Rothko, Morris Louis, Kenneth Noland, and Frank Stella, installed for the first time in monumental galleries whose scale fully matched their own; mini-retrospectives of the work of Robert Rauschenberg and Jasper Johns, the artists who had broken out of the Abstract Expressionist net in the 1950s and opened the way for a whole galaxy of new image-makers; rooms and rooms filled with the bold, single-image color painting of the 1960s; and, beyond them, more rooms containing the brash "new American landscape" of Pop Art (formerly one of Geldzahler's primary enthusiasms, but no longer— he had written in the catalogue that Pop now seemed "an episode, an interesting one . . . but not a major movement which continues to spawn new artists"). The real guiding principle behind Geldzahler's selections had been color, and his show was above all a color show— "a marriage of history and the pleasure principle," he called it. It was a gorgeous and dazzling display of pure chromaticism, which seemed, under the circumstances, to be as reflective of 1960s America as violence or frozen apple pie.

And at the pulsating center of it all was Geldzahler himself, rotund and effervescent, wearing a blue velvet dinner jacket he had had Blades run up for the occasion, and greeting everybody with the insouciant charm that makes it so difficult even for his enemies to dislike him. There was Geldzahler at the top of the grand staircase chatting with Andy Warhol and Warhol's new superstar, a personage of indeterminate sex in a silver dress and silver-painted sneakers. (When people asked Warhol why he didn't go inside and see the show, he replied inscrutably, "I am the first Mrs. Geldzahler.") There was Geldzahler with Mrs. Robert C. Scull, the wife of the biggest collector of Pop Art, whose portrait by Warhol *(Ethel Scull 36*

Times) was on public exhibition for the first time in Henry's show. There was Geldzahler with Thomas P. F. Hoving and Arthur A. Houghton, Jr. (the director and the president, respectively, of the museum), with Marion Javits, with Robert Rauschenberg and Leo Castelli, with Frank Stella, with Jasper Johns. If Geldzahler's show could be seen as a reflection of the 1960s art world, with all its costume-wearing, role-playing, art-as-a-branch-of-show-business permissiveness, then Geldzahler was surely that world's archetypal figure, and, as such, a historical artifact in his own right. And how on earth, it might be asked, had he managed that?

Like a lot of people who became well known in the 1960s, Henry Geldzahler is sometimes said to have made himself up—to have projected a somewhat outlandish public image and then taken up residence inside it. Nothing could be further from the truth. Even as a child, he showed most of the qualities by which he is well known today, and never in his life has he seen any particular reason for being dissatisfied with himself.

Geldzahler was born in Antwerp in 1935. The family, which had originated in Poland, had long been prominent in the Belgian diamond business. Geldzahler's mother had come to the United States at the time of World War I and stayed for several years before returning to Belgium. During this period, she became a naturalized American citizen, which made emigration easier when World War II broke out. The family left Antwerp on March 1, 1940, ten weeks before the Germans invaded Belgium. They settled in a comfortable apartment on Riverside Drive in New York, and Mr. Geldzahler quickly reestablished himself here as a diamond broker, acting between the large mining concerns and the hundreds of retail diamond dealers. Henry and his older brother, David, had grown up speaking French and Flemish, but they learned English so rapidly that within a few weeks of their arrival they pretended not to know their mother when she addressed them in French in public.

The two brothers were not at all alike. David was well built and athletic—a natural leader who seemed immediately at home in the environment of P.S. 166 and, later, at the Horace Mann School, in Riverdale. Henry was more exotic. A beautiful child whose white-blond hair and blue eyes gave him a Scandinavian look, he developed into a pudgy, moonfaced adolescent with a lisp. Until he was eleven, he did poorly at school. Then, after therapy had disposed of the lisp, he suddenly zoomed to the top of his class and stayed there. Neither

the lisp nor a total absence of athletic ability ever interfered with his popularity; he was friendly, gregarious, and at ease with everyone—adults included—and any boy who tried to intimidate him was certain to be put in his place by one of Henry's larger classmates. He was elected president of his senior class at Horace Mann, by one vote. He was also voted the second "most respected" member of the class. At Yale, which he had chosen because one of his best friends from Horace Mann was going there, Geldzahler became a moderately prominent personage. "There was no subject on which he wasn't well informed," a classmate recalls. "He always managed to see every movie before you did. When you suggested going to something that had just opened, he'd say that it was 'sort of interesting' and agree to see it again. I used to wonder if he had special screenings arranged for himself. Henry was also famous for his low threshold of boredom, but actually he was terribly nice, once you got used to the fact that he was going to be insufferable about fifty per cent of the time."

Geldzahler's father wanted both his sons to become lawyers. David did become one, but Henry decided very early that he would not. At

HENRY AT EIGHT

Horace Mann, he had been interested chiefly in modern literature—he once planned to read the complete Modern Library, and he did get through a good part of it—but in his freshman year at Yale he took an art-history course that decided his future career. Geldzahler had always loved looking at pictures. As a child, he had made his mother take him to one museum or another nearly every Saturday, and in 1951, when he was fifteen, he had what he now considers his Great Revelation. An important retrospective exhibition of paintings by Arshile Gorky was being shown at the old Whitney Museum, on Eighth Street. Geldzahler wandered in one day and stayed for three hours. "It made me sick, physically sick," he has said. "I went home and slept for eighteen hours, and then went back and saw the show all over again. This was the first time I realized that modern art was interesting enough to make me sick." From then on, he did a lot of gallery visiting. He went to all the Whitney Annuals—exhibitions that attempted to display the full spectrum of contemporary American art. "I'd go to the Whitney day after day and spend hours," he has said. "I hadn't come to any critical sense, and I thought that what you had to do was look at every picture. Now I've had enough experience so that I can walk into a room and know immediately whether I'm going to stay or whether I'm seeing something that's been done before in a stronger way. But I couldn't do that then, and so the Whitney Annuals always affected me as, you know, a sickening experience. But I'm grateful to them, because by showing the bad along with the good they helped me to learn the difference."

His interest rekindled by the art-history course at Yale, Geldzahler spent nearly all his college weekends in New York, taking in the galleries and the museum shows. In the summer of his sophomore year, he applied for and got a volunteer job at the Metropolitan, working in the Department of European Paintings. Margaretta Salinger, who was running the department in the absence of Theodore Rousseau, then its senior curator, took to him immediately. "I would send him down to the library to do some research and say to myself, 'That'll keep him busy for a few hours,' " she recalls. "He would be back in forty minutes with the job done and the letter to the appropriate person already typed out on his portable Olivetti, which he insisted on bringing to the office. Henry was so bright and so *educable*." That September, he went to Paris, and he spent his junior year studying at the École du Louvre and at the Institut d'Art et d'Archéologie of the Sorbonne. He also found time to travel extensively, looking at pictures, re-polishing his French, and learning some Italian and Spanish.

When he returned to Yale the following September, his friends found him more sophisticated, even better informed on a variety of subjects, and just as intent on the avoidance of boredom. He belonged to a secret society, Manuscript, and to two other extracurricular clubs, the Elizabethan and the Pundits. Geldzahler's teachers in the Department of the History of Art considered him a hard-working, conscientious student but by no means a flamboyant, or even a particularly memorable, one; the chairman of the department at that time recently described him as being "somewhat mousy." Geldzahler graduated in 1957, *magna cum laude,* and went to Harvard to do his graduate work. "I knew that NYU had the best graduate school for art history," he has said, "but I also knew that it had a reputation for demanding six or seven years for a Ph.D., and that Harvard was quicker."

For a while Geldzahler felt somewhat isolated at Harvard, which was less cohesive and more self-consciously individualistic than Horace Mann or Yale. A lot of strange new styles of dress and behavior were making their appearance in Cambridge about this time—styles that were also in evidence in Greenwich Village and across the continent at Berkeley but nowhere else, and certainly not at Yale. In candlelit coffeehouses around Harvard Square, undergraduates mingled with the advance guard of the new subculture, listened to folk music, and absorbed the new vibrations. Joan Baez got her first important job at the Mount Auburn 47, a coffeehouse opened in 1957 by two girls who borrowed money from Geldzahler to get it going; Baez was only seventeen when she started singing—a striking, dark-haired girl with a voice so pure that it brought tears. A good deal of experimentation was going on, with ideas as well as with drugs; it was becoming imperative to do your own thing, whatever that was, and to encourage others to do theirs.

Under the circumstances, Geldzahler's sense of isolation did not last long. Buoyed by psychoanalysis, which he embarked on as a first-year graduate student and continued for two years (with what he considers highly beneficial results), he developed his own thing to such an extent that he was soon a kind of guru of the coffeehouse scene, first at the Mount Auburn 47 and later at the Mozart, which he ran for three months the next summer, because his father thought the experience would be useful. ("It was hideous work," Geldzahler says, "and I ended up clearing about fifty bucks a week.") An undergraduate who knew him in this period says that Geldzahler's effect on younger students was phenomenal. Students of both sexes were mesmerized by

his brilliant, amusing perceptions on every imaginable subject, and by his unusual but not unattractive appearance—short, plump, his round face wreathed in fair, straight hair (considerably longer than it had been at Yale) and ending in a neat little chin beard, he looked, as his Yale friend Calvin Trillin once observed, like Charles Laughton at the age of sixteen. Geldzahler's conversational style was greatly admired. He did not really seem to have original *ideas,* but he knew a lot, and his mind moved so quickly that sometimes his perceptions *seemed* like original ideas. He would ask questions, bring others into the conversation, draw forth their opinions, and allow everybody to go home feeling that something extraordinary had taken place. "Somehow, any place where Henry was currently holding forth sort of became the place to be," another friend of his has recalled.

The full flowering of Geldzahler's new style could best be observed at the Bick—the Hayes-Bickford cafeteria that became a gathering place for a group of Harvard wits, among whom Henry shone with singular but by no means exclusive brilliance. The group included a graduate student in Oriental languages, a biochemistry major from Nebraska, a mathematical wizard who had switched his major to Middle English, and an undergraduate named Paul Richard, who has said that the conversations at the Bick were by far the most important aspect of his own education at Harvard. Geldzahler was the only one of the group who was involved with the plastic arts. The others leaned toward music (folk and blues) and literature, but they were quite prepared, as was Geldzahler, to talk with great confidence and *brio* on any branch of aesthetics. Richard, who is now the art critic for *The Washington Post,* feels that they were really experimenting at the Bick with a new kind of intellectual style and attitude—an attitude that was to be reflected in the art of the 1960s. "What went on there was a terrific kind of rapid-fire wit that was different from what you heard anywhere else," he recalls. "You never got hung up on any one subject, and there were no fixed positions or ideologies; it was a *field* situation, in which everything interacted with everything else—a whole new area of awareness that was wide open for discovery. Nobody was trading on his own special areas of study, although we all learned a lot from each other—Henry in particular, because he could always recognize it when someone knew more than he did. There was a constant, shifting movement of thought, without connectives, and you had to move with the flow and not hang on to things. We didn't talk politics—that would have been uncool. The basic preoccupation was with aesthetics, but aesthetics without any sort of hierarchy ex-

cept quality. Baez and Bob Dylan were interesting, and so was Bach. It was a new language, somehow, and for me it anticipated all sorts of things that came later. The Beatles, for example. They spoke the same language in their music, and John Lennon got a lot of it into those books he did: puns, put-ons, W.C. Fields one-liners, McLuhan-type perceptions—the whole cool style."

Moving with the flow did not prevent Geldzahler from studying. He took eight courses the first year, and spent the next year studying for his generals and teaching in the basic undergraduate art-history course. His students found his lecture style heavy and pedantic, without a trace of the bubbling wit that brightened the hours at the Bick; like his teachers at Yale, his students at Harvard saw only his conscientious and dutiful side, which some of his closest friends barely even suspected. Although he was acquiring a solid grounding in art history, Geldzahler's main interest remained twentieth-century art. "I remember once asking an Episcopal minister whether it was possible to stay alive, with an open and fresh mind, after you were thirty, because I'd noticed that around me it was very rare," he once said. "And I thought that by being involved with twentieth-century ideas and contemporary art I'd be continually challenged by new stimuli— that it would be a way of not hardening or ossifying." Sometimes he wished his teachers would take him a little more seriously. He often studied in the Widener Library with another art-history student, Svetlana Leontief, and nearly every afternoon Professor Sidney Freedberg, the eminent art historian and Renaissance scholar, would pass by their table. Invariably, he would nod to Geldzahler and then lean over Miss Leontief's shoulder to see what she was reading. "Why don't you ever want to know what *I'm* reading?" Geldzahler asked him one day. Professor Freedberg observed him reflectively. "Svetlana is a mind, Henry," he said. "You are an eye."

In the middle of his third year at Harvard, Geldzahler passed his Ph.D. general examinations and was starting in to work on his thesis, dealing with the sculpture of Matisse, when he received a telephone call from James J. Rorimer, the director of the Metropolitan Museum. He had met Rorimer a few times in the summer of 1954, when he was working at the museum. Rorimer had then been curator of the Medieval Department and director of The Cloisters, the museum's medieval branch uptown; he was named director of the Metropolitan the following year, and, like all museum directors, he kept a sharp eye out for bright young graduate students in art history. Rorimer remembered Geldzahler, and had made inquiries about him at Har-

vard; he was calling to invite him to breakfast at the Ritz, in Boston, where he was staying briefly. The breakfast lasted from nine until after one. They talked about a great many things, and at the end Rorimer asked whether Geldzahler would like to come to work for the Metropolitan. Geldzahler, who is rarely anything but frank, said that he was interested in contemporary American art and that what he really wanted to do was to work for the Whitney Museum. Rorimer seemed surprised.

Within the next few weeks, however, two things happened: Geldzahler found out through one of his professors that there was no chance of his getting a job at the Whitney in the foreseeable future, and Rorimer called back with an offer of a job as a curatorial assistant in the Metropolitan's Department of American Paintings and Sculpture. "Everybody urged me to stay on and take my Ph.D. so I could get a good job," he recalls, "but here I was being offered a good job." He left Harvard in June, without a Ph.D., and reported for work at the Met on July 15, 1960.

American art had always been something of a problem at the Metropolitan. In 1870 the museum's founding board included three painters and one sculptor, but even they seemed to share the other trustees' belief that real art was something that occurred in Europe, and to feel that one of their museum's prime functions was to improve the quality of American art by exhibiting French Barbizon pictures. Over the years the museum had acquired a sizable quantity of American paintings as a result of two purchase funds given in 1906 and 1911 by the department-store owner George A. Hearn, who stipulated that the income be used to buy pictures by living American artists. From the time of Hearn's death, in 1913, however, the Metropolitan's purchases in this field had been ultraconservative; the trustees, in fact, even succeeded for a while in reinterpreting Hearn's bequest so that the funds went to buy works by artists *living at the time of the gifts* but long since safely dead. The museum's serene obliviousness to every major trend in twentieth-century art was actually an important factor in the establishment of the Museum of Modern Art, in 1929, and the Whitney Museum of American Art, in 1930. Finally stung to action in 1947 by rising complaints from artists and critics, the Metropolitan trustees worked out a complicated legal scheme called the Three Museum Agreement. The Met was to make regular purchases of older works of American and European art from the Modern (works that had become "classic" in the modern tradition), and the

Modern would apply the money to the purchase of new works—an arrangement similar to the one that had existed for some time between the Luxembourg and the Louvre, in Paris. The Whitney, meanwhile, was to move into a new wing of the Metropolitan, where the two museums' collections of American art would be brought together. The Three Museum Agreement did not last long. Unable to concur with the Metropolitan's architectural plans for the new wing, and angered by what they considered the contemptuous attitude toward modern art in general of the Metropolitan's director, Francis Henry Taylor, the Whitney's trustees pulled out after the first year. The Museum of Modern Art followed suit a few years later, for a number of reasons, among them the fear that too many of its future benefactors might decide, since their benefactions were likely to end up at the Metropolitan anyway, to give them to that institution in the first place.

The failure of the Three Museum Agreement did lead to the establishment, in 1949, of a Department of American Art at the Metropolitan; until then, American art had been a sort of minor responsibility of the Department of European Paintings. Francis Taylor also mollified the critics by bringing in Robert Beverly Hale, a well-known artist and art teacher, to run the new department. Hale accomplished a good deal over the next decade, against fairly heavy odds. A number of trustees on the purchasing committee used to break into laughter whenever he brought an abstract picture to their attention, and he once came close to being fired for buying a small Pollock out of his own modest curatorial budget. Nevertheless, Hale saw the Abstract Expressionists as the strongest new force on the horizon, and he did his best to acquire their work and to fill other gaps in the Metropolitan's contemporary holdings. He even managed to persuade a few of the trustees that modern art was not entirely a hoax, although one of the most active members of the board let it be known that he looked only at the floor every time he had to walk through the single gallery set aside for modern painting.

Rorimer had told Geldzahler that he would be specializing in twentieth-century art. Since there was still relatively little of that in the Metropolitan, both Rorimer and Hale urged him to spend a good deal of his time outside the museum, visiting artists and studios and galleries, and generally keeping up. Nothing could have suited Geldzahler better. As one of his Harvard friends put it, "Henry had been a cult figure at Cambridge. We wondered how long it would take him to make his mark in the big city, and we soon found out—in six

vard; he was calling to invite him to breakfast at the Ritz, in Boston, where he was staying briefly. The breakfast lasted from nine until after one. They talked about a great many things, and at the end Rorimer asked whether Geldzahler would like to come to work for the Metropolitan. Geldzahler, who is rarely anything but frank, said that he was interested in contemporary American art and that what he really wanted to do was to work for the Whitney Museum. Rorimer seemed surprised.

Within the next few weeks, however, two things happened: Geldzahler found out through one of his professors that there was no chance of his getting a job at the Whitney in the foreseeable future, and Rorimer called back with an offer of a job as a curatorial assistant in the Metropolitan's Department of American Paintings and Sculpture. "Everybody urged me to stay on and take my Ph.D. so I could get a good job," he recalls, "but here I was being offered a good job." He left Harvard in June, without a Ph.D., and reported for work at the Met on July 15, 1960.

American art had always been something of a problem at the Metropolitan. In 1870 the museum's founding board included three painters and one sculptor, but even they seemed to share the other trustees' belief that real art was something that occurred in Europe, and to feel that one of their museum's prime functions was to improve the quality of American art by exhibiting French Barbizon pictures. Over the years the museum had acquired a sizable quantity of American paintings as a result of two purchase funds given in 1906 and 1911 by the department-store owner George A. Hearn, who stipulated that the income be used to buy pictures by living American artists. From the time of Hearn's death, in 1913, however, the Metropolitan's purchases in this field had been ultraconservative; the trustees, in fact, even succeeded for a while in reinterpreting Hearn's bequest so that the funds went to buy works by artists *living at the time of the gifts* but long since safely dead. The museum's serene obliviousness to every major trend in twentieth-century art was actually an important factor in the establishment of the Museum of Modern Art, in 1929, and the Whitney Museum of American Art, in 1930. Finally stung to action in 1947 by rising complaints from artists and critics, the Metropolitan trustees worked out a complicated legal scheme called the Three Museum Agreement. The Met was to make regular purchases of older works of American and European art from the Modern (works that had become "classic" in the modern tradition), and the

Modern would apply the money to the purchase of new works—an arrangement similar to the one that had existed for some time between the Luxembourg and the Louvre, in Paris. The Whitney, meanwhile, was to move into a new wing of the Metropolitan, where the two museums' collections of American art would be brought together. The Three Museum Agreement did not last long. Unable to concur with the Metropolitan's architectural plans for the new wing, and angered by what they considered the contemptuous attitude toward modern art in general of the Metropolitan's director, Francis Henry Taylor, the Whitney's trustees pulled out after the first year. The Museum of Modern Art followed suit a few years later, for a number of reasons, among them the fear that too many of its future benefactors might decide, since their benefactions were likely to end up at the Metropolitan anyway, to give them to that institution in the first place.

The failure of the Three Museum Agreement did lead to the establishment, in 1949, of a Department of American Art at the Metropolitan; until then, American art had been a sort of minor responsibility of the Department of European Paintings. Francis Taylor also mollified the critics by bringing in Robert Beverly Hale, a well-known artist and art teacher, to run the new department. Hale accomplished a good deal over the next decade, against fairly heavy odds. A number of trustees on the purchasing committee used to break into laughter whenever he brought an abstract picture to their attention, and he once came close to being fired for buying a small Pollock out of his own modest curatorial budget. Nevertheless, Hale saw the Abstract Expressionists as the strongest new force on the horizon, and he did his best to acquire their work and to fill other gaps in the Metropolitan's contemporary holdings. He even managed to persuade a few of the trustees that modern art was not entirely a hoax, although one of the most active members of the board let it be known that he looked only at the floor every time he had to walk through the single gallery set aside for modern painting.

Rorimer had told Geldzahler that he would be specializing in twentieth-century art. Since there was still relatively little of that in the Metropolitan, both Rorimer and Hale urged him to spend a good deal of his time outside the museum, visiting artists and studios and galleries, and generally keeping up. Nothing could have suited Geldzahler better. As one of his Harvard friends put it, "Henry had been a cult figure at Cambridge. We wondered how long it would take him to make his mark in the big city, and we soon found out—in six

months he was famous." Geldzahler's arrival coincided with the crystallization of a new art scene in New York. The Abstract Expressionists, after a decade of dominance, were being challenged by another generation of experimenters and iconoclasts. Robert Rauschenberg's collages and "combine-paintings," which incorporated Coke bottles, torn posters, light bulbs, automobile tires, and other bits and pieces of the urban environment, and Jasper Johns's talismanic paintings of flags, targets, and numbers had pointed in a new direction while retaining some of the painterly qualities of Abstract Expressionism. Inspired to a large degree by Rauschenberg and Johns, a group of younger artists had seemingly abandoned abstraction altogether, in favor of the brash new style of Pop Art, whose subject matter and technique were drawn from advertising and commercial art. Several of the new artists were working in total isolation, unaware that they were part of a movement; others had joined forces to put on improvised theater pieces called happenings in downtown lofts and galleries. Within a very short time, Geldzahler had met them all, seen their work, appeared in their happenings, and become a prominent and highly visible Pop Art personality.

Ivan Karp got him started. Karp, a volatile young dealer who was then the assistant director of the Leo Castelli Gallery, had also run a small gallery during several summers in Provincetown, which was where Geldzahler met him. Geldzahler had impressed Karp as a very bright kid who was an odd combination of sophistication and adolescence. When Geldzahler came to New York in 1960, he immediately called Karp, who took him around that fall to all the important openings and filled him in on who was interesting or useful. "Henry remembered all the names, too," according to Karp. "He was always good at that." Geldzahler would spend the morning at his desk at the Metropolitan, and then, in the afternoon, go downtown with Karp—sometimes *way* downtown, to places like Coenties Slip, near the Battery, where James Rosenquist and Larry Poons had their studios, more often to loft buildings between Fourteenth and Houston Streets. After climbing four or more flights of rickety stairs, Geldzahler might arrive somewhat winded, but his enthusiasm rarely flagged. He would always ask if there was anybody else in the building whose work he should see, or anybody in the neighborhood. One of the first artists he met was Claes Oldenburg, whose early constructions had been shown that spring in the first of two eye-opening group shows called "New Forms-New Media," at the Martha Jackson Gallery.

Oldenburg was also doing happenings, and he asked Geldzahler to

be in one of them. Geldzahler appeared the following February in Ol-
denburg's *Ironworks/Fotodeath,* at the Reuben Gallery, downtown.
He played the role of the father in a "soft family" of three persons,
who sat on a bench while a photographer tried vainly to take their
portrait—every time the photographer got them propped up, the fam-
ily would slowly collapse and slide floorward. In the second part of
the happening, Geldzahler had a scene in which he sat at a table and
made faces at the audience while a piece of black velvet slowly des-
cended over him. "He had such a great face," Oldenburg has ex-
plained, "and he obviously wanted to be used, so I used him."
Rorimer had made Geldzahler shave off his beard before he came to
work for the Met, and without it he looked more adolescent than
ever. According to Karp, there was always something *wholesome*
about Henry—you laughed, but not unkindly.

Geldzahler also spent a great deal of time at Frank Stella's place,
on Sixteenth Street. Geldzahler liked the energy and verve behind
Pop, but the artist he admired most was Stella, whose severe, sym-
metrically striped and ruled canvases were taking him, and a number
of others, in what seemed at the time to be a different direction en-
tirely. The two people who have most influenced Geldzahler's way of
looking at art, he says, are Clement Greenberg, the critic, and Stella.
"There's a kind of moral quality about Stella's work that really hits
me," he said recently. "When I look at one of those big, L-shaped
paintings, it gives me something like the Greek idea of the golden
mean—the scale is just right. It's a way of organizing your life." He
also finds a "moral grandeur" in the writings of Greenberg, whom he
describes as "a great man who has been right for twenty years."

At this time, too, Geldzahler saw a great deal of Andy Warhol. Al-
though Warhol was still two years away from his first New York
show, Geldzahler never doubted that he was an important artist. "We
talked to each other every day for six years," Geldzahler says. "Every
day would begin with a telephone conversation with Andy and end
the same way. Andy is always more real on the telephone than he is
in person—he needs some sort of mechanical funnel in order to get
through to you. What always impressed me about him was the way
he seemed plugged into the *Zeitgeist.* He was really the unconscious
conscience of the sixties. But the thing that truly fascinated me about
the Pop artists was that when I first went to see them in their studios
in 1960 they'd never heard of each other. They were all hitting their
stride, but they hadn't begun to show uptown yet. I remember going
out to New Jersey to see Roy Lichtenstein's comic-strip paintings and

being staggered by how close they seemed in sensibility to a whole previous experience in art—to Stuart Davis and Gerald Murphy and Léger, and even back beyond that to Jacques-Louis David and Poussin. So I think that my art-history training may have helped me to legitimatize to myself things that freaked a lot of people out at the time."

Nothing ever freaked Geldzahler out. He rode the gathering wave of Pop like a cork, bobbing happily from studio to studio (seven or eight studios a day, on the average), attending all the openings and all the parties, going out every night of the week unless the party happened to be at his apartment, in a brownstone on West Eighty-first Street. Within a remarkably brief period, it seemed, he had managed to become an integral part of the rapidly evolving 1960s art scene. Barbara Rose, the critic, who was married at that time to Frank Stella, used to say that Henry was the oil that kept the art machine turning. When he came across an artist who was really up against it, he would find some money for him. His enthusiasm was cheering, even though the Metropolitan did not buy any of the new art, and his readily proffered friendship was helpful in the increasingly important social context of the art scene. Through Henry, an artist might get to know some of the real art-world powers, like Leo Castelli and Alan Solomon, or receive a visit from one of the small but growing band of collectors of post-Abstract Expressionist art. Robert Scull, the taxi-fleet owner, who was crazy about Pop Art and spent half his time running around to artists' studios, thought of Henry practically as a member of his family. "We became lifelong friends in ten minutes," Scull has said. Henry, too, was plugged into the *Zeitgeist,* and the *Zeitgeist* was a field situation where there were no hierarchies or fixed positions; if you clung to a fixed position you were bound to miss a lot of what was happening all around you, and Henry didn't want to miss anything. Henry was moving with the flow.

The *annus mirabilis* of Pop Art was 1962. Nearly all the leading practitioners had their first uptown shows that year—Roy Lichtenstein at the Castelli (paintings of comic strips and household appliances), Jim Dine at the Martha Jackson (neckties, tools), Andy Warhol at the Stable (Campbell Soup cans, silk-screened Marilyn Monroes), and Jim Rosenquist (billboard-size auto parts) and Claes Oldenburg (giant "soft" hamburgers, ice-cream cones, etc.) at Richard Bellamy's Green Gallery, which was financially supported by Scull. Most of the established critics were scornful of the new work. Clem-

ent Greenberg dismissed Pop as "a new episode in the history of taste," and Peter Selz, a curator at the Museum of Modern Art, saw its apparent espousal of American mass-product materialism as an indication of "profound cowardice." The big-circulation news magazines treated the movement as a huge joke. They played it up as news, however, and this was no small factor in the public acceptance of Pop. The news media and the Pop artists suddenly discovered that they had a great deal in common, and it was no coincidence that Geldzahler, Leo Castelli, Alan Solomon, and other key figures in the promotion of the art of the 1960s made a point of being friendly to reporters. Abstract Expressionism had been difficult to write about, but Pop, with its blatant and literal subject matter, was a journalist's paradise. Pop Art was sheer McLuhanesque information. Although some people tried at first to link it with Dada and looked for evidence of social criticism in the subject matter, the fact was that the Pop artists were simply painting what they saw around them—painting quite literally and without much comment. Hamburgers, automobile tires, billboards, toothpaste grins, plastic appliances, F-111 fighter-bombers —this *was* the American landscape of the 1960s, as far as the artists were concerned, and instead of looking inward for their own personal reactions the artists were looking straight at it, accepting it, and reporting on it.

The year 1962 began with a great Pop event—a fantastic "store" on East Second Street that Claes Oldenburg had filled with plaster and papier-maché reproductions of the sort of discount food and clothing found in real stores on the Lower East Side. On opening night (which was actually in December 1961), neighborhood kids wandered in and out, pocketing items that the visiting uptown art crowd was buying for $50 and up—it was still a little hard to know how much of a put-on was involved. The following November, though, Sidney Janis's two-gallery show of American and European "New Realists," as he called them, officially certified that Pop was Art. A great many older artists and their supporters felt they had been betrayed when Janis, the leading Abstract Expressionist dealer, put his invaluable stamp of approval on the upstart movement. Several of Janis's artists were so furious that they left the gallery, forgetting that Janis, who had started out in the 1940s showing the work of Mondrian, Léger, and other School of Paris modernists, had made a similar commitment to the new in the 1950s, when he began showing Pollock, de Kooning, Rothko, and Kline.

The public triumphs of Pop went more or less unnoticed inside the

Metropolitan. Not many of the museum's curators and administrators were even aware that Geldzahler, who became an assistant curator in 1962, was considered one of those responsible for the spectacular success of Pop Art. That December, when the Museum of Modern Art decided to present a public seminar on the whole Pop phenomenon, Geldzahler was invited to be on the panel, along with Stanley Kunitz, Hilton Kramer, Leo Steinberg, and Dore Ashton. Rorimer had no objection to Geldzahler's attending, so he accepted. (Afterward, he found out that Rorimer had misunderstood him—Rorimer thought he had been invited to discuss the recently rediscovered New York artist known as Pop Hart.) Geldzahler, it turned out, was the only member of the panel who was willing to defend Pop Art *as art*. The others either condemned it as fraudulent or wished to reserve judgment, but Geldzahler argued that "it is the artist who decides what is art," and that the techniques and subject matter of Pop were legitimate expressions of contemporary sensibility. He also gave his view that Pop was not the *only* new art that he found legitimately admirable. "The best and most developed post-Abstract Expressionist painting is the big, single-image painting, which comes in part out of Barney Newman's work—I am thinking of Ellsworth Kelly, Kenneth Noland, Ray Parker, and Frank Stella," he observed at one point. When people accuse him these days of switching his allegiance from Pop to pure color abstraction, he reminds them of what he had said in 1962.

Warhol remained his primary link with the Pop world. Geldzahler spent part of every day at the Warhol "Factory"—the studio on West Forty-seventh Street, which was covered from floor to ceiling with silver foil. He was on friendly terms with all the odd types who hung around the Factory, and sometimes he gave Warhol ideas for paintings. It bothered Geldzahler that so many people thought that Pop Art was just a celebration of advertising values and mass taste; one day he handed Warhol a copy of the *Mirror* with a front-page headline reading "129 DIE IN JET"—two airplanes had collided over Brooklyn—and told him to do a painting of it. Warhol did. It was the start of a whole series of Warhol "death" paintings—electric chairs and automobile wrecks and people jumping from buildings. A few years later, Geldzahler told Warhol that he had done enough death pictures; it was time for life again, he said. Warhol asked what he meant, and Geldzahler picked up a photography magazine and opened it, at random, to a double-page color close-up of four flowers. "Like that," he said. Warhol had a silk screen made of the pho-

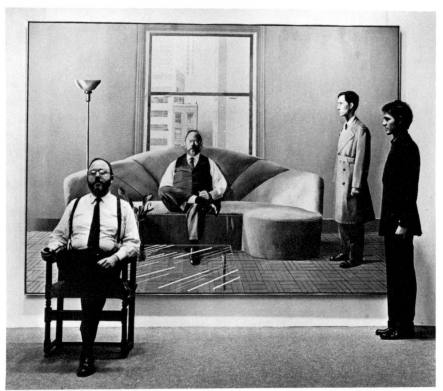

**WITH CHRISTOPHER SCOTT;
PAINTING BY DAVID HOCKNEY
(Cecil Beaton)**

tograph and used it to turn out a large series of flower paintings. "Henry gave me all my ideas," Warhol sometimes says, in his soft, deadpan way. In 1963, when Warhol began making films, Geldzahler appeared in them. The first film Warhol ever shot was a six-minute study of Geldzahler brushing his teeth. A year later, Warhol shot a hundred minutes of Geldzahler sitting on a couch smoking a cigar. Geldzahler considers it the best portrait ever done of him. "I went through my entire vocabulary of gestures," he says. "When someone turns the camera on you and doesn't tell you what to do or anything —Andy just goes off and plays rock 'n' roll—you find yourself making all sorts of faces and gestures just automatically. The film gives me away entirely."

Quite a few other artists have found Geldzahler an irresistible portrait subject. George Segal has cast him in plaster; Martial Raysse, Larry Rivers, Marcia Marcus, Alice Neel, and David Hockney have painted him; Marisol has carved a double likeness of him in wood;

and Frank Stella has summarized him abstractly in a canvas called *Henry Garden*. Salvador Dali wanted him to pose, too, but when Geldzahler learned that Dali was planning to sculpt a gold head with a tongue that wagged, he declined. The various portraits undoubtedly helped to make his features better known, although it is hard to believe that by 1963 there was anybody in the art world who did not already know Henry Geldzahler. Journalists found him an unfailing source of merry quotes. His influence was hugely exaggerated, to the extent that an awed correspondent for the San Francisco *Chronicle* once referred to him as "the single most powerful modern art figure in New York, and perhaps in the country." Unrecognized artists might say that "if Henry likes you, you're in," but the truth of the matter, as Stella pointed out, was that a boost from Henry might make an artist as many enemies as friends. No artist ever really got "in" on the strength of Geldzahler's favor alone, and his "power" was never supported by any significant purchase funds. Geldzahler certainly helped to spread the word about the artists he liked, though, and in his capacity as a highly sociable being he certainly achieved a sort of tribal, word-of-mouth influence on the scene generally. At any rate, he enjoyed all his publicity without being taken in by it. His friends called him the Little King, after the comic-strip character by Soglow. He refused to take himself as seriously as others did, which was one reason people found him so likable.

Geldzahler had so many people calling him up at work that the museum's telephone operator told him it would have to stop. "Two out of every three calls through here are for you," she complained. Geldzahler said he couldn't help it if he was the only curator whose artists were still alive. But his circle of acquaintance was not limited to artists. He saw people like Norman Mailer, whom he had met in Provincetown one summer; and Dennis Hopper, the actor and film director; and Jean Stein VandenHeuvel, whose husband was a special assistant to Robert Kennedy in the Justice Department. Geldzahler and Mrs. VandenHeuvel had met by accident back in 1958, at the Barnes Foundation, in Pennsylvania; she had seen him surreptitiously photographing a van Gogh (the Barnes Foundation does not allow photographs), and they had both giggled. A year later, they ran into each other on Madison Avenue, and after that she began inviting him to parties, where he met wealthy collectors and financiers and political bigwigs. Sometimes he would meet Metropolitan trustees at the VandenHeuvels', which did him no harm; it helped to dispel the aura of outrage that attached itself to some of his Pop activities. The Met-

ropolitan and the avant-garde still inhabited different social strata then, although barriers kept dissolving and you never knew whom you might meet at a New York party. When Truman Capote gave his masked ball in 1966, the only Metropolitan staff members he invited were Theodore Rousseau, the suave and elegant curator of European paintings, and Henry Geldzahler. Geldzahler, who went with Andy Warhol, wore a mask of his own face that Martial Raysse had made for him. Warhol turned to Geldzahler after they had been there for half an hour and said, "Gee, we're the only nobodies here."

And then there were the Woodwards. Stanley Woodward, a well-to-do retired diplomat who lived in Washington, was starting a private foundation to buy contemporary American art and place it in U.S. embassies and consulates. Woodward and his wife wanted someone to advise them, and their friend Mrs. William Lescaze, the wife of the architect, suggested Henry Geldzahler. Geldzahler and the Woodwards took to each other immediately, and he has been advising them ever since, for a small monthly retainer. "He's a wonderful guide," Woodward says. "He has marvelous taste and complete mental and aesthetic integrity. He points out what's there and lets you decide." The Woodwards liked Geldzahler so much that they invited him to go to Iran with them in the summer of 1963, and again in 1964. Geldzahler took Frank Stella along on the second trip, which led to a new series of Stella paintings, inspired by Islamic art. They went off the beaten track to Soltaniyeh, Yazd, and Mahan, looking at mosques. Geldzahler proved to be an indefatigable sightseer and shopper in native bazaars.

Geldzahler's energy and stamina in those days never failed to amaze his friends. How he managed to keep up with so many different people and places and events was a mystery to anyone who did not understand about the field situation. He would arrive late at openings and parties, stay for a little while, and then move on to other places, where everyone would be delighted to see him. There always seemed to be more laughter in the room when he arrived, although later it was hard to remember just what he had said that was so funny. His wit was evanescent and ephemeral, like so much of the new art. Sometimes, when the atmosphere of the field was just right, he could go beyond the bright one-liners and talk eloquently about a subject that interested him. It would have surprised a number of Geldzahler's friends to know that the real focus of his life was the Metropolitan Museum. A few of the trustees and several of the curators there were offended by the publicity he was getting, but they

found it nearly impossible to dislike him on personal grounds. Geld-zahler was so warm and friendly, so thoroughly *nice,* that he dis-armed criticism. Kay Bearman, a Smith graduate who worked in the Metropolitan's slide library until Geldzahler brought her into the Department of American Paintings and Sculpture in 1961, feels that he has been a major influence on her life. "He was incredibly kind to me," she says. "I didn't know anybody in New York then. He took me everywhere—to all the openings—and made a point of introduc-ing me to all the right people." Later, when Miss Bearman began to feel that she should strike out on her own, Geldzahler helped her to get a job working for Leo Castelli; she is now back at the Metropoli-tan as an administrative assistant to the vice-director. Although Geld-zahler's specific duties at the museum were a bit vague for several years, he did his work there conscientiously and efficiently. A few of his colleagues used to find his efficiency somewhat trying. He could not bear any sort of wasted time or effort, and it annoyed people when he called them and said, "Let's see each other for ten minutes this afternoon," and they found that he meant precisely ten minutes and no longer. But one always ended up liking him. "He's a genius with people, at creating the atmosphere of affection he needs," ac-cording to Allen Rosenbaum, who came to the museum soon after Geldzahler did, to work in the Education Department. "If anyone does show hostility toward him, he automatically assumes they must have some problem—that they're 'going through' something. He's hurt, but not diminished in his own eyes."

In 1965, when the Department of American Paintings and Sculp-ture got together a special exhibition of its collections (most of which had been in storage for years), Albert Ten Eyck Gardner and Stuart Feld wrote the catalogue for the nineteenth-century section, and Geldzahler did the one for the twentieth century. Geldzahler's text proved to be rather pedantic. Reviewing it in *Book Week,* Susan Son-tag called it "a perfect example of its genre—the institutional publi-cation . . . lifeless, tasteless, wholly uncontaminated by the human voice." Those who had heard Geldzahler lecture were not surprised by the earnest, plodding tone of his prose. Although scholarship was not his forte, he took all its implications very seriously, and he was writing more for his peers than for the general public. In any event, there was no indication that the catalogue injured his standing within the museum, where heavy prose has never been considered a draw-back.

One day early in 1966 Geldzahler received a telephone call from

the office of Roger Stevens, the chairman of the National Endowment for the Arts. Conceived under the Kennedy administration and established in 1965, the Endowment had recently received its first substantial appropriation from Congress and was in the process of expanding its programs in support of the arts generally. Stevens was looking for someone to run the Endowment's visual-arts program. Several people had recommended Geldzahler to him, and their first meeting was enough to convince Stevens that he had found his man. Rorimer, when Geldzahler reported the offer to him, seemed to think it would be a fine idea for the Metropolitan to have someone close to the font of federal gifts to the arts, and he asked whether Geldzahler was interested. Geldzahler said that he was, but not to the extent of giving up his chance to succeed Robert Hale. "Rorimer suggested that I take a year's leave of absence from the museum and we'd see what happened, and that's what I did."

Geldzahler soon discovered that being program director for visual arts did not require a great deal of his time, and so, when he was reappointed for a second year with the National Endowment, he came back to the museum and continued to handle the visual-arts job on the side. Some of Stevens' other program directors were a bit put out that Geldzahler spent so little time in Washington, but somehow he could manage to get his work done in half the time it took them, and Stevens was thoroughly pleased with his efforts. "Henry makes up his mind very fast, and he has plenty of self-confidence," Stevens has said. "So many people in the arts want to call up four or five experts and get their opinion before making a decision, but Henry doesn't do that. Besides, he was a lot less emotional than some of my other program directors."

Geldzahler's main function at the National Endowment was to give away money to individual artists. He originated a program of $5000 grants, set up regional juries to decide who would get them, and managed, in the three years he held the post, to pass out 119 grants, for a total of $595,000, which came to 35 per cent of the National Endowment's total budget for visual arts in those years. Starkie Meyer, Geldzahler's assistant in Washington, has said that whenever there was any unspent money in the budget, Geldzahler would ask Stevens to let him use it as a grant, and Stevens, who had complete trust in Geldzahler's judgment, would usually agree. Geldzahler also insisted that there be no strings attached to the grants—no progress reports, no follow-up letters, no checking to see how the money was being used. The artist, he said, was "involved not in products but in pro-

cess." He even refused to have photographs of the artists' work in his Washington office, because he didn't want some congressman coming in and making judgments on the basis of photographs. Stevens went along with all these stipulations, and it is perhaps an indication of Stevens' extraordinary skill as an arts administrator that not one of Geldzahler's grants—most of which went to artists who could hardly be described as conservatives, artistically or politically—caused so much as a ripple of protest in Congress. Moreover, when the first National Endowment grants were announced, in February 1967, the editor of *Artnews,* Thomas Hess, who had never been notably sympathetic to Geldzahler, wrote a glowing editorial in which he called it "the best list of grants . . . we have ever seen in the field." Hess said that the money had gone to artists at a point in their careers when it could make a real financial or psychological difference, and he characterized the enterprise as "a major contribution to our culture."

Several other National Endowment programs owe their inception to Geldzahler, among them a series of matching grants that enabled fifteen regional museums to spend a total of $300,000 to buy works by living artists, and his energy and initiative are still looked upon with admiration by his successors in Washington. Geldzahler did not really want to give up the job. After the 1968 election, though, he announced that if Roger Stevens was not reappointed by the new administration he would resign, and that's what happened. Nothing would please him more than to be appointed to the National Endowment's advisory board. As he often says, "What I really like to do best is give away money."

While Geldzahler was on leave from the Metropolitan, he was also invited to serve as commissioner for the U.S. pavilion at the Venice Biennale, the oldest and most highly regarded of all the big international art exhibitions. The offer came about in a rather backhanded way: The National Collection in Washington, which sponsors U.S. participation in such affairs, had originally invited Lawrence Alloway, a curator at the Guggenheim (and the British critic who coined the term "Pop Art"), to select and install the American exhibition in Venice. Alloway and Thomas Messer, the Guggenheim's director, got into a public dispute over which artists they wanted to show, however, and the National Collection thereupon rescinded the commission and offered it to Geldzahler. Naturally, he accepted. Just as naturally, the art world assumed that he would put together an exhibition heavily weighted toward Pop Art, with particular emphasis on his close friend Andy Warhol. Geldzahler did nothing of the kind. He realized,

he said, that if he took Warhol to Venice he would end up having to take Warhol's entourage as well—the Velvet Underground rock group, superstars of all sexes, and assorted publicity-seekers. Geldzahler was a little uncertain of his own position at the Met around this time. That spring, he had been in an Oldenburg happening that took place in a swimming pool; *Life* magazine had covered the event, and had run a photograph of Geldzahler lying in a rubber boat wearing a terry-cloth robe and smoking a cigar, which several Metropolitan trustees had considered a serious affront to the dignity of the museum. As Geldzahler has since put it, "I knew that if I took Andy to Venice I would never succeed Bob Hale."

There were other reasons as well. By 1966 Pop Art was neither new nor shocking. The strengths and weaknesses of the school had been thoroughly exposed in a dozen or more group shows here and abroad, notably at the 1964 Venice Biennale, where Alan Solomon, the U.S. commissioner that year, had exhibited works by Dine, Oldenburg, John Chamberlain, and Stella, along with paintings by the four "germinal" artists Rauschenberg, Johns, Noland, and Morris Louis. The Europeans' reaction to Solomon's show had been highly favorable, and Rauschenberg had become the first American artist to win the Biennale's Grand International Prize for painting—an event that several American critics angrily attributed to (unspecified) pressures on the jury by the Solomon-Castelli "cabal." Since that time, new tremors had been occupying the attention of art-world seismologists. Op Art, a form of trompe-l'oeil abstraction that turned out to be neither new nor a movement, had been briefly celebrated by the press following the Museum of Modern Art's 1965 show "The Responsive Eye." In the spring of 1966 the Jewish Museum's new director, Kynaston McShine, put on an extremely significant exhibition of "Primary Structures," whose impersonal, machined surfaces proclaimed an art stripped of everything but basic color and shape—Minimal Art. Another development was the kind of painting that Clement Greenberg called "Post-Painterly Abstraction." Some abstract painters of the 1960s, following certain tendencies in the work of such older artists as Barnett Newman, Mark Rothko, and Clyfford Still, applied color in simple shapes or bands (like Stella), or thinned it and poured it on the canvas (like Louis or Noland) so that it flowed and spread in "veils," seeking to achieve an effect of chromatic intensity that would resonate in the eye of the attentive viewer. Greenberg coined the term "color-field painting" to describe the work of Louis and Noland, which he had been supporting for several years in his writings and in

exhibitions that he organized for the New York gallery of French & Co. and, in 1964, for the Los Angeles County Museum of Art. Geldzahler never tried to conceal his admiration for Greenberg. "I feel that he's the best critic we've ever had, and that if I disagree with him I'm probably wrong," he said once. As early as 1962, at the Museum of Modern Art's symposium on Pop Art, Geldzahler had stated his belief that the new color abstraction was the best and most important art of the moment, and so it was not really surprising that he chose to put on what he called a "color show" in Venice. Louis, Noland, and Stella, the *chefs d'école*, had all been in Alan Solomon's show at the previous Biennale, which ruled them out for Geldzahler. He chose to exhibit Helen Frankenthaler and Jules Olitski—two color-field painters admired by Greenberg, but in Geldzahler's view underappreciated by the public; Ellsworth Kelly, a Paris-trained painter whose hard-edge abstractions presented an alternative to color-field painting; and Roy Lichtenstein, the Pop artist whose work, as several critics had observed, possessed strong formal qualities that linked up very nicely with color-field painting.

Although Geldzahler's choices were essentially conservative, he managed nevertheless to make himself controversial in Venice. "The day I got there," as he explains it, "I walked across the Piazza di San Marco with Martial Raysse, the French artist, who happens to be one of my best friends and who also happened to have a portrait of me hanging in the French pavilion. Right away, I began hearing rumors about a Franco-American cabal—Raysse politicking to get the Americans to throw their weight behind him for the International Prize. It made me ill. So I just sat down in my hotel room and worked out a press release and had it mimeographed." The press release deplored the Biennale's emphasis on politics and prizes, stated that no jury could proclaim aesthetic quality, and concluded that "the prize and jury system must be abandoned." It ruffled a number of Biennale sensibilities, and in the opinion of some it may have kept Lichtenstein from winning the international painting prize, which went that year to the Argentine artist Julio le Parc. Geldzahler was not alone in his disgust with Biennale politics, however, and two years later, when the system of prizes and awards was abolished, he was pleased to take part of the credit.

By 1966 a good deal of the glamour had seeped out of the New York art world. It was not exactly a lessening of artistic activity, although two of the most influential artists, Robert Rauschenberg and Andy

Warhol, had more or less stopped painting—Rauschenberg to explore the benefits of collaboration between artists and engineers, Warhol to make films. Art was still being produced in vast and dismaying quantity, but without the multiple shocks and astonishments of the years 1962-63. The Pop artists offered variations on themes that had grown familiar, and only Roy Lichtenstein and Claes Oldenburg seemed able to come up with new ideas. Nobody was doing happenings any more; the last big event of this kind had been Alan Solomon's and Steve Paxton's "First Theatre Rally" in the spring of 1965—a series of performances that included Geldzahler's epiphany in the swimming pool. Experiments in Art and Technology, or EAT, a foundation set up by Rauschenberg and his associates to further artist-engineer collaborations, had a great appeal for many young artists around the country, but EAT's first major project, the *9 Evenings* of art-and-technology performances, at the 69th Regiment Armory in October 1966, convinced many people that artists and engineers could never find true happiness together. ("We made a lot of people awfully happy, but not the audience," Rauschenberg conceded afterward.)

Geldzahler's adherence to color abstraction did not go down too well with some of his former friends. He and Warhol did not speak for two years after the 1966 Biennale, although this may have been in part because Geldzahler had picked up a piece of chalk from Warhol's studio floor that spring and written on a blackboard, "Andy can't paint any more, and he can't make movies yet." Some people accused him of becoming a mere acolyte of Greenberg's circle. It was sometimes said that Henry's eyes weren't too good but his ears were great. The truth was that Henry, as usual, was just being himself. Only later did it begin to occur to people that Henry's true self was essentially conservative, and even somewhat traditional, and that one of the reasons he so admired the kind of painting he did was that it was traditional *painting,* done with brushes (or, at least, with paint) on canvas, beautiful to look at, and highly suitable for hanging on the walls of the Metropolitan Museum.

In any event, ever since 1966 Geldzahler has settled more and more firmly into the role of a Metropolitan curator—dedicated, mildly eccentric, and thoroughly knowledgeable in his field. There was a brief period in 1967 when he worried about his future there. The sudden death of James Rorimer the previous spring left a good many unanswered questions dangling at the Met. For some time, Geldzahler had been urging Rorimer to establish a Department of Twentieth-Century Art, which would include not only American and European painting

and sculpture but decorative arts as well. Rorimer had seemed to favor the idea, yet nothing had been done about it. Now with Rorimer gone and Robert Hale getting ready to retire, there was great uncertainty within the Department of American Paintings and Sculpture. The new director, Thomas P. F. Hoving, eventually resolved the matter by establishing a Department of Contemporary Arts—a rather vague concept that was not at all what Geldzahler had had in mind—and putting Geldzahler in charge of it. The Department of American Paintings and Sculpture suffered an almost total collapse soon afterward, when Hale retired, Albert Gardner died, and Stuart Feld left to join the firm of Hirschl & Adler, dealers specializing in nineteenth-century American art. John Howat, a young assistant curator who was suddenly elevated to the top position, pulled things together admirably, and he and Geldzahler get along splendidly. Although Geldzahler was not entirely pleased with the new arrangement—"Contemporary Arts" being far narrower in scope than "Twentieth-Century Art"—he was now a full curator, and he felt reasonably confident of his ability to get along with Hoving.

There is no doubt that Hoving considers him one of the chief ornaments of his staff. "Henry really does his job," the director has said. "He's tops in his field—he knows as much about his field as any Egyptologist knows about his, and he's got the scholarly background to base it on. He's bought well, he handles himself well with the trustees, and he couldn't care less about what the critics say, which I love." Hoving, who has had his own bouts with the critics, values Geldzahler's willingness to say clearly what he thinks. Soon after becoming director, in 1968, Hoving made an arrangement with Robert Scull to show the Sculls' huge *F-111,* a ten-by-eighty-six-foot painting by James Rosenquist, at the Metropolitan. Geldzahler was not consulted, which annoyed him. Shortly thereafter, the French government offered the Metropolitan a loan show of French twentieth-century paintings; Geldzahler thought the quality of the works was poor and advised against accepting them. When he learned that Hoving had agreed to hang the show anyway, Geldzahler telephoned him long-distance—Hoving was in Palm Beach—and tendered his resignation. Hoving talked him out of it, but he conceded later that the incident had taught him a lesson. "Since then, I've tried to keep out of a curator's personal bailiwick," Hoving said. "A lot of people around here get furious with me, but at least Henry had the guts to come out and say so."

The title of Geldzahler's bailiwick was changed in 1970 to "Twen-

tieth Century Art"—a gratifying victory that solved some problems and created others. Geldzahler's department now includes all European and American painting and sculpture of this century, and also decorative arts, such as furniture and ceramics. (He spent the summer of 1968 studying at the Musée des Arts Décoratifs in Paris.) His functions thus overlap those of several other curators, but so far there have been no serious jurisdictional disputes. The museum, for one thing, still does not buy very much twentieth-century art; like all the curators there, Geldzahler spends a lot of time pressing hard for more space.

Geldzahler's purchasing policy is not, strictly speaking, contemporary. "The burden of what I'm trying to do is to catch up on what we missed during the last heroic period of painting," he said not long ago. "We don't have a Clyfford Still, we don't have an important David Smith, we don't have a Noland or an Olitski or an Anthony Caro. For that matter, we don't have an Arp, an important Henry Moore, or a great Matisse.* If it turns out ten years from now that I've missed something major from the present period, then will be the time to get it. I don't subscribe to Alfred Barr's idea that if one out of ten things you buy works out well, then you're doing a good job. That's all right for a museum that's devoted strictly to contemporary art, but I'm in the fortunate position of taking the long view, since I work for a museum that takes in the whole history of art." Geldzahler appears to have complete confidence in his own ability to spot the major works he is after. Whenever he gives a lecture, as he does fairly frequently, somebody in the audience usually asks him at the end how he knows when something is first rate, and he has a ready reply. "I say that it's primarily a visceral thing—a gut reaction. If it really upsets me, I know it's good. Then, there's memorability—if you remember it without trying to. And the third thing is if it continues to reveal more of itself on subsequent viewings—if it has an existence in time. Something by Robert Indiana or Tom Wesselmann or Marisol that tells you everything the first time interests me less. But with an artist like Edward Hopper you get that terrific shock of

* Geldzahler said this in 1971. In 1976 the museum has yet to acquire major works by Still, Olitski, Caro, Moore, or Matisse, but it does have a Noland and in 1972, through a transaction that was heavily criticized in *The New York Times* and elsewhere, it got David Smith's large stainless steel sculpture, *Becca,* from the Marlborough Gallery, together with a painting by Richard Diebenkorn, in exchange for six modern pictures from the bequest of Adelaide Milton de Groot. Geldzahler considers *Becca* one of the most important works by America's most important postwar sculptor. He had been trying to buy it since 1969 (the Metropolitan board had turned it down twice), and its acquisition, he feels, was well worth the controversy.

recognition on first view, and it continues to enthrall you, and you get the shock again and again. Incidentally, the other question I'm always asked after a lecture is what's going to happen next in art, and I usually paraphrase what Bob Rauschenberg once said when he was asked the same thing: 'I don't know, but I hope I'm in it.' What I say is, 'I don't know, but I hope I'll recognize it.' "

Although the Metropolitan's purchases in his field may never be extensive, Geldzahler does hope and expect to receive the kinds of works he wants by gift or bequest, and his many warm friendships with collectors like the Sculls and the Woodwards are by no means the least of his assets to the Museum. Collectors tend to like him because he makes them feel witty and knowledgeable, if only in agreeing with what he says. Businessmen also like him, because he is so businesslike. He does not waste time on the telephone, and he goes right to the point. As his old friend and mentor at the Metropolitan Margaretta Salinger said once, "I always think it's hardest to understand people who aren't quite sure what they want. Henry knows *exactly* what he wants, and he goes about getting it in the most direct and open way possible."

The art world is much quieter now than it was in the mid-1960s, and Geldzahler himself leads a considerably quieter and more private life than he did then. He no longer goes out every night, and his name appears only rarely in the gossip columns. Geldzahler moved to Greenwich Village in 1973 (the idea of living on the Upper East Side horrifies him), and he and his friend Christopher Scott spend most of their evenings at home, reading and listening to Geldzahler's huge collection of classical records (mostly opera and other vocal music). Geldzahler reads more than ever—six hours a day, on the average. He reads books on art and art history whenever an important one appears, but for the most part he prefers novels—and nineteenth-century novels at that. He has read his way through all of Trollope; recently he discovered Mrs. Gaskell, and he is now reading everything he can find of hers.

With his neatly trimmed beard, which he grew again in 1968, his well-cut, conservative clothes, his wide-brimmed leather hat, and his perpetual cigar, Geldzahler no longer looks much like Charles Laughton at sixteen; indeed, several of his friends have commented that he is getting to look more and more like the comfortable Victorians in the English novels he favors. Now and then, it occurs to him that he has become just what he always said he did not want to be. "I didn't want to go into the diamond business, but I realize that what

GELDZAHLER PONDERS A WALL;
LIGHT SCULPTURE BY DAN FLAVIN,
(Courtesy The Metropolitan Museum of Art)

I'm doing is essentially the same thing—I'm a sort of broker, or middleman, between precious objects and the people who buy them. It doesn't bother me. I love my job at the Met, and I really wouldn't want to be doing anything else—not at the moment, anyway. I had my palm read once, and it seems I have a career line that breaks in half. So it could be that I'll end up doing something entirely different, like producing movies with Dennis Hopper. I could see myself doing that."

Geldzahler still gets around to a lot of galleries and studios, and he keeps a sharp eye (and ear) on the current art scene. He is interested in the grandiose projects of the earth artists Michael Heizer and Walter De Maria; he has been to see Heizer's *Depressions* in the Nevada desert, and he believes it possible that future earthworks may declare themselves with such power and authority that they will be acquired by museums and maintained for the public in perpetuity—somewhat like the Sphinx and the Pyramids. The art-and-technology movement interests him less, although he did manage to get a $50,000 grant for EAT when he was working for the National Endowment for the Arts. "It's a good idea," he has said of the collaboration of artists

and engineers, "but in art there is no such thing as a good idea—there's only good work." As for the work of the conceptual artists—those who feel that the idea alone is what counts, and that the artist's idea, sketched or written down, need not necessarily be carried out—Geldzahler finds it provocative, but he doubts whether it will have much historical value. When Kynaston McShine put on a major show of conceptual art at the Museum of Modern Art in 1970, Geldzahler's comment was "Thank God you did it—now nobody else has to." Looking back at the 1960s today, Geldzahler tends to think that while all the excitement was going on in the New York art world "the really important work was being done in private, quietly and without publicity—Hans Hofmann's last paintings, David Smith's sculptures, the late work of Mark Rothko. Although ideas seem to be what count now, in the end it still comes down to a few masterpieces."

In some advanced art circles, Geldzahler is looked upon today as a sort of period figure—a 1960s personality who has proved to be as ephemeral as a great deal of 1960s art. Those who know him scoff at such a notion, however, and the stars belie it. One of Geldzahler's friends recently cast his horoscope, and read the results to a small gathering in Henry's apartment. To nobody's surprise, the forecast was almost embarrassingly rosy.

RAGGEDY ANDY

I'd prefer to remain a mystery.
I never give my background,
and anyway, I make it all up
different every time I'm asked.

There is a snapshot of Andy Warhol at the age of fourteen, taken in one of those do-it-yourself booths in a bus station. The features are delicate and well formed, the expression trusting, angelic. Time treated him unfairly. His face grew coarse, Slavic, with a fleshy nose and narrow eyes weak as a mole's. And of course the famous pallor—an almost total absence of pigmentation, the result of a childhood disease that may have been rheumatic fever, although his mother's reference to "nervous fits" suggests other causes. In spite of time's jokes, however, the face of that beautiful fourteen-year-old is instantly recognizable.

The first year Andy came to New York he lived with a whole group of boys and girls in a basement apartment at 103rd Street and Manhattan Avenue. This was in 1949. Everybody did something interesting or planned to—study dance, paint, write, make jewelry. Andy was very much the baby of the family. Although he may or may not have been nineteen at the time (his birth date varies each time he is asked), he seemed even younger. And so shy—he rarely spoke at all. One of the girls in the apartment remembers getting so mad at Andy for not talking to her that she threw an egg and hit him on the head with it. They all had a lot of fun, sharing food, money, and clothes and being such good friends—there was no sex involved. They went to the movies a lot, and had a communal crush on Judy Garland. When one of her films played the neighborhood Loews they all saw it six times.

Andy had no money at all then. Lila Davies, who went through art school at Carnegie Tech with him and who brought him into the Manhattan Avenue kibbutz, knew that he came from very poor peo-

ple. Andy's father, a coal miner and part-time construction worker, had come over from Czechoslovakia in 1912 to make his fortune, but fortunes were elusive even in America and it had been nine years before he was able to send back for his wife. Andy and his two older brothers grew up in McKeesport, Pennsylvania. Their name was Warhola—Andy shortened it when he came to New York. Not even Lila knew where the money had come from to send Andy through Carnegie Tech. The father had died in 1941, and for a while after that Andy had worked part time in the Five and Ten and had sold vegetables from a truck. He occasionally mentioned his mother and his two brothers, but never his father.

To the others in the apartment Andy seemed unbelievably naïve—so innocent that you felt the need to protect him. He spent a lot of his time in the apartment, drawing. Andy had worked out an unusual technique. He would sketch with a pencil until he got what he wanted, then copy the sketch very rapidly in ink on tissue and press the tissue down on watercolor paper before the ink dried. The result was a blotted, broken line that looked spontaneous and fluid and, oddly enough, highly sophisticated. Periodically, Andy would take his drawings around to magazines and advertising agencies. He couldn't afford a portfolio, so he took them around in a brown paper bag from the A & P.

One day he took his paper bag into the office of Tina Fredericks, who at that time was art director of *Glamour* magazine. She was intrigued both by the drawings and by Andy, pale and shy and a little forlorn in his old chino pants and dirty sneakers. She told him the drawings were good, but that what *Glamour* really needed at the moment were drawings of shoes. Andy came back the next day with fifty shoe drawings in the brown paper bag. *Glamour* eventually used several of them, and this led to his first commission from I. Miller. For the next few years I. Miller was Andy's meal ticket. Nobody had ever drawn shoes the way Andy did. He somehow gave each shoe a temperament of its own, a sort of sly, Toulouse-Lautrec kind of sophistication, but the shape and the style came through accurately and the buckle was always in the right place. The kids in the apartment noticed that the vamps on Andy's shoe drawings kept getting longer and longer, but I. Miller didn't mind. I. Miller loved them.

Andy never seemed to be working terribly hard. When his eyes began bothering him, though, Lila made him go to an oculist who told him he had "lazy eyes" and prescribed rather grotesque glasses to strengthen the muscles—the lenses were opaque, with a tiny pin-

hole to see through. To everyone's surprise, Andy wore them dutifully when he was working and a lot of the time when he was not. It began to occur to the others that Andy worked pretty hard. Still, he wasn't what you'd call ambitious, although he did have this thing about famous people. He was always writing to movie stars to get their autographs. He once wrote a letter to Truman Capote, to ask if he could illustrate *Other Voices, Other Rooms* (Capote did not answer), and then he had some wild idea about movie stars' underwear, that you could go into business selling underwear that had been worn by the stars; it would cost $5 washed and $50 unwashed. But all that was just fun and games, and nobody took it seriously when Andy said that he was going to be famous himself. Andy was so naïve, so fragile. The kids in the apartment would have done anything to shield him from the hard, aggressive, urban rat race.

> *Money doesn't worry me, either,*
> *though I sometimes wonder where*
> *is it? Somebody's got it all!*

Fritzie Miller felt that her husband, a commercial artist, was not getting the attention he deserved from his agent, so she said, "Why don't you let me take your stuff around?" and he said, "All right, why don't you?" Her husband and a couple of friends were her first clients. One day in the 1950s, soon after she started out as an agent, she went to see an art director named Will Burton. In Burton's office when she arrived was a slender boy in paint-splattered clothes, holding a hand-painted Easter egg. The egg was a present for Burton. "Andy, meet Fritzie," Burton said. "You need her."

They never signed a formal contract. In fact, a month or so after this first meeting Andy called up Fritzie in great agitation and said that a friend of his, who had taken his stuff around to the agencies in the past, had just returned from Europe and was angry with Andy for getting an agent. Andy, who was subject to a lot of anxieties at this time, worried that his friend might be going to beat him up. (The group in the Manhattan Avenue apartment had broken up by this time because the building was being torn down, and Andy had moved into a cold-water flat in the East Seventies with his mother, who had come to New York to visit him one day and just stayed on.) "Listen, Andy, forget it," Fritzie told him. "You don't owe me anything." But a month later Andy called up again and said he wanted Fritzie to represent him, and that's what happened.

Andy was still doing shoes for I. Miller, and quite a few other things as well. He designed stationery for Bergdorf-Goodman, Christmas cards for Tiffany's and for the Tiber Press, and record jackets for Columbia Records. For a brief period he drew the little suns and clouds in the weather chart on an early-morning television program— only his hand was visible on screen, but he had to get up at 5 a.m. and go to the studio to have his hand made up because otherwise it looked too white. He took any job he was offered, and everything he did was done professionally and stylishly, and on time.

Fritzie got him into the big women's magazines, first *McCalls* and *The Ladies' Home Journal,* and later *Vogue* and *Harper's Bazaar.* A lot of people in the industry began to notice Andy's magazine work. Whatever he illustrated—shampoo or bras or jewelry or lipstick or perfume—there was a decorative originality about his work that made it eye-catching. It was amazing, Fritzie thought, how someone with Andy's background could hit the right note so unerringly. The childish hearts and flowers and the androgynous pink cherubs that he used were not quite what they seemed to be; there was a slight suggestiveness about them that people in the business recognized and approved. He could kid the product so subtly that he made the client feel witty.

Andy never wore anything but old clothes. He would show up at *Vogue* or *Bazaar* looking like some street urchin in his torn chinos

TWO OF ANDY'S SHOE DRAWINGS
(Courtesy George Klauber)

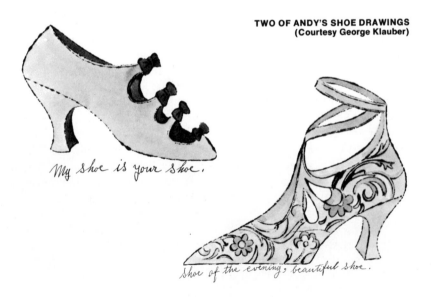

My shoe is your shoe.

Shoe of the evening, beautiful shoe.

and dirty sneakers—Raggedy Andy—and the editors and art directors found this irresistible. Imagine coming in here looking like that! Actually he was starting to make quite a lot of money—enough, at any rate, to rent two nonconsecutive floors in an apartment building on East Seventy-fourth Street, over a bar called Shirley's Pin-Up. Andy and Mrs. Warhola had their living quarters on the lower floor. Andy bought some furniture and other objects from Serendipity, but the place never really got to look furnished because Andy was always too busy. He was out all day and half the night, taking art directors to lunch at expensive restaurants, keeping appointments, going to parties. Andy went to all kinds of parties, even the ones given by somebody's secretary, because you could never be sure whom you'd meet or what it might lead to. Shy, inarticulate Andy, using his shyness and inarticulateness to superb effect, made a lot of contacts that way; most people found him charming and oddly fascinating. He hardly ever got home until past midnight, and then he would spend the next three or four hours working. Luckily he had a quick technique and could sketch a whole layout in a couple of hours. He worked on the top floor of the building, in a large, incredibly littered room. Magazines and newspapers and clothes and half-full coffee containers and swatches of this and that and discarded drawings and unanswered mail piled up in drifts on the floor, providing sport and concealment for Andy's cats. There were eight cats, all named Sam. Nathan Gluck, a designer who came in part time to help with layouts, occasionally tried to clean the place up a little, but it was hopeless. The cats lived there. The smell was something.

Through Emile de Antonio, a dropout college English teacher who knew everybody and made a sort of living in those days by putting artists and other talents in touch with people who could help them (he is now a film-maker), Andy went to see Eugene Moore at Bonwit Teller. Gene Moore, one of New York's little-known geniuses, was then in charge of window display at Bonwit's and also at Tiffany's, and he made a point of using serious young artists to do window decoration—Robert Rauschenberg and Jasper Johns supported themselves in this way for several years in the 1950s. According to Moore, Andy was unfailingly cooperative. "He worked hard and made it seem easy," Moore remembers. "On the surface he always seemed so nice and uncomplicated. He had a sweet, fey, little-boy quality, which he used, but it was pleasant even so—and that was the quality of his work, too. It was light, it had great charm, yet there was always a real beauty of line and composition. There was nobody else around then who worked quite that way."

Dan Arje, who took over the display department at Bonwit's when Moore went to Tiffany's full time, was equally enthusiastic about Andy. Andy was a real pro. He understood deadlines, and where other artists might freeze up under the pressure of having to do a window in two or three evening hours Andy would just come in and go right to work, painting freehand on the inside of the glass his witty and whimsical images—cherubs, pincushions, ice-cream fantasies. Once he built a wood fence out of scrap lumber and decorated it with graffiti and flowers and suns and the kind of stick people that kids draw. The mannequins looked fabulous against it.

Andy never stopped pushing. Every week or so, the art directors and fashion editors and display people would get some little reminder —a wash drawing of butterflies in candy-mint colors, for example, or a fanciful shoe on gold paper, just in case they forgot that Andy was around. He was furious when other illustrators started to imitate his blotted line and his cherubs. Gene Moore and others explained to him that he had to expect this, anybody with talent was bound to have imitators, but Andy didn't like it a bit. He seemed to want all the accounts, all the windows, all the business. Was it the memory of his grim childhood that drove him? "He does love money," Fritzie Miller conceded. "Not for himself, though—for what he can do with it."

But what was he doing with it?

> *I delight in the world,*
> *I get great joy out of it,*
> *but I'm not sensuous.*

Could that be Andy? In chinos and sneakers, a handkerchief knotted at the four corners on his head to ward off the sun, stepping gingerly around the ruins of Angkor Wat? Accompanied by Floyd Davis, the well-known *Saturday Evening Post* illustrator, and Gladys Rockmore Davis, the well-known Floyd's even better-known wife?

Andy and his friend Charles Lisanby were on a trip around the world. Lisanby, who designs sets for television and is an inveterate traveler, happened to mention that he was thinking of such a trip, and Andy, who had never been anywhere except Pittsburgh and New York and McKeesport, said, "Gee, can I come?" Lisanby was delighted. He and Andy had met at a party the year before, and they had taken an immediate liking to one another. As is the case with so many New Yorkers who come from somewhere else, Lisanby, who was born on a farm in Kentucky, had the easy assurance and polish

that Andy so much admired; Lisanby was fascinated by Andy's oddness, by the contrast between his naïveté and the extraordinary sophistication of his work. They left in June 1956, flying first to San Francisco and then out to Japan.

Lisanby planned the trip. From Japan they went to Hong Kong, Formosa, Djakarta, and Bali, and then to Cambodia, where they met the Davises. Andy did a lot of sketching. He seemed interested most of the time, although not what you'd call thrilled about anything; he particularly liked the gold-and-black-lacquer work they saw in Bang-kok. After Angkor Wat they went on to India. Lisanby wanted to go up to Nepal, which had recently been opened to tourists, but just before they were to go there he came down with a fever. An Indian doctor pumped him full of antibiotics, but the fever hung on and so instead of going to Nepal they booked tickets on a plane to Rome.

It was August by this time. As their plane came down for a landing at Cairo airport, they looked out the window and saw a great many tanks, soldiers, and machine guns ringing the perimeter; no one was permitted to disembark. Both Andy and Lisanby were quite surprised to learn, later, that there had been some sort of international crisis over Suez and that they had landed right in the middle of it.

In Rome they stayed at the Grand Hotel until Lisanby had fully recovered. Lisanby kept urging Andy to go out and see the sights, but Andy didn't feel like going out alone; he seemed quite content to stay in the hotel. When they got to Florence, however, Lisanby, who had been there several times, insisted on Andy's going into every church and museum, and Andy seemed to enjoy that. Andy's reactions to art were never very verbal. Faced with a Titian or a Botticelli, he might produce a mild "Wow!" or "Great!" but that would be the end of it. Lisanby once asked him what he really wanted out of life, and Andy replied, rather memorably, "I want to be Matisse." Lisanby in-terpreted this to mean that he wanted to be as famous as Matisse, so that anything he did would instantly become marvelous. Fame was certainly very much on his mind.

From Florence they went to Amsterdam for a week and from there they flew directly home, stopping in neither Paris nor London.

The artificial fascinates me,
the bright and shiny.

The boys at Serendipity helped Andy decorate the apartment over Shirley's Pin-Up. Serendipity, which was partly a restaurant and

partly a shop, catered to the kind of taste that had not yet been identified as camp. It had Tiffany glass before people were buying Tiffany glass. Andy bought a Tiffany lamp and some bentwood chairs, a long, soft couch, and a lot of white-painted wicker furniture, and from other shops on Third Avenue he picked up some American antiques. He had also started to buy pictures—a Magritte, some Miró lithographs, things like that. One of his friends from this period described the apartment's style as "Victorian Surrealist."

Serendipity also carried Andy's work. The original drawings for his I. Miller shoe ads were for sale there, and so were the drawings of imaginary footgear that he had taken to designing, fantastically ornate boots and slippers "dedicated" to famous personalities such as Truman Capote, Julie Andrews, Zsa Zsa Gabor, and James Dean. Serendipity carried Andy's books as well. The first of these was called *25 Cats Named Sam and One Blue Pussy.* Andy did the drawings, had them printed and bound, then got his friends to come in and help hand-color them. After the cat book came *The Gold Book,* a collection of Andy's blotted line drawings of friends, flowers, shoes, and other images on gold paper (the idea came from the gold lacquer work he had seen in Bangkok). Then there was *In the Bottom of My*

FROM ANDY'S CAT BOOK, C. 1954
(Courtesy George Klauber)

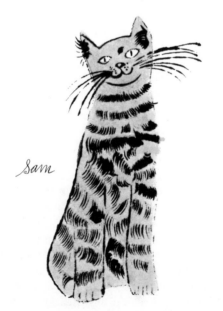

Sam

Garden (slightly suspect cherubs), and *Wild Raspberries,* a joke cook-
book with Suzie Frankfurt's recipes for dishes like "Salade de Alf
Landon" and "Seared Roebuck." The recipes in the cookbook were
written out in longhand by Andy's mother. Mrs. Warhola, who could
barely speak English, could not write it at all, but Andy liked her
handwriting and so he would give her the text and have her copy it
letter for letter, laboriously, missing or transposing a letter here and
there, which always delighted Andy enormously. Serendipity also had
a book called *Holy Cats* that really was by Andy's mother—she did
the drawings herself, as well as the captions, the rather risqué innuen-
does of which she probably did not understand.

Andy's friends all thought Mrs. Warhola was fabulous. Although
her English never improved very much, she was cheerful and sweet,
and she liked all of Andy's friends. Some of his friends thought it a
shame that Andy didn't let his mother come to the parties that Seren-
dipity gave whenever one of his books appeared. Even when he had a
show of his gold-shoe drawings in 1959 at the Bodley Gallery, a few
doors down from Serendipity's new store, on Sixtieth Street, Andy's
mother didn't come to the opening. But Mrs. Warhola never seemed
to mind. She was happy taking care of Andy, and seeing to it that he
went to mass every Sunday. Once, when Andy talked about going
somewhere in an airplane, Mrs. Warhola got very upset. "Too many
big shot die in the air," she said. Mrs. Warhola knew Andy was a big
shot.

> *I never wanted to be a painter.*
> *I wanted to be a tap dancer.*

In the late 1950s, the fashion crowd started to take an active interest
in the New York art scene. This was not without precedent, but it
was a change from the recent past. Throughout the heroic period of
American art in the 1940s and early 1950s, the era that saw New
York painting achieve international fame and influence, the artists
had kept pretty much to themselves, fighting private battles and forg-
ing private myths. *Vogue* and *Harper's Bazaar* had duly noted the
emergence of the New York School, had posed their mannequins
against Abstract Expressionist, dripped-paint backdrops and in-
formed their readers that "people are talking about" Jackson Pollock
and Willem de Kooning, but there had been no real interaction be-
tween the worlds of art and fashion. Now, however, a new spirit was
coming into vanguard art. Robert Rauschenberg and Jasper Johns

had broken out of the Abstract Expressionist net. Rauschenberg's paintings, which incorporated everyday images from the urban environment and actual everyday objects such as Coke bottles and street signs, had opened the way for a whole generation of artists who tended to look out at the world, rather than in upon their own reactions to it. Magazines such as *Life* and *Newsweek*, discovering that art was news, had begun to devote considerable coverage to the New York art scene, and in doing so had helped to swell the public that was already flocking in ever-increasing numbers to galleries and museums. Art was *in*. The fashion crowd, which knew Rauschenberg and Johns as display artists, realized with a slight start that people really *were* talking about Rauschenberg and Johns.

No one realized it more keenly than Andy. "Jasper is such a star," Andy would say, wistfully, to Emile de Antonio. It bothered Andy that Rauschenberg and Johns, who were also friends of de Antonio's, seemed to have no interest in becoming friends of his. Andy often asked very naïve questions, and he couldn't resist asking de Antonio ("Dee") why Bob and Jap didn't like him. Dee said that, among other things, they found Andy too frigging commercial. Bob and Jap took only enough window-display jobs to pay the rent on their studios. They clearly did not consider the drawings that Andy showed at the Bodley and at Serendipity essentially different from his commercial work, for which he made close to $50,000 a year.

De Antonio's wife could not imagine what her husband saw in Andy. To her Andy was just a silly little boy. But behind the innocence and the naïveté, de Antonio thought he could discern an iron streak. "Andy was blindingly ambitious," he said. "I was sure he was going to make it, although not necessarily in art—he could have made it in just about anything he tried."

> *Q. Do you think Pop Art is—?*
> *A. No.*
> *Q. What?*
> *A. No.*
> *Q. Do you think Pop Art is—?*
> *A. No. No, I don't.*

Andy called up Charles Lisanby one day in 1962. "Listen," he said, "there's something new we're starting. It's called Pop Art, and you better get in on it because you can do it, too." Lisanby thought Andy

was putting him on. Oddly enough, the whole thing happened so fast that Andy himself almost didn't get in on it.

For two years Andy had been more and more intrigued by the art scene. He went around to the galleries with his friend Ted Carey, and occasionally they bought things—paintings by Robert Goodnough and Larry Rivers, a Jasper Johns drawing of a light bulb, a double portrait of themselves by Fairfield Porter. Andy wouldn't buy anything if he thought it was too expensive—in fact, if you ask him today what impressed him about the Johns drawing he will say it was the price: "I couldn't understand how he could get five hundred dollars for a drawing. Even Picasso didn't get that much, did he?" Andy decided against a small Rauschenberg collage that Carey wanted to buy because it cost $250. "I could do that myself," Andy said.

"Well," said Carey, "why don't you?"

Andy lost the I. Miller account around this time. A new art director had come in and decided to change the I. Miller image: since Andy was totally responsible for the image, that meant no more Andy. His income dropped off as a result, although he was still making more than almost any other illustrator in the business. Andy had started to make some friends in the art world, and he saw fewer of his friends in the commercial field. At some point in 1960 he did a series of paintings that had no apparent relation either to his commercial work or to the drawings for his books. The new pictures were based on comic strips—*Popeye, Superman, The Little King, Dick Tracy*. They were painted in the broad, crude style of the originals, from which he would select some detail and present it on a greatly enlarged scale. He also did two large paintings of Coca-Cola bottles. One of them showed a pure, literal, unadorned Coke bottle, greatly enlarged, while the other had a lot of Abstract Expressionist hashmarks—dripped paint and agitated brushwork—at the bottom. Andy asked de Antonio which of the Coke bottle paintings he liked best, and Dee said the unadorned one, absolutely.

Some of Andy's friends from the commercial field didn't like the new paintings at all. They couldn't understand why he had chosen those images, and they said there was nothing of Andy in them. What bothered Andy more than his friends' opinions was that he could not get a gallery to show the pictures. For a while he toyed with the idea of renting the Bodley again, but renting was so expensive, and anyway it no longer seemed like the thing to do. By this time Andy was feeling pretty depressed.

Several factors had contributed to his depression. From Ivan Karp,

the associate director of the Castelli Gallery, he had learned about Roy Lichtenstein's comic-strip paintings. Lichtenstein had done some paintings based on *Nancy and Sluggo* and *Mickey Mouse,* among others, and Ivan and Leo Castelli and Andy himself agreed that Lichtenstein's were much more authoritative than Andy's. Soon after this, Andy also learned for the first time about James Rosenquist, whose pictures were made up of greatly enlarged details of common objects —one of them featured a Seven-Up bottle.

Pop Art, in fact, was just about to burst upon the scene. Claes Oldenburg's plaster replicas of food and merchandise were shown at his "Store" on East Second Street during the winter of 1961-62. Jim Dine's necktie paintings, George Segal's plaster casts, Lichtenstein's comic strips had been discovered by the newsmagazines, and the artists involved, who in most cases had not previously known one another or been aware of each other's work, found themselves the leaders of the most swiftly recognized and efficiently promoted art movement in history. Almost before the older generation of artists and critics could get around to registering their disapproval, Pop had established an impregnable beachhead and set about colonizing the natives. But where was Andy? Leo Castelli liked his work, but Castelli had already taken Lichtenstein into the gallery and he was reluctant to take on another artist who seemed at the moment so similar. Richard Bellamy, the other leading promoter of Pop, had taken Oldenburg, Rosenquist, and Tom Wesselmann into the Green Gallery; he, too, balked at Warhol. Andy's paintings were all over town—Castelli, Bellamy, and Allan Stone all had a few in the back room—and in the summer of 1962 Andy's comic strip pictures were even seen briefly in the window of Bonwit's annex on Fifty-seventh Street. But nobody was buying them.

Andy was desperate for ideas. "What'll I do next?" he kept asking his new art-world friends. Ivan Karp and Henry Geldzahler had urged Andy to develop images that were not being used by anyone else, but he couldn't think of any. One evening in early 1962, in the apartment over Shirley's Pin-Up, Muriel Latow told Andy she had an idea but it would cost him money to hear it. Muriel ran an art gallery that was going broke. "How much?" Andy asked her. Muriel said, "Fifty dollars." Andy went straight to the desk and wrote out a check.

"All right," Muriel said. "Now, tell me, Andy, what do you love more than anything else?"

"I don't know," Andy said. "What?"

"Money," Muriel said. "Why don't you paint money?"

Andy thought that was a terrific idea. Later on that evening Muriel also suggested (gratis, this time) that he paint something that was so familiar that nobody even noticed it any more, "something like a can of Campbell's soup."

The next day Andy went out and bought a whole lot of canvas and painted the money pictures and the first of the Campbell's soup pictures. This was before he had discovered the silk-screen process, so everything was painted by hand; when he learned about silk-screening it went much faster. The soup-can paintings were exhibited that summer, but not in New York. Irving Blum, who owned the Ferus Gallery in Los Angeles, saw them and offered to show them there, which he did in July. The show came in for a lot of heavy ridicule. A gallery next door to the Ferus piled up Campbell's soup cans in its window and advertised "the real thing" for twenty-nine cents a can. Irving Blum sold six of the thirty-two soup-can paintings for $100 apiece, but later he bought them back from the customers so that he could have the complete set himself.

In addition to soup cans and dollar bills Andy began doing silk-screen portraits of Marilyn Monroe and other stars. (Andy and his friends thought Marilyn was just great, even better than Judy Garland.) Eleanor Ward, who ran the Stable Gallery in New York, had come to the apartment that spring of 1962 to see Andy's work, and although she had liked it she could not offer him a show because she had just given the only free spot on her next season's exhibition calendar to Robert Indiana. During the summer, however, one of her older artists left the gallery, and so she called Andy from her summer place in Connecticut and said he could have a show at the Stable in November. Andy was just ecstatic, she remembers. "I'll never forget the sight of him coming into the gallery that September, in his dirty, filthy clothes and his worn-out sneakers with the laces untied, and a big bunch of canvases rolled up under his arm. 'Look what the cat dragged in,' he said. Oh, he was so *happy* to have a gallery!"

Examples of nearly all the paintings that Andy had been doing since 1960 were in the Stable show, with the exception of the comic-strip paintings. The show caused a huge sensation. It was widely reported in the press, and it virtually sold out. That same month, November 1962, Sidney Janis put on his two-gallery show of Pop Art, and in December the Museum of Modern Art sponsored a symposium devoted to the new movement. Andy had got in just under the wire.

> *I feel I'm very much a part of*
> *my times, of my culture,*
> *as much a part of it as*
> *rockets and television.*

In the group of artists who gained prominence through the triumph of Pop, not one knows fame on the level that Andy does. As Alan Solomon once remarked, Andy is the first real art celebrity since Picasso and Dali. Housewives in Keokuk who may never have heard of Lichtenstein, or even of Rauschenberg and Johns, are aware of Andy Warhol. His dream has come true.

It all happened so fast, this stardom. After the first Stable show Andy went into mass production. He had taken a studio on East Forty-seventh Street—"The Factory," he called it—and with the help of his new friend Gerard Malanga he turned out hundreds of pictures during the next few months: multiple-image silk-screen portraits of Troy Donahue, Roger Maris, Liz Taylor, Ethel Scull; Campbell's soup cans by the hundred on single canvases; the new "death" series (suggested originally by Geldzahler) of grisly automobile wrecks, a suicide in mid-air, the electric chair at Sing-Sing. Every week he would show up at the Stable with another roll of canvases under his arm for the gallery assistants to stretch and mount, and everything he did was immediately bought. *Almost* everything, that is—the auto wrecks proved too tough for most buyers, although for some reason the electric chairs were hugely popular. For his next show, Andy filled the Stable with boxes—wooden boxes made to his order and silk-screened on all sides to look exactly like the cartons of Brillo pads and Mott's Apple Juice and Heinz Tomato Ketchup that you saw in the supermarkets. Visitors threaded their way through narrow aisles between the piled-up boxes. So many people came to the opening that there was a long line on the street outside waiting to get in. After that Andy moved to the Leo Castelli Gallery, where he had two shows. The first, in 1964, was all flowers, silk-screened from a photo in a photography magazine; the second, in 1966, consisted of Andy's cow portrait repeated over and over on wallpaper, together with silver, helium-filled pillows that floated. Production at the Factory continued at full blast. Then, with awesome timing, Andy declared Pop Art dead and moved on to the next phase.

The Factory, by now a famous Pop artifact lined from floor to ceiling with silver foil, was converted from silk screens to movies. The flickering strobe light of Andy's energy illuminated a series of his

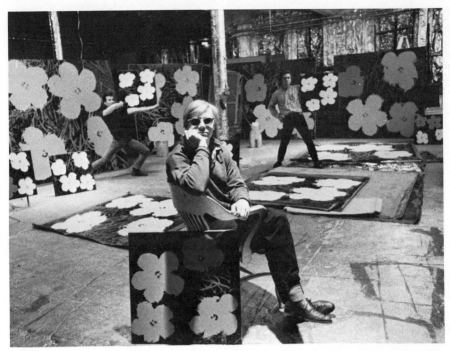

ANDY WARHOL: THE FACTORY
(Ugo Mulas)

girls-and-boys-of-the-year: Baby Jane Holzer, Gerard Malanga, Edie Sedgwick, Henry Geldzahler. Andy's early films celebrating the splendors of total boredom won the Independent Film Award—the highest accolade of the underground cinema. Andy's Exploding Plastic Inevitable group act plugged into the rock-music scene at the Electric Circus, and boomed the fad for multimedia light shows of all kinds. The fashion crowd went gaga with admiration; artists were now dictating the new clothing styles and everyone wore a costume. Andy, whose soiled chinos and sneakers had been superseded by a black leather jacket and silver-sprayed hair, seemed to be everywhere at once. For two years he was out every night. Passive, pale as death, wearing his strange melancholia like a second skin, he was supremely visible. At the opening of Andy's 1965 show at the Institute of Contemporary Art in Philadelphia, the huge crowd went berserk at their first sight of Andy and Edie Sedgwick on a balcony; they had to be smuggled out a side door to escape being crushed. Andy-Matisse.

But why? Surely those monotonously repetitive flowers and cows, those gaudy portraits, and those torpid films were not all that compelling. Not more so, at any rate, than Lichtenstein's drowning

heroines or Oldenburg's giant hamburgers. True, Andy went further than the other Pop artists. The death series, the endless repetitions, the mass-production methods carried certain ideas implicit in Pop to an extreme point, but a point not unknown to earlier and more radical artists than Andy. After all, Duchamp removed the artist's hand from art in 1913, when he began signing "readymade" objects. It has been said that Andy's real art is publicity, but even this is debatable. Although Andy knows more or less precisely what he is doing at all times, and continues to capitalize brilliantly on his own drawbacks, he does not really manipulate events. Andy remains essentially a voyeur, letting things take their course and looking on with cool detachment, interested but uninvolved. Then how do we explain the fact of his celebrity?

The word, I think, is resonance. From time to time an individual appears—not necessarily an artist—who seems to be in phase with certain signals not yet receivable by standard equipment. The clairvoyance with which Andy touched the nerve of fashion and commercial art, the energy emanating from God knows where, the inarticulateness and naïveté, the very mystery and emptiness of his persona—

THE FACTORY AT 4:00 P.M

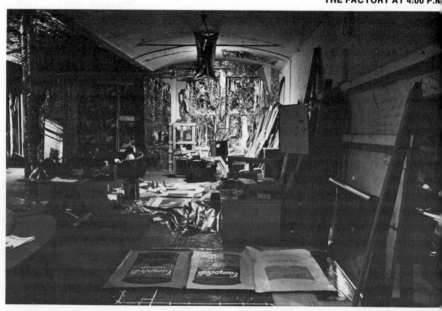

all suggest the presence of an uncanny intuition. Always somewhat unearthly, Warhol became in the 1960s a speechless and rather terrifying oracle. He made visible something that was happening beneath the surface of American life.

> *I've always had this philosophy*
> *of: it doesn't really matter.*

A great deal of what took place in America during the 1960s decade is missing, of course, from Warhol's house of mirrors. He has had nothing whatsoever to say to the young militants, the activists on either side of our contemporary conflicts. Participation, confrontation, and martyrdom do not interest him; if Andy contributes a painting to a liberal benefit it is only because a refusal would be awkward and uncool. And no one in the history of cool has ever been cooler than Andy.

One feels that Lichtenstein got to his Pop image intellectually, by logical steps, while Andy just *was* there by instinct. Take the soup can, for example. Although the idea may have come from Muriel

—AND AFTER MIDNIGHT (both photographs: Ugo Mulas)

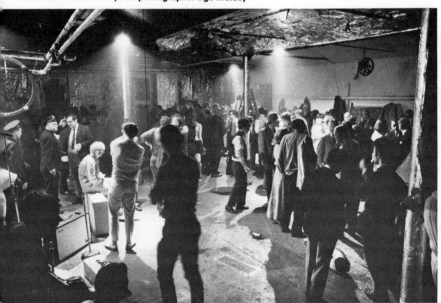

Latow, it was Andy who sensed its absolute rightness and saw just how to present it. Banal, stupid, loaded with sentimental associations as it was, Andy painted his soup can with icy precision and utter objectivity. No interpretation, no reaction, no judgment, no emotion, no comment—and not an echo of his former I. Miller insouciance. The same is true of his other paintings (a possible exception being the Jackie Kennedy series, where some emotion seems evident on the part of the artist), and it is equally true of the films. Every Warhol image comes across frontally nude, without a shred of feeling attached. Andy's camera lens is the ultimate voyeur, but his films, for all their funny-sad sex scenes and their preoccupation with drugs and transvestism and pubic hair, are antierotic and utterly, numbingly cool.

The cool style requires a mastery of the put-on, of course, and in this area Andy knows no peer. Asked by a reporter why he painted the soup cans, Andy replies that for twenty years he has eaten soup for lunch. To an interviewer he gives deadpan nonanswers and asks at the end, "Have I lied enough?" Alan Midgette, the actor hired to impersonate Andy on a lecture tour, lectures at a dozen or more colleges before the hoax is discovered, whereupon Andy explains that Midgette is "more like what people expect than I could ever be." The put-on, another talisman of the 1960s, has been raised by Andy to the status of a minor art. It is also, let us note, a perfectly valid means of anesthetizing despair, without resort to hypocrisy. The absurd public world and the even more absurd private world are both treated as an in-joke, and sanity is preserved a little longer.

Over it all, however, lies the shadow. Vietnam, racism, urban blight, the poisoning of the environment, the alienation of the young, the murder of those few leaders who showed any real stomach for attacking the problems, and the sickening hypocrisy of our elected officials have drained us of hope. Even Andy has been ripped from grace, shot twice in the stomach by a woman who mistook him for a god ("He had too much control over my life," she told the police), his life nearly extinguished and still not wholly restored to him (one of the wounds would not heal for months). By a truly supernatural irony he was denied even the fruits of publicity that were due him; forty-eight hours after he was shot another assassin killed Robert Kennedy in Los Angeles. Afterward, he would say that his own life had come to seem like a dream, that he could not be sure whether he was alive or dead. Nor can we.

Andy kept his cool, but things are not the same. At the new Factory, down on Union Square (Andy moved out of the old one after a

man walked in off the street and started to play Russian roulette with a loaded gun—another irony), Andy's friend and business manager Paul Morrissey has more or less taken over the Warhol films operation. Andy comes in for an hour or so each afternoon, but his heart is not in it. Brigid Polk, who has been around since the early 1960s and is one of Andy's established confidantes, thinks he may get out of films. "Andy buried painting," Brigid says, "and he may just bury movies, too." Andy is said to be interested in videotape. He wants his own television show, where people come on and talk and do whatever they like, while Andy watches.

Will his face inhabit the future as it has the past? Ivan Karp suggests that Andy's reputation may rest as much on his face as on anything else—the pale cast of those Slavic features, sensitive/ugly, angelic/satanic, not-quite-of-this-world. "One of the things he would have liked most," says another friend, "was to have been beautiful." Perhaps he is. At the moment, though, what we seem to see reflected in that strange face is a sickness for which there may be no cure. This is the new shudder brought by Warhol's art. Andy, in what one fervently hopes is just another put-on, begins to look more and more like the angel of death.

Note: Since this was written in 1970, Warhol has shown new signs of life: a series of surprisingly painterly portraits, some on commission (Philip Johnson, Leo Castelli), others on intuition (Chairman Mao); *Andy Warhol's Interview Magazine,* which charts the folk wisdom of various stars and superstars; a book, *The Philosophy of Andy Warhol (From A to B & Back Again).* He goes out more, is seen at parties and theaters wearing a Brooks Brothers suit and a rep tie. Andy endures.

THE SKIN
OF THE STONE

The general trend of art in this century has been somewhat discouraging for collectors, most of whom still harbor a fugitive belief that works of art ought to serve some decorative purpose. Collectors find it sad and rather perverse that so few contemporary artists paint nice, bite-size pictures that look well over the living-room sofa, preferring instead to produce giant canvases too unwieldy for anything but a museum wall, or jagged sculptural constructions that imperil one's living space, or, worse yet, deliberately ephemeral works—Australian coastlines wrapped in polypropylene, mile-long furrows in the desert —whose only preservation is in photographs. Just as it was beginning to seem as though collectors might be phased out of the contemporary art scene entirely, however, a surprising thing happened. During the 1960s, a number of leading American artists became interested in making lithographic prints. The old-fashioned, painstaking process of fine-art lithography, which had more or less died out in this country, has had a vigorous and widespread revival, and in the living rooms of more than a few collectors lithographs have begun to hang prominently on the walls—even, in some cases, over the sofa.

What is sometimes referred to as a "renaissance" in American lithography is not, strictly speaking, a renaissance at all, simply because there was never a real tradition of fine-art lithography in America. Winslow Homer, George Bellows, Arthur B. Davies, Thomas Hart Benton, and others made prints, to be sure, but their lithographic work was not particularly distinguished, and it formed only a minor part of their total *oeuvre*; until recently, in fact, the only American-born artist who did do significant work in lithography and whose lithographs can be said to compare in quality and inventiveness with those of his European contemporaries was Whistler, an expatriate living in England. The reason for this is simple enough. Lithography, the most complex of the print techniques, requires for its use as an art form the closest possible collaboration between the artist and a printer who is himself a master of his difficult craft. The

tradition of master lithographic printers has survived for well over a century in France, and most of the major French artists, from Toulouse-Lautrec and Manet to Picasso and Matisse, have made lithographs that stand as important works of art. In the United States, however, the commercial applications of the medium have always predominated, and the number of lithographic printers able and willing to collaborate with artists has been limited.

All print techniques, of course, were developed originally for commercial purposes. The wood block, which had been used in Europe since early Christian times to stamp patterns on textiles, proved to be a cheap and efficient method of illustrating the books that Gutenberg's invention of movable type made available in the fifteenth century. The intaglio techniques of etching and engraving, which date respectively from the mid-fifteenth and the beginning of the sixteenth century, were from the beginning devoted primarily to reproductive rather than creative ends; for every Dürer or Rembrandt, whose prints were major works of art, there existed hundreds of nameless engravers and etchers who made their living copying pictures by other artists. Lithography is believed to have been perfected about 1796 by a Bavarian printer named Alois Senefelder, who thought of his invention as a cheap way to print literary and music manuscripts. Senefelder's method was vastly more efficient than any of the others; it soon proved, in addition, to have enormous appeal for artists.

Lithography is based on the mutual antipathy of oil and water. In its classic form, the lithographer draws with a greasy substance on a smoothly ground block of limestone; the stone is etched, processed, and then moistened with water, which the greasy markings reject; it is then rolled with printer's ink, which adheres to the greasy, drawn portions and is rejected by the moist, undrawn portions; a sheet of paper pressed down on this surface absorbs the ink, and the result is a reversed impression of the original drawing on the stone. With subsequent inkings the process can be repeated through many impressions before the drawing wears out. For an artist, the method offers a great many advantages. No special tools or technologies must be mastered—he draws directly on the stone (the word lithography comes from the Greek *lithos,* or stone, and *graphein,* or drawing), using a special lithographic crayon or an oily compound called tusche, which he applies with a brush. If he chooses, in fact, he can even make his drawing on lithographic transfer paper, which is then pressed down on the stone, leaving a reversed image which is then re-reversed back to its original state when the stone is printed—

Whistler often used this method. Tones from the densest black to the most delicate shades of gray can be achieved, and by using more than one stone the artist can employ a wide and subtle range of color—for this reason alone lithography is considered the most "painterly" of the print techniques. The technical manipulation of the process, the "cookery" involved in graining the surface of the stone to prepare it for the artist; etching the artist's design with a weak acid solution, so that it will last through multiple impressions; inking and putting the stone through the press; adjusting and altering the various steps until a proof has been pulled that satisfies the artist—all this is done by a professional printer, a specialist who has spent several years learning his trade and who can often help the artist to achieve precisely the effect he is seeking.

Lithography caught on in the United States about 1818, mainly as a means to mass-produce book illustrations, posters, and popular decorative prints such as those turned out in great quantity by Currier & Ives. The standing rule at Currier & Ives was that the artist who painted the original was not allowed to touch the lithographic stone— that was done by professional artisans who could presumably copy the scene more efficiently on the stone, and could do so in the approved, highly standardized manner. When photo-lithography appeared during the 1890s, the commercial presses all converted as rapidly as possible to the new technique. Lithographic limestones were replaced by zinc plates and then by aluminum plates. The number of printers who could hand-pull an impression from a stone declined steadily. By 1950 an American artist who wanted to make lithographs was obliged to print them himself, with inadequate equipment, or else go to France, where Mourlot, Desjoubert, and other ateliers maintained the tradition of fine-art lithography.

It is true that a great many *non*lithographic prints were being made and sold throughout the United States. The arrival in New York in 1940 of Stanley William Hayter, whose Atelier 17 in Paris had attracted the interest of many European artists, led Jackson Pollock, Jacques Lipchitz, Alexander Calder, Robert Motherwell, and others to experiment with the intaglio techniques of etching and engraving. Leonard Baskin, Carol Summers, and a few others had rediscovered the woodcut, and a number of young artists were investigating the possibilities of silk-screen printing, a technique that involves the transfer of an image to a stretched square of silk, through whose fine mesh ink is forced to make the print; since the image in this case has been transferred to the silk by a photomechanical process, silk-screen

prints do not usually qualify as "original" prints—a classification
that is much in dispute lately, but which usually implies that the artist
has created the master image directly on the printing surface.* Most
of the printmaking in America before 1960 was being done by profes-
sional printmakers, however, rather than by major artists. Aside from
Pollock's brief experiment with etching in 1946, none of the Abstract
Expressionists had shown any interest in making prints, and not a sin-
gle artist of stature in this country was making lithographs.

The remarkable flowering of lithography during the 1960s is due in
large part to the unrelated efforts of two women, one on the East
Coast and one on the West. The West Coast operation got started in
1958 when June Wayne, a California artist and printmaker, stopped
off in New York on her way back from Paris and had what seemed to
her at the time a casual conversation with W. McNeil Lowry, the
director of the Ford Foundation's newly formed Program in the Hu-
manities and the Arts. Ms. Wayne told Lowry that she had gone to
Paris to make an edition of lithographs because there was not a single
printer in America who could handle the job, and she suggested that
the Ford Foundation might sensibly spend some of its millions to
revive the dying art. Lowry was interested. Soon after their conversa-
tion he wrote to Ms. Wayne, asking whether she had any specific
ideas on the subject. She did, and the result was Tamarind Li-
thography Workshop, established in Los Angeles in 1960 with a grant
from the Ford Foundation. A brilliantly organized teaching studio,
Tamarind's influence has been mainly in the training of master
printers, many of whom have gone out and established their own fine
lithography studios.

The East Coast venture began a year earlier, in 1957, without subsidy
or plan of organization, in Tatyana and Maurice Grosman's modest
wood frame house in West Islip, Long Island. The workshop has
expanded only slightly since then, and the number of artists who have
printed there has been limited so far to seventeen. Both technically
and aesthetically, however, the prints published by Tatyana Grosman's
Universal Limited Art Editions are generally acknowledged to be
equal or superior to anything being done in Europe or anywhere
else, and a good many of them have been recognized as works of
art of a very high order indeed.

*When the artist draws directly on the silk screen, the resulting print is called a "seri-
graph."

"It's amazing how few bad prints Tanya has put out," William S. Lieberman, the director of Painting and Sculpture at the Museum of Modern Art, has observed. "Maybe one out of twenty-five of her prints doesn't stand up as a work of art, and I don't know of another workshop in the world of which that could be said." Lieberman's museum gets the first number of every edition printed by Universal Limited Art Editions—a convenience made possible in recent years with the help of Armand and Celeste Bartos, who are themselves ardent print collectors. The museum is grateful for this arrangement, because ULAE prints have become exceedingly difficult to acquire. Several important collectors have standing orders for one of every print produced there (although Mrs. Grosman discourages this practice), and a number of others wish they did. When the prints of some of Mrs. Grosman's artists change hands subsequent to the initial sale, they may go for as much as ten times the original price. Mrs. Grosman does not concern herself with this form of escalation. Although her own prices have risen steadily—a print that might have cost $75 to $100 in 1959 now costs anywhere from $450 to $3000—she herself has never made much money from her operation. "Tanya is completely committed to her artists and to her idea of quality," Lieberman has said. "The commercial side of the operation, if indeed there is one, is incidental."

Tatyana Grosman, as her first name suggests, is Russian by birth, and after more than thirty years in this country her English is still so freighted with unfamiliar accents and inflections that most people have trouble understanding what she says. She is a tiny, soft-spoken lady with a manner so exquisitely polite and considerate that one is tempted to apply to her the antique term "gentlewoman." She is also, in her quiet way, implacably persistent. Mrs. Grosman spends a good deal of time on the telephone. She will often excuse herself from a lunch table or from a gathering of people in order to telephone someone in a remote part of the country or the world, and, as the late John McKendry, curator of Prints and Photographs at the Metropolitan Museum, pointed out some time ago, there is always a very specific point to her call. "Whenever Tanya calls me," McKendry said, "with all that incredible charm of hers, I know there's a reason, and that something good will come of it, and that I'll have several hours or days of work to do as a result." Once, McKendry and Henry Geldzahler had both been invited to Mrs. Grosman's house for lunch; both of them had bad colds that day, and wanted to get out of the train trip to West Islip, but after discussing the matter they decided

that it would be easier to go than to explain why they were not coming. "She can be embarrassingly generous," according to McKendry. "She has this great maternal thing—she takes care of her artists, makes sure they eat a lot, gives them lavish gifts, insists on paying the check in restaurants. But at the same time she also expects a great deal from you—and you always find yourself working twice as hard for her as you would for anyone else. She's so gentle and yet so strong—strong enough to be flexible where it matters."

The flexible side of Mrs. Grosman's nature has enabled her to work more or less harmoniously with some exceptionally strong-willed artists, virtually all of whom made their first lithographs as a result of her persistent urging. The first of these was Larry Rivers, who was introduced to stone-printing by Mrs. Grosman in 1957 and who has continued to make lithographs at her studio ever since. The others, in chronological order, are Fritz Glarner, Sam Francis, Grace Hartigan, Jasper Johns, Helen Frankenthaler, Robert Motherwell, Robert Rauschenberg, Jim Dine, Lee Bontecou, Barnett Newman, Marisol, James Rosenquist, Cy Twombly, Edwin Schlossberg, Claes Oldenburg, and, most recently, R. Buckminster Fuller. Several more well-known artists would like very much to work there, but Mrs. Grosman has been quite firm in stipulating that her workshop is not a printing facility, and she has no wish to enlarge her "family" of artists. The family, by and large, includes several of the most innovative and influential artists now at work in America, and this fact is often cited as a primary reason for Mrs. Grosman's extraordinary achievement. With the exception of an occasional genius like Piranesi or Callot, the great prints and the major developments in printmaking have all been made by the major artists of the period. Mrs. Grosman has been interested exclusively in publishing work by the artists she admires. The results, which have been extraordinary by any standards, are even more remarkable when one considers that Mrs. Grosman herself, by her own frequent admission, knows surprisingly little about the craft of lithography.

"Even today I don't know anything about lithographic techniques," she noted quietly, one day, while sitting with a friend at the long dining table in her sunny kitchen. "The way we work is very simple—the artist makes his drawing on the stone, the printer makes a proof, and then the artist decides what he likes or doesn't like, and makes changes, and maybe I make some suggestions, and we select the paper, and that's how it is." Although she does know that the process is a good deal more complicated than her explanation of it,

Mrs. Grosman prefers to leave the technical details to others and to concentrate her own attention on the rather mysterious, intangible qualities of the medium. "I think what happens here," she said, "is that I'm not very interested in production. Barnett Newman said a wonderful thing—he said that printing is like music; the artist is the composer, and the printer is the interpreter. And the interpretation is so important! Here, the intention has always been that whatever the printer can do in one day, that becomes the size of the edition. If he prints twenty, thirty, forty, then that's it, and I don't want him to continue the next day and do more because his touch will be different, everything will change. The printer must be *with* the work. He is not imitating a machine, because a machine can do much better so far as speed is concerned. The printer must be with it, like music; he knows that here is a crescendo, here a diminuendo—he feels it!

"But I don't know how these things happen, really," she continued. "You see, my husband is a painter, and through most of our life together it was his work that interested me—that was my life. And then, in 1955, Maurice had a bad heart attack, and I brought him out here to get well—we had been spending summers in this little house since 1944—and then the doctor told me that Maurice would never be so strong again, and I knew that I would have to do something, right away. What was I to do? My great interest, my real passion had always been books, books with visual images. I had just read a book that inspired me very much, a book by Monroe Wheeler called *Modern Painters and Sculptors as Illustrators,* in which he spoke about artists doing graphic work to illustrate books of poetry—Picasso and Matisse and others did that in France—and he said that the most ideal thing would be for an artist and a poet to work together on a book. The idea seemed very beautiful to me. And so I started to work with artists I admired, on silk-screen prints at first. Then, by pure luck, I had just found two lithographic stones in the front yard of our house. Real lithographic stones, which had been discarded years and years ago and were being used as part of a path. And somehow I got the idea that I could use these stones to make a book of the kind Mr. Wheeler had described.

"I went to see Mr. Rosset, Barney Rosset, of the Grove Press, to ask if he could perhaps suggest a poet for such a book, and he suggested Frank O'Hara. Well, I read some of O'Hara's poems, but I didn't really understand them very well, they were so abstract. But then a few days later Maurice and I drove out to Larry Rivers' studio in Southampton. Larry was also a friend for some time. I talked to

Larry about this idea of a book that would be a real fusion of poetry
and art, a real collaboration, not just drawings to illustrate poems,
and Larry listened, and then he called out, 'Hey, Frank!' And down
the stairs came a young man in blue jeans. It was Frank O'Hara.
And that is how things have happened to me in my life, they have just
worked out somehow.''

Although she rarely thinks about the past these days, Mrs. Gros-
man does retain a few vivid memories of her childhood. She was born
in Ekaterinburg (today it is called Sverdlovsk), the city in the eastern
Urals where Czar Nicholas II and his family were imprisoned and
then executed by the Bolsheviks in 1918. Tatyana was fourteen at the
time. She remembers her father, Semion Michailovitch Agusche-
witsch, the owner and publisher of *Ural Life,* the area's leading
newspaper, coming home with the proof of the next day's front page,
with its headline on the execution. While the family was at dinner, the
doorbell rang, and the maid announced that two officials of the Eka-
terinburg Soviet wanted to see Mr. Aguschewitsch. He received them
in his study, and returned to the dining room about fifteen minutes
later. After telling his family to say nothing about the royal family's
deaths, he went back to his office, remade the paper, which had not
yet been distributed, and substituted an edition that made no mention
of the shootings, which were not reported in the paper for another
two weeks.
 Up until 1918 not much had happened to disturb the comfort of
this well-to-do family. Tatyana's father had come out to Ekaterin-
burg around the turn of the century to found the paper, and his suc-
cess was a reflection of the city's rapid growth as an important min-
ing and industrial center. *Ural Life* was read in Moscow and Saint
Petersburg and throughout Siberia; like the recently completed Trans-
Siberian Railway, it served as a link between western, European Rus-
sia and the vast eastern region that stretched from the Urals to China
and the Pacific. The paper had a regular literary page, with oc-
casional contributions by political exiles in Siberia who wrote under
pseudonyms. Aguschewitsch himself was something of an intellectual,
as well as a hard-working and astute businessman who invested in
real estate. As a result, Tatyana and her younger brother grew up in
an atmosphere of modest wealth and liberal culture.
 Nearly every summer they went to visit their maternal grand-
parents in Munich. Tatyana rather enjoyed the trip, which used to
take thirteen days by train—later it was reduced to six—but she

would have preferred to spend her summers in some Russian village with her friends. Mrs. Aguschewitsch's family had emigrated from Russia to Bavaria in the nineteenth century, and according to Tatyana her mother, who had grown up in Germany, never quite adjusted herself to living in the Urals. "My mother was—somewhat eccentric," she recalls. "She was full of energy and very gifted, she spoke several languages with ease, played the piano, and she was always traveling, always doing things. I admired her, but I felt that I could never be such a person as she was. When I think about it now, it seems to me that I was a very inward child, and that I had nowhere to grow but inside. I was reading very much, always. The theory in our house was that a child must read only good literature, whether or not he understands it, and in Russia even the children's books were mostly excerpts from the major authors, Turgenev, Dostoevski, Nekrasov, and, of course, Pushkin. The trips to Europe every summer seemed endless to me, but still, that was six days on the train when I could be alone with my books, more or less.

"The theater also played a great part in my imagination. I think my exact, precise first memory was of going to the theater, to see a play by Gogol. My father loved the theater, and he had two permanent seats for every performance. There was one theater in the

**TATYANA AGUSCHEWITSCH
WITH HER PARENTS**

town, and half the year it presented opera and the other half, drama. The most important companies from Moscow and Saint Petersburg came. Ekaterinburg was not really so provincial. It was a very wealthy city, and growing rapidly. I remember Father was always building extensions to his printing plant.''

The Aguschewitsch children and their mother spent the summer of 1914 in Berchtesgaden. When the war broke out that August, they went first to Switzerland, where the Russian consulate arranged for them to travel, with a group of other displaced Russians, to Trieste, then to Athens, and by train through the Balkans (where she saw the signs of war for the first time, the wounded soldiers in stations rank with carbolic acid), and then on to Odessa. Back home in Ekaterinburg, a thousand miles from the fighting fronts, they were scarcely aware of the devastation taking place in western Russia and in Europe. They spent the summer of 1916 in the Siberian village of Kutikha, on the edge of the taiga forest. The following summer, while Kerensky's provisional government sought ineffectually to cope with the revolutionary chaos following Nicholas II's abdication and Russia's withdrawal from the war, the Aguschewitsch family took a leisurely boat trip down the Volga, from Kazan to the Caucasus and the spas of Kislovodsk and Essentuki. "I was enchanted," Tatyana recalls. "Everything reminded me of Lermontov's poems. And it was on this trip that I read Tolstoi's *War and Peace* for the first time—an encounter that has stayed with me to this day. Actually the Revolution was relatively peaceful for us until 1918."

After the October Revolution brought the Bolsheviks to power in the fall of 1917, local groups of Bolshevik workers and soldiers seized control of most of the leading towns and cities, including Ekaterinburg, where Aguschewitsch continued to put out his paper. The children continued to go to school, and life went on much as it had until, in the summer of 1918, the counterrevolutionary White Army of Admiral Aleksandr Vasilievich Kolchak drove close enough to threaten Ekaterinburg. It was at this time that the Ekaterinburg Soviet, fearful that the advancing Whites would liberate the Czar, sentenced him and his family to death.

The Whites did succeed in taking Ekaterinburg. A year later the tides of battle had turned, however, and the Red Army was advancing on the city. Aguschewitsch and his family, who had survived thus far without serious hardship, decided at this point to leave the country temporarily. Accompanied by several trunks full of belongings, and by one of their maids, they took the Trans-Siberian Railroad east to

Vladivostok, which was still in White Russian hands. From Vladivostok they went on to Japan, where they lived for about ten months in the European section of Yokohama. "We did not feel that we were emigrating," Tatyana recalls. "We were just going to wait until things had settled down at home, and Japan was the nearest country. My parents engaged a Russian tutor for me, so that I would not get behind in school, and I also attended the Sacred Heart Convent school in Tokyo. But eventually there came a time when my parents had to make a decision. Russia was not settling down, it seemed. We could not go back. My parents were thinking about Europe, and their first idea was to go to Switzerland, where the children would have good schools. But for Switzerland, and for America, there was too long a wait for visas. Somehow we managed to get a transit visa to Italy, and so we sailed for Venice—the whole family and Maria, the maid. I remember the trip took fifty-eight days."

From Venice the Aguschewitsch family went to visit Mrs. Aguschewitsch's relatives in Munich, and shortly thereafter they moved to Dresden. They still hoped to go eventually to Switzerland, but Mr. Aguschewitsch managed to find them a comfortable house in Dresden and soon began investing in other properties, and so they settled there instead.

The eight years that she lived in Dresden were lonely ones for Tatyana. Although she spoke fluent German, she felt like an outsider at the German lyceum she attended. "Germany at that time, after the First World War, was very coarse, the coarseness that George Grosz reflected so well in his work," she remembers. "The family went regularly to the mountains at Christmastime, and in the spring my mother and I went to the Czechoslovakian spas or to Prague, Vienna, and Paris. The summers we spent at North Sea resorts or in Italy. As you can see I was a very devoted daughter and I accompanied my mother everywhere, doing everything a young lady is supposed to do. But there were very few people I could relate to, and I spent a great deal of time reading."

For a period after her graduation she did nothing, but then, more to secure her independence than for any other reason, she enrolled in the Dresden Academy of Applied Arts, and through friends there she met Maurice Grosman, a young student at the Academy of Fine Arts. Grosman had been born in Poland, but he had lived most of his life in Germany. He was attractive, amusing, and poor, as art students are expected to be, and although he had started to make a name for himself and already had pictures hanging in several museums, Tat-

yana's parents did not approve of the relationship. When the inevitable crisis occurred, Tatyana went off by herself to the Alpine skiing village of Lech, where she decided, after much thought, that she would have to break with her family. It was a painful decision. Soon after making it, she became seriously ill, and had to spend two months in the hospital. When she recovered, early in 1931, she and Grosman were married.

They went to Paris, settling first in the little suburban town of Herblay, on the Seine, where their daughter, Larissa, was born in 1933. Later they moved to a tiny apartment in Montparnasse. Their friends were foreign artists and writers, men like Jacques Lipchitz, Chaim Soutine, and Ossip Zadkine, who had been drawn to Paris for the usual reasons. Generally speaking they had little contact with the White Russian exile colony. Tatyana Grosman has never been subject to the kind of passionate nostalgia that afflicts so many exiles from pre-Revolutionary Russia—even today she rarely thinks about the country of her birth, and her memories of it tend to come mainly from the books that she read as a child. They lived on Maurice's meager earnings as an artist, supplemented by a small allowance

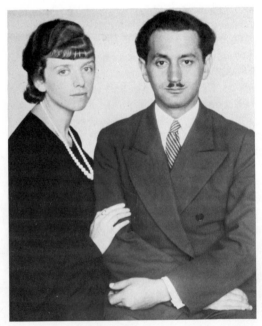

**WEDDING PORTRAIT
WITH MAURICE, 1931**

from Tatyana's father. Although Maurice was receiving some recognition at the time, and had been given a one-man show at the Vignon Gallery, life became increasingly difficult. Often, there was barely enough money for food. Mrs. Grosman still can hardly bring herself to speak of the tragedy that engulfed them at this time. "Larissa was a beautiful child," she once confided to a friend. "She gave me the greatest moments of happiness in my life. One day she became suddenly and inexplicably ill. We brought her to the hospital, and she died there the following day. She was sixteen months old."

In the Siberia of her childhood, Mrs. Grosman had heard many tales of exile and flight. She often had occasion to recall these stories during the years between 1940 and 1943, when she and her husband lived in daily fear of being arrested by the Germans. Two days before Paris fell, they left the city with the exodus. They were invited by their concierge to join her and some of her woman friends and their eleven children in an ancient truck driven by a young boy. After three weeks on the road, with frequent bombing and strafing attacks by German planes, they reached the tiny village of Céret, in the Pyrenees, where they lived for the next year. Céret had been something of an artists' colony before the war; the Grosmans had spent several summers there, and for a while it seemed a fairly secure refuge. As time passed and the Nazi policy toward Jews became clearer, however, unoccupied France began to seem less and less safe. It was in the hope of getting visas to the United States that they moved down in 1941 to Marseilles, where one day, without warning, the police arrested several thousand Jews. Maurice was among them.

Instead of being shipped to one of the dreaded camps, Grosman had the good fortune to be sent to a *"résidence assignée"*—a sort of limited detention—in the village of Alzon, above Nîmes. Tatyana joined him there. The following spring a letter came from the American consulate in Marseilles, saying that their visa had been approved and that they should present themselves for immigration. In order to leave Alzon, Grosman had to have a permit signed by officials in all the towns between Alzon and Marseilles. Obviously it would take weeks to get the necessary signatures by mail, so Tatyana took the permit to each official in person, got their signatures, and brought it back within a few days. The permit was valid for fourteen days. Maurice and Tatyana hoped that on receiving the visa they could leave on the ship *Nyassa,* which was then anchored in Marseilles harbor. But the U.S. consul now informed them that still another docu-

ment was needed: an official statement that they had never been con-
victed of a crime. Frantic letters to Paris elicited a police statement
clearing Maurice, but a similar clearance for Tatyana was delayed.
When it finally did arrive, the *Nyassa* had sailed and Maurice's four-
teen-day permit had expired. A friendly policeman told them that the
only way to get the permit extended was for Maurice to be hospita-
lized, and so, in desperation, they went around to all the hospitals
they could find, trying to have him admitted. A private sanitarium
for the insane, near Marseilles, finally took him in, on the logical as-
sumption that he appeared to be "nervous."

Tatyana returned to their small room in a cheap Marseilles hotel,
and they waited. One night, the police came to her hotel and knocked
at the entrance. She went to the roof and hid behind the chimney of
an adjacent building while they searched the premises. Hearing them
leave, she crept back inside and started to get dressed when she heard
another knock at the hotel's entrance. This time she clung to the roof
and then jumped to a balcony of the next house, and hid in the bed-
room of a terrified teen-age girl until morning.

The next day Tatyana learned of the announcement that had come
over the British radio the night before: All Jews in France were to be
arrested. She left her belongings in her room upstairs, and asked the
hotel's owner to tell the police that she would be back. Then she went
to Maurice's sanitarium, where she spent the next few weeks hiding
under his bedclothes every night and slipping out to be the "first visi-
tor" each morning. A woman patient was deeply impressed by her
devotion. *"Ah, quelle femme!"* she would sigh, every time she saw the
Grosmans together. Then one morning, a sûreté official came to the
sanitarium to arrest Maurice. The doctor in charge managed to stall
him off, and the Grosmans fled.

After several weeks of hiding out in various friends' houses, they
managed to procure false identity papers, and then, with the help of a
friendly Vichy official, a man whom they had known in Céret before
the war, they made their way to a small town in the Pyrenees, not far
from Céret, called Le Boulou. Le Boulou was very close to the Span-
ish border. A local resident gave them rough directions for crossing
the mountains. They set out at noon the following day, because they
thought that the border guards would be having their lunch at that
hour. To make their intentions appear even more innocent, Maurice
carried his easel and paintbox, and Tatyana wore her fur coat. They
had no other possessions with them.

They climbed into the mountains and crossed the border before

nightfall, spending the night in a Spanish farmer's cottage. Before starting out the next morning, Tatyana insisted on hiding all their false identification papers in the beams of the barn. The only document they did not destroy was a well-worn copyist's permit issued and stamped by the French Minister of Culture—Grosman had occasionally copied paintings in the Louvre while they lived in Paris. After doing that, they started walking toward Barcelona. The trip took three weeks, and along the way Mrs. Grosman was reminded vividly, over and over, of the books she had read as a child. The forests of northern Spain seemed as familiar to her as the birch forests of Siberia, and all the old Russian tales of escape and miraculous survival were fresh in her mind. Only once were they stopped, by a guardia civil officer who asked to see their papers. Maurice, who had seen him approaching in time to get out his sketch pad and begin drawing a tree, held up his copyist's permit, and the ministerial seal satisfied official curiosity. "All during that walk through Spain I was absolutely so *happy*," Tatyana remembers. "I was never afraid, and I felt free. Somehow we just discovered what we needed; we found food to eat and places to sleep. Later, in Barcelona, when we finally were able to legalize ourselves, I was almost sad."

The Hebrew International Aid Society (HIAS) helped them to get visas and transportation to Lisbon, and from there to the United States, which they finally reached in the summer of 1943, landing at Philadelphia and going directly to New York. The HIAS authorities first told them that Maurice would have to work in a factory, but Tatyana scolded them so severely—artists were in too short supply, she said, and their training was too valuable to be thus ignored—that they told him to do as he pleased. With the help of Ossip Zadkine, who had preceded them to New York, the Grosmans found a small studio apartment on Eighth Street. They had no money at all. Maurice gave private lessons in drawing and painting at the apartment. He continued to paint, and had several one-man shows. He also taught himself the technique of silk-screen printing, which he used to make copies of modern paintings that were sold by the New York Graphic Society and the Marboro Bookshop. They lived quietly and inexpensively, on the fringes of the New York art world that was rapidly becoming, after the war, the vital center of new energies and a new style in art.

People who knew the Grosmans during the 1940s and early 1950s remember Tatyana as being very much in the background. Maurice

was the center of the household; his work and his ebullient per-
sonality were the predominant elements. All this changed abruptly
after Maurice's heart attack in 1955, although, looking back, it could
be seen that the strength and resilience that Tatyana then showed had
been there all along. Her first step was to get rid of the Eighth Street
studio and move Maurice out to the clearer air of West Islip, Long
Island, where they had been spending summers since 1944. The house
they lived in there had been the gardener's cottage for a nearby es-
tate. When the widow of the property owner died, the estate had been
given to the Dominican religious order. In 1949, however, the proper-
ty was sold to a developer, and Grosman had managed to scrape up
enough money to buy the cottage. Now, with Maurice too ill to work,
the problem was how to develop enough income to stay there.

It was at this point that Tatyana decided to go into business as an
independent publisher of silk-screen reproductions. Her editions
would be small, of the highest quality, and, most important, in each
case she would get the artist to collaborate actively in the reproduc-
tion process—to supervise the matching of colors, the choice of
paper, and all other details. The first artist she approached was Mary
Callery, the sculptress, whom she had met once at the Curt Valentin
Gallery, and who happened to live nearby in Huntington. Mary Cal-
lery readily agreed to the idea. She made a drawing for Maurice to
reproduce on a screen, and she came over regularly to West Islip to
discuss and correct the work. Tatyana was so grateful that she decid-
ed the edition must be printed on a special paper handmade for the
occasion, and her search for someone qualified to do the job led her
to Douglass Howell in Westbury. Howell, who specializes in hand-
made papers, produced a beautiful run of paper in which each sheet
was slightly darker than the last, so that the series started white and
ended brown. Mary Callery was delighted with the final edition of
twenty-eight prints (a miniscule production by most commercial stan-
dards). Mrs. Grosman was so pleased that she took several of the
prints to New York and showed them to Bill Lieberman. Lieberman
asked whether Mary Callery had actually done the drawing on the
silk screen, and when Mrs. Grosman said she had not, he said, "Why
did you tell me? Now I can't buy it—it's not an original!"

Only slightly daunted, Mrs. Grosman managed to sell most of the
prints in this initial venture to friends or commercial establishments.
Another silk screen by Mary Callery turned out equally well, and it
was followed by reproductions of works by Max Weber and by the
Grosmans' old friend Jacques Lipchitz. Mrs. Grosman next paid a

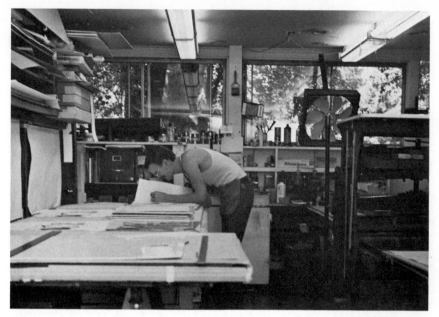

THE STUDIO AT ULAE
(Judy Tomkins)

call on Carl Zigrosser, the greatly respected curator of prints at the Philadelphia Museum of Art. Zigrosser was impressed by the quality of the work, and said so. He also suggested that Maurice himself sign the prints, since they were in effect his original work *after* Callery, Weber, and Lipchitz. Maurice, who does not lend his name to anything he considers commercial, refused. Tatyana, nevertheless, was so buoyed by Zigrosser's encouragement that she came back determined to put the venture on a fully professional basis, under the somewhat grandiloquent title, chosen some time previously, of Universal Limited Art Editions.

Just about this time, in 1957, Mrs. Grosman discovered that she had the two lithographic limestones in her front yard. Limestone with the strength and surface texture suitable for fine lithographic work is extremely rare. It all comes, in fact, from the Bavarian quarries where Senefelder got his original stones. Commercial lithographers in this country often used Ohio limestone, but for subtlety and precision of tone nothing has ever been found to compare with the Bavarian stones, whose smooth, soft texture gives an artist the feeling that his

crayon or brush glides on a film of air. Since the quarries where the
Bavarian stones were found are now exhausted, the new artist-
lithographers have had to reclaim hundreds of old stones that had
been discarded by the commercial lithographers when they converted
their shops to photo-offset methods. Each stone can be used over and
over—the grinding process that effaces the previous image removes
only a fraction from the stone's thickness—but eventually they do
wear out, and unless some new source of lithographic limestone is
found, future lithographers will have to make their drawings on zinc
or aluminum plates, or some other substitute. The two stones that
Mrs. Grosman found in her front yard were small but excellent exam-
ples.

"William Lieberman and Carl Zigrosser had made me realize the
difference between work made without the artist's collaboration and
original prints, where the artist himself participates," Mrs. Grosman
said. "After that, I knew I wanted to make originals, and the fact was
I didn't really like silk screens—didn't like the smell or something.
What I really wanted was for the artist to work with his hand on a
surface, and by some miracle here were the two stones!" By another
coincidence, a man and woman came by one evening to ask the Gros-

WITH JIM DINE
(Judy Tomkins)

mans to sign a petition having to do with bathing rights at the local beach. They got to talking, and it turned out that the neighbors were commercial silk-screen printers, too, and that they had an old flat-bed lithography press that they were not using. The Grosmans signed the petition; Tatyana also bought the press, for $15. A few days later, she took her two stones out to Larry Rivers' studio in Southampton, and her real work began.

Stones, the portfolio of lithographs and poems that Larry Rivers and Frank O'Hara started to work on in 1957, was not published until 1959. Rivers and O'Hara had completed their work on the stones long before that, but Mrs. Grosman wanted to have a special paper made for the edition, and the paper she chose was so difficult to make that Douglass Howell could turn out only a few sheets a day, "if it didn't rain." The choice of paper has always been extremely important to Mrs. Grosman, who remembers her father going to Finland to buy good-quality paper stock, and who now buys papers from special sources in France, Switzerland, Italy, and Japan. She tends to think of the paper for an edition in much the same way that a sculptor thinks of stone or wood—as the material for the creation of works of art. And from the outset of her printing operations, Mrs. Grosman has wanted to print nothing but works of art. *Stones* itself, which started out to be a book, became in the end a portfolio of twelve loose prints, the first number of which was purchased by the Museum of Modern Art (O'Hara was working there at the time). Twenty-five portfolios were printed, and they came, as Mrs. Grosman's editions usually do, in an elaborate and costly folder. The paper for *Stones* was made out of linen-rag cuttings and blue denim. "The first time I saw Frank, he was in blue jeans," Mrs. Grosman explained. "Most of the time they both wore jeans, that was their uniform, and so I asked Mr. Howell could he do something with blue jeans, and he tried and did it."

While waiting for O'Hara to work with him on *Stones,* Rivers executed several more lithographs that appeared as individual editions. "He was very eager to experiment, and his impatience really got me started in single editions," Mrs. Grosman says. "Until then I had been thinking only of books." Although he chafed at the extremely slow pace of hand printing, Rivers found he liked the medium and he greatly enjoyed trying to shock "this Siberian lady Tanya," who, as he later wrote in an essay on the experience, "had dedicated herself with a gentle fury to the production of lithographs." These first Rivers prints were put through the $15 flat-bed press by Robert

Blackburn, a lithographer who had his own commercial studio in New York and whom Mrs. Grosman, with her usual persuasiveness, had induced to come out several times a week to West Islip. At first the printing was done in the living room there; later, they bought a somewhat larger, secondhand press and moved the operation into the garage. When a print had been achieved that came up to everyone's expectations, Mrs. Grosman showed it to a few carefully selected individuals: William Lieberman; Zigrosser; Una Johnson at the Brooklyn Museum; Adelyn Breeskin at the Baltimore Museum; Jacob Kainen at the Smithsonian. "These people have been my teachers," she says. "Also John B. Meyers at the Tibor de Nagy Gallery, and later Leo Castelli, have been unfailingly helpful." Eventually, for reasons of her own, she might decide to launch a new edition in Boston or Philadelphia, or even in London. She had no trouble at all placing her prints or finding buyers; her primary concern, always, was to place them where they would be properly appreciated and understood.

In 1958 Mrs. Grosman invited a second artist, Fritz Glarner, to make an edition of prints. Glarner was a friend of Mary Callery's, and Mrs. Grosman liked his abstract, Mondrian-influenced paintings. "I thought it might be an interesting counterbalance to Larry, to invite an artist who was very pure and very calm," she said. "Glarner happened to live near Mary Callery in Huntington, so I brought him some stones. Mr. Blackburn had told me where to buy more lithographic stones, so I had several by this time. It's funny, when Max Weber heard that we were doing lithographs, he told me, 'You must invite *young* artists, so they can carry those heavy stones.' And that's more or less what I did."

Following her own instinct about the artists whose work appealed to her, she brought stones the following year to Sam Francis, a peripatetic abstract artist who went to Japan before finishing the stones (which Mrs. Grosman kept inviolate until he returned, nine years later, and finished them), and also to Grace Hartigan, who belonged to the second generation of Abstract Expressionists. Since 1958 she had been following with great interest the work of Jasper Johns and Robert Rauschenberg, two young painters whose use of common objects and images from everyday life was to be of such crucial importance for the new post-Abstract Expressionist generation. "I really wanted to invite Rauschenberg first," she recalls, "but I was a little afraid I might not be strong enough, that he would tear everything to pieces—as he actually did a few years later! And then I saw Jasper

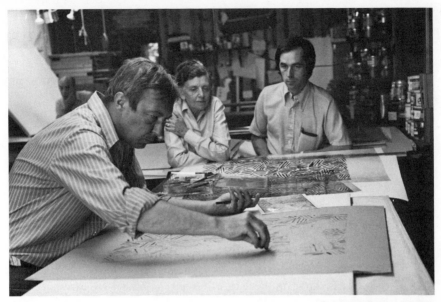

JASPER JOHNS, TATYANA,
AND BILL GOLDSTON
(Judy Tomkins)

Johns's target painting at the Museum of Modern Art, and in 1960 I wrote to him a letter and he answered, a card, saying that he was in South Carolina but that he would come out when he returned, and one day he did. He came with his little animal, I must not call it a monkey [it was a kinkajou], which he put in the catalpa tree in the yard."

Johns and Rauschenberg both had studios then in the same loft building on Front Street, on the edge of the downtown financial district in Manhattan. When Mrs. Grosman brought three large stones there for Johns to work on, Johns got Rauschenberg to help carry them upstairs; the stones were so heavy that they had to enlist the additional aid of a passing derelict, who did it for wine money. Rauschenberg was intrigued by the archaism of the whole idea—that in the middle of the twentieth century anyone should be "drawing on rocks." The backbreaking labor of getting the stones upstairs made Johns decide he would never again work on them in his own studio, and from then on he and Mrs. Grosman's other artists came out to West Islip to make their prints.

A good many people today consider Johns the most important printmaker of our time. His graphic work is in great demand—both the Philadelphia Museum of Art and the Museum of Modern Art devoted one-man shows to it in 1970—and the prices now paid for Johns's prints are well beyond the reach of most collectors. Johns, a

highly enigmatic artist, has said that he began making lithographs in 1960 because, knowing nothing about the process, he wanted to see how much he could complicate it.

His first lithographic project, started in 1960 but not completed until 1963—it took Mrs. Grosman that long to find the right paper— was a series of thirty lithographs portraying the Arabic numerals zero through nine. Each print in this series is, in a sense, a portrait of one of the numerals, all ten of which appear additionally in a double line at the top of the print. The series is repeated three times—in black ink on off-white paper, in gray ink on unbleached paper, and in colors on white paper, making a total of thirty prints in all—and what made it so complicated was Johns's decision that the entire series be printed from *one stone*. Taking the zero first, he saw it through its three separate printings, then altered the image and redrew, on the same surface, the figure 1; in most cases, however, Johns took care not to efface the previous image entirely, so that each successive numeral bears traces of the one preceding. The table of small numbers above the main image also underwent constant transformations through the series. As a result of Johns's incredibly skillful drawing and the transparency of the lithographic inks, the series is not only a bravura demonstration of the possibilities of the medium but a subtle essay on change, seen through the visual symbol of change.

By the time Mrs. Grosman had ordered the right paper to print *0-9*, Johns had made several other individual prints and ULAE had acquired a new printer, a young man named Zigmunds Priede, who succeeded Robert Blackburn in 1963. Priede, Blackburn's former assistant, proved to be a marvelously sensitive and resourceful printer, and as much of a perfectionist as Tatyana Grosman. Working very closely with Johns, who came out from New York to stay at the Grosmans' house, he was able to solve the difficult technical problems of *0-9* and to pull impressions whose delicacy of tone revealed every nuance of Johns's drawing. Mrs. Grosman still marvels at the results. "First, the zero, very classic, in black ink on off-white paper, and then printed in gray on the unbleached paper—very mysterious and moody—and then once again, very luminously printed in yellow on pure white, like sunshine! And after that came the metamorphosis to the number one, but you could still see the zero through the one. What a discovery, that the same stone could have so many moods! And that is what I think fascinates me to work with Jasper. His subjects are so familiar—flags, targets, numbers, alphabets—everything is so known. But it is so unexpected each time. In lithography, on

stone, in etching, or in etching with aquatint, or on the hand-fed off-set press—each medium he is really playing as an instrument, and the subjects become different personalities. Zigmunds Priede said about working with Jasper, that he had the overwhelming feeling of being present while great art was being created."

Johns has made more than a hundred lithographs at ULAE since 1960. When the news gets out that he is going to make a new print, Mrs. Grosman and Leo Castelli, Johns's dealer, are both besieged with orders for it, most of which cannot be filled because the ULAE editions remain quite small—there were only ten impressions made of each of the *0-9* series. Johns's 1964 "Ale Cans," a lithograph whose glossy, lustrous blacks, subtle gold-and-green tones, and uncanny three-dimensionality have made it probably the most coveted of modern prints, came out in an edition of thirty-one, which Mrs. Grosman sold originally for $175 apiece. The fact that a print of "Ale Cans" was resold recently for $10,000 came as no particular surprise to Mrs. Grosman; she herself has always referred privately to this print as "Peter and Paul," because from the moment she saw it the image (of two rather meticulously rendered cans of Ballantine's ale) struck her as a miraculous modern ikon. According to Johns, Mrs. Grosman decided very early in her printing career that ULAE was going to be the finest lithographic studio in the world, and nothing has happened since then to change her mind.

This insistence on pre-eminent quality creates certain problems. "Everything that happens out there happens awfully slowly," Johns has said. "When something doesn't come out just right, for example, Tanya gets upset and has to figure out why. It may be that if the same process is repeated it will come out fine the second time, but she can't accept that, she has to *know*. Sometimes, when there were two ways of doing something, I would ask her which one cost more. Tanya wouldn't tell me—she said that was for her to worry about. Usually I didn't care which way we did it, and knowing about the cost would have helped me to decide, but she wouldn't have that. Also, she's terrifically secretive. One day when I was working out there, she took a bunch of prints in to New York to show to Bill Lieberman at the Museum of Modern Art. When she got back in the afternoon, I asked how it had gone, and she said that Lieberman had been called into a meeting just before she arrived, and so she had turned around and brought the portfolio back home. She wouldn't dream of leaving her prints with somebody's secretary! There are times out there when it takes weeks before you can see the results of

some decision you've made, and by then you may have already decid-
ed otherwise. All Tanya's prints show the effects of this kind of
slowness, this deliberation. They're more dense, maybe. Somehow,
everything that comes out of there gets stamped with her per-
sonality."

By 1962 Mrs. Grosman felt strong enough to invite Robert Rausch-
enberg to her studio. "Tanya called me so often that I figured the
only way I could stop her was to go out there," Rauschenberg has
explained. He immediately fell in love with the lithographic process.
"It's such a paradox," he says. "The stone is so heavy and clumsy
and immobile, and yet at the same time it's the most flexible, respon-
sive surface there is. And every stone is different. Some of them will
be much better for me than others, easier to work with. It's like
you're drawing on the skin of the stone."
 Where Johns had been interested in complicating the process,
Rauschenberg's approach was wholly experimental. In all his work,
Rauschenberg likes to feel that he is "collaborating" with materials
rather than using them to carry out some preconceived notion of his
own. The collaborative aspects of lithography, the mutual interdepen-
dence of artist and printer, appealed to him very much, but he also
wanted to explore the medium and to try all kinds of methods and
materials that had not been used by anyone else. He tried pressing
leaves from trees, magazine pages, and various other objects down on
the stone, to see whether they contained enough natural oil to leave
an imprint that would hold ink; some did and some did not. He went
to *The New York Times'* morgue and bought leaded type and zinc
cuts of old news photos, which he then dipped in the greasy li-
thographic tusche and used to create images on the stone. By such
means he was able to adapt his collage technique in painting to li-
thography, and to make prints that were direct, visual reports on the
contemporary world. While one of these early Rauschenberg stones
was being put through the press for its first proofing, it cracked in
half—a fairly rare but not unprecedented occurrence in hand printing.
Rauschenberg recreated the images on another stone, which also
cracked (a small piece of cardboard lodged under the roller was caus-
ing uneven pressure on the stone), whereupon Rauschenberg told
Robert Blackburn, who was still doing the printing then, to go ahead
and print the edition anyway, using the cracked stone. Blackburn was
incredulous—such a thing had never been done. Taking some of the
chips of stone that had fallen from the break, Rauschenberg dipped

them in tusche and applied them to the lower portion of the sundered halves of limestone, leaving marks that resembled the debris of a break. With great difficulty Blackburn managed to print from the broken stone. The result was one of the most striking prints ULAE has published—a collage of images that seem somehow to be unified, rather than separated, by the jagged fissure running down the middle. Twenty-nine impressions were made of this lithograph, which Rauschenberg, logically enough, decided to call "Accident," and those who own one consider themselves extremely fortunate.

Rauschenberg points out that in spite of Mrs. Grosman's dedication to the classic methods of lithography, she has always been willing to go along with all his experiments, and has given him and her other artists complete freedom to satisfy their own curiosity about the medium. For her own part, Mrs. Grosman is enormously fond of Rauschenberg, whom she treats like a somewhat wayward son. "Bob is always bringing something new, some new discovery," she has said. "Like the 'book' he did, called *Shades,* which is a series of lithographs on Plexiglas. Nobody ever heard of printing on Plexiglas, but he wanted to try it, and we did, and it worked. And those photosensitive stones that he and Zigmunds Priede and Bill Goldston, Zigmunds's apprentice, did in 1969. Together they worked out the chemistry, the technique of somehow coating the stone with photographic emulsion, and using night as a darkroom—I don't know *how* it was done. Afterward, Goldston said, 'You know, Bob, it worked, but we don't know why it worked, or why sometimes it doesn't work.' With Rauschenberg, to work is something heroic. There is always a conquest, a subduing of something, the conquering of something unprecedented and unexpected—and he utilizes it all."

The instinct for complexity and experimentation has led both Johns and Rauschenberg to make prints at the Gemini GEL workshop in Los Angeles, a much bigger and better-equipped establishment than ULAE. Established in 1965 by Kenneth Tyler, a former technical director of June Wayne's Tamarind workshop, Gemini chose to concentrate, as Mrs. Grosman has, on graphic work by New York artists. Tyler also went out of his way to accommodate these artists's technical needs, installing presses capable of handling very large stones, for example, and developing the means to produce three-dimensional objects in multiple "editions." The revival of interest in printmaking has taken a highly technological turn in the last few years, and many artists are now experimenting with aluminum, Mylar, polyurethane, vinyl, and other plastics to produce what, for

want of a more precise term, are still being referred to as prints. The results, for the most part, tend to be more novel than aesthetic. At Gemini, however, Johns, Rauschenberg, Frank Stella, Claes Oldenburg, and others have made prints of exceptional quality, and because the Gemini editions are large—a hundred and fifty is a common printing there—the artists have profited rather handsomely as a result.

Considering her personal and somewhat possessive feelings toward the artists in her "family," it is hardly surprising that Tatyana Grosman has mixed emotions about their work at Gemini. "It was a kind of sadness on both sides," she said not long ago, "for the artists and for me. But it is like a mother with children—the time comes when she has to send them out. And when they come back they are different, their vocabulary is different, and they have had different experiences. And I learn from their experiences."

Whatever Mrs. Grosman may have learned in this manner has not induced her to change her methods or her approach. In 1966 she received a $15,000 grant from the National Endowment for the Arts which she used to buy an etching press and to build an addition to the garage in which to house it. Working with the master intaglio printer Donn Steward, several artists including Johns, Marisol, Helen Frankenthaler, Lee Bontecou, and Robert Motherwell have achieved etchings comparable in quality to their lithographic work. Motherwell's *A La Pintura*, a portfolio of twenty-four aquatints together with passages from Rafael Alberti's poem in homage to the art of painting, became the first contemporary book to be exhibited at the Metropolitan Museum of Art, in 1972. The project took four years to complete, and John McKendry said that if all Motherwell's paintings and other works were destroyed, this *livre de luxe* alone would secure his reputation.

In 1970 ULAE acquired a lithographic offset press, of a type used commercially for proofing color separations. The idea was that this would be used to print unlimited editions of work done at ULAE, in various forms—replicas, productions, books, postcards, and so on—always with the advice of the artists concerned, so that the spirit of the original would be maintained. A new imprint, Telamon Editions, was chosen for work from the offset press. In five years, however, Telamon has produced five posters by artists (the first was Rauschenberg's "Centennial Certificate," done on the occasion of the Metropolitan Museum's one-hundredth birthday in 1970), and not much else. Bill Goldston, who is now the head printer at ULAE, and James

Smith, Telamon's offset lithographer, have spent a great deal of time during this period experimenting with the new press, evolving methods by which it can be made to re-create, step by step, the laborious process of stone-printing. Jasper Johns wanted to try running a hand-drawn plate through the offset press, which is designed to take photographic plates. The printer said it had never been done, but he would try; the result was "Decoy I" and "Decoy II," two of Johns's most complex and beautiful prints. Other ULAE artists have since used the offset press to make limited editions, the most spectacular of which, to date, is James Rosenquist's "Off the Continental Divide," a print that measures three and a half feet by six and a half feet, and which required twenty-nine separate plates. In effect, Goldston and Smith have converted a mechanical technique to an extremely sensitive hand-process.

More and more, though, Mrs. Grosman's thoughts return to what John McKendry once called her "unrelenting and unreasonable love of illustrated books." "Always from the beginning," she says, "my idea was books. I let the artists do single editions because that was what they wanted, but for me the book was always the primary goal."

LUNCH AT ULAE, AUGUST 1975
(Judy Tomkins)

Telamon Editions may bring this goal within reach. Several book projects are under way there, the first of which is a re-creation of all Jasper Johns's work at ULAE, in three volumes. Johns is supervising every step in the production, determining the size of each print, correcting color and tone, spending in many cases more time on the photo-offset process than he did earlier on the original print. Telamon is also producing a book that will document the collaboration of Larry Rivers and Frank O'Hara on *Stones*, and it will eventually print offset editions of other books now in progress at ULAE—notably a collaboration of lithographs and writings by Rauschenberg and the French novelist Alain Robbe-Grillet, and a book of lithographs, not yet titled, recently undertaken by the century's protean, all-purpose genius R. Buckminster Fuller. There is no telling, of course, how long any of these projects will take. The pace is monastic, and schedules do not exist.

Mrs. Grosman's "family" changes very little these days. Bill Goldston, the studio manager, oversees operations both at ULAE and at Telamon. Glenn Lee is entrusted with keeping the prints in pristine condition. Tony Towle, a young New York poet who has developed a thorough aesthetic and statistical knowledge of every print produced there, shares the administrative burdens. Since 1968 only two new artists have been invited to the West Islip workshop—Claes Oldenburg and Buckminster Fuller. "I don't really know the younger ones," Mrs. Grosman explains, "and I also feel a certain obligation to continue working with those we know so well. I'll tell you something, I think artists are great people. I had a slight little disappointment once with an artist, a very *slight* disappointment, but that's all. For me, the pleasure is in being able to help an artist achieve something unique. Take, for example, Jasper, working on some very complex print such as "False Start II," each print requiring fourteen different impressions from eleven stones and all in varying shades of gray, playing with the image, seeing it change, building it up layer by layer—only Jasper can do that. Or Larry Rivers, entirely the opposite, touching many interesting things without developing them, very emotional. Or Rauschenberg, always bringing something new, some discovery.

"For me, graphics is neither a means to supply art to young collectors nor a reproduction of an artist's work, but rather the creative expression of an artist through lithographic stones or plates. I do have great love for the lithographic stone itself, for the majesty of the natural element. No stone is alike, you see; each one has its own size,

shape, color, and texture. But the technical aspect of printing is not really important for me, and 'technique' should never be the predominant feeling in a print. What matters is that the print be alive, with the heartbeat of the artist in it. And always between the idea and the execution of a print there is—something, I don't know what. Maybe I ask a question, and the artist thinks about the question and it leads to other thinking. Sometimes, you see, the artist himself does not realize that between putting a mark on paper and printing, is a difference. Putting it on paper is like writing a letter to a friend. But if you publish a print, an edition, a book, and let it go out into the world, to be distributed so many different ways, that is something else. It must not be rushed. Sometimes it is good just to let an edition sit for a while, and maybe you will later add something or take something away. I think it is my responsibility that the artist should not ever have reason to regret what he has done."

EAT

Technology may be anathema to a lot of people these days, but it has seldom been in higher repute among artists. Although there are a few painters and sculptors around who still work with traditional materials and in a more or less traditional manner. one sometimes gets the feeling that their days are numbered, and that the majority of young artistic Lochinvars, heirs to a half century of violent assaults upon all previous notions of what art is and what artists do, have turned from paint and canvas, stone and wood to the tools and processes of modern industrial technology. This wedding of art and engineering is often celebrated upon the altar of big business; only a large corporation is really in a position to further the grandiose technological collaborations that so many artists now seem determined to undertake, and a surprising number of such companies have shown themselves willing to do so. Because the businessman's motives in sponsoring projects of this sort are seldom entirely clear to anyone, however, the relationship between the new art and its potential patron remains somewhat confused and confusing.

When one tries to retrace the steps by which the Pepsi-Cola Company became involved with art and technology in planning its exhibition for Expo '70, in Osaka, Japan, the question of motive becomes tantalizingly elusive. It almost seems as though the whole thing came about inadvertently, through a series of productive confusions that never quite reached the level of corporate decisions. Pepsi, to be sure, had often shown an interest in the arts before; it had given out awards and scholarships to young artists, held art exhibitions in the lobby of its Park Avenue office building, and sponsored numerous cultural events, such as the Metropolitan Opera's summer concerts in Central Park. Never before, however, had the company put its corporate image in the hands of the artistic avant-garde, and the chances are that it would not have done so this time if it had not been for David Thomas, who came to work there in 1967 as vice-president for marketing coordination and planning of PepsiCo Inc.'s international divi-

sion, and thus assumed responsibility for the Pepsi Pavilion at Expo '70, preparations for which were already in progress.

World's fairs, as Thomas knew, are risky propositions. Pepsi had retained the Walt Disney organization to design its pavilion at the 1964-65 New York World's Fair: a boat ride through a fanciful landscape populated by animated, singing dolls in the costumes of many nations. The show was popular, and it was subsequently transferred almost intact to Disneyland; unfortunately, however, the production exceeded its budget by a figure that Pepsi concedes to have been "several million dollars," and those Pepsi executives who survived the debacle would prefer not to think about it. Pepsi had no pavilion at Expo '67, in Montreal; it settled instead for "traveling troubadours" —groups of minstrels who went about entertaining the people in line outside popular exhibits.

The importance of the Japanese market dictated a more ambitious Pepsi effort for Expo '70, the first international exposition ever held in Asia. Outside the United States, only Mexico and West Germany consume more cola beverages than Japan does, and Pepsi-Cola, which was being outsold in Japan eight to one by Coca-Cola, was extremely anxious to improve its position. Alan M. Pottasch, the president of PepsiCo's Japanese company, had pushed hard for a large and showy Pepsi Pavilion, arguing that the Japanese placed great importance on "bigness." The leading Japanese bottlers of Pepsi-Cola agreed with him. As a result, a tentative decision was reached, toward the end of 1967, that Pepsi-Cola, Japan, and seventeen Japanese bottlers would jointly sponsor a pavilion whose over-all budget for construction and six months' operation would be in the neighborhood of $2.5 million. Only two other U.S. companies—Eastman Kodak and IBM—applied for pavilions of their own at Expo '70. Both were awarded space in the exhibition area, near the main Festival Plaza; Pepsi got a site off by itself, on relatively high ground in the amusement section. Shortly after being granted the site, Pottasch engaged the Takenaka Komuten Company, one of Japan's largest architectural-construction firms, to design and put up a pavilion.

At this point, nobody had any clear idea of what would go into the Pepsi Pavilion. Having no new models or designs to show off, Pepsi can be more freewheeling in its exhibits than, for example, General Motors can. There are certain concepts, however, that the company likes to get across in all its advertising, and one of these is its association with youth. Pottasch, a young, dynamic type who had been marketing services vice-president for Pepsi before becoming president of

the Japanese branch in 1966, was responsible for the advertising campaign that launched "the Pepsi Generation." In addition to its emphasis on youth, Pepsi likes to stress what it calls "community," or "the people side of what's happening today"—a concept that the company had been promoting by sponsoring a traveling musical show called *Up with People,* whose young and gladsome cast owed its genesis to the Moral Re-Armament organization. Bigness, youth, and community were to be the governing themes, then, but for quite a while no one could decide how best to put these across at Expo '70.

Discussions centered at one point on the idea of an International Youth Pavilion, where young people of all countries would be welcome to express their views and exchange ideas. Worldwide student disorders and reports that left-wing Japanese student groups were planning large-scale protests against Expo '70 cooled Pepsi's enthusiasm for this idea. At the time Thomas entered the planning discussions, early in 1968, Pepsi was thinking in terms of an auditorium for film showings. Thomas argued vigorously against this plan. New techniques in film and film projection had been the big thing at Expo '67, he said, and this in itself more or less guaranteed that they would no longer seem contemporary in 1970. Having asked for and received authority to rethink the whole concept of the pavilion, Thomas did some research of his own on the youth market and became convinced that some form of multimedia discotheque, with continuous rock music, would fit in excellently with Pepsi's aims. The only trouble was that the programing budget, based on the estimated costs of a documentary film, was only $250,000—not nearly enough to provide for live rock groups of any stature.

In September 1968, casting about for ideas, Thomas went to see a neighbor of his in Rockland County, an artist and film-maker named Robert Breer. Thomas wanted to know whether Breer could make any suggestions for a pavilion that would be part discotheque and part multimedia show and almost entirely automated, because this was all that the budget would allow. As they talked, a thought took shape in Breer's mind.

Breer makes moving sculptures. He had had two shows of them at the Bonino Gallery, in New York—Styrofoam "floats" with concealed, battery-driven motors that caused them to move, but so slowly that their motion was imperceptible except on very close observation. He had several of his floats in the studio behind his house, and he took Thomas out to see them. Breer's mind is extremely allusive. As he later recalled its workings, the idea of rock music had somehow

suggested to him the famous Zen rock garden of the Ryoanji Temple, in Kyoto, where fifteen rocks in five groups, set in raked sand and bounded on two sides by an ancient earthen wall, suggest to rapt meditators the shape of the universe. Some initiates maintain that if one gazes at the Ryoanji garden long enough, the rocks will appear to move. "What with David asking all this advice," Breer said, "it just occurred to me that maybe I could make my own little Japanese contemplation garden over there, the difference being that my rocks really *would* move."

This idea appealed immediately to Thomas, whose background—he is a transplanted Londoner whose father, in the best tradition of English eccentrics, spent two years as a Shinto priest in Kyoto—is perhaps a bit broader than that of most Pepsi-Cola executives. Thomas has an allusive mind, too, and as he and Breer talked they both became more and more excited at the thought of having Breer and other artists become involved in planning the pavilion. Breer knew most of the leading artists of the Pop and post-Pop generations. He was also a close friend of Billy Klüver, a research scientist at the Bell Telephone Laboratories in Murray Hill, New Jersey, and a cofounder, with the artists Robert Rauschenberg and Robert Whitman and the engineer Fred Waldhauer, of a foundation called Experiments in Art and Technology, or EAT. In the course of the conversation Breer and Thomas had that September afternoon, Breer telephoned Klüver, and Klüver showed his interest in the possibilities by driving up from his home in New Jersey to join them.

A museum director once described Klüver as "the Edison-Tesla-Steinmetz-Marconi-Leonardo da Vinci of the American avant-garde." The son of a Swedish hotel owner, Klüver (who uses his given names—Johan Wilhelm—only when he publishes a scientific paper) graduated from the Royal Institute of Technology in Stockholm in 1951, and then took a Master's and a Doctor's degree in electrical engineering at the University of California at Berkeley. He joined the technical staff of Bell Laboratories in 1958 and spent the next ten years in electron-beam and laser research. Since 1960 Klüver had also devoted a great deal of time to helping his artist friends realize projects that involved complex technological elements, the first such project being Jean Tinguely's heroic self-destroying kinetic sculpture *Hommage à New York,* which committed suicide in the garden of the Museum of Modern Art in the spring of that year. Bell Labs had been surprisingly tolerant of Klüver's avant-garde activities. The Bell

research department maintains an open attitude toward experimentation of all kinds, and Klüver's superiors seemed to have no objection to his frequent involvement in projects that had little to do with improving everyone's telephone service. Between 1962 and 1966 Klüver and his colleagues at Bell Labs invented a portable power-supply unit for a painting by Jasper Johns that incorporated neon lights; designed a complex sending-and-receiving sound system for a sculpture group by Robert Rauschenberg; enabled Andy Warhol to make silver pillows that floated in the air; and collaborated with the composer John Cage on the electronic score for Cage's "Variations V." He also helped organize several avant-garde art exhibitions, in this country and abroad, and was the chief coordinator and impresario of a series of art-and-technology performances called *9 Evenings: Theater and Engineering,* presented at the Sixty-ninth Regiment Armory in New York in the fall of 1966 and comprising *very* mixed-media works by ten artists working in association with forty engineers, most of whom Klüver recruited from the staff of Bell Laboratories.

Although *9 Evenings* was characterized by engineering breakdowns and aesthetic confusions on a grand scale, it was nevertheless recognized even at the time as the beginning of a movement that was destined to generate great interest among contemporary artists. Klüver and Rauschenberg, who was the other moving spirit behind *9 Evenings,* had already become so strongly convinced of this interest that they decided in September 1966, a month before the performances, to set up an organization to facilitate future artist-engineer collaborations. This was the start of EAT, which was incorporated as a nonprofit, tax-exempt foundation and designed—as a prospectus written by Rauschenberg and Klüver phrased it—"to catalyze the inevitable active involvement of industry, technology, and the arts." More than three hundred artists showed up for EAT's first organizational meeting, in December 1966, and eighty of them had specific requests for technical advice or assistance. The response from the engineering community was slower. At a subsequent general meeting at the Park Place Gallery, when the engineers present were asked to stand and identify themselves, only twelve stood up. They were warmly applauded.

Primed by a modest initial grant from the New York State Council on the Arts, EAT rented space in a loft building at 9 East Sixteenth Street, hired a small staff, got out a newsletter, and started holding gatherings at the loft on Sunday afternoons to encourage informal contacts between artists and engineers. During the next two years

EAT continued to attract artists; it also managed, surprisingly, to attract engineers and money. By the fall of 1968 it had enrolled just under a thousand engineers and just over a thousand artists, scattered widely around the country. Furthermore, as a result of personal interest shown by Theodore W. Kheel, the labor mediator, Frank Stanton, the president of CBS, and several other influential citizens, grants had come in from IBM, AT & T, Xerox, and Atlantic Richfield. The source of these grants was a matter of considerable gratification to Klüver and Rauschenberg, who had said from the beginning that they counted on industry to provide the major part of EAT's financial support. The organization was still far from financially stable, though, and in the fall of 1968, despite its expansion as a clearinghouse for artist-engineer collaborations, its continued existence was decidedly uncertain. Francis Mason, a former cultural-affairs officer for the United States Information Agency who consented in 1968 to become president of EAT, had resigned after only six months on the job. "His experience had been with the government," Klüver explained. "This situation was a little too uncertain and messy." (Mason remained on EAT's Advisory Council, and he was very helpful in other ways.) Rauschenberg, a strong innovative and inspirational force, was beginning to devote more time to painting and less to EAT, to the immense relief of his dealer. Klüver himself had been offered a job by the National Academy of Science, in Washington, D.C. It was at this juncture that Klüver drove up to Rockland County to discuss the Pepsi-Cola Pavilion with Breer and Thomas.

Thomas wanted to know whether anything interesting could come of an artist-engineer collaboration on a budget of $300,000—the original $250,000 for the filmed documentary plus $50,000 that Thomas had tucked away in his own operating budget. Then and later, Klüver was reluctant to discuss money. At that point, he did not even know whether a nonprofit foundation such as EAT could take part in what was essentially a commercial venture. The possibility seemed to him well worth exploring, however; the real question was whether EAT could work with Pepsi-Cola, and vice versa.

There were serious reasons for doubt on both sides. As Thomas soon discovered, the only large-scale undertaking that EAT had engaged in as a group was *9 Evenings,* and most of the clippings that Klüver sent to him about that event referred to it as a catastrophe. Thomas screened this material carefully before showing it to anyone at Pepsi-Cola. Some of Klüver's art-world friends, on the other hand,

argued strongly against EAT's having anything to do with Pepsi-Cola, which they somehow seemed to regard as part of the military-industrial complex. Klüver took the position that EAT would simply be acting in an advisory capacity. It was Klüver who suggested that Thomas see the Electric Circus, a well-known multimedia discotheque in the East Village. Thomas went down there one evening with Breer and Breer's wife, and they talked with the Electric Circus owner, Stanton Freeman, about participating in the Expo project. Freeman expressed interest. Earlier, at a Pepsi-Cola bottlers' convention in New York, Thomas had seen a multimedia light show put on by USCO, an art-and-technology group based in Cambridge, Massachusetts, and as a result he had insisted that Gerd Stern, one of the USCO artists, be included in the EAT planning. "I felt that Stern would be able to do something that ninety per cent of the Japanese people would understand, and I wasn't at all sure that the EAT people would do that," Thomas said later. From the outset, though, Thomas rather favored EAT. He liked the energy and the spirit of the EAT people he had met, and their apparent ability to work together without undue effusions of ego. (At the Brooklyn Museum, where a number of EAT-inspired art-and-technology projects were shown that fall in an exhibition called "Some More Beginnings," Thomas had been impressed no end by the sight of Klüver, the laser expert, fixing an art-and-technology malfunction with a pair of pliers.) Klüver and Breer were also a lot further out in their thinking than the Electric Circus people, and Thomas took this to indicate that by 1970 their ideas might seem more contemporary and in. On Thomas' recommendation, at any rate, Pepsi-Cola invited both EAT and the Electric Circus to make formal proposals for the Pepsi Pavilion at Expo '70. The invitations carried modest grants to cover the necessary costs— $10,000 to the Electric Circus and $25,000 to EAT. Shortly thereafter, Klüver left Bell Labs, assumed the vacant presidency of EAT, and began devoting much of his time to the Pepsi project.

Klüver and Breer had no trouble finding artists willing to collaborate with them. Breer chose three, who, with Breer, became the "initiating and design" artists on the project: Robert Whitman, who had done some of the more interesting happenings of the last ten years and also one of the few relatively well-received events of the *9 Evenings*; David Tudor, a musician and composer long associated with the avant-garde, who knew as much about electronic sound systems as most audio engineers; and Forrest ("Frosty") Myers, a young sculptor who had recently done some spectacular outdoor light works

in and around New York. Stern was included at Thomas's request. Fred Waldhauer, an electrical engineer from Bell Labs and one of the founders of EAT, and John Pan, another Bell Labs engineer, completed the initial planning group, which held a series of chaotic meetings, starting on October 2, at the EAT loft on Sixteenth Street.

Each artist brought to these meetings a more or less complete plan for the pavilion, which he barely had time to outline before the others proceeded to demolish it. "It was a little hard on the various egos, but we stayed friends," Breer said later. About the only idea that everyone present did agree on was Whitman's suggestion that the Pepsi Pavilion be an "environment" in which visitors could create their own experience. As Whitman explains it, "We all wanted to get away from the Walt Disney-type of thing—taking people through a building and pointing out what they should look at and then ejecting them at the other end." His suggestion, of course, was very much in keeping with the insistence of many contemporary artists that the spectator *participate* in the art process—experience the work of art actively and make of it whatever he chooses.

Whitman's idea also appealed strongly to John Pearce, a young architect whom Klüver had hired as architectural coordinator for EAT's Expo project. Pearce had just come back from Japan, where he had worked for a month with the architectural firm of Davis, Brody on the United States Pavilion at Expo. One reason he had left this job was his own disenchantment with the business of herding mobs of people through depressingly similar exhibits, and Whitman's notion that the visitor should make his own sensory experience caught Pearce's imagination. The early meetings in the loft reminded Pearce of late-night bull sessions at Yale (he graduated from the Yale School of Architecture in 1965). By this time it was becoming clear to all those present that they were not making much progress.

What broke the planning logjam was a suggestion by Rauschenberg at a meeting on November 10. Rauschenberg, the chairman of EAT's board, had been asked to join the original group of artists but had been unable to do so because of other commitments. He came to the meeting on November 10, though, and during this highly argumentative session he made the observation that most of the ideas being debated were visual ideas; perhaps, he said they should start to think more in terms of sound and the other sensory avenues, or, as he put it, in terms of "an invisible environment." Both Klüver and Breer are convinced that this suggestion jarred the others loose from their usual ways of thinking and brought about a much more productive

atmosphere. Ideas poured forth. Rauschenberg himself talked of controlling traffic flow by "natural obstacles" rather than by rules and guards—he proposed a dance floor flooded to the depth of two inches, so that visitors could decide whether or not they wanted to dance in water. Other suggestions included air-cushion pods—miniature hovercraft—on which people could sit and float around; hot zones and cold zones, and zones where people's skin would seem to change color and their hair stand on end; a large overhead mirror; shafts of water pouring from the ceiling into holes in the floor; taste and smell fountains; "positive silence" zones (anechoic chambers); a ceiling that would rise and fall; rear-projection films on a glass floor that would make one appear to be walking through flames, over water, or among vastly magnified newts and lizards; a fog cloud; a freak snack bar with edible plates; and even—this from the engineer John Pan—a "fountain of youth" that would catapult children and teen-agers, on a powerful air current, from one level of the pavilion to another. Although Pepsi-Cola did not know it yet, the concept of a rock-music discotheque was rapidly being superseded.

Most of the early ideas were discarded over the next few weeks, during which Breer, Myers, and Whitman mapped out the basic design scheme in a series of intense and somewhat alcoholic sessions in Whitman's loft studio. (Stern, the USCO artist, had withdrawn from the discussion, leaving EAT in full command.) Pearce, the architect, proved invaluable at these meetings. He had been to the site of the Pepsi Pavilion, and he was able to tell the artists that construction on it had not yet begun—the artists had assumed it to be nearly finished —and that they could make changes in the over-all design. As it turned out, they made a great many. The Japanese architect for Takenaka Komuten had designed what Breer called a "Buckled Fuller" dome—a false geodesic, which looked like a crude version of one of R. Buckminster Fuller's tension structures, its exterior broken by triangular peaks and troughs. The irregular roof construction would obviously make the interior space an acoustical nightmare, in addition to creating severe installation problems. With Pearce's architectural approval, the artists decided to build another structure inside the dome—a spherical room with a sloping floor divided into sections. Each section would have a different surface texture—stone, wood, plastic grass, bouncy rubber—and each would have its own corresponding sounds, which the visitor would listen to by means of a flashlight-size, hand-held receiving set that would pick up signals from audio loops under the floor.

Overhead, in addition to lighting effects and an audio system incorporating thirty-seven loudspeakers, Whitman proposed that they install a large hemispherical mirror. Whitman had already done several works using mirrors—one of them, a room-filling installation called *Pond*, was on exhibition at the Jewish Museum in New York. Although his knowledge of optics was limited, he was fascinated by the strange, ghostly images that a curved reflecting surface gives back, and by the way an image turns upside-down when the subject moves back from it. He had also learned that a hemispherical mirror will produce what is called a "real image," a three-dimensional, upside-down image in the space in front of the mirror itself, in addition to the two-dimensional "virtual image," optically centered in the space behind the mirror's surface, that one sees when looking in an ordinary mirror. Moreover, the "real image" is repeated in a number of spots around the room. A large hemispherical mirror seemed ideally suited to Whitman's idea of a free space where each visitor's sensory experience would be unique and unrepeatable, and where the visitor himself would be, in effect, the show.

Under the floor of the spherical room would be a space that the artists decided to call, because of its shape, the Clam Room. This, they thought, could be a sort of orientation room—a dark chamber that visitors would pass through on their way to the mirror dome upstairs. In the entrance tunnel, visitors would receive their handsets and would be ceremonially bathed, if someone could figure out how to do this safely, in a shower of laser light. At one point, they thought of having Breer's moving floats in the Clam Room (the floats had been an accepted part of the planning right along), but it was later decided to place them outside, on a concrete plaza near the main entrance to the pavilion. There they would coexist with Myers' *Suntrak*, a thirty-six-foot sculpture engineered to follow the sun's path and to cast, by means of two mirrors, a ten-foot beam of sunlight upon a fixed point on the pavilion.

The exterior of the pavilion, which would supposedly withstand earthquake or typhoon, was not subject to design changes. The artists thought its design was boring and ugly, and their joy was great when Myers, at an early meeting, proposed shrouding it in a permanent cloud of man-made fog. No one knew then how this might be done, but everyone agreed that it was a beautiful idea and that the engineers would find a means of carrying it out. Breer later told people that the fog was related to Japanese prints, such as those by the nineteenth-century artists Hiroshige and Hokusai; it seemed, at any rate, a curiously Japanese solution to the problem.

All through November Thomas continued to give his employers carefully worded versions of EAT's evolving ideas. Thomas thought it best not to dwell on the concept of a sensory environment, and stressed instead the more readily comprehensible ideas, such as the rear projections of magnified newts—for some reason, several Pepsi executives loved the idea of walking through flames and among newts. In a crucial five-minute interview with Peter K. Warren, the president of Pepsi's international division, Thomas managed to get the budget for the pavilion interior raised from $300,000 to $500,000. Warren said that he didn't quite grasp what the pavilion was going to look like inside but that he had faith in Thomas's judgment. Until the end of November all the EAT thinking had been filtered through Thomas's rather acute sense of what his employers would and would not accept, but the time was rapidly approaching when both EAT and the Electric Circus, competitors in what was still not admitted to be a competition, would have to make their formal presentations, in person, to the client. For Thomas, this prospect was not without anxiety.

The Electric Circus made its presentation at Pepsi's Park Avenue offices on December 2. It was a polished, professional job, complete with a scale model in color, and oral and written explanations that were models of confident lucidity. At the end, one of the Pepsi executives present asked whether such an impressive proposal—for a multimedia discotheque rather like the Electric Circus—could really be carried out on a budget of $500,000. Stanton Freeman coolly replied that it could not; it would cost at least a million, he said. Thomas was furious. He later told Freeman that the Electric Circus owed him another presentation, for the agreed-on budget of $500,000. Freeman said it would be impossible to do anything interesting at that price.

EAT's presentation took place the following day, and, by comparison, it was ludicrously inept. Before the formal presentation, however, Klüver took Pottasch and several other Pepsi executives to the Museum of Modern Art, which was then featuring an exhibition called "The Machine." This exhibition had been organized by an old friend of Klüver's—K. G. P. Hultén, the director of the Moderna Museet, in Stockholm. "The Machine" show included several art-and-technology pieces that had been entered in an international competition sponsored by EAT—the rest of the entries were in "Some More Beginnings" at the Brooklyn Museum. After viewing the exhibit, the Pepsi group went up to the museum's sixth-floor restaurant to have lunch with Breer, Klüver, Pearce, and Rauschenberg. Rauschenberg's presence obviously made an impression on Pottasch. Pottasch, it developed, was moving back from Japan in a few months to take

over Thomas's job. Thomas would resign from Pepsi-Cola soon afterward, but for the time being he was doing his best to transfer his own enthusiasm for EAT to his successor, and he was pleased to see that Rauschenberg's talk was having such a favorable reception. After lunch, they went down to the third floor of the museum, where Rauschenberg's *Soundings,* a thirty-six-foot-long mixed-media work on Plexiglas, was on temporary exhibition. In the gallery where *Soundings* hung, any noise, such as a voice or a footstep, would activate light sources behind the Plexiglas surface and thus disclose images that had previously been invisible. It was similar in spirit to some of the ideas that had been discussed at lunch. And here it was, hanging prominently in the Museum of Modern Art.

Rauschenberg left to keep another appointment, and the rest of the group went back to the Pepsi offices, at Fifty-ninth Street and Park Avenue. Trooping in past a rather startled secretarial corps (both Whitman and Myers affect shoulder-length hair, flowing mustaches, and high-visibility clothing), the EAT team sat down in a conference room and proceeded to spread amiable confusion. They had architectural drawings as well as some rather fanciful rough sketches of the pavilion that Breer had made; these were augmented by equipment that demonstrated the various effects that EAT hoped to achieve, including a laser and a spherical mirror. Klüver, who speaks in a flat, Swedish-accented voice, talked abstractly about invisible environments and the necessity of humanizing technology. He was followed by Breer, Whitman, and Myers, who gave their versions of what the pavilion would be like—versions that did not always coincide. Pearce had brought along a model of the pavilion to show, which helped some; his obvious capability and good sense also made a favorable impression. When everyone had finished talking, though, and Pottasch asked to see their budget, it turned out that EAT did not have one—not on paper, anyway. Growing increasingly baffled, the Pepsi executives left the room for an hour while the EAT group drew up a budget. As they estimated and added up their costs, they were disconcerted to find that their figure was going to be well above $500,000. In the end, they settled, a bit arbitrarily, for the figure of $859,000. The Pepsi group returned. After some more discussion, Klüver and Pearce conceded that their budget represented a "fat" $859,000, and could be reduced considerably by hardheaded cost-cutting. On this basis, the meeting adjourned.

Whether or not a firm decision was ever made by PepsiCo regarding the EAT presentation is an interesting question. No hardware

contract was signed until more than a year later—less than a week before the opening of Expo '70. A day or so after the meeting, though, Thomas advised the Electric Circus that its proposal was regretfully declined, and told EAT to go ahead on the Expo project—with a budget that was to be "squeezed down" from $859,000 to $550,000. Most of the subsequent disputes between EAT and Pepsi had to do in one way or another with the budget. There was, however, an underlying uncertainty about the entire project and what it was supposed to achieve—a confusion that deepened when Thomas, the only effective communications link between EAT and its client, resigned later in 1969. "I don't think there ever was a decision made about anything," Klüver announced several months later, half seriously. "I think Pepsi just sort of slid into the whole thing."

Klüver likes to describe EAT as "an experiment in organization." The artist and the engineer, he says, are still poles apart in their thinking. All too often, the engineer who consents to work with an artist finds himself reduced to being a kind of source material, a mere cog in an art machine whose value seems dubious at best. ("All the art projects I have worked on have at least one thing in common," Klüver once remarked. "From an engineer's point of view, they are all ridiculous.") From his own experience, though, Klüver knew that the artist's unfettered approach to art and life could open up all sorts of new insights to the engineer—insights to which many engineers were becoming increasingly responsive now that technology had come to be seen as a very mixed blessing. As the long-range poisoning of the environment by unrestricted technological progress became better known, it had begun to appear that technology was far too dangerous to be left to the technologists. The more Klüver thought about technology, in fact, the more he came to believe that the engineering community needed the artist—his insights, his respect for the human element—even more than the artist needed the engineer. In Klüver's mind, EAT's role had taken on broad social overtones, environmental as well as aesthetic. He spoke of working toward a new aesthetic that would go beyond any previous conception of art or technology, an aesthetic that would have "an organic relationship with the contemporary world." EAT, he said, would become involved in all sorts of projects in the developing countries of the world where the imaginative insight of the artist joined to the technological power of the engineer would develop solutions to problems that the politicians had been unable to master. EAT was going to situate itself at the "inter-

face" between technological hardware, on the one hand, and the programs, or "software," that would be designed to improve the quality of human life, on the other. Its future commitment would be to what Klüver called "projects outside art."

This kind of talk, of course, had made enemies for Klüver and EAT within the New York art world. If contemporary art was indeed headed toward Klüver's new aesthetic (and a good many young artists seemed to hope that it was), then a lot of reputations and entrenched positions were being undermined.

Klüver had become, as his friend Kheel put it, a zealot in the cause of art and technology. If zealots do not always make the best administrators, they do have the advantage of knowing precisely what they want, and the extraordinary fact is that throughout the next year, and in spite of many disputes and disagreements with Pepsi-Cola over funds, Klüver managed to get just about everything his artists wanted while giving up virtually nothing that they prized. Three weeks after the presentation meeting, for example, Klüver, Pearce, and Waldhauer were scheduled to fly to Osaka and reconnoiter the pavilion site. At the last minute, it occurred to Klüver that the four "core" artists should go, too, and he informed Thomas that he was taking them along. Since Pepsi was paying for the tickets, this caused Thomas a certain amount of anguish. The four artists went to Osaka, however, and between that first visit and the official opening of Expo, EAT personnel made more than a hundred trips to Japan and back. There were complaints, but there were no compromises.

Financed now almost completely by Pepsi-Cola funds, EAT took office space in a building on Park Avenue South, where Klüver, installed in a smallish room with a huge blackboard, conducted his experiments in organization. Recruiting engineers was the next major step. Klüver got a lot of help in this from Waldhauer, whose career as a digital systems designer at Bell Labs had undergone seismic changes as a result of his involvement with 9 Evenings. Although Waldhauer's personal view was that 9 Evenings had been "horrendous," he had been deeply impressed by the sense of commitment that the artists and several of the engineers brought to the enterprise. Since 1966 he had become a strong believer in EAT's future role "outside art," as a bridge between technology and the individual. Waldhauer and his family were on vacation in the Adirondacks when Klüver got in touch with him about the Pepsi project. Overcoming his

initial resistance to the idea of world's-fair commercialism, he had devoted nearly all his spare time to the project ever since, his main efforts going into planning the sound system with Tudor and Gordon Mumma, another electronically oriented composer.

A total of thirty-six engineers worked on various aspects of EAT's Expo project during the next year. Some of them became involved on a full-time basis, taking leaves of absence from their jobs, or even quitting jobs they had held for many years, to work with EAT. The artist-engineer relationships that developed were among the more interesting by-products of the enterprise; not all the engineers felt that their contributions were sufficiently recognized, perhaps, but for a good many of them the experience was every bit as stimulating and as unsettling as *9 Evenings* had been for Waldhauer. Getting topflight engineers to work on the project was, in any case, no real problem.

Klüver also managed to find the ideal liaison between East and West in Fujiko Nakaya, an engaging, tireless, and quietly efficient young woman who served as EAT's coordinator in Japan. Miss Nakaya, a painter and a friend of Rauschenberg's, was the daughter of the late Ukichiro Nakaya, a famous Japanese physicist who had done pioneering work in the study of snow crystals and, incidentally, had invented the process for making artificial snow. Klüver had not been thinking of this when he persuaded Miss Nakaya to join EAT, but once the project got under way it seemed natural to put the woman whose father had invented snow-making in charge of the project to make fog. At first, it was thought that both the fog and the mirror projects could be carried out in Japan. The center of fog research these days is in the United States, though, and it was soon apparent that this was where the work would have to be done. After considering several chemical methods of producing fog, Miss Nakaya decided that the best prospects lay in a pure water system. Miss Nakaya, on a trip to the United States that June, discovered that a pure water system that would meet their needs was being developed, largely for the purposes of outdoor frost protection, by a California firm called Mee Industries, Inc. Thomas R. Mee, the firm's president, was an atmospheric physicist himself and a great admirer of Ukichiro Nakaya, whom he had met several times. He was delighted to be able to collaborate with the eminent scientist's daughter, although this was the first time he had had anything to do with art or artists.

From an engineering standpoint, the toughest problem of all was the mirror. Having decided relatively early in the planning to build a

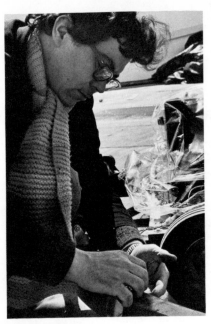

ROBERT BREER

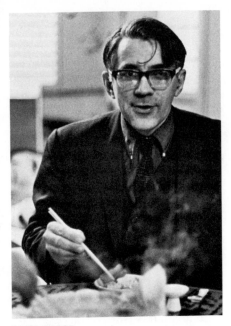

DAVID TUDOR

FUJIKO NAKAYA

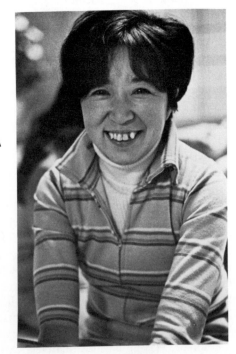

BILLY KLÜVER

FORREST MYERS

(all photographs: Shunk-Kender)

complete hemispherical mirror ninety feet in diameter, the EAT planners faced the question of how, or even whether, it could be done. No one had ever built a hemispherical mirror that large. Should it be a rigid hemisphere, made up of thousands of hand-fitted panels, or an air structure—a balloon with a reflective inner surface? The engineering consensus was that a rigid structure offered better optical properties and fewer problems; with an air structure, for example, entrances and exits to the pavilion would require air locks to retain the interior pressure. A Japanese firm was engaged to develop and manufacture the panels. Month after month, sample mirror segments were flown to the United States, tested, and found to be optically inaccurate. Because the tolerances were so fine, not even the slightest degree of warp or variation could be permitted. Klüver and his associates kept hoping that the difficulties could be corrected. Fortunately, some work had also been done on the air structure as an experimental model, so that when the rigid-panel concept was finally abandoned, in October 1969, there was something to fall back on.

The costs of basic research, as Pepsi-Cola was beginning to realize, are nearly impossible to estimate in advance. Nine months were spent in trying to perfect the rigid mirror panels, which could not be perfected. Several more months went into researching the alternative air structure. In May 1969 Klüver, who needed a model of the mirror for optical experiments he wanted to conduct, went to the G. T. Schjeldahl Company, a Minnesota engineering firm whose development of special Mylar tapes had led to its involvement in space technology. (Schjeldahl had built Echo 1, the aluminized Mylar balloon that was the first communications satellite, and several of its successors.) Schjeldahl's estimate of the costs seemed discouragingly high to EAT, so Klüver turned the project over to a South Dakota firm called Raven Industries. Raven produced a balloon mirror ninety feet in diameter, which Ardison Phillips and David MacDermott, two young California artists associated with EAT, managed (with the help of some architectural-school friends of theirs) to install in an old dirigible hangar near Los Angeles. This prototype—which had come to be thought of as an alternative to the rigid-panel structure—was successfully tested and shown off to the press on September 30, 1969. The optical properties of its mirrored interior delighted Klüver's people and greatly impressed several Pepsi officials, including Pottasch, who came out to see it, but there were still a number of bothersome technical problems.

At this point, Klüver went back to Schjeldahl, which was responsi-

ble for the final version. The costs, meanwhile, were mounting steadily. Pepsi-Cola had quietly added 10 per cent to their own estimate of the cost of the pavilion, to cover unforeseen expenses, but it soon became evident that this figure was going to be far too optimistic. The EAT budget, which had theoretically been squeezed down from $859,000 to $550,000, was back up to $800,000 by the fall of 1969 and was obviously headed higher. Whenever anyone brought this to Klüver's attention, he seemed vaguely annoyed. Klüver thought Pepsi-Cola should be grateful that so many top-notch engineers were working on the project, in many cases for little or no remuneration. Good engineers, he said, could be trusted to find the most economical solutions; whether those solutions lay within the budget remained to be seen.

To Pottasch, who by this time had returned to New York as vice-president for marketing services, with direct responsibility for the Pepsi Pavilion at Expo, the project was rapidly becoming a nightmare. The cash-flow problem was a particularly unnerving one for him. EAT, having virtually no cash reserves of its own, was continually in need of funds that had to be forwarded *right away*. One of Pottasch's nightmares was that when the final bills came in, the total costs would run a lot higher than the current estimates. Most of the electronic equipment was being purchased in Japan, for example, but it now appeared that, instead of costing less there, this equipment, for various reasons, was going to cost more than it would have in the United States. To complicate matters further, the president of PepsiCo, Inc., the parent company in New York, was not enthusiastic about EAT's plans for the pavilion. He had told Pottasch that no money from the New York office could be used toward the project; all the funds would have to come from Pepsi-Cola, Japan, and from the Japanese bottlers, he said, and their soft drink sales had better show an improvement as a result. At his lowest moments, lying awake in the dead of night, Pottasch was sure that nobody would ever understand what they were trying to do. "I don't understand more than half of what Billy Klüver says myself," he confided to an acquaintance. "And sometimes I don't think he does, either."

Sigvard Stenlund, the engineer in charge of the EAT balloon project at Schjeldahl, seemed to have surprisingly little trouble in communicating with Klüver and his group. A tall, rugged Minnesotan who had worked on Echo 1 and been project engineer on the Pageos satellite, Stenlund, like Tom Mee, had never had anything to do with artists before, and his initial reaction to Whitman, Phillips, and other

long-haired EAT personnel was somewhat dubious. Having seen few
hippies in his life, he assumed that hippies were what he was seeing
now. He didn't let it bother him, though, and within a short time
Stenlund and his artist-collaborators had come up with an extremely
simple and elegant solution to the technical problems. Instead of a
balloon inflated from the inside, they designed a *negative* air struc-
ture. It was decided to build an airtight plywood shell slightly larger
than the circumference of the balloon, so that when air was pumped
out from between the shell and the balloon, the balloon's normal air
pressure would cause it to expand to full size. This did away with the
need for air locks at the entrances and exits. The balloon was made of
a plastic film called Melinex, only one two-thousandths of an inch
thick but quite strong; it had been cut in long strips, or gores, which
were then sealed together. Aluminum-coated on the inside surface, it
was not so sharply reflective as glass, but the optical effect—the
three-dimensional "real" images hanging upside-down in space and
repeated here and there around the room—were mysterious and strik-
ing. The Pepsi executives who went out for the press viewing, Pot-
tasch included, seemed favorably impressed. As far as Klüver was
concerned, this was the turning point; from here on he had no doubt
whatever that the pavilion was going to be a work of art.

While the hardware for the project was being designed and built,
Klüver and Whitman spent a lot of time thinking about what Klüver
called its software—the events that would take place inside the pavi-
lion. The original idea of a rock-music discotheque had been super-
seded by the concept of an automated "environment," with sound
and lighting and other effects programed in advance. By the spring of
1969, though, the infinite range of possibilities offered by the sound
system, the lights, and the optical marvels of the mirror led Klüver,
Whitman, and Tudor to decide that automation would be too limit-
ing. Only if this unique theatrical space was made available to other
artists as well, they felt, could that range of possibilities be tapped.
Live programing would mean, of course, a substantial increase in the
operating budget—something in the neighborhood, Klüver thought,
of $100,000. Pottasch agreed with the new idea in principle, but he
did not quite see the need for inviting as many artists as Klüver had
in mind—at least twelve Americans and an equal number of Japa-
nese, each of whom would spend four weeks at the pavilion during
Expo's six-month run. Why not just get four *good* artists, Pottasch
suggested, and let them come up with a basic program that could
then be repeated several times a day? Klüver said that nobody could

tell who was going to make the best program until he had actually made a program, because nothing like the mirror dome had ever existed before. The situation was open-ended, and this, as Klüver kept trying to tell Pepsi, was *what it was all about.* The process of artists working in the pavilion interested EAT, more than guaranteed results. It was this kind of argument that drove some of the Pepsi executives up the wall.

As usual, EAT got its way. A tentative live-programing budget of $100,000 was approved—although no contract was signed. Whitman and Peter Poole, a young British geographer who joined EAT in 1967, began lining up American artists on the basis of proposals submitted for programs fifteen minutes long; Miss Nakaya and Toshi Ichiyanagi, a Japanese composer, did the same for Japanese artists. Proposals involving formal dramatic presentations or performances were discouraged. The New York group wanted to have the mirror dome used as a generalized theatrical space, in which the spectator himself would participate as much as possible. Some spectators might pass through with hardly a pause; others might stay there for hours. The best programs of all, everyone said, would undoubtedly come toward the end of the fair, by which time all concerned would have passed on what they had learned about the mirror and the sound and light systems. To Pepsi, it all seemed a long way from traveling troubadours and singing dolls. The Pepsi public-relations department was having a terrible time thinking up a name for the pavilion. Someone hit on the word "Sensosphere" to suggest the kind of total sensory experience visitors would have there; the name stuck for several weeks, until it was discovered that in Japanese "senso" means "war."

Three weeks before the official opening of the fair, on March 15, 1970, the EAT artists and engineers, who had been scattered over an area from New York to California, started to come together in Japan. EAT had reserved a number of apartments and hotel rooms in and around Osaka. Klüver and Whitman, who had brought their wives and children, were living in a brand-new suburban apartment house, called Senriyama Grand Heights, about ten minutes from the Expo site by taxi, provided a taxi could be found. The real problems, Klüver said wryly, had turned out to be taxis and food. Miss Nakaya had persuaded her friend Sachiko Tamai, a Tokyo girl with a delicate face and a saving sense of humor, to come and help out with the various logistical arrangements, and both of them spent a large part

of each day trying to get people from one place to another and seeing to it that the engineers at the pavilion got something for lunch that they could eat. (Engineers, it seems, have a great resistance to raw fish and other Japanese staples.) In the evenings Miss Nakaya's mother came to the EAT apartment at Senriyama Grand Heights and cooked dinner for a group whose number was never predictable. The language barrier made it hard for the Americans to fend for themselves. David Tudor and one or two of the other artists were at home in Japan from the start, as artists often are anywhere, and most of the EAT people learned enough Japanese to direct a taxi driver in the general direction they wanted to go, but people were always getting stranded all the same. Klüver finally engaged an immensely agreeable Japanese taxi driver to work full time for EAT, and this arrangement helped somewhat. Ozaki-san, the driver, wore a silver EAT button and displayed photographs of Klüver and Julie Martin, Klüver's assistant, on the visor of his windshield. He drove at breakneck speed, and greeted each near-collision with an ecstatic smile.

Taxis and food were not the *only* problems. Thanks largely to Miss Nakaya and John Pearce, who had been on hand much of the time the pavilion was going up, relations between the Americans and the Japanese contractors were generally smooth, but there had been a few misunderstandings. The Japanese could not seem to help making their work look tasteful and finished. This conflicted with the basic approach of the American artists, who took a rough-and-ready attitude toward craftsmanship and wanted cruder effects; when they specified that one sector of the floor in the mirror dome should be "rough wood," for example, what they had in mind was old planks taken from a barn or a railroad siding, and not the hand-planed, artistically uneven floor that the workmen gave them. The most serious dispute of this kind concerned the main entrance to the pavilion. Robert Breer, the artist entrusted with over-all responsibility for the "aesthetics" of the pavilion, threw out the Japanese architect's design for an elegant entrance to the tunnel that led down to the Clam Room and substituted for it a simple, cylindrical opening. The architect, who did not yet know that his building was going to be shrouded in fog most of the time, took serious offense at this development. He had gone along grudgingly with the other design changes requested by EAT, but this was evidently too much; hints were dropped that Takenaka Komuten might withdraw from its contract with Pepsi-Cola. Breer, who was then in New York, flew to Osaka and held a daylong

meeting with the architect and his associates, and it ended with Breer's making an impassioned personal plea for his own design. After a great deal of Japanese translation, with frequent references, Breer thought, to the words "art" and "fun," the architect bowed coolly, said that he himself had played in empty water pipes as a child, and agreed to Breer's design.

EAT's problems with Pepsi-Cola continued to revolve around money. The budget for the pavilion interior now hovered close to $2.2 million, and, in addition, Pottasch had agreed orally to an additional budget of $185,000 for live programing and operations of the pavilion. But the cash-flow problem persisted. Klüver bitterly resented having to spend time on such matters. "What they can't seem to realize is that they're getting these things at cost," he said. Twice, Klüver threatened to pull all the EAT people off the project and go home. Since Pepsi had no one immediately capable of operating the complex technological hardware of the pavilion, this was an effective threat. Relations between EAT and the man Pepsi had designated as general manager of the pavilion, a youngish executive named Richard J. Collins, were polite but guarded. On specific operations, EAT preferred to work through Sebastian Hiraga, the pavilion's deputy commissioner and secretary, a tough, bullet-shaped Oriental who had once been chief of the riot police in Tokyo, and whose influence, when it came to getting EAT equipment through Japanese customs in a hurry, was gratifyingly potent. Collins, Hiraga, and other members of the Pepsi staff occupied comfortable offices in the rear of the pavilion. EAT had one small, unheated, temporary office, with two telephones and an improvised desk, where the thirty-odd artists and engineers congregated once a day, for lunch. They all wore silver EAT buttons, and they worked, on the average, from twelve to fourteen hours a day.

A week before Expo '70 opened, it began to look as though the Pepsi Pavilion might conceivably be ready on schedule. The mirror had been installed and was functioning, in spite of a rip that had opened up in the Melinex when it was inflated for the first time; fortunately, the rip was near an opening for one of the overhead spotlights, and Sig Stenlund and John Pearce were able to reach through the spotlight housing and repair the damage with pressure-sensitive tape. Stenlund, the Schjeldahl balloon specialist, had a backup balloon that he said could be installed in eighteen hours if necessary. Klüver was trying hard to talk Pepsi into paying for a third one, just in case.

The electronic console that controlled the lights and the sound system had been a week late in arriving—a faulty waybill had kept it sitting at Kennedy Airport while EAT sent frantic tracers. Larry Owens, the young Bell Labs electrical engineer who had built the eight-foot-long console in New York and who was serving as EAT's coordinating engineer for the pavilion, was having problems getting the console installed and functioning. Not all the sound circuits worked properly, but enough were operating so that each evening, after six o'clock, when the workmen knocked off for the day, the artists could experiment with programing. The lighting was simple in concept but extremely difficult to handle. Essentially, there were three sets of lights situated behind the cut in the dome near its apex. Each set contained two fixed-position tungsten lights, and one quartz-iodide light which could be directed by means of pan-tilt, motor-driven mirrors to throw an eight-foot circle of light anywhere in the space. The winch light, a semicircular reflector containing three bulbs, could be lowered on a cable from the apex of the dome to the floor, a spectacular process that caused light to blossom in rippling waves down the mirror walls. Anthony Martin, the artist who had taken over and designed the lighting when Robert Whitman became involved in another art-and-technology project, was the only person who could make the spotlights do what they were supposed to do; the pan-tilt mirrors did not work properly, and getting the light where it was wanted was fiendishly difficult, even for him.

A genial, quiet young man who had also helped design the original lighting system for the Electric Circus, and whose independent interest in spherical mirrors and real images had led him to EAT, Martin hoped that the interior lighting would help visitors to get involved with the EAT environment and with each other. He spoke of individuals' "spiraling out, becoming participants and performers," and he was not happy about the program that was being planned for the EAT press preview, scheduled for March 11. The programer for this lead-off event was Remy Charlip, an artist, designer, and theater director best known for his work in the field of children's theater (he was a founder of the Paper Bag Players, in New York). Charlip had made up several large squares of bright-colored, very thin China silk, which the participants in his program (in this case, EAT wives, girl friends, and female staff members) held by the corners and lifted, so as to make them billow and float. The reflections were colorful, but Martin and several others felt that they did not exploit the mirror's extraordinary properties to best advantage. For the sound accom-

paniment to his piece (which he had decided to call "Homage to Loie Fuller"), Charlip had made a tape recording of his own breathing. Amplified over thirty-seven loudspeakers that were mounted in a rhomboid grid behind the mirror walls, it sounded very much like a man breathing into a tape recorder.

While Charlip rehearsed, the engineers continued to work on the sound system. In addition to the loudspeakers and the console, there was the sound-loop system under the floor. The sounds came from loop antennas embedded in each of the eleven floor sections; they could be heard over the flashlight-size, hand-held receiving sets that would be given out to visitors as they arrived and—or so it was hoped —collected from them when they departed. Any sounds required could be fed into the loops; for the time being, each floor sector had been given more or less appropriate sounds—bird song for the plastic grass, breaking glass for the stone floor, a car stopping and starting for a section with a surface like a bumpy road, a "boing, boing" noise for the rubber "bounce" section. The floor sloped upward to a center section of clear glass. Just to one side of the glass section was a sort of raised platform called the "berm" (architects use the word, for some reason, to refer to a hill), upon which one was at the ideal elevation for viewing one's own real image.

The Clam Room, directly under the mirror dome, was at this point a fairly forbidding orientation chamber. Its only light source was the glass floor of the Mirror Room. The krypton laser that was to go into the Clam Room had arrived with its plasma tube broken; another tube was on order from Palo Alto. Lowell Cross, the electronic composer, who had collaborated with Tudor and an engineer named Carson Jeffries on the laser's design, kept his spirits up with the aid of tequila, while waiting for the tube's arrival. Except for the Pepsi offices, where heat had been installed, the entire pavilion was numbingly cold. The Clam Room, being underground, was the coldest of all.

On March 6, to make matters slightly worse, EAT turned on its fog system for the first time. It was immediately evident that the fog project was an enormous success. In fact, when Mee and Miss Nakaya gave the signal to turn on only half the twenty-five hundred jet-spray nozzles that had been mounted along the ridges of the pavilion roof, the ensuing fogbank was so thick that it drifted, intact, into the neighboring Amphitheater, an outdoor stage, and silenced a Canadian high-school band that was practicing for a concert there. The sight of fog pouring from the roof of the Pepsi Pavilion also brought several fire engines to the site, sirens screaming. Miss Nakaya, who made

the necessary explanations, heard the fire chief relay the news to his headquarters by radio. "It *looks* like smoke," he said. "But they say it's water." The fire chief demanded that he be notified in advance whenever EAT intended to turn on its fog. He simply refused to believe that it was going to be on for ten hours a day.

For an experiment in organization, EAT had come through, on balance, rather well so far. Its unique strength, the ability to draw upon talent from almost any sector of industry or art, had brought thirty highly skilled people to Osaka, where they did what was required of them without supervision. There was no real chain of command. Klüver had a small group of people with whom he communicated; in it were Whitman, Pearce, Stenlund, Waldhauer, Mee, Miss Nakaya, Julie Martin, and, at times, Tudor, the infinitely gentle, infinitely solid father figure for countless fellow artists. Others on the project found Klüver all but unreachable. Tall, gangling, and habitually distracted, Klüver was often so totally focused on one set of problems that his mind automatically shut out all others. At other times, he might listen attentively to critical advice, and he sometimes changed his mind with bewildering rapidity. His regular costume at Expo was a worn suède jacket and a nondescript fur hat. Soon after he arrived in Japan, one of his front teeth had fallen out, and this bothered Miss Nakaya no end. She kept making appointments with a dentist for him, and he kept breaking them.

Some of the engineers were getting a little fed up with Klüver and EAT. Larry Owens, harassed by continuing problems with the control console, became increasingly irritated by the atmosphere of casual confusion on the project. Owens himself was accustomed to the tight organization of Bell Labs, but, beyond that, he felt that he was being expected to compensate for the inefficiency of others. Owens and Pearce were the indispensable men on the job, the ones who climbed up scaffoldings to fix lights, who arrived first in the morning and were the last to leave at night. As far as Owens was concerned, some of the artists might as well have stayed home.

The reactions of some of the other engineers on the project were rather surprising. Stenlund was now working full time for EAT. A few weeks previously, his boss at Schjeldahl had told him to turn over the EAT project to someone else so that he could supervise a large government contract that he had been in charge of before he started the EAT project. Stenlund had refused and, when the issue was pressed, had quit. He had a few things in mind for the future, but for

the time being he was going to stay in Osaka and see to it that the Melinex mirror did what it was meant to do. Stenlund, who wore a pair of white coveralls and a construction worker's hard hat at all times, was on congenial terms with everyone, artists included. The artists seemed like capable people, he said, but he was not familiar enough with their "skills" to have an opinion on what they were accomplishing. He was reserving judgment on that.

A similar reticence kept Tom Mee from saying much about the fog system, which had proved so disconcertingly successful. Mee was clearly pleased with his fog, though, and so was Miss Nakaya. She said that the jutting triangular planes of the roof actually worked to their advantage, causing the fog to eddy and billow in interesting and unforeseen ways. Mee and Miss Nakaya tested a different section of the fog-making nozzles every day, flushing out the system and making minor adjustments. On wet or humid days, the system would operate only at half strength or less; dry, windy days would require more pressure. Miss Nakaya had recorded the atmospheric conditions and the precipitation in Osaka during the last year, and Mee had designed his system accordingly. Each time he turned it on, though, no matter how small an amount of the hissing fog appeared, workmen throughout the area dropped their tools and came running, and the manager of the Amphitheater complained.

The official opening of the Pepsi Pavilion was to take place on Saturday, March 13, two days before Expo '70 itself opened to the public. Pepsi's own press preview was scheduled for the afternoon of March 11, to be followed that evening by an EAT party on the premises. Two days before this event, a great many things started to go wrong.

The replacement tube for the laser arrived and was found to have been broken in transit. Another tube was ordered. Klüver tried to get Elsa Garmire, a California Institute of Technology physicist who works closely with EAT on the West Coast, to buy a first-class airline seat for the tube and bring it with her from Los Angeles, but Dr. Garmire was already on her way to Osaka. Meanwhile, Frosty Myers was having serious problems with his *Suntrak*. The contractors had exceeded the specified weight ratios, and the *Suntrak*'s two mirrors had had to be scrapped and rebuilt. A further irritation was that EAT had lost its office space in the pavilion. No real provision had ever been made for an EAT office, and the room that EAT had been occupying temporarily was the dressing room for Pepsi's forty Japanese hostesses. These young ladies reported for duty on March 10, and for

the next twenty-four hours, until John Pearce and his crew knocked together a makeshift room in an unused corner of the pavilion, EAT was cast adrift. At Pepsi's urgent request, Klüver made a little speech to the EAT group about the hostesses—they had been carefully selected, most of them were strictly brought up, and there were to be no liberties taken. Some of the girls spoke a little English, but they all seemed much too shy to recognize liberties.

Bob Breer's floats were delivered on the morning of March 10. There were seven of them—large, dome-shaped objects consisting of a white Fiberglas shell, six feet high and six feet in diameter, resting on a four-wheeled chassis. In each was a motor powered by four automobile storage batteries. Each float weighed about eight hundred pounds. The floats moved slowly and noiselessly, just as Breer had intended, so that somebody standing next to one might not be aware of its motion until it nudged him. When a float encountered a solid obstacle, a switching device caused it to reverse direction. Inside each shell was a transistorized tape player equipped with a continuous tape loop that made various sounds at irregular intervals—a bird singing, a man sawing wood, a truck starting and slowing down, three people discussing a landscape. Smooth and noncommittal on the outside, the floats became oddly appealing on better acquaintance; they were like large, friendly sheep. Breer even thought of getting a man with a shepherd's crook to round them up in the evening for their nightly battery recharge. When they first arrived, it was thought that the Japanese contractor had done a flawless job, but closer examination disclosed several bugs. Breer and John Ryde, his collaborating engineer, had to adjust the switches and the wheel bearings on all seven. Also, the Fiberglas shells were too close to the ground; whenever a float came to a slight incline in the plaza, it would run aground and stop. A lot of work remained to be done on them.

The United States Pavilion had its press preview on the afternoon of March 10. A few of the EAT people went over to it and brought back reports. The pavilion, a low-lying air structure that was something of an architectural breakthrough in itself, was given over inside to exhibits of U.S. space technology (including a moon rock), American folk art, the pageant of sport (Babe Ruth's uniform), and blown-up photographs of Americans in what used to be called "all walks of life." There was also a section of art and technology, organized by Maurice Tuchman, the chief curator of modern art of the Los Angeles County Museum, which included a laser display by the California art-

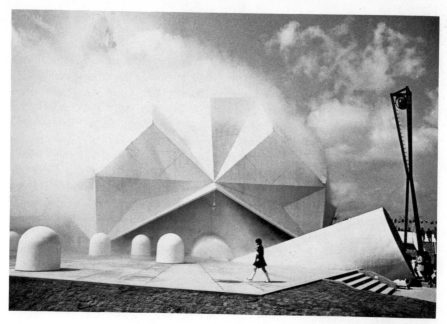

**THE PAVILION:
TESTING THE FOG SYSTEM
(Shunk-Kender)**

ist Rockne Krebs; an "environmental light sculpture" by Newton Harrison, another West Coast artist, based on the principle of glow discharges of rare ionized gases; and a mirror piece by Robert Whitman. Tuchman's project involved the pairing of more than twenty artists with an equal number of West Coast industrial and other companies; the results, of which these were in a sense the first, would all be exhibited at the Los Angeles County Museum in the spring of 1971. Whitman had designed his work in collaboration with John Forkner, an engineer at Philco-Ford Aeroneutronics, in Newport Beach, California. Forkner, who believed that his superiors had chosen him for the collaboration because he was the only Philco-Ford engineer with a beard (and a considerable beard it was, arrestingly red and reaching to his breastbone), had found the project so mind-expanding that, after seventeen years at Philco-Ford, he was thinking seriously of leaving in order to continue working with Whitman and other artists.

Most of the EAT people were aware by this time that some of the things they were doing at the pavilion were not exactly unique. If Montreal's Expo '67 had been the fair for film projections, Expo '70 was shaping up as the fair for mirrors, air structures, and multichannel sound systems. The Canadian pavilion and half a dozen others

had made striking use of mirrors, while both the main Festival Plaza and the Iron and Steel Pavilion had elaborate sound systems. There was no other ninety-foot mirror dome at the fair, though, and no other negative-pressure air structure, nor was there another krypton laser; the other Expo laser displays, at the United States Pavilion and the Iron and Steel Pavilion, employed helium-neon or argon lasers, which produced single-color (red or green) beams; the kyrpton beam could be broken down into four colors. Of course, EAT did not yet have an *operating* krypton laser, but the third tube was on the way by air from Los Angeles. Furthermore, nobody else had a fog cloud. With the fog turned on, the Pepsi Pavilion stood out as the only soft shape among the hard-edge wonders of Expo, visible from nearly any point at the fair. At night, framed in a square of brilliant white xenon light from four black metal light towers, designed by Myers, the fog looked like snow blowing off the top of a high mountain.

On the afternoon of March 10 the fog was making things increasingly miserable for Breer and Myers. A cold rain had been falling since noon, and when Mee turned on the fog-making apparatus the high humidity caused a dense cloud to settle over the Pepsi Plaza, reducing ground visibility to zero. Myers, a tall scarecrow in a tight-fitting black raincoat, his long hair hanging in wet strings and an empty cigarette holder clamped between his teeth, bore it with fortitude. Nothing had gone right for him all day. Twice, the heavy steel armature that held the *Suntrak*'s two mirrors had been hoisted into position atop its cone-shaped base, and twice the joint had buckled; the mirrors were too heavy. Pearce clung morosely to the log-and-baling-wire scaffolding that the Japanese riggers had thrown up around the object. He blamed himself for not having given enough attention to the *Suntrak*. The riggers were going to try once more to mount the armature.

Breer and Ryde had spread tarpaulins over the uncovered chassis of several floats to protect them from a torrent of water pouring down off the roof. Breer, in a battered storm coat and a long orange-and-blue scarf that his eleven-year-old daughter, Sophie, had knit, was nursing a heavy cold. The only bright spot in his afternoon occurred when a Japanese carpenter who was sawing a one-inch strip from the bottom of each Fiberglas shell paused for a moment and heard, from another float that had crept up behind him, the rather startling sound of a man sawing wood.

The only project that seemed to be going well at this point was the installation of a large Pepsi-Cola sign at the northern end of the

pavilion. The sign, a revolving silver globe with "Pepsi-Cola" in raised block letters, was not an EAT design. Whitman and Forkner had made a proposal to Pepsi, three months before, for a sign based on the same principle as their optical piece in the United States Pavilion—two concave mirrors casting a three-dimensional, real image of the company's trademark out into the space in front of the mirrors. Pottasch liked the idea until he learned that it would cost $30,000 to build and that it could not be guaranteed that it would be finished until a month after Expo opened. Whitman then came up with another idea, which was for a man to be painting "Pepsi-Cola" continuously on a large cylinder while another man continuously washed it off. Pottasch seemed a little hurt by this proposal; his associate Charles Quigley, director of public relations for PepsiCo International, said it "was not worthy of EAT." Pepsi had then gone ahead and designed its own sign. It was, however, with the exception of a modest snack bar tucked away behind the pavilion entrance, the only obtrusively commercial blot on EAT's invisible environment.

At eight o'clock that evening, a Japanese electrician working on the winch light accidentally raised it beyond the safety stop and sent it right through the top of the mirror. The balloon sagged immediately, and lost all its reflective power; it looked, Waldhauer said, like the inside of a large silver prune. Owens and Pearce climbed up to assess the damage: a rip eighteen inches long. It was too late in the evening to attempt repairs. They would start the first thing in the morning— the day of the press preview.

In spite of these misfortunes, the press preview took place as scheduled, beginning at 1:30 p.m. on March 11. Owens, clinging for an hour to a rope ladder suspended through the winch-light opening, had patched the rip in the mirror. The balloon was tight again, and was casting real and virtual images in profusion. The presence of a large number of people in the mirror dome added a new element of animation, which greatly pleased Whitman and Breer. Half a dozen hostesses in bright-red maxicoats and red cloches had been stationed at intervals around the perimeter, and their reflections lent a festive note to the scene. The trouble was that very few of the visitors ever looked up into the mirror. Handsets held to one ear, they walked around looking down at the variously textured floor sections, or else they watched the EAT girls playing with Remy Charlip's silk squares. A good many of the visitors came over to stare at the control console, which stood on a raised part of the floor behind the berm; its dozens of switches and buttons and colored signal lights exerted a fascination

all their own. Ardison Phillips, the EAT pavilion manager, went around the room directing visitors' attention upward and pointing out the real images, but the majority of those who came left in a spirit of perplexity. There had not been enough Japanese-language press kits to go around, and the hostesses, who had stood like statues, had been no help at all. Yasuharu Tamiya, Pepsi's Japanese press chief, was visibly concerned. "Everyone ask me what do it do, what do it mean?" he reported to Breer. "I tell them it mean nothing. Okay?" Breer assured him that this was an excellent answer. But everyone was depressed. The preview seemed to bear out Pepsi's fears that the Japanese would not get what was going on in the pavilion at all. The Japanese were too literal, too used to being told what to look at and why.

Outside, on the plaza, the *Suntrak* was being dismantled and removed. It had been decided to have it made over again at the factory, which would take from four to six weeks. Myers, his natural exuberance gone for the first time that anyone could recall, had disappeared. It had stopped raining, but the weather was turning even colder. The third laser tube had not arrived.

EAT's party began at seven o'clock that evening. Friends from other pavilions, Takenaka Komuten construction engineers, Pepsi people—anyone who had had anything to do with EAT was invited, and more than a hundred showed up. They came in through the Clam Room, dimly lit and icy cold, where they were served small sandwiches and Suntory whisky in plastic tumblers, and for a while the party showed no signs of coming to life. Gradually, though, people started to drift upstairs into the mirror dome, where Tudor was putting a tape of monkey chatter through electronic modifications while Martin worked the lights. The balloon was tighter than it had ever been, and, consequently, more reflective. There was a greater brilliance and variety to the light. The electronically generated sounds had a changing, rhythmic beat that suggested rock music, and Martin had keyed it in to an automatic light program on the console. A lot of people were in the mirror dome now, and some of them began reacting to what Martin and Tudor were doing. Four Japanese men in black suits found Charlip's China silks and started to play with them the way the EAT girls had done at the press preview. Several couples danced. Breer, still wearing his storm coat and his daughter's scarf, picked up a blue silk square by one corner and ran around the room with it trailing out behind him, catching people up momentarily in its folds. Nearly everyone was gazing up into the mirror, from which the

movement and light and color were thrown back transformed into up-
side-down real images. Little by little, the spectators were themselves
being transformed into participants and performers. Time passed im-
perceptibly. At one point, the chief project engineer of Takenaka
Komuten, a dour Japanese who had not been seen to smile for six
months, stood all by himself on the berm, doing a strenuous dance
with three of the silks, shaking and whipping them with both arms
and eventually winding himself up in them and subsiding vividly to
the floor amid wild applause. "My God, this is *it!*" Larry Owens
said. "This is how it ought to be. No program, no nothing—just all
this marvelous hardware." Unfortunately, by this time the Pepsi-Cola
executives had gone home.

Donald M. Kendall, the president of PepsiCo, Inc., arrived in Osaka
on March 12. Kendall was the chairman of the Emergency Commit-
tee for American Trade, an extremely high-level delegation of Ameri-
can businessmen who had come over to see what could be done about
solving some of the tariff and import-quota problems that were dis-
turbing trade relations between the United States and Japan. On his
arrival in Tokyo, the day before, Kendall had made a statement that
rather ruffled Japanese sensibilities—the Japanese, he said, would
have to liberalize some of their trade and investment policies if they
expected American businessmen to help hold off protectionist pres-
sures in the United States—and there had been a few personal attacks
on him in the Japanese press as a result. This had led to a certain
increase in the nervousness of Collins and the other Pepsi employees
at the pavilion. When Kendall and his entourage came through the
pavilion on March 12, however, he gave every indication of being
delighted with what he saw. Klüver took him on a tour, pointing out
what had been accomplished and demonstrating some of the un-
foreseen optical effects of the mirror dome. The most striking of
these was what Klüver called "the berm effect." If one person stood
on the berm and someone else stood on the plastic-grass floor section
on the other side of the room, and they turned their backs to each
other and faced the wall, each could converse, in whispers, with the
other's upside-down image in the mirror before him. What each of
the two actually saw was the virtual image of the other's real image—
a real image reflected. The acoustical properties of the hemisphere
made it possible to converse in whispers. Klüver had Mr. and Mrs.
Kendall try the berm effect, and they were both entranced by it. The
mirror, Mrs. Kendall said, was "a toy for grownups." Kendall was

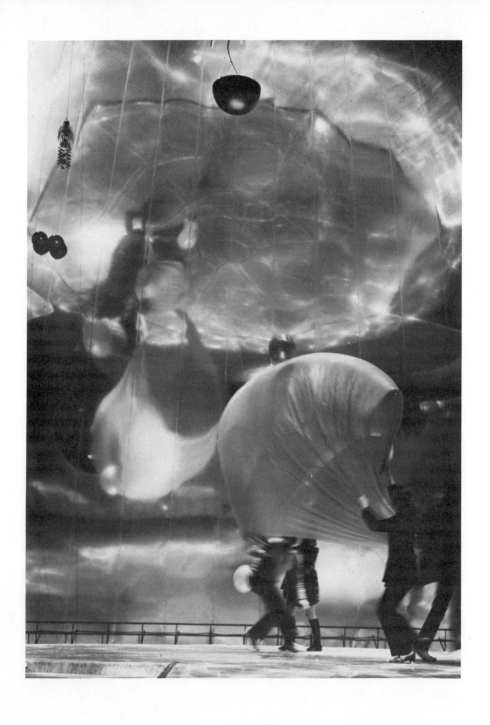

INSIDE THE MIRROR DOME
(all photographs: Shunk-Kender)

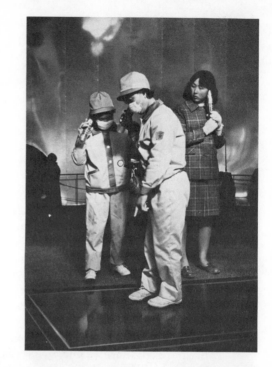

extremely surprised to learn that several of the EAT engineers had taken leave from their jobs to work on the project, or else were doing it on their vacation time. The president said he thought EAT had done "a magnificent job." It was the first time any Pepsi executive had ventured a forthright opinion one way or the other, and it cheered Klüver no end.

The third laser tube arrived, intact, on the afternoon of March 12. Lowell Cross and Dr. Garmire, whose special field at Cal Tech is lasers, worked until after midnight getting it installed on a narrow platform suspended from the ceiling of the Clam Room, and they were working at it again at eleven o'clock the next morning, when the Japanese bottlers of Pepsi-Cola began arriving for a private tour of the pavilion before the formal opening ceremonies, which were scheduled for 1:00 p.m. Kendall, Pottasch, and the rest of the top Pepsi executives made their appearance at noon and retired to their heated offices to wait for the ceremonies to begin. In spite of Kendall's favorable reaction the day before, Pottasch was worried. "I just wish the sound wasn't all that electronic business," he said. "People get tired of that after five minutes. I wish that once in a while they'd play some kind of melody, something that people could relate to." Katsuhiko Fujiyama, the most important of the Japanese bottlers and the nominal commissioner of the pavilion, joked with Peter K. Warren, the president of PepsiCo International, about the time two years previously when he had volunteered in an expansive moment to put a million yen into the Pepsi Pavilion, and had then been unable to get out of it.

Kendall, a distinguished-looking man with a luxuriant growth of white hair, was telling Mr. Fujiyama's wife about the number of engineers who had taken leaves of absence to work for EAT. He said he wanted to give a reception for the EAT people. He also noted, however, that the whole EAT group was too "engulfed" by the project to have an objective point of view about it, and that the real test of the pavilion's success would come with the reactions of people seeing it for the first time, without advance knowledge.

In the mirror dome upstairs, Japanese workmen were setting up an altar for the traditional Shinto dedication ceremony. It was an elaborate structure, curtained off on three sides and laden with fruit, vegetables, *mochi* (boiled, beaten rice), salt, dried fish, and several bottles of *sake*, and it was being set up in the center of the room, directly above the glass floor, which had been covered for the occasion with a blue carpet that effectively cut off the main source of illumination for

the Clam Room underneath. This had come as quite a surprise to Klüver, but the Shinto priest seemed to know exactly what he was doing, and it had been thought unwise to interfere with his instructions. Myers, his high spirits restored, stood in front of the altar while his girl friend took his picture; he was dressed for the occasion in red herringbone trousers and a zebra-striped shirt.

At ten minutes to one, Cross got the krypton laser working perfectly. An interlacing pattern of red, green, blue, and yellow lines, reflected downward from a mirror opposite the laser, looped and flowed across an area half the length of the Clam Room, tracing what the art critic Barbara Rose called "an electric Pollock." The light played over the faces and clothing of the people walking through it, most of whom were unaware of the effect, and none of whom, fortunately, was blinded by it. Dr. Garmire had recalculated the light factors and decided that they were within safe limits. She stood admiring the patterns for a few minutes before going upstairs for the dedication.

Shortly afterward, the daughter of Emperor Hirohito was ushered down the tube into the Clam Room. Pepsi's public-relations people had scored a major coup in securing such an exalted personage for their opening ceremonies—the emperor and his son, the crown prince, were officiating only at the major national pavilions—and a phalanx of photographers greeted her appearance with volley on volley of flashbulbs. The former Princess Suga (now the wife of Hisanaga Shimazu, a Japanese businessman) proved to be an exquisitely beautiful young woman wearing a white suit in the best tradition of Paris couture. The Pepsi hostesses bowed uncontrollably, like windup toys, as she slowly made her way past the photographers and was escorted up the stairs to the mirror dome.

The Shinto ceremony began promptly at 1:00 p.m. and lasted twenty minutes. While three seated, green-robed musicians produced plaintive sounds on bamboo flutes, a white-robed priest alternately chanted, clapped his hands loudly, and thrashed the air with a leafy branch. After about fifteen minutes, he made a complete circuit of the room, thrashing the air at intervals; when he came to the "bumpy road" section of the floor his heavy wooden clogs caught on a bump and nearly sent him sprawling. He returned to the shrine with his dignity unimpaired, placed his branch on the central part of the altar, and proceeded to hand out similar branches to Kendall and the other assembled Pepsi-Cola executives, who came forward one by one to receive them and to place them—with appropriate bows and hand-clappings—upon the altar. The last to receive and place a branch was

Klüver, who looked unusually solemn in a business suit, white shirt, and necktie. This concluded the Shinto part of the ceremony.

Brief addresses followed, by Kendall, who said that Pepsi-Cola was proud of what "searching minds and skilled hands have created here"; by Mr. Fujiyama, who spoke in Japanese; and, finally, by Klüver. Klüver said that Pepsi-Cola had shown "enormous vision" in sponsoring the project, and prophesied that the pavilion would "set a precedent in the new corporate participation in the arts."

Tethered by a red ribbon to one corner of the altar throughout the ceremony was a large helium balloon, bearing aloft one of Charlip's somewhat wrinkled China silks. Immediately after Klüver's speech, the princess was led forward to the berm, where she posed for photographers while holding the balloon's ribbon in one hand. Unnoticed, Kendall went over to the control console, where one of the engineers showed him which button to press to lower the winch light. The princess cut the ribbon, Kendall pushed the button, and the balloon floated up past the winch light coming down. Rippling light filled the mirror and thunder rolled around the room from thirty-seven speakers. The Pepsi Pavilion, ready or not, was officially open.

On the day of the Expo opening, a nearby "aerial snack bar" suffered a mechanical failure that trapped about a hundred people—many of them reporters and Expo officials—aloft in glass cages for upward of three hours. Compared to this disaster, the EAT problems seemed almost manageable, although from an engineering point of view the pavilion was still only about 50-per-cent operational. The console had fallen far short of its promise; many of its intricate switching functions were still unusable. Fred Waldhauer and Skip Savard, another electrical engineer, were working with Larry Owens on the console; Owens' nerves were visibly frayed, however, and he spoke of going away for a few days to preserve his sanity. The lighting system in the mirror dome remained highly recalcitrant. The fog and the moving floats both presented problems of another sort. Pottasch and several other Pepsi executives were worried that visitors would not realize that the floats were moving or making sounds. They urged Bob Breer to speed up the motors and increase the volume of the tape players inside. Breer listened politely and suggested that perhaps Alan Pottasch was suffering from "motion anxiety." To Breer, one of the most interesting things about the floats was their surprise element—people suddenly realizing, with a slight shock, that the floats were moving. Their speed and volume were exactly the way he wanted them, and if people failed to notice the floats, that was their problem.

There was no danger that anyone would fail to notice the fog. In fact, whenever it was turned on, some neighboring pavilion or concession lodged a frantic complaint. The manager of the Amphitheater had finally gone to the Expo authorities about it, with the result that on the day following the Pepsi opening Klüver was informed that any further fog banks would cause Pepsi's water *and* electricity to be shut off. Klüver had learned by this time that in Japan it is standard business practice to issue an ultimatum and then negotiate, and after considerable discussion EAT agreed to put up a "fog trap"—a large polyethylene net—between its pavilion and the Amphitheater.

Expo '70 opened to the general, paying public on Sunday, March 15. The crowd was much smaller than had been expected. Even so, there were huge lines in front of the major pavilions, with the biggest crowds waiting patiently for hours to get a look at the United States Pavilion's moon rock. For most of the day, in spite of a wet snow that began falling toward midafternoon, a line of some sort waited to get into the Pepsi Pavilion. The line built up each time the fog was turned on, but then so did the complaints from nearby pavilions and concessions, as a result of which it was on for about two hours all told.

Although a depressing majority of the Japanese fairgoers passed through the Pepsi Pavilion in exactly the same way as they passed through all the others, keeping rigidly to the shuffling, rapid gait that Klüver would later call "the Expo trot," quite a few of the younger visitors did react to the mirror dome with wonder and delight. The red-coated Pepsi hostesses, responding to Klüver's pleas, took a much more active part than they had on previous occasions. They explained to visitors about the real and virtual images, and showed children how, if they threw a hat in the air, the hat's real image appeared to soar faster and faster up to the ceiling. Nearly every child had on a hat of some sort, so the dome was full of rising and falling headgear. Some of the children became a little overexcited once they found that there was no formal exhibit to look at. By noon, several sections of the floor were showing evidence of youthful exuberance; the edges of the berm were scuffed ragged, and at least half the rubber tiles of the bounce floor had come loose. Shortly after 3:00 p.m., a Japanese teen-age boy, who had discovered that by shaking the handset he could make the light in its bottom end flash off and on, shook too hard and sent the handset crashing through the mirror wall at eye level. The balloon had to be deflated to its silvery-prune condition, and it remained that way for forty minutes, until Owens taped the rip. The culprit seemed properly contrite, and no one thought that his act

had been deliberate. Anticipated student protests at the opening had failed to live up to expectations, for that matter; all that the massed concentrations of Japanese police had to cope with was a small left-wing group handing out leaflets saying the government should spend its money on schools and housing instead of world's fairs, and an even smaller right-wing group whose leaflets demanded that the government spend its money on building up Japan's Army and Navy.

At 4:30 p.m. Kendall gave a cocktail reception for EAT in a newly furnished VIP lounge behind Pepsi's Pavilion offices. Kendall himself could attend only briefly; he was returning to Tokyo that evening for further trade meetings with Japanese businessmen. By five-thirty, in fact, most of the Pepsi people had left the party. The EAT group stayed on for a while, enjoying the warm lounge and Pepsi's imported scotch. They might have stayed indefinitely if the team of European photographers, Shunk-Kender, who had been documenting the Pepsi Pavilion and a few other Expo projects had not come around and asked them all to pose for a group photograph. Everyone trooped outside into the fog and the snow, and, in a rare burst of unanimity, it was decided that the picture should be taken among Breer's floats. Four passing members of a Canadian high-school brass band—the same band that had been silenced several times by EAT fog—were cajoled into coming over and posing with their instruments, and three small Japanese boys ran out of the pavilion line to get in the picture. When it was over, the manager of Pepsi's snack-bar concession, an angular Canadian named Van Godbout, came up to Klüver in something of a rage. No one had come around all day to buy his imported hamburgers, he said, because no one could even see the snack bar through the fog. Klüver gave him a characteristically vague reply. There were plenty of other problems to cope with, including a potential new EAT project with which he was becoming rather deeply involved just then. A "project outside art" on an even larger scale than the Pepsi Pavilion, this one concerned a plan to develop educational-television programing that would help the members of a large dairy cooperative in India to improve the processing and distribution of milk from their buffaloes. Klüver had been put in touch with the dairy cooperative by Dr. Vikram Sarabhai, who was chairman of India's Atomic Energy Commission. Dr. Sarabhai had arrived in Japan on March 14. Klüver gave a dinner for him that evening in Kyoto (which was only about forty minutes by taxi from the Expo site), and Dr. Sarabhai, who had left a Japanese government reception to attend the dinner, spent a long evening talking with Tom Mee, Elsa

Garmire, Sig Stenlund, and other engineers who were interested in cooperating with EAT artists on what they referred to as "the buffalo project."

When Klüver stood on the berm during the opening-day ceremonies and praised Pepsi's "enormous vision," which he said would set a precedent for all future collaborations between art and industry, he was simply stating what he had hoped all along would be the case. Klüver saw the Pepsi Pavilion as a steppingstone to other and grander projects "outside art," and it came as a severe shock to him to find, in spite of Kendall's warm words, that the precedent was still endangered by the old problems of budgets and operating costs.

The contract for EAT's maintenance and programing operations at the pavilion had not yet been signed. Once EAT's lawyer, Robert Mulreany, saw the degree of wear and tear inflicted on the premises by the Expo crowds and estimated some other unforeseen expenses, it became obvious to him that a six months' operating budget of $185,000, which was the sum discussed with Pottasch, would be woefully inadequate. The argument over operating costs dragged on for several more weeks after the opening, complicated by the knotty question of who would own what after Expo closed in September. Pepsi, of course, would keep all the hardware and materials that it had paid for, but Klüver wanted to make sure that the artists retained rights to their own program ideas, tapes, and other items of "software." Early in April, Klüver wrote a letter to Donald Kendall, in which he suggested that Kendall declare the Pepsi Pavilion "a work of art"; that way, he said, there "would be no thought of its being used in another context, commercialized, or reproduced beyond Expo '70." There was no reply to this letter.

Asked by Pottasch to propose a new operating budget that EAT considered realistic, Mulreany presented a figure of $405,000. This cast a very large, very dark cloud over Pepsi's enormous vision. Such a sum, Pottasch said, was utterly out of the question. EAT insisted that the pavilion could not be run for six months for less, and continued its programing and operation of the pavilion. The ominous silence that ensued was broken, on April 20, by a letter from W. Perry Keats, counsel for Pepsi-Cola, Japan, to Mulreany, stating that inasmuch as Mulreany's client had withdrawn its offer to perform programing operations for the agreed-on figure of $185,000, EAT's services in the pavilion were no longer required, effective immediately.

Mulreany advised Klüver and his stunned colleagues to go back to

New York without arguing the matter, which they did, on April 25—managing, in spite of Keats's explicit warnings, to remove all their programing tapes from the pavilion before they left. Pottasch, who had returned to Osaka at the peak of the crisis, stayed up all that night getting together substitute tapes, some of which he borrowed from a Japanese television station. For the next few days, the pavilion's thirty-seven loudspeakers filled the mirror dome with band music and the theme song from *It's a Small World*, Pepsi's offering at the 1964-65 New York World's Fair.

Having spent several years as a television producer-director before he joined PepsiCo, Inc., Pottasch was not entirely without resources in coping with the emergency. He also had the assistance of Larry Owens, who, alone of all the EAT personnel, agreed to stay on and work for the exhibit. (Owens explained that he felt his primary responsibility was neither to Pepsi nor to EAT but to the equipment that he had spent so much time building and installing.) Within a week, Pottasch, Owens, and the Japanese engineers they were able to recruit had worked out a six-minute, repeatable program for the mirror dome that included what Pottasch described as a "happy section," with lots of light and color and more or less singable melodies, and a more serious, "poetic" section with night-sky effects and electronic sounds. The Pepsi team also made some changes in the Clam Room, bringing the laser down to the floor, where people could watch it in operation, and on the outdoor plaza, where Breer's floats were speeded up slightly and identified as "moving sculptures." The fog was turned on at intervals, but gingerly. The daily attendance figures were not encouraging.

Amid the tangled wreckage of EAT's hopes, there was occasional talk of retaliation. It was suggested that Klüver had only to give the word and a militant protest against Pepsi-Cola would be unleashed by Japanese artists, several of whom had signed a telegram to Klüver deploring Pepsi's "imprudent action" at the pavilion. Klüver, however, was anxious to salvage whatever he could, and his mood, though bitter, was conciliatory. He could not fully understand why matters had turned out so badly. He and the artists were inclined to think that the real basis of the dispute had been aesthetic rather than economic —that Pepsi had just disliked what EAT was doing and decided to put on its own show. Asked about this later, Pottasch conceded that Pepsi had never gone along with EAT's concept of *constant* experimentation, or even with the idea that there would be twenty-four dif-

ferent programs by twenty-four different artist-programers during the six-month period. "We wanted to give the artists freedom, and to let them have the experience of working with industry," Pottasch said. "But we also wanted to get a pavilion that would serve our needs, in the sense that people would like it and talk about it. If the program is going to be totally different each week, though, you're never going to get that sort of word-of-mouth working for you. We *have* to think about these things, you know. And if artists want to work with industry, they're going to have to make more of an effort to understand the ground rules we operate under. The corporate people here have been willing to bend those rules quite a lot for the artists, because they realize that artists can't work the same way they do, but I honestly don't feel the artists in this case made an equal effort to understand us or our needs."

In the end, though, Pottasch thought it all came down to the question of money. "If we hadn't been presented with a programing bill that was so far in excess of anything previously suggested, we would still have gone along with their evolving concepts," he said. "But when that happened—and it has to be seen in context, as part of a pattern of constantly escalating costs that had been a problem right from the beginning—we had no alternative."

For a few weeks after the debacle, it seemed that EAT, heavily in debt and with all Pepsi funds cut off since February, might have to go out of business. This threat was averted as a result of negotiations carried on by Theodore Kheel with PepsiCo, Inc., for a cash settlement of EAT's outstanding expenses. The notion of projects outside art in which artists and engineers pool their energies to serve social change had received a severe setback, however; no one had any doubts on that score.

The Pepsi project may nevertheless have established some lasting precedents for the individual artists and engineers who were involved with it. The day after Expo opened to the public, for example, Tom Mee was flying home to Pasadena to attend to several business matters that had cropped up in his absence. At dinner in Senriyama Grand Heights the night before, the art critic Barbara Rose had warned him jokingly that he would not be able to get his affairs in order so easily. "You'll see," she said. "You'll get back and try to put the pieces together, and you'll find they won't fit!" Mee was inclined to agree with her. He was thinking of hiring Sig Stenlund and giving him a laboratory in which to work out some of the tech-

nological problems of Mylar antennas. Mee also planned to bring Miss Nakaya to California. He wanted to give her the equipment and the opportunity to make fog sculptures in the desert—"not for any particular reason," he said. "Just because I'd like to see them."

Immediately after takeoff from the Osaka airport, Mee unfastened his seat belt and, to the stewardess' annoyance, went across the aisle to look back at Expo '70. The site was already vanishing under low clouds, but two structures on it were clearly visible: the Soviet pavilion, whose forty-foot sickle-shaped roof made it the fair's tallest building, and the Pepsi Pavilion—or rather, its enveloping cloud of fog. The fog, he noted with pleasure, was going full blast.

MAYBE A
QUANTUM LEAP

A lot of people have not yet made up their minds about earth art. Although the phenomenon has been with us for several years, examples of it are so inaccessible that hardly anyone has actually seen an earthwork, and this in itself has led to misconceptions. Some people refer to the form as "conceptual art"—the term applied to works by those contemporary artists who simply specify an art project in writing and then feel no need to carry it out. "Friends of mine often look very surprised when I tell them that Michael Heizer's *Double Negative*, say, has nothing to do with conceptual art," Virginia Dwan, whose New York Gallery, the Dwan, represented several of the leading earth artists until she closed it in 1971, has noted. "They say, 'But you can't really *see* it, can you?' or they try to argue that it exists only in photographs. So I have to explain that anybody can see it simply by going to Nevada, and that when an artist has moved two hundred and forty thousand tons of dirt around, it is *not* just a concept."

Earthworks are real enough—there is no doubt of that—and at this point in the twentieth century no one has to ask whether or not they are art, because art today, as we are only too frequently reminded, is whatever an artist says it is, and if an artist wants to dig into a Nevada mesa instead of carving a block of wood or marble, that is well within the mainstream of current aesthetic practice, and may even strike future art scholars as historically inevitable, in the light of space exploration, the ecology movement, and other recent developments that have tended to make us all more keenly aware of our own perishable planet. At any rate, enough artists have loosed their creative energies upon the landscape to give earth art (or land art, as it is sometimes called) the status of an international movement.

Michael Heizer works mainly in the desert, displacing large masses of rock and dirt with the aid of bulldozers, pneumatic drills, and dynamite. Walter De Maria also favors desert regions, although he spent the better part of 1971 on a project (eventually abandoned) to

sink a 390-foot air shaft through the center of a mountain near Munich, on the site of the 1972 Olympic Games. Robert Smithson's recent works have all incorporated water, the most ambitious one to date being his 1500-foot-long *Spiral Jetty* in Utah's Great Salt Lake. Dennis Oppenheim, who used to chop large semicircles in the ice of frozen rivers and direct the seeding and harvesting of wheat fields in prescribed patterns, has abandoned earth art in favor of body art, a form involving the use of the artist's own body in various ways that one hopes will not prove fatal; Richard Long has imposed geometric patterns on fields of daisies and has draped in cloth (and then photographed) the summit of Mount Kilimanjaro, in Africa; Peter Hutchinson, a British earth artist, has cultivated bread molds on the lip of an active volcano in Mexico; Uri Buru, an Argentine, has poured dyes into the waters of the River Plate, the Seine, the East River, and the Grand Canal in Venice.

Some of these doings are ephemeral by nature, but others may be around for centuries, and the problem of what to do about the more durable earthworks is much discussed. Robert C. Scull, the collector, commissioned Heizer's *Nine Nevada Depressions* in 1968, but because they were done on government-owned land their future is somewhat uncertain. A Swiss dealer named Bruno Bischofberger and a German dealer named Heiner Friedrich *thought* they had acquired Heizer's *Double Negative* from the Dwan Gallery in 1971. (*Double Negative* is on sixty acres of land bought by Heizer, who made over the property deed to the Dwan.) Bischofberger was planning to sell it to a German collector at a price rumored to be in the neighborhood of $65,000, but Heizer abruptly decided that he didn't want dealers dickering over the work, and he canceled the deal. In 1971, Jennifer Licht, an associate curator at the Museum of Modern Art, showed slides of Heizer's *Double Negative*, Smithson's *Spiral Jetty* and De Maria's untitled Nevada land work to the trustees on the museum's purchasing committee. "I told them beforehand that I knew they weren't going to buy the works but that I thought this was one of the most interesting areas in recent art, and what *should* the museum do about it?" she has said. According to Mrs. Licht, the trustees seemed impressed by the works, but no clear answers to her question emerged.

So far, the earth artists have had to rely on private patrons, like Mr. Scull, or on the two or three dealers who have elected to support them (the Dwan Gallery and the John Gibson Gallery here, the Heiner Friedrich Gallery in Munich), or on their own limited re-

sources. The sale of preliminary sketches and working drawings, models, and even photographs of the earth projects has helped to some degree, but clearly no one is making a bundle from earth art at the moment. The artists themselves, most of whom are in their twenties or early thirties, seem content to put everything they can scrape together into the next project and let the future take care of itself. They are a dedicated lot, and a certain scorn for the New York art world and its commercial machinations is seldom absent from their thinking. "One of the implications of earth art might be to remove completely the commodity status of a work of art and allow a return to the idea of art as . . . more of a religion," Heizer said in an interview. In fact, he went on, "it looks as though the whole spirit of painting and sculpture could be shrugged off in two years' time, perhaps. It's almost totally inconsequential. Of course, it'll never happen, but it's conceivable; it *could* happen." Walter De Maria believes that art galleries are "as outmoded as night clubs" today, and something like the same notion may have induced Miss Dwan to close her gallery. None of the earth artists appears to suffer, at any rate, from a lack of confidence. "Whether we have made a jump beyond style— that's the real question," De Maria said in the spring of 1971. "Everybody talks about the art world as a succession of styles—Cubism, Surrealism, Expressionism, Abstraction, Minimal, and so forth. But this may be something way beyond all that—maybe a quantum leap. I think the experience of this work will make you feel different than you've ever felt before in the presence of art."

The jumping-off place for a tour of American earth art is Las Vegas, a city whose signal achievement has been to obliterate or subvert nature in all its forms, and in June 1971 I flew out there for a few days of intensive earth-art appreciation. I had expected to meet Michael Heizer in Las Vegas, but the manager of the motel where he was staying said that he had left a few days before to go to Wyoming, or perhaps Montana—no one knew for sure. Virginia Dwan, who had arrived from Los Angeles on the same day, seemed a little put out that he had gone off without leaving a message, but she said philosophically that this was typical of Heizer's current frame of mind. "Michael is very negative right now," she told me. Earlier that spring, during his one-man show at the Detroit Institute of Arts, Heizer had undertaken an outdoor project called *Dragged Mass*, which involved hauling a thirty-ton granite block a hundred feet across the lawn in front of the museum. Heizer considered the whole

thing a great success, but afterward, when he offered to give the piece to the institute, the trustees declined to accept it. "He's fed up with the art world," Miss Dwan said. "All he wants to do is work, and he feels he hasn't really worked for a year, because he's been that long looking for a site for his new vertical piece." She explained that the vertical piece was to be executed on the face of a granite cliff; Heizer planned to cut out a large section of rock—two thousand tons or more—in one piece and move it down the cliff face, or perhaps across the cliff face, to a previously prepared cavity. He had spent several months looking for a site in the Swiss Alps, because a European benefactor wanted him to do the work there. Although most of the suitable Swiss cliffs overhung tidy villages, whose inhabitants might react unfavorably to the prospect of art-engendered rockslides, Heizer did find a site in the Säntis Alps and began work there. Winter stopped him, though, and he decided to relocate the project in the United States. Only granite would do—any other sort of rock would shatter into fragments when dynamited—and so far Heizer had not been able to find a proper granite cliff in Nevada, the site of most of his other works. In any case, he had gone off to Wyoming, or to Montana, leaving no address, and Miss Dwan seemed reasonably certain, on the basis of past experience, that no one was likely to hear from him for some time.

In New York, in his barren loft studio on Spring Street, Heizer had struck me as a quietly keyed-up young man who saw no particular value in talking to strangers. He did say that he had been born in Berkeley, California, in 1944, and that his father, Professor Robert Heizer, was a well-known archeologist there. (I later found out that Professor Heizer is a world authority on the methods by which the Olmecs and other pre-Columbian people had managed, without benefit of the wheel, to move stone blocks even larger and more recalcitrant than Heizer's own *Dragged Mass*.) Heizer, who traveled around Mexico and Latin America with his parents as a child, went to school in Berkeley. After graduating from high school there, he spent a year or so at the San Francisco Art Institute, without bothering to enroll formally. He told me that he had "always" painted, and that when he came to New York, in the early 1960s, this was what he had done, mainly, experimenting with various current styles in the usual exploratory manner. "After I'd been in New York for a couple of years, I saw art here as really dead," he said. "A lot of things had been killed off at the same time, because the forms themselves were coming into question. I was lucky. Because I wasn't really involved with all that, I

was prepared to deal with the new situation."

Heizer's new situation turned out to be the desert. Because he was a Californian, he said, the desert had been present in his thinking for a long time, even though he had never been to one. One day in 1968, weary of New York and its dead art, Heizer flew out to Nevada and began to work on a piece called *NESW*, which he does not care to discuss at present but whose name implies that it had to do with the four points of the compass. He returned to New York a few weeks later and resumed work on his paintings; he also had the good fortune to meet Robert Scull, who liked his paintings but seemed even more interested in his rapidly proliferating ideas for desert works. The result was that Scull financed Heizer's extremely productive summer of 1968, which he spent in various desert regions of Nevada.

From the outset, Heizer's land works were inclined to take the form of excavations, or "displacements," rather than additions to the landscape. *Displaced Replaced Mass*, one of the principal works of that summer, involved dynamiting huge boulders out of a mountainside, moving them sixty miles by truck, and depositing them in concrete-lined holes ("depressions") of varying sizes and shapes. Heizer rented heavy-duty construction equipment and hired local contractors to assist him, and at one point he even permitted his patron to come out and watch one of the displacements. Scull speaks rapturously of the experience. "I saw Mike Heizer stand on top of a fifty-ton piece of granite and then jump down and give the order, and the dynamite split it right in half!" he told me. "I watched them take it to the place where he'd dug out a huge hole. It was night, and the cars of the workmen lit up the place with their headlights. And suddenly I realized that art didn't have to involve the walls of my house. I was involved with nature—the whole desert became part of my experience."

Displaced Replaced Mass was one of *Nine Nevada Depressions* executed by Heizer during the summer of 1968. The eighth in the series, called *Dissipate*, took the form of a group of five rectangular holes, each twelve feet long and a foot wide, dug in conformity with a pattern established by five matches that Heizer dropped at random and then taped down on a sheet of paper—a somewhat Duchampian gesture that seems out of place in Heizer's *oeuvre*. In addition to the *Depressions*, Heizer, using a pick and shovel, also managed to carve a graceful loop, a foot deep and a foot wide and forty yards long, in the basin of Nevada's Massacre Dry Lake (*Isolated Mass: Circumflex*) and, using a motorcycle, to carve a series of eight fifty-foot circles in Coyote Dry Lake, California (*Ground Incision: Loop Drawing*). The

circles were cut by the tires of a professional motorcycle racer's Triumph, driven flat out in the soft, dry soil of the desert.

The most ardent collectors of advanced American art in recent years have been German—a phenomenon traceable in part, at least, to the activities of several young, magnetic, and vastly enterprising German art dealers. Heiner Friedrich, who may very well be the most magnetic German since Wotan, was sufficiently impressed by Heizer's land works to offer him a one-man show in his Munich gallery in the spring of 1969. Heizer elected to exhibit two works there. The first, which was shown in the gallery, was *Line Drawing*, consisting of the gallery's printed announcement of the show canceled out by a crayon line drawn through the words. The other work of art was situated in a vacant lot on the outskirts of Munich. It was a circular pit, a hundred feet in diameter, whose sides sloped symmetrically to a central point fifteen feet deep, and it was called, naturally, *Munich Depression*. Heizer's most important work to date, which also happens to be the world's largest sculpture (provided that is what it is), was started in the fall of 1969. The Dwan had offered him a one-man show in January 1970, with the understanding that he would do a major earthwork somewhere and that the gallery would pay for it. Heizer went out to Nevada in October, and nobody heard anything from him for a couple of months. He returned in December with photographs of *Double Negative*. This was the work that really made Heizer's international reputation, and it was the one I had come to see. Although Heizer was not around to take us out to it, Miss Dwan, having been there a number of times, felt reasonably certain that she could locate it. We rented a car and set out from Las Vegas at about four o'clock in the afternoon, heading northeast on the freeway.

Driving out of Las Vegas into the arid and empty Nevada landscape is a fairly memorable experience in itself. After the preposterous air-conditioned hotel lobbies, with their twenty-four-hour gambling tables and housewife-mesmerizing slot machines, the seared desert valleys and eroded hills looked equally unreal, and nearly as hostile to life. The military installations and nuclear-test sites, which show up on the road map as "Danger Zones," are for the most part invisible to freeway traffic; we saw jet fighters flash down over a rust-colored mountain range as they headed for Nellis Air Force Base, eight miles north of Vegas, but we could not see the huge base itself. Roughly 87 per cent of Nevada is government-owned land, and one has the impression, from the radar and other electronic sentinels on

the hilltops, that the owner is watching. "Walter De Maria and Michael really dig this place—no pun intended," Miss Dwan told me. "They feel it sums up where we really are now in this country—all the materialism and vulgarity of Vegas, and the death industries outside. It's a kind of instant America—instant marriage and divorce, instant winning and losing, instant life and death. The boys cut their hair before they come out here, because the local police are tough on hippies, but they like the frontier mentality, and they're very much into the whole gambling thing. Michael's title, *Double Negative*, really refers in part to the double zero on the roulette wheel."

Approximately thirty miles north of Vegas, we left the freeway and drove east, in the direction of an immense plateau that Heizer calls Virgin River Mesa. A filling-station attendant told us how to get up on top of this eminence, and added a warning about going there on such a blistering day—the temperature, which had been 105° when we left Vegas an hour before, showed no signs of relenting. As we approached the mesa, the blacktop road changed to dirt. Suddenly it became quite steep. The rented car churned and skidded through soft sand that had drifted over the track in places, and I became acutely aware of the sharp drop at the outer edge of each hairpin turn. Just as the road seemed about to disappear completely, we lurched over a ridge and were on top of the mesa, which was just as flat as it had looked from a distance. Twin car tracks led across to the other side, where *Double Negative* was situated. "We've done it!" Miss Dwan said, prematurely.

The next hour and a half were spent searching up and down the mesa's far side. *Double Negative* had turned out not to be where Miss Dwan thought it was. The mesa extends for miles and miles, and is cut into at frequent intervals by narrow canyons, each of which looked as though it might be the site of Heizer's dig. Miss Dwan, a tall, chic woman dressed in dark-blue slacks and a Western-style shirt, reconnoitered every one. The temperature remained above 100°; the car shuddered on the verge of boiling over. Just after seven, with the sun approaching the horizon, we finally found it.

Two enormous rectangular cuts, each thirty feet wide and fifty feet from top to bottom, had been dug out on opposite sides of a narrow canyon as neatly and precisely as though someone had sliced into the mesa with a gigantic cake cutter. Following Miss Dwan's lead, I started to descend the sharply sloping back wall of one cut, trying to decide en route whether a cautious sidestep or a sit-down slide was less likely to result in a sprained ankle, and ended up in a dead run

that took me to about the middle of the cut. I looked up. Some
erosion had taken place in the year and a half since the piece was
finished, and the vertical side walls showed striations and indentations
near the top which, when viewed from fifty feet down, suggested the
stone carvings of a medieval church. The color was a warm ocher
with yellowish streaks, verging to dull reds and greens in places where
the minerals had leached out. Heizer had said that he didn't know
how rapidly the work would erode but that he hoped it would last a
hundred years. It had already acquired graffiti: peace symbols, a
fashionable four-letter word, and the name "Willie Weed" had been
scratched into the wall, and there was also a surprisingly realistic
drawing of a shark. We walked to the front edge of the cut and
looked down into the valley. The 240,000 tons of earth and rock that
Heizer's bulldozer had pushed over the edge were barely noticeable;
the debris blended into the ocher of the canyon's walls—a minor
landslide in a vast uninhabitable landscape.

We climbed back up the wall, drove the car around to the other
side of the canyon, and clambered down into the other cut. It was ex-
actly the same as the first, only longer from front to back. Willie
Weed had been here, too, and he or someone else had left a beer can.
Miss Dwan sat down on the ground and looked up, getting the sky
and the setting sun into her perspective. A small lizard watched,
unblinking, while I emptied the dirt from my shoes. "My personal as-
sociations with dirt are very real," Heizer had said once in an inter-
view. "I really like it; I really like to lie in the dirt."

Every time she saw *Double Negative*, Miss Dwan said, it took her
by surprise. "It's so much bigger than I remembered," she added. I
thought it seemed smaller than I had anticipated. Seen in relation to
the long mesa, with its wind-carved sandstone ridges and turrets and
ravines dropping sharply down to the green valley below, *Double
Negative* looked distinctly man-made, and somehow less majestic
than the blown-up photographs of it that I had seen. Heizer, I re-
membered, had said that he really didn't think about his works in
terms of size, because they were not that big—"just big enough to
give the idea," he said. The experience of being inside *Double Nega-
tive* was certainly different from the experience of looking at a land-
scape by Claude or Turner, but whether it could qualify as a religious
experience, or as a quantum leap beyond style, I must leave to the

MICHAEL HEIZER SURVEYS HIS *DOUBLE NEGATIVE* (Gianfranco Gorgoni)

judgment of more physically robust critics than I. Heat and thirst had dulled my perceptions; I was thinking of the trip back.

The little lizard disappeared behind a rock. He seemed to be very much at home in this work of art. It was nearly eight o'clock. According to Heizer, one should really spend twenty-four hours experiencing *Double Negative*, so as to see it in all the changing conditions of light. I am sure that all the physically robust critics do this. Miss Dwan and I started back just as the sun was disappearing behind the horizon, and managed to make it down the dirt track on the other side of the mesa before dark.

The next day, we started earlier, leaving Las Vegas at about two o'clock in the afternoon—the car radio gave the temperature as 108° —and again heading northeast on the freeway. Walter De Maria had drawn a rough map showing how to get to his untitled piece. "Walter is a very mysterious person," Miss Dwan said as we left the freeway and started to follow a dirt road leading straight back into the desert hills. Several other people had told me the same thing, although when I had talked with him in New York a month before he had impressed me as the most articulate of all the earth artists I had met. Somewhat older than Heizer, he was born just outside Berkeley, California in 1936. His grandparents had come from northern Italy about the turn of the century. De Maria grew up in and around San Francisco, graduated from the University of California at Berkeley with a B.A. in history, and then went on to do graduate work there in fine arts. "As soon as I graduated—in 1959—I stopped painting, because I realized that what we had been taught was basically a closed-end system," he told me. "At Berkeley, they started you with plaster casts, then went right to Cézanne—breaking up the casts into facets. Then to Picasso —breaking them up a little more and getting wilder. Then on to Hans Hofmann, who taught there at one time. Everything kept getting a little looser and more broken up, but you still kept essentially to some kind of a balanced picture, with a little green here, a little red there, and so forth. And at the end they brought you right up to de Kooning, which at that time was being up to date. Having gone through all those stages, you were considered a bona-fide painter, and you could go out and become an art teacher, too. The system was just *doomed*. I was so disgusted that I quit painting and started making little boxes."

De Maria also moved to New York, where he saw a lot of his friend La Monte Young, a fellow Californian and a composer, who had been powerfully influenced by the composer John Cage. De

Maria lived in a very small loft on the Bowery with a San Francisco girl he had married, and during their first New York winter, 1960-61, he made a total of thirteen plywood boxes in various shapes and sizes. Robert Scull, who likes to find young artists before they find themselves, admired De Maria's work and, in 1965, commissioned him to remake several of his plywood pieces in stainless steel. One of these was a narrow, seven-foot-high cage constructed of inch-think rods and entitled *Cage*, which Scull had admired in an earlier version in wood, when it was called *Statue of John Cage*. Another, somewhat more enigmatic, was a series of *High Energy Bars*—stainless-steel ingots fourteen inches long and one and a half inches square, each inscribed with the words HIGH ENERGY BAR and accompanied by a certificate affirming that it was indeed a high-energy bar. The steel version of the *Cage* statue impressed a number of critics as one of the best pieces in the 1966 "Primary Structures" exhibition at the Jewish Museum in New York, the first comprehensive showing of the stripped-down, nonrelational, highly impersonal objects that became known as Minimal Art. De Maria has continued to make sculptures, although earthworks now claim the major part of his interest. In 1969 he exhibited at the Dwan Gallery five rather dangerous-looking Spike Beds—rectangular platforms bristling with stainless-steel spikes honed to the sharpness of barracuda teeth; visitors were asked to sign a release absolving the artist and the gallery of responsibility in the event of spectator impalement. De Maria said that the five-part piece, which was recently purchased by the Kuntsmuseum, in Basel, "summarized some of my ideas about New York at the time."

Theoretically, at least, De Maria's involvement with earth art goes back to 1962, when he made drawings for what he called *Walls in the Desert*. What he envisioned then were two parallel cement walls, at least fourteen feet high and eight feet apart, running in a straight line for a mile. "As you walk between them," he explained, "you can look up and see the sky; as you continue to walk, and get near the halfway point, the perspective will appear to close, and then as you come near the end it will open up. The walls will be constructed so that when you come out you'll be able to see for an enormous distance, and you'll really feel what space is." His first earthwork, in 1968, was a kind of sketch for *Walls in the Desert*—two parallel lines, half a mile long and twelve feet apart, put down with a chalk marker in the Mojave Desert. They blew away within a month. That year, while Heizer was busy with his *Nevada Depressions*, De Maria had a show at Heiner Friedrich's gallery in Munich, which consisted of filling the gallery's three rooms with 1600 cubic feet of earth—a wall-to-wall

dirt carpet three feet deep. From Munich, bankrolled by the endlessly agreeable Herr Friedrich, he went down to the Sahara, hired a bull-dozer and crew, and dug a mile-long twelve-foot-wide line, running from north to south, which was to be the first installment of a Three Continent Project. The two other parts were to be a one-mile square, cut somewhere in the western United States, and another one-mile line, this one running east to west, in India; when completed, the three works would be photographed from the air and the photographs superimposed to show a cross within a square. Unfortunately, De Maria and his crew were unable to photograph the first cut. Local authorities in the tiny Algerian village where they were staying be-came suspicious of their activities and insisted that they leave the country immediately. By now, the original bulldozed line has un-doubtedly eroded to some extent, but De Maria plans to go back and recut it. He will do the two other parts when time and funds become available.

Although photographs would seem to play a key role in the Three Continent Project, De Maria took a firm stand in 1969 against any photographic reproduction of his land work. His refusal to let his recent earthworks be photographed has not helped his reputation, and he is a little resentful about that. "I felt that I had to go back toward direct personal experience, no matter what the difficulties were," he told me. "Maybe only twenty or thirty people would see my work in a year, but that was better than a lot of people partially seeing it through photographs." De Maria did not even want people to know ahead of time what his major land work to date (the one that Miss Dwan and I were searching out) looked like. In New York, he had described it to me as three miles of lines cut in the Nevada desert by a bulldozer "in a certain configuration," and he had added that "basi-cally, the piece is experienced by walking." As Miss Dwan and I drove along the dirt road into the Tule Valley, throwing up a long cloud of dust and subjecting the rented car's tires and front axle to severe abuse, she further explained that one was supposed to walk the piece alone, solitude being an essential aspect of the experience. "It's a kind of ritual," she said. Another important element was time. "It really takes all day to see my piece, counting the time spent getting there and back," De Maria had told me. "You're involved with it for ten hours or so. There's no other kind of sculpture that demands that of you—if you come into an art gallery you may spent one minute, two minutes, five minutes looking at a David Smith or a Brancusi. Rarely more than five minutes. But with an earthwork you're really

WALTER DE MARIA IN THE MOJAVE DESERT
(Gianfranco Gorgoni)

in the piece, you're in time, and your whole personality cuts through it in a much larger way."

About an hour and fifteen minutes after we left the freeway, it became evident that we were on the wrong road. The landmarks on De Maria's map were not materializing. We went back about ten miles, found a turn we had missed, and continued on in hopeful silence. But half an hour later, having followed this road to an abandoned mining site that did not appear on De Maria's map, we realized that error had again crept in. The evening drew on apace. We doubled back and, after a period of eagle-eyed reconnaissance, managed to locate one of De Maria's landmarks. We turned there, drove one mile, as instructed, parked, and set off on foot, taking pains to skirt the juniper and the low-growing cacti, because De Maria had said they might harbor snakes or scorpions. Twenty minutes later Miss Dwan said we must have missed the earthwork somehow. We retraced our steps to the car, drove it a little farther along, and then struck off again into the purple sage. The two desert hikes were not without their compensations. The wide, level valley, ringed with jagged mountains, some of which were still snow-capped; the desert flowers; the pungent smell of juniper carried by the light breeze; the hot disc of the sun sinking luridly toward the horizon—all this was admittedly something that I had not previously experienced in an art

gallery or a museum, although I did get a few brief, semihallucinated associations with old John Wayne movies. In the end, having spent a little more than ten hours looking for it, we never did find Walter De Maria's earthwork.

Driving back to Las Vegas that evening, Miss Dwan mentioned that De Maria was deeply interested in the idea of invisibility. Two of his earth pieces—the 1968 parallel lines in white chalk, and a more recent chalk cross, also in Nevada, whose longitudinal axis was a thousand feet long—had both disappeared within weeks, she said. At the Cordier & Ekstrom Gallery in 1966, De Maria had shown a *Large Landscape* made up of six of his "invisible drawings"—framed sheets of blank paper on each of which was inscribed, in the exact center, a faintly penciled word: "TREES," "SKY," "RIVER," "FIELD," "MOUNTAIN," "SUN." "Invisibility may be the main common denominator in art," De Maria had told me. "After all, science says that all matter is composed of invisible particles—electrons, that is." De Maria's projected work for the 1972 Olympics in Munich—the 390-foot shaft in the mountain—would have been about 90 per cent invisible. He felt that the concrete-lined shaft, surmounted by a raised solid-bronze disc, 21 feet in diameter, on which people could stand, would serve to "activate" the mountain itself as a piece of sculpture. The mountain was an artificial construct, made of rubble from the wartime bombings; by turning it into sculpture, the artist hoped to make a statement about the earth, cities, wars, nations, and (one guessed) athletic contests. Unfortunately, the Olympic officials decided against the project. Although it had received the support of the Games' architectural committee and had become front-page news in several German newspapers, the officials eventually decided to commission a more visible work by a German artist.

Robert Smithson was born in Passaic, New Jersey, in 1938. He spent most of his childhood in Rutherford; his pediatrician was William Carlos Williams. Smithson is, in a sense, the theoretician of the earth-art movement, but his published articles have not always pleased the other earthworkers, and a certain degree of bad feeling exists between Smithson and Walter De Maria. Neither artist cares for the other's work, and neither hesitates to say so.

As a boy, Smithson had a private museum in the basement of his house, where he kept collections of rocks and shells. "I was always on the lookout for fossils," he said when I interviewed him in New York. "It was a sort of private world that kept me going. At that time, I

was interested in becoming a zoologist or a naturalist, but gradually I discovered that my interest was more aesthetic than scientific. When I was fifteen, I decided to be an artist." While he was still in high school, he started taking classes at the Art Students League, in New York. After graduation and six months in the Army, plus another six months spent hitchhiking around the country, he found a cheap room in New York, got to know a number of young artists, and worked his way through some of the leading influences of the late 1950s and early 1960s—de Kooning, Dubuffet, Pollock, Rauschenberg. This took about three years. By 1964 he had made his way out of painting and into three-dimensional plastic constructions. Smithson had his first one-man sculpture show at the Dwan Gallery in 1966, and he was prominently represented in the "Primary Structures" show that year at the Jewish Museum. But Minimal abstraction turned out to be only another transitional stage. "Abstraction, in a funny way, seems to take you very far away from any kind of natural problem, and I've always been drawn to natural problems," he told me. "There are maybe a hundred different ways of looking at nature, but abstraction is a kind of renunciation of all that."

Smithson dropped out of the New York art scene for a while in the 1960s and did a lot of reading and thinking. He was not at all happy, he said, with the whole art-gallery setup—"the business of things going from one white room to another"—and he felt, along with Heizer and De Maria, that painting and sculpture were pretty well played out. He found himself thinking a lot about the growth of crystalline structures and other natural forms, and about the possibility of working with nature directly, instead of at some sort of aesthetic remove. Out of that thinking, in part, came the first of his three-dimensional "nonsites." A typical Smithson nonsite consists of a section of a topographical map cut out and mounted on the wall, in front of which stand two or three steel bins containing natural particles— stones, earth, gravel, and such—taken from the actual area shown on the map. The nonsites are for Smithson a kind of "personal archeology." A number of them have been bought by collectors and museums. Smithson sees a somewhat ironic parallel between this activity and the Apollo missions to the moon. "The moon shots are like very expensive nonsites," he says. "Going all that way to bring back some particles from up there. The whole idea of gathering together remnants and then trying to make sense of them—that's what I find interesting."

Although art for Smithson is primarily a mental activity, he has

no real interest in conceptual art, which exists solely in the realm of ideas. "A lot of the so-called conceptual art is nothing but atrophy," he told me. "I think we're just discovering the multiplicity of nature's ways." Smithson, however, is far from being a nature freak, and he tends to be a trifle scornful of the recent wave of environmental concern. "The ecology thing has a kind of religious, ethical undertone to it," he said. "It's like the official religion now, but I think a lot of it is based on a kind of late-nineteenth-century, puritanical view of nature. In the puritan ethic, there's a tendency to put man outside nature, so that whatever he does is fundamentally unnatural. There's this dualism lurking around the subject—this Teddy Roosevelt, John Muir, return-to-the-wilderness idea. To me, nature has three different aspects: there's wilderness; there's the country, where man has been; and then there's the urban area. It's like a crystal growth; the urban area is no more unnatural than Yellowstone Park. A lot of people have the sentimental idea that nature is all good; they forget about the earthquakes and typhoons and things like that. Not that I'm opposed to the ecology movement—far from it. One of the things that interests me most, in fact, is the idea of using abandoned quarries, old strip mines, and such places as sites for earth art. These ruined landscapes could be recycled, too, and given over to a different type of cultivation."

Early in 1969 Smithson read a book called *Vanishing Trails of Atacama*, which described the strangely colorful process of mineralization in isolated bodies of water. He subsequently called a ranger in Utah, and found that at the northern end of the Great Salt Lake extremely heavy concentrations of salt and other minerals promoted a growth of algae that made the water red—"the color of tomato soup," the ranger said. Smithson went out to Utah and spent a couple of months scouting the area. Then, with financial support from the Dwan Gallery here and the Ace Gallery, in Los Angeles, he took a twenty-year lease on ten acres of lakefront land, hired a contractor, and in April 1970 started work on the *Spiral Jetty*.

At the Dwan Gallery, I had seen Smithson's thirty-five-minute color film of his jetty. The film interspersed shots of maps, charts, and prehistoric bones with scenes of Smithson staking out the design with string in the shallow reddish water; trucks backing cautiously to the edge of the steadily lengthening spiral form to dump their loads of rock and dirt; white salt crystals forming on the rocks; and a final, spectacular view from a helicopter of Smithson running the length of the completed jetty—from its terminus on shore to the central point

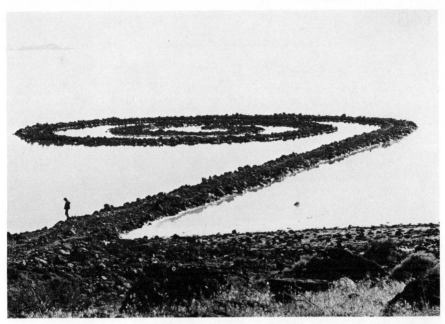

ROBERT SMITHSON AND *SPIRAL JETTY* (Gianfranco Gorgoni)

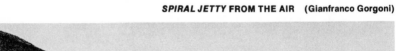

***SPIRAL JETTY* FROM THE AIR** (Gianfranco Gorgoni)

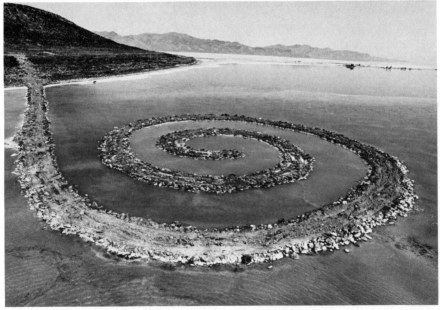

of the curling spiral, sixty yards out in the lake. The film had excited considerable interest in New York and in Europe, and, partly because of it, the *Spiral Jetty* had become the most widely reproduced example of contemporary earthworks.

In order to confront the *Spiral Jetty*, Miss Dwan and I flew from Las Vegas to Salt Lake City, rented another car, and drove about ninety miles north, to Brigham City. Smithson, who was in Holland at the time, creating a new earthwork in a sand quarry (he had intended to do it in a peat bog, but that idea fell through), had suggested that we stop in at the Golden Spike Motel in Brigham City, where he and his wife, the artist Nancy Holt, had stayed while they were working on the jetty; the manager there, Lafe Jensen, he said, could give us precise directions to the site. We had a terrible time finding the Golden Spike Motel, which seemed rather a poor omen, and, when we finally did find it, Mr. Jensen offered directions so detailed and so thick with homely rural landmarks that our spirits sank. He also mentioned that we might find the jetty under water, because the lake was unusually high at the moment. Mr. Jensen had not been out there since the previous fall, he said, but he was hoping to take his wife out again some Sunday for a picnic. So far as he knew, nobody else had been there recently, except for a group of newspapermen from out of state.

Thirty miles beyond Brigham City, just past the Golden Spike National Historic Site, where the first transcontinental railroad was linked together in 1869 (two antique locomotives and a memorial plinth mark the spot), we took a dirt road that led across rolling acres of rich farmland, but from that point on none of Mr. Jensen's local landmarks were in evidence. However, the landscape looked vaguely familiar to Miss Dwan (she had been there twice before, but each time someone else had been driving), so we held our course for another eight miles, in the general direction of the lake. We got down to the water at about five in the afternoon, and great was our relief to find, as prophesied by the seer of the Golden Spike, a ramshackle wooden jetty with some oil-drilling rigs on it. About half a mile down the shoreline, we could just make out Smithson's *Spiral Jetty*, and we covered the remaining distance on foot.

Lafe Jensen had been right about the high water, because most of the *Spiral Jetty* was submerged. Only the big boulders at the edges of the causeway were above water, and when I took off my shoes and tried to wade out I sank to my knees in mud. A whitish salt crust formed on my ankles as the water evaporated. The water was rust-

colored, warm, and smooth as glass. I remembered Smithson's saying that there were three different ways of seeing the jetty—walking on it, from a hill on the shoreline, and from a helicopter. "I like to think the piece has a multiplicity of scale," he had said. The action of salt-crystal formation also changed the look of the work, according to Smithson. In the late summer, as the water in the lake evaporated, heavy concentrations of salt made a whitish sludge all along the edges of the spiral, with yellow streaks where the sulphur content showed through. The water became much redder then, he said—more like tomato soup. In the winter, the lake rose and the salt crystals dissolved. The *Spiral Jetty* was thus an organic work of art, responding like a tree or a plant to the changing seasons.

Unable to walk out on the jetty and lacking a helicopter, I climbed the hill behind the beach. The shape of the jetty was very clear from up there, just as Smithson had said, and the scale was altogether different. Set down in that flat immensity of water bounded by hazy, towering mountains, it looked precise and gemlike, obviously man-made yet unaccountably believable as a natural object. (The spiral itself, as Smithson had pointed out, is one of nature's basic forms.) There was something decidedly pleasing about Smithson's stone-and-earth spiral down there, curling so gracefully upon itself in the placid, reddish water. The dialogue between abstraction and nature that Smithson often mentions in connection with his work seemed to be going on very agreeably, in a modest and nonassertive way, and the problem of art competing with nature did not arise. Later on in the summer, when I was back in New York, I got a postcard from Smithson, in Utah, saying that the water in the lake had receded and that the jetty was surfacing nicely. "Half of the tail is completely covered with salt crystals," he wrote. "The rest is like an archipelago of white islands. I have never seen the water so red."*

Christo Javacheff does not consider himself an earth artist. Although the focus of his extraordinary projects has broadened in recent years to include rural as well as urban areas, these projects tend to be in the nature of "events" rather than stationary works of art—to involve varying numbers of people in a common enterprise that exists for a brief time and then dissolves, leaving only photographs and con-

*Robert Smithson died on July 20, 1973, when the light plane carrying him and a photographer over the site of his *Amarillo Ramp*, a projected earth sculpture near Amarillo, Texas, crashed into the side of a mesa. He was thirty-five at the time.

troversies in its wake. Christo (he uses only his first name) is a Bulgarian artist, born in 1936, who escaped to Vienna from Prague at the time of the Hungarian revolt, made his way to Paris in 1958, and came to New York, where he lives now, in 1964. He established his reputation, in the early 1960s, as a wrapper, rather than as a maker, of art works. He began by wrapping bottles, furniture, and other familiar items in rough canvas or polyethylene and tying off the bundles with yards of heavy twine—a process that struck some admirers as a wry Surrealist commentary on the modern preoccupation with packaging in industrialized societies. Since then, he has gone on to wrap motorcycles, trees, nude women, museum buildings, and, in 1969, a million square feet of rocky coastline near Sydney, Australia—surely one of the most ambitious art works of the 1960s. Although the emphasis on spectacle in Christo's work has barred him from consideration as a true earthworker, it would have been unthinkable for me to conclude my earth-art tour without a visit to Rifle, Colorado, where he was making preparations to hang an orange nylon curtain across a twelve-hundred-foot-wide canyon in the Grand Hogback area of the Rocky Mountains.

The *Valley Curtain* project had been initiated more than a year before—in March 1970—and I had been following its progress with interest and awe. Not the least of Christo's talents is his ability to raise money for his bizarre undertakings. The wrapped coastline in Australia had cost about $80,000, most of which Christo and his wife, Jeanne-Claude—a Parisienne whose financial, promotional, and administrative genius just might make her the ideal person to reorganize the Democratic party—had raised from various private sources in Europe and the United States. *Valley Curtain* was going to cost a good deal more than that. The initial estimate by Lev Zetlin Associates, the engineering firm engaged by Christo to make the structural-feasibility studies, came to $259,000, which was subsequently revised upward to $400,000. By early June 1971 Christo and Jeanne-Claude had raised $370,000 of that, most of it from European collectors, dealers, and museums. They felt confident that they would bring in the rest by the time the curtain itself was raised, in late July—it was to stay in place for three months—and they were rather proud that not one penny had come as a donation; the backers were all being paid off with individual art works by Christo.

In order to finance the project, Christo had incorporated himself. He was the sole stockholder of something called the Valley Curtain Corporation. Christo gave the corporation all his drawings, models,

and photomontages relating to the *Valley Curtain*, together with a number of unsold Christos (wrappings, mostly) that dated back to 1958. All the money generated by the sale of these things would be spent on the *Valley Curtain* project, so that when the corporation closed its books and dissolved itself, the final audit would show no profits, and, accordingly, there would be no federal tax. Scott Hodes, a Chicago lawyer who worked out the legal details of the corporation, told me that Jeanne-Claude had been absolutely invaluable to the project. "She runs the books, and she sees to it that everything gets done and that the materials get sent where they ought to be at the right time," he said. "She's an amazing woman." Hodes, who collects modern art and owns three small Christos (two sketches of the *Valley Curtain* project and a copy of the 1966 annual report of the Chrysler Corporation wrapped in canvas and stout twine), had been highly enthusiastic about the *Valley Curtain* from the beginning. Oddly, so had many of the citizens of Rifle, a town of some two thousand inhabitants not previously known for its devotion to modern art. The local Chamber of Commerce likes to describe Rifle as the Oil-Shale Capital of the World, but the only local oil-shale plant—an experimental one run by the federal Bureau of Mines—closed down three years ago, throwing a number of Riflians out of work. The town, in fact, has been in something of an economic depression for several years. Although a Union Carbide vanadium refinery just outside town provides a number of jobs, the big-game hunting that is Rifle's other major industry had not been as good as usual in recent years (some people claim that Union Carbide's smokes and effluents have offended the elk, bear, and mountain lions), and, to compound the environmental irony, what was described as the World's Largest Trout Fish Hatchery, established by the Colorado State Game, Fish, and Parks Department in Rifle Creek, a few miles to the northeast, had to be closed down indefinitely a few years ago because *it* was polluting the water downstream. And yet it was not economic considerations alone that caused so many of Rifle's prominent citizens to look with favor upon an enterprise whose very oddity, it seemed, might help to put Rifle on the map.

Rifle Gap, some seventy miles due west of Aspen, is an exceptionally narrow valley, running between nearly perpendicular sandstone cliffs. Christo looked at a number of other possible sites in Colorado, but none of them could match Rifle Gap's natural advantages, and so, in the spring of 1970, he approached the landowners on either side of the valley. One of them, Lloyd Wilson, was an airline pilot who

happened to have seen Christo's wrapped coastline in Australia the year before. He wanted, and got, $6000 for a nine-month lease on his land. Mr. and Mrs. Stanley Kansgen, who owned the land on the west side, were so startled at first by the whole idea that for several weeks they were afraid to mention Christo's proposal to anybody. When they finally met the artist in person, though, he so charmed them that they said he could rent their land for $400. Christo promised to give Mrs. Kansgen, who runs a small historical museum of Western artifacts about a mile from Rifle Gap, a good-sized piece of the *Valley Curtain* to put on display there when the project was terminated.

Although Christo's English is still a little erratic, his obvious sincerity and his beautifully considerate manners seemed to captivate nearly everyone in Rifle, including those who thought he must be off his rocker. In Denver, however, two hundred miles away, opposition to the *Valley Curtain* soon began to build up. The Colorado Open Space Council, a recently formed conservation group, expressed grave anxiety that the curtain's shadow, falling across the Gap for three months, would adversely affect the animal, insect, and plant life of the area, and that birds might be injured by flying into it. Christo referred the ecological question to Professor William Weber, the head of the Biology Department of the University of Colorado, who assured them that the curtain's shadow would have no effect whatever on the wildlife or plant life (neither of which abounds in the Gap), and he intimated that any bird that could not manage to fly over the curtain would have to be in pretty bad shape to begin with. His arguments apparently satisfied the environmentalists. The Open Space Council expressed its continued disapproval of what it termed a "frivolous use of the land" (since most of the project's financial backing seemed to have come from Europe, Edward Connors, the council's president, said, why were the Europeans being "deprived of the opportunity of having such art in their back yard?"), but it agreed to take no legal action against the project.

More serious problems were being generated, however, by the Colorado State Highway Department. State Highway 325 runs right through Rifle Gap. Christo had designed an arch in the curtain—fifty feet wide by twenty feet high—to accommodate passing traffic, but the Highway Department wanted to make very sure that an eight-thousand-pound curtain in a narrow valley where strong gusts of wind could be expected was not going to fall upon the vehicles of the "traveling public." Before it would issue a permit to proceed, therefore, the

department demanded a thorough investigation of the project by an independent engineering consultant; it also demanded that liability insurance of up to $1.5 million be taken out, and that it have access to the premises at all times, "in the event it becomes necessary to remove the curtain." The extra insurance policy (the Valley Curtain Corporation already had its own) was a major factor in the steadily mounting costs, which Christo and Jeanne-Claude were spending most of their time trying to meet. They had also engaged the Ken R. White Company, of Denver, to make the independent engineering study. The curtain was originally scheduled to be raised on July 1. When I flew down from Salt Lake City on June 21, however, work was still being held up by a series of test borings into the sandstone cliffs on either side of the valley, to make sure they would support the weight of the art.

The project director for *Valley Curtain* was a Dutchman named Jan van der Marck, who was also vice-president of the Valley Curtain Corporation. (The president and treasurer, naturally, was Jeanne-Claude.) He seemed moderately cheerful in spite of all the delays and difficulties, which he told me about after dinner on the night of my arrival. Van der Marck is full of enthusiasm for the work of Christo and other vanguard artists. As chief curator of the Walker Art Center, in Minneapolis, and, more recently, as director of the Museum of Contemporary Art in Chicago, he gained a reputation in museum circles for putting on highly original and, at times, somewhat controversial exhibitions, the most spectacular of which involved the wrapping of the Chicago museum, inside and out, by Christo in 1969—an event that led a fellow museum director to refer to van der Marck as one of those heathens "who have defiled the sanctuary." Having resigned his museum position early in 1970 (for reasons that had nothing to do with Christo), he agreed to work on the *Valley Curtain* project, not only because the idea appealed to him but because of his own belief that certain art forms can no longer be contained within museums. The *Valley Curtain* and some of the more celebrated earthworks struck him, he said, as "the primitive beginnings of a new type of art," with which, he felt, contemporary museums must sooner or later come to terms.

We talked for a while, van der Marck and I, about Christo's rather curious position in the contemporary art world. Christo has never been quite accepted by the avant-garde establishment in New York, as one might gather from the fact that the overwhelming majority of the *Valley Curtain*'s sponsors were Europeans. Van der Marck

thought this was due in part to cultural chauvinism. Some of the critics still tend to look on Christo as a European aesthete, he said, whereas earth art is very American. "It reflects the vast scale of the country, the back-to-the-earth sentiments of the ecologists, and also a kind of frontier romanticism that many Europeans find so appealing," van der Marck said. He paused and then went on, "Maybe Christo is not tough enough, either. He never spits in your eye, the way some of the earth artists do. People seem to like that truculence now; there is the new mystique of the slap in the face. But Christo is always courteous and helpful, so some think he's just a self-promoter. And yet, you know, I have never heard him make a snide or vicious remark about another artist's work, which is unusual, to say the least. Few artists of my acquaintance are as fair or objective about others' work as Christo is."

I met Christo and his eleven-year-old son, Cyril, at the Aspen airport the following morning (Jeanne-Claude was in New York, too busy with financial and other matters to leave), and the three of us drove over to Rifle that afternoon with Charles Russell, a graduate student from Cornell, who was spending the summer helping out. It is a spectacular drive, gradually descending the western slope of the Continental Divide and running parallel to the Colorado River for many miles. Christo was in fine spirits. He is a slim, rather frail-looking man with shoulder-length dark hair and a thin, intelligent face that frequently breaks into an engaging smile. He told us that his Aspen friends had been horrified when they learned he was going to hang the curtain in Rifle. "In Aspen, they are very intellectually conscious," he said. "They said that the people in Rifle were all Nixonians and hard-hats and cowboys, and that they would probably kill me. But, you see, we have nothing but good relations with the people there. They are good people, very straight."

I asked whether the idea of a curtain was not something of a departure for him, inasmuch as he had been principally known as a wrapper. Not at all, he said. As far back as 1962, in Paris, he had made an *Iron Curtain* out of oil drums—204 oil drums, piled to a height of 15 feet—which completely blocked the Rue Visconti for three hours. "The idea of closing off, of stopping the circulation between two places, has always interested me," he said. In 1969 he proposed the temporary closing off of all east-west highways in the United States by means of glass walls 48 feet high, but so far this work has remained in the conceptual stage.

Rifle has the dusty, hard-bitten look of a good many Western

towns. As we drove through it, Christo pointed out Mc's Café, where he and van der Marck had held several meetings with the local citizenry over the preceding six months. He also pointed out the Harris Jewelry Store, whose owner, William J. Tadus, was the mayor of Rifle and a good friend of the *Valley Curtain*. By the time he had singled out these landmarks, we were out of town, heading north on Highway 325 toward Rifle Gap. The countryside, watered by Rifle Creek, offered pleasant vistas of green meadows being cropped by well-put-together horses and cows. About seven miles north of town, the valley narrowed abruptly; we were approaching the Gap. Just beyond its narrowest point, we turned off to the right and parked beside a large air compressor marked "Morrison-Knudsen, Boise"— the name of the contracting firm that was going to hang the curtain. The engineering crew greeted Christo with great warmth. Cyril, who was going to be staying with Charles Russell and his wife in Rifle for the next few weeks, gave each man a brisk, European-style handshake and asked about the swimming. The Morrison-Knudsen people, it appeared, were feeling somewhat frustrated, because they were still being held up by the independent engineering survey. In fact, several rock drillers were high up on both cliffs at the moment, taking samples of rock at various levels. Wes Hofmann, the Morrison-Knudsen project manager, said that the results so far looked very promising, and that he and his crew hoped to start installing the cable anchors the following week. The 110,060 pounds of cable—custom-made for the project by the United States Steel plant in Trenton—had arrived a few days earlier at the railroad siding in Rifle. The curtain itself, made by the J. P. Stevens Company—250,000 square feet of industrial nylon polyamide, dyed bright orange to screen out the sun's infrared rays and prevent loss of tensile strength—was not expected until the end of the month. (At the factory in Richwood, West Virginia, where it was made, a foreman said it was the biggest sewing job they had ever attempted; it had taken eight people four weeks to sew the estimated sixty miles of seams.)

I asked Hofmann what he thought of the project, and he said that it was somewhat similar to stringing a high line over a dam, except for the problem of wind load. "The curtain isn't heavy," he said. "It's the force of the wind blowing on it that you have to consider." Hofmann didn't want to get into a discussion of the aesthetics of the *Valley Curtain*, but he did say that he found it "one hell of a challenge." Jack Webb, his associate, said that they had had some difficulty explaining to people passing through Rifle Gap just what it

was they were doing. "Trouble is, after you explain what it is, then you're *really* in deep water," Webb said. "Now I've got so I just tell 'em it's to feed my wife and kids." The plan, he said, was to string four main cables across the Gap and anchor them securely. The curtain would be furled around a slack fifth cable, and when all was ready this would be gradually tightened and pulled up into position. The last step would be to fasten the curtain to the four main cables and then unfurl it. In a strong wind, the curtain would billow out as much as 35 feet, and the engineers had to allow for 2.5 million pounds of pull on the cables. Hofmann said that getting the curtain up there was going to take a lot of thinking.

Charles Russell suggested that we climb up the western cliff—a suggestion that young Cyril greeted with enthusiasm. We struggled up the nearly perpendicular ascent, slipping on loose shale all the way, and at the top held a brief shouted colloquy with the drillers over the roar of their equipment. The head driller showed Christo a box full of long, sausage-shaped cores he had drawn out of the cliff, and said the rock was as good as any he had ever seen. This pleased Christo, because the question of the rock's solidity was the only remaining obstacle to the Highway Department's issuance of a permit. The driller said he expected to finish the test borings the next day and get the results through in a hurry. Sargis Sako Zafarian, the chief structural engineer of the White Company, had already told van der Marck that he hoped to see the project approved. According to van der Marck, Zafarian had said that while he didn't understand Christo's curtain from an artistic point of view, he thought it interesting enough from an engineering point of view to want to see it go up. This was always the way it was with engineers on his projects, Christo explained. At the beginning, they would be suspicious, but then they would get into the spirit of things and become very involved and enthusiastic—would become, in Christo's mind, "artist-engineers" collaborating in the creative process.

On the way back to Rifle, we stopped off at the Rifle Golf Club, a mile or so down the road from the Gap, to see Jimmy Ledonne, the manager there. Ledonne had been one of Christo's stanchest supporters from the beginning, speaking up for the *Valley Curtain* at every opportunity and offering the use of the club restaurant and bar to all *Valley Curtain* personnel. (He was also enlarging the club parking lot to accommodate sightseers.) "Some of these old farmers around here were pretty skeptical when they first heard about the curtain," Ledonne said, "but I told 'em you've got to be a little broadminded in

this world. Different people do different things. Christo here knew what he wanted and he had the money to do it with, so why not let him go ahead?"

I was impressed by Ledonne's readiness to accept the curtain on its own terms, without bothering about whether or not it was a work of art. This struck me as a Western attitude, and I found it reflected in my conversations with other local citizens that afternoon. Most people had apparently assumed at first that the curtain was going to have something painted on it—a portrait or a design of some kind—and the idea that it was just going to *hang* there was a little hard to fit into Rifle's conception of the fine arts. But in the end, nearly everyone had been willing to take it on faith that Christo, a famous artist from New York, knew what he was doing, and ought to be allowed to do it, so long as it didn't cost Rifle any money. "I thought it was the greatest thing I'd ever heard of," Anthony C. Macchione, who owns Mc's Café, Mc's Boat and Camper Sales, a block of apartments, and about seven hundred head of cattle, said to me later that afternoon. "It sounded just fine to me. I want people to be people. To me, the important thing is that there's a man in this world who's thinking great things. Christo's putting up all his own money—he's not out here begging for cash. And I think as long as that's the case, in *any* country a man ought to be able to express his ideas."

A few weeks earlier, in May, a telephone poll by the manager of the Rifle radio station had found 127 people in favor of the Valley Curtain and 23 opposed to it. Jimm Seaney, who runs Station KWSR from the lobby of the Winchester Hotel (Teddy Roosevelt once stayed there on a hunting trip), took down the name and address of each person he called, and he claims that most of the negative votes came from people in other towns. As soon as he had finished his poll, Seaney got together with the mayor of Rifle and some of his fellow members of the Chamber of Commerce and put through a conference call to the governor's office in Denver. Governor John Love had rather carefully avoided taking a position on the *Valley Curtain* up to this time. He had been quoted as saying that the project "doesn't appeal to me as a great work of art"—undoubtedly a prudent remark in a state where newly hatched conversationists are thicker and more active politically than lovers of advanced art. According to Seaney, though, the governor took their call right away and listened respectfully to the results of the telephone poll. "Why do you people want that curtain, anyway?" Seaney remembers his asking. "I told him that we were in a depressed economic situation over

here, and that, if nothing else, Christo's curtain would bring an influx of tourists and give us a shot in the arm," Seaney said. "The governor said, 'I'll accept that.' He asked how the weather was, and hung up, and the next day he got thrown off a horse." A lot of people think that Seaney's poll was a big factor in the Highway Department's decision to give Christo his permit, which came through on July 12.

Time was going by, and I had to get back to New York. Christo, too, had to leave—in his case for Houston, where the Houston Museum of Fine Arts was opening a special exhibition of documents, photographs, drawings, and models related to the *Valley Curtain*. From time to time for the rest of the summer, I kept wondering how the project was faring. Then, at a dinner party one evening in October, a New York art-world luminary reported with enormous glee and satisfaction that the *Valley Curtain* had come to grief that very afternoon —had broken loose from its moorings while it was being raised into position, and had torn itself to pieces on the rocks below. The local anti-Christo brand of cultural chauvinism had never been more clearly in evidence.

By the time I saw Christo again—in New York, about a week later —he had more or less recovered from the experience. Disasters of one sort or another were not altogether new in his career. During the wrapping of the Australian coastline, for example, a freak storm, with winds up to 100 miles an hour, had destroyed about a third of the fabric and set the project back for several weeks; the year before, a 280-foot sausage-shaped balloon called *5600 Cubic Meter Package*, which Christo was making for the Documenta IV exhibition in Kassel, Germany, ripped apart three times while being inflated or hoisted into position. In Rifle, Christo had announced that the *Valley Curtain* would be hung without fail in June 1972, and he and Jeanne-Claude were now throwing themselves cheerfully into the work of raising funds for a new curtain. This was going to cost at least $70,000 (the insurance on the original curtain applied only to potential victims, not to the fabric itself), but neither Christo nor Jeanne-Claude seemed worried about that. As she put it, in her brisk and chipper fashion, "the money is not the problem."

The real problem, according to Christo, van der Marck, and several other witnesses I talked with subsequently, had been the Morrison-Knudsen contracting crew. For a long time, Christo had been unwilling to take seriously the reports he kept hearing from friends in Rifle—reports that the construction workers looked upon the whole

project as a joke and were saying so night after night over their beers in Mc's Café. It is important to Christo to believe that the workers become artists when they work on one of his projects, and he kept on believing it in this instance as long as he could. As the summer wore on, though, the number of engineering breakdowns and failures did begin to seem a little excessive. Equipment proved inadequate for the job at hand and had to be replaced. A winch that was to pull the steel cable from its shipping drum pulled too fast, causing a monumental tangle that took the whole day to straighten out. Soon afterward, one of the main support cables for the curtain came loose as it was being moored to the cliff and went crashing down into the valley, narrowly missing several workmen and a passing Buick. Morrison-Knudsen had designed a special cable car that was supposed to ride above the support cables and serve as a vehicle for the men who would attach the curtain, but it did not work at all and had to be replaced by an improvised platform hung from the cables on pulleys. Unforeseen problems kept arising, and each one meant a further delay in the hanging schedule. Christo and van der Marck got several extensions of their permit from the Highway Department, but by late August the end still was not in sight. Finally, in desperation, Christo put in a call to Dimiter S. Zagoroff, the engineer who had worked with him on the Kassel air structure. Zagoroff, who lives in Boston, came out to Rifle and made a number of helpful suggestions, but this, in turn, accelerated the deterioration in relations between Christo and Wes Hofmann, the Morrison-Knudsen crew chief.

Not until the first week in October were the cables at last in place. The original plan had been substantially modified to meet the Highway Department's specifications. The four heavy cables spanning the Gap were now attached to two 210-ton concrete blocks anchored to the sandstone cliffs by dozens of stressed-steel rods driven 40 feet into the rock. Eighteen men were at work on the site, including a team of six structural ironworkers from Chicago. The raising was now to take place on Saturday, October 9. Alerted by the Christos, art-world followers from both coasts, reporters, and camera crews of the three major television networks were converging on Rifle, along with scores of curious Coloradans and friends or relatives of the local boosters. By raising day, Rifle's motel and hotel rooms were booked solid, and the merchants who had set high hopes on the project were feeling distinctly bullish.

A sizable traffic jam developed on both sides of Rifle Gap that Saturday morning. Some people arrived before eight o'clock, and spent

the next four or five hours wondering when something was going to happen. There were, inevitably, more unforeseen difficulties and delays. Shortly after noon, though, the crew started to raise the slack cable around which the curtain had been carefully furled. The curtain itself, wrapped in tarpaulins to protect the nylon fabric while it was being raised from the valley floor, would be left overnight in its furled state. Then, on Sunday, it would be unfurled gradually and secured to its thirty ground anchors.

Christo was nervous about the plan that Hofmann had worked out for lowering the curtain. The furled curtain was fastened with ropes tied in what the construction team called "magic knots," each of which trailed a long end that reached the ground; a tug at the rope end would untie the magic knot and allow the curtain to fall free. Christo lacked faith in the knots, and his anxiety increased when he learned that the workmen on the east cliff, having run out of the special tape that was to be used in securing the knots, were making do with some used tape. Communications between Christo and Hofmann were almost nonexistent at this point. But at four-fifteen in the afternoon, when Hofmann let it be known that his crew was going to quit work at four-thirty, even though the curtain on its pickup cable had been raised only about two-thirds of the way to the top, communications suddenly became very heated indeed. Christo and Jeanne-Claude argued with marked vehemence that to leave the curtain in that state, without securing it in any way to the four main cables, would jeopardize the entire project. What if a strong wind came up? They implored Hofmann to keep his men on the job at least until nightfall, so that the pickup cable could be secured. Hofmann said that it would be dark before they could secure it, and that the lives of his men were more important than Christo's curtain.

At four-thirty sharp, the construction crew knocked off for the day. Christo, Jeanne-Claude, van der Marck, and a few others worked frantically for the next hour or so, trying to make everything as secure as possible. At about five-fifteen, while there was still light, they went down the road to Jimmy Ledonne's golf club for a drink. Just before six, van der Marck and two friends of his who had driven down from Salt Lake City for the hanging decided to walk back for a last look at the site. As they approached Rifle Gap, van der Marck suddenly saw a fold of orange curtain material come loose from its shroud and begin to flap in the wind. "It was amazing," van der Marck said afterward. "You somehow never expect to be there when disaster strikes—you're usually somewhere else. But we saw the

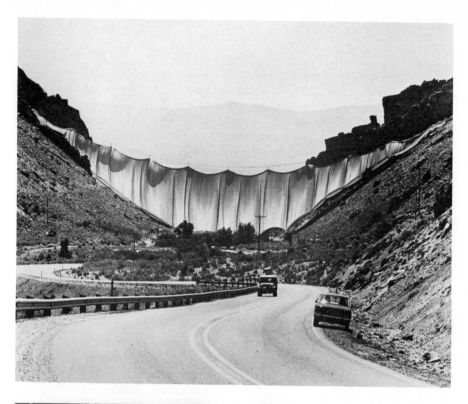

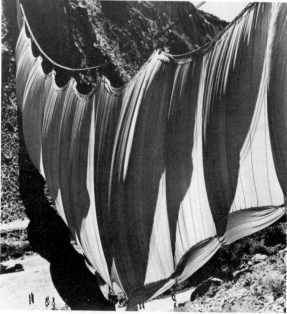

**CHRISTO'S *VALLEY CURTAIN*:
RIFLE, COLORADO**
(Shunk-Kender)

whole thing happen before our eyes. Up there on the east side of the valley, one of the magic knots had come loose. Then a lot more of the orange material poured out, and more and more, as other knots gave way. It was astonishing and frightening, and also strangely beautiful, in a way. The sky was a sort of deep blue—and in that light the billowing orange fabric looked like flames, and the noise it made in the breeze even sounded like a huge conflagration. About half the curtain came loose in all, and reached all the way to the ground on the east side. Although there was not much wind—only eight or ten miles an hour, I'm told—the curtain moved with such force that it picked up boulders and flung them around, and even turned over some of the heavy equipment. Everybody came running back, of course—you could see what was happening from the golf club. Some people saw it from farther away and thought the curtain was going up after all. There was nothing anybody could do. We drove up to the top of a hill nearby and watched until ten o'clock, and then I went back to Christo's apartment in Rifle and we called our lawyer."

Christo had wept openly during the destruction of the curtain, more than 50 per cent of which was irreparably damaged, and he left Rifle four days later without saying good-by to Wes Hofmann. At a press conference held at Jimmy Ledonne's clubhouse on Tuesday, October 12, however, Christo and van der Marck, on the advice of their lawyer, blamed the accident on "mechanical failure," and refrained from saying what they really thought about the construction crew. The press conference was well attended by Rifle citizens, most of whom joined in a standing ovation for Christo after his statement, in which he promised to return the following June to finish the project. One woman, a member of the Rifle City Council, got up and said that until the accident most people had tended to look on the curtain as a crazy idea that just might help the town, but that since they had seen how beautiful it looked, even in its death throes, the *Valley Curtain* had become *their* project as well as Christo's, and they all looked forward impatiently to his return next year. Christo was moved. It was as though the town of Rifle had become, through his efforts, a community of artists.

Note: Christo's second *Valley Curtain* billowed down over Rifle Gap at 11:00 a.m. on August 10, 1972, cheered by several hundred spectators. It lasted just twenty-eight hours. A vicious sandstorm came up during the afternoon of August 11, and wind gusts of up to sixty miles an hour ripped it to shreds—but not before the work had been exhaustively documented on film. The final cost of the project was $850,000.

ALL POCKETS OPEN

One rainy spring afternoon in 1967, Jonas Mekas and P. Adams Sitney were standing under a canopy on Lexington Avenue discussing their summer plans. Mekas was going to take a number of American underground films on a tour of European cities, starting in June. Sitney, a Yale senior and a film theorist, would come over later to relieve him, and they were trying to decide where they should meet. On an impulse, Mekas suggested the Spanish town of Avila, birthplace of Saint Theresa, whose autobiography he had recently been reading. "The moment I said the word 'Avila,' " Mekas recalls, "two fresh roses appeared on the sidewalk at our feet. They just *appeared* there, and the next moment an old man—a bum—also appeared, as though out of nowhere, picked up the roses, and placed them on the steps of a building next door, saying, 'These belong here.' " Mekas and Sitney decided on the spot to adopt Saint Theresa as the patron saint of the underground cinema. "From then on, whenever problems began to seem overwhelming, we called on her for help," Mekas says. "And it always seemed to work—except for getting a license from the city to show our films. Even Saint Theresa couldn't quite manage that."

For Mekas, who is himself often referred to as the patron saint of the underground cinema, it must have been a relief to shift the burden of sanctity a bit. Being a saint has its drawbacks, and there have been many times when Mekas has wished he could get out from under the demands and frustrations of his role as standard-bearer for the New American Cinema—which he named and whose leading champion, polemicist, and organizer he has been for the last ten years—so that he could devote more time to his own film-making. For Mekas is a film-maker, too, and one whose work is increasingly admired by his peers in the movement. In *Diaries, Notes, and Sketches*, finished in 1969, and in the more recent *Reminiscences of a Journey to Lithuania*, Mekas has achieved what many of his colleagues regard as a breakthrough into a new form—a highly personal, idiosyncratic film

diary that may well become one of the more influential styles of the 1970s. "His Lithuania film brought something really fresh and new," Ken Jacobs, a leading film innovator of the 1960s, has said. "Now Jonas has to be thought of as a major artist, in addition to everything else he's done."

Underground, or experimental, or independent cinema—nobody really likes any of the terms applied to it—is, roughly speaking, the cinema that exists outside commercial distribution channels, and it consists of films of various lengths whose distinguishing characteristic is that their authors look upon them as works of art rather than sources of entertainment. The underground cinema has taken many forms during the last decade. Some of the films have been notable primarily for their subject matter, which in certain cases—perhaps because underground film-makers usually lack funds and have to make do with what's nearest at hand—has featured male and female nudity and rather variegated sex. Although it is undoubtedly true that the underground cinema served as a sort of distant early warning of the sexual revolution in other areas, the widespread tendency to view the movement as virtually synonymous with pornography is far from accurate. The fact is that the underground's most significant achievements have very little to do with subject matter; they reflect, rather, a thorough reinvestigation and opening up of the film medium itself. The largely abstract collage films of Robert Breer; the animations of Stan VanDerBeek and Harry Smith; the "direct-cinema" documentaries of Richard Leacock, Don Pennebaker, and David and Albert Maysles; the incredibly complex image-making of Stan Brakhage and Peter Kubelka; and the new "structural" films of Michael Snow, Hollis Frampton, Ken Jacobs, and others have all been concerned at some level with the visual nature of film and the nature of seeing. In their concentration on materials and processes, rather than on content, these film-makers have taken the path of contemporary artists in other fields, and parallels between their work and recent art history are often noted. Brakhage's camera, which becomes an extension of his own emotions and sensibilities, is frequently compared to the Action painting of Jackson Pollock. Structural cinema seems clearly related to Minimal Art, and presents many of the same difficulties for the uninitiated viewer. Peter Kubelka, who is Austrian, and Tony Conrad, who is not, have both made movies reduced to the four basic

FROM *DIARIES, NOTES, AND SKETCHES*—CENTRAL PARK

elements of cinema—light, darkness, sound, silence—which is rather a long way from pornography (Conrad's film *The Flicker* reportedly can cause an epileptic seizure in one out of every 15,000 viewers), and some West Coast devotees of "expanded cinema" are currently working with computers, videotape, and other techniques that do away entirely with such old-fashioned matters as film and movie cameras.

Most of these developments go more or less unnoticed by the average movie critic, who has all he can do to keep up with commercial films, and the critics who do pay regular attention to the underground are not overly admiring of its works. Andrew Sarris, who writes film criticism for *The Village Voice* and other organs, differs sharply with his old friend and fellow *Voice* columnist Mekas on the underground's importance. "I find the commercial cinema more adventurous today than the underground," Sarris has said. "Film is *not* just a visual medium. Take away narrative and psychological interest, and what do you have? Simply an optical experience, which to my mind isn't enough. Besides which there is the time element to consider. Films can't function in the same sense as painting or sculpture, because the viewing experience is entirely different—ten minutes of experimental-film viewing can begin to seem pretty agonizing." To Mekas and his colleagues, this sort of talk simply indicates the blindness of Established Movie Critics.

Whatever their feelings about the underground, though, critics and film-makers agree that its development and spectacular growth since 1960 are due in large part to the effort of Jonas Mekas. Stan Brakhage, whom Mekas considers the most important film-maker in America, states flatly that without Mekas's help and encouragement at least a third of his films would never have been made, and many other film-makers could say the same thing. "Jonas has many pockets," Brakhage said, "and all of them are open." Mekas has tirelessly championed the cause of the independent film-maker in his weekly column in *The Village Voice*, in the more abstruse pages of *Film Culture*, the somewhat irregular journal that he founded in 1955 and still edits, and through every other public and private channel he has been able to find. He has kept many a film-maker going with timely sums of money raised by one means or another (out of thin air, it often seemed), while his own film projects often went begging. His long struggle to establish a permanent showcase in New York where independent film-makers could screen their work has brought him into bitter conflict with censors, police, and city licensing authorities—the bitterest being his arrest in 1964 on the charge of showing an obscene

film (Jack Smith's *Flaming Creatures*), which resulted in a six-month suspended jail sentence. And it is thanks in large part to Mekas that the underground cinema is no longer underground. In 1962 he served as midwife to the Film-Makers' Cooperative, a library and a distribution agency for avant-garde films, situated at 175 Lexington Avenue; today the organization has about five hundred active members, only a few of whom make a living from rentals paid for their films. Similar cooperatives, modeled on the New York original, have been established in other cities, from San Francisco to Ann Arbor. In every case, the major audience for their films is found in colleges and universities, hundreds of which now offer credit courses in film history or technique, and fifty-one of which offer degrees in film. It is often enough remarked that the undergraduates who in former times might have been writing poems or novels are now making films, but the movement seems to have survived even this.

Reminiscences of a Journey to Lithuania, Mekas's diary film, was shown at the 1972 New York Film Festival. It records the visit that Mekas and his younger brother, Adolfas, made in the summer of 1971 to the Lithuanian village of Semeniskiai, where they were born and brought up, and which they had not seen since they left it, twenty-seven years before. Adolfas, who is also a film-maker, naturally brought back his own cinematic record of the trip, and it was shown together with Jonas's at the Film Festival. Although many of the same scenes, people, and incidents occur in both accounts, the two films could hardly have seemed more dissimilar in tone and feeling. Adolfas's, like most of his work, is a comedy, full of visual jokes shot in a more or less traditional manner. Jonas's, by contrast, is shot and edited in the jumpy, staccato, yet oddly lyrical style that marks his earlier *Diaries, Notes, and Sketches* and that serves uncannily to suggest his own personality: the camera is in constant motion, darting here and there, noticing every sort of detail, sometimes deliberately out of focus, often at frame-by-frame speeds that telescope minutes of action into quick-flashing, almost subliminal images. At first it is difficult to look at the film; the demands made on the eye are dizzying. But after twenty minutes or so one grows accustomed to the camera movement and begins to accept it as a legitimately expressive, personal style. We are seeing Semeniskiai through Jonas Mekas's eyes— seeing the tiny farm village and the fields of his youth, the farmhouse in which he grew up, his eighty-seven-year-old mother (still drawing water from the well, cooking, picking berries, digging potatoes), the

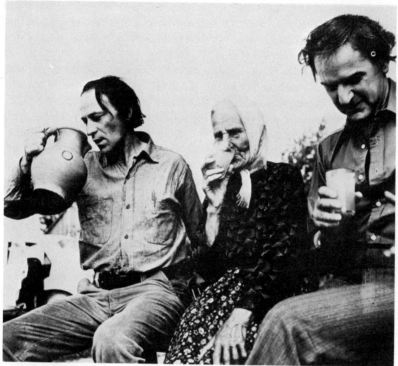

**HOMECOMING, 1971,
JONAS AND ADOLFAS
WITH THEIR MOTHER**

three brothers and one sister who never left Lithuania, the uncle who advised Jonas and Adolfas to "go west and see the world," and, occasionally, Jonas himself, a lean, ascetic-looking man with a self-mocking smile and alert eyes. Much of the time, the sound track is synchronized with the scenes being shown. There is a lot of singing—Mekas remarks at one point, "Whenever more than one Lithuanian get together, they sing"—and the sweet, mournful folk songs become one of the themes of the film. From time to time, Mekas's voice is heard "over," commenting and reflecting on these scenes. The voice is quiet and halting (Mekas still speaks English with a strong accent), and the undertone is profoundly nostalgic. According to Adolfas, the trip was an intensely emotional experience for his brother, who broke down and wept several times when he was called on to say something before a gathering. Adolfas, three years younger than Jonas and com-

pletely at home in America, apparently was not subject to the same emotions. For Jonas, the trip seemed to confirm his long-standing suspicion that he has not yet found any place of his own in the world.

Semeniskiai, which is in northeastern Lithuania, not far from the Latvian border, had about twenty families living in it when Mekas (the family name is pronounced "Meckas") was born there in 1922, and the population has grown only slightly since then. The nearest town, Birzai, is sixteen miles away. Like their three older brothers before them, Jonas and Adolfas worked in the fields and took care of the livestock from May to October. Some years, they were needed all winter on the farm, too, and had to stay out of school. By the time Jonas graduated from the local grade school and went off to attend the Gymnasium in Birzai, he was seventeen, and the school authorities told him that he was too old to enroll in the first-year class. Instead of going home, he spent the winter in Birzai tutoring himself, made up five years' schoolwork in five months, and the following spring passed the entrance examinations for the sixth-year class. That was in 1940, the year the Red Army crossed the border and proclaimed Lithuania a Soviet Socialist Republic. By the time Jonas graduated from the Gymnasium, in 1942, the Russians had been driven out and the country was under German occupation.

Mekas's interests had always been literary. Jonas read everything he could get his hands on, and he wrote poetry and fiery critical articles on literary subjects. All five Mekas brothers wrote poetry, as a matter of fact—a family trait that Adolfas attributes to their mother's delightful habit of improvising songs all day while she went about her household duties—but Jonas was obviously the most talented, and his published poems soon attracted attention in literary circles. After graduating from the Gymnasium, he took a job as literary editor of Birzai's weekly newspaper. Early in January 1943 he moved to the larger town of Panevezys, to become assistant editor of a literary weekly there. He and Adolfas also started publishing a clandestine anti-Nazi newspaper, cutting the stencils on an old typewriter, which they hid in a woodshed near the family home in Semeniskiai. One day the typewriter was stolen. The two Mekas brothers realized that it would turn up sooner or later, and that the police would have no trouble tracing it to them. At the time, bands of anti-Nazi partisans were operating in the woods near Semeniskiai, but nobody in the family thought that Jonas could go into hiding with them. "Jonas was always the weak brother, the sickly one," Adolfas recalls. "As a child, he wasn't expected to live." For years, their parents feared that

Jonas might be tubercular, and Jonas (after narrowly escaping one German Army recruiting patrol by putting on women's clothes) had bribed a local doctor to sign a certificate stating that he indeed did have t.b. and was unfit for military service. The boys' uncle counseled them to go west. He was the Protestant pastor of Birzai and also something of an intellectual—he had been educated in Switzerland, knew Oswald Spengler, and owned a library that gave Jonas his real education. The pastor even managed to secure forged papers for the boys, giving them permission to study at the University of Vienna. They left Semeniskiai one night in July 1944. The train they boarded was supposed to go to Vienna, but somewhere along the route it was attached to a train carrying Russian and Polish war prisoners to German slave-labor camps. The Mekas brothers ended up in a labor camp at Elmshorn, a suburb of Hamburg, where their forged papers were of no help whatever.

After seven months in the Elmshorn camp they decided to make a break for it. Hamburg was under constant Allied bombing at the time, and the German armies were in retreat on all fronts. Taking advantage of the general confusion, Jonas and Adolfas simply walked out of camp one night and headed north. Their plan was to cross into Denmark and then take a boat to Sweden, and they nearly made it. At the Danish border, though, they were caught by the German military police and thrown into a train headed back to Hamburg. They escaped again before the train moved out, and managed to jump into a truck filled with war refugees. That evening, local farmers came into the refugee camp looking for experienced farm workers, and the Mekas brothers volunteered. They were hired on the spot by a German couple who lived near Flensburg and who needed help so badly —all the local men being away in the Army—that no questions were ever asked. "We stayed there long enough to do the spring sowing," Jonas says. "We didn't know the war had ended until two weeks afterward."

For the next few years Jonas and Adolfas were displaced persons. They lived in DP camps in southern Germany and went to college— to Johannes Gutenberg University, in Mainz, and later to the University of Tübingen—taking philosophy and literature courses free of charge, under the auspices of UNESCO. Jonas also edited a Lithuanian literary magazine called *Zvilgsniai (Glimpses)*, which was devoted to the work of refugees like him, and he managed to write and publish five books of his own during this period—two collections of fairy tales, two of short stories, and his first volume of poems, *The Idylls of Semeniskiai.* He wrote only in Lithuanian. The poems are so deep-

ly rooted in the particular texture of this language (one of the oldest of the Indo-European family, with no Slavic roots) that Mekas does not believe they could be translated into English. A Lithuanian critic has described them as having little in common with most pastoral verse: "They show instead a hard, country landscape, whose beauty is an expression of the courage and patience of the people who live in it." Jonas thought of himself primarily as a poet; Adolfas hoped to write for the stage. Both brothers had been strongly influenced, however, by a book called *Dramaturgy of Film*, which Jonas found in a bookshop in Heidelberg when they went there to hear Karl Jaspers lecture. "It was not a great book, but after reading it we both started writing film scripts," Jonas has said. "The fact was we felt lost in those DP camps, where hardly anybody spoke our language. When I read that book, I realized that cinema was the tongue in which we could reach everybody."

By 1949 the camps were starting to close down. The Mekas brothers had no desire to go back behind the Iron Curtain, but neither were they eager to emigrate to the United States. America's image was already somewhat tarnished in European intellectual circles, and several DP friends of theirs who had gone to the States had sent back unfavorable reports. The Mekases' first idea was to go to Israel and start a film industry. "We'd had a romantic education," Adolfas has said. "We remembered Byron, and we thought, Here is a new nation—we'll go and help build it!" But Israel had no quota for non-Jewish Lithuanians, and they were turned down by the immigration authorities. Their next thought was to go to Egypt and *walk* to Israel, but the Egyptians turned them down, too. Then, as they were weighing the relative merits of becoming merchant seamen or Canadian woodcutters, they were unexpectedly provided with papers and passage to Chicago, arranged for them through the International Refugee Organization by a former DP who had emigrated a few months before. They sailed from Hamburg the following week, and landed in New York on a cold, gray November morning in 1949.

"We went to Times Square that evening," Jonas wrote in his diary. "I will never forget the impact which hit us upon emerging from the subway, right smack into the very middle of a sea of Neon Lights. And in the middle of the sky, there was the moon. But I wasn't sure if it was real or not. . . . The moon had no longer a reality of its own; it was a prop in a huge set of New York." Instead of taking a train to Chicago (where their friend, as they learned some years later, had arranged for them to work in a bakery), they took the subway to

Brooklyn. Some other friends from the DP camps put them up until they found a room of their own, on South Third Street, in the Williamsburg section, on the block where Henry Miller once lived.

It took the Mekas brothers nearly a year to master English. "Before we came, I could read Hemingway with the help of a dictionary," Adolfas recalls, "but when we got here I found out that people don't speak that way." Life in the DP camps had given them practical experience in a number of trades, though, and they had no trouble finding jobs. Jonas worked in factories, in a plumbing-supply company, and on the docks; he ironed clothes in a tailor shop and got to know Manhattan as a messenger for the Graphic photography studios, on West Twenty-second Street. Adolfas's first job was in a small shop making plastic wallets—he was paid $12 for a twelve-hour day. Both brothers had kept diaries since they were children, and they continued to do so—in English, to help them learn the language. They also continued writing poetry and fiction. But film-making was rapidly becoming the master passion of both of them. Within three weeks of their arrival, Jonas had borrowed $300, bought a 16-mm Bolex, and begun shooting footage for a documentary on the Williamsburg section, some of which appears in the introductory scenes of his *Reminiscences of a Journey to Lithuania*. They took jobs that would let them off in time to attend the five-thirty screenings at the Museum of Modern Art, and they went as often as possible to the New York Film Society, in Greenwich Village, where they had seen *The Cabinet of Dr. Caligari* on their second evening in New York. From 1950 on, Jonas was also a habitué of Cinema 16, the very successful film society whose programs, given in a succession of theaters from 1947 to 1963, were then the main outlet for avant-garde and experimental films of all kinds.

What came to be known as the second film avant-garde was in full flower at that time. The first avant-garde, which had emerged in Paris during the 1920s and gave birth to such works as Jean Cocteau's *The Blood of a Poet*, Luis Buñuel's and Salvador Dali's *An Andalusian Dog*, and the René Clair-Francis Picabia *Entr'acte*, had guttered out during the Depression. The development of highly versatile 16-mm film equipment during World War II helped to launch a new wave of American independents, first on the West Coast and later in New York. The goddess and catalyst of this second avant-garde was Maya Deren, a Russian-born, Smith College-educated girl, whose fourteen-minute film *Meshes of the Afternoon*, while echoing

to some extent the psychological Surrealism of the pre-1930 European avant-garde, nevertheless struck a new, personal, and poetic note. Maya Deren had returned to New York from Los Angeles in the mid-1940s and made herself the center of a group of independent film-makers, who would meet—along with free spirits from the other arts—at her apartment, on Morton Street. She also wrote and lectured, organized screenings in New York and elsewhere, proselytized college and university students, and established a Creative Film Foundation, to help promising talents get their films shot and printed. She was, in addition, a beautiful woman and a student of voodoo—she had learned how to perform certain magic rites in Haiti. Willard Maas, a fellow film-maker, claimed that she once invoked her occult powers while he was shooting a film and thus saved the evening's production from collapsing entirely in ruins.

Jonas Mekas had reservations about the films of Maya Deren, along with those of Sidney Peterson, James Broughton, Kenneth Anger, and other luminaries of the second avant-garde. His own inclinations then were still largely those of a postwar European intellectual: he admired the neorealism of Rossellini and De Sica, read Camus, and took part, along with Julian Beck, Judith Malina, and others, in the earliest protest demonstrations against the war in Vietnam. Too many of the avant-garde films of that period struck him as outdated, watered-down versions of European Surrealism. Mekas made a film in which he parodied the various avant-garde styles; but he didn't like the results, and it has never been shown. In 1955, though, in the third issue of *Film Culture*, which he had founded earlier in the year, he gave vent to his adverse opinions in an article entitled "The Experimental Film in America."

It is typical of Jonas Mekas that he has never tried to explain away the arguments he advanced in this article, most of which he later recanted entirely. In it he said that the majority of avant-garde films not only "suffer from a markedly adolescent character" but are "shallow and incomprehensible," lacking in artistic discipline, narrow in range, repetitious, poorly photographed, loosely constructed, devoid of any moral dimension, and seriously marred by "the conspiracy of homosexuality that is becoming one of the most persistent and most shocking characteristics of American film poetry today." The article, understandably, caused a stir. Willard Maas spat in Mekas's face at the premiere of Maas's new film, *Narcissus*. Maya Deren called up Stan Brakhage—of whose work Mekas had written that it "seems to be the best expression of all the virtues and sins of the

American film poem today"—and said that they should sue. She thought that the article was libelous, and felt sure they would be able to clear enough in damages to pay their filming costs for a year or so —the publisher of *Film Culture*, she reasoned, must have access to considerable financial backing.

Film Culture's backing at that point, and for many years thereafter, was actually no more substantial than Jonas's weekly salary at the Graphic studios. The Mekas brothers, who had moved from Brooklyn to a $15-a-month apartment on Orchard Street, on Manhattan's lower East Side, had rounded up a list of film-makers and their friends as "sponsors" of the new journal, to be published "every two months for the advancement of a more profound understanding of the aesthetic and social aspects of the motion pictures," but none of the sponsors had much money to dispense, and in order to print the first issue the Mekases enlisted the good will of a Lithuanian branch of the Franciscan Brothers, who ran their own printing shop in Brooklyn. The first issue appeared in January 1955, with a picture of Orson Welles on its cover. Its appearance was celebrated by a party at the Waldorf-Astoria—a friend in the Foreign Press Association had managed to arrange it at no cost to the Mekases. But there was no money afterward to pay the Franciscan Brothers, and a different printer had to be found for the second issue. The Mekases couldn't pay him, either.

While they were preparing the third issue, undaunted by the threat of lawsuits by their creditors, Harry Gantt showed up. Harry Gantt was a free lance in the magazine-publishing business who had an interest in the arts. "He just came around one day and said he believed in what we were doing, and asked us to let him handle our printing," Adolfas says. "Harry has handled it ever since, although he's never made any money out of us. It used to cost about twelve or fifteen hundred dollars to put out an issue, and there were never enough subscriptions or ads, and a lot of our own money went into it. Sometimes Harry would carry us for four or five issues—up to ten thousand dollars. He's been the savior of us all."

As *Film Culture* evolved from a bimonthly to a monthly to an "unperiodical" (there was once an interval of almost two years between issues), its content and point of view also changed. The early issues dealt with cinema in general—European and American commercial films as well as the avant-garde—and the intellectual tone of the magazine was determined largely by Jonas Mekas's friend Edouard de Laurot, a heavy thinker and a Marxist critic. "During the early fif-

ties, I was very much influenced by the rather doctrinaire Marxism of de Laurot," Mekas said recently. "But then I decided that there were too many people attacking the independent film-maker and that I would take the defender's position." Willard Maas, Maya Deren, and the others welcomed his conversion. They had even greater reason to welcome it in the fall of 1958, when Mekas began his weekly movie column in *The Village Voice*. The *Voice* was only three years old at the time. It had been running an occasional piece on film, and one day Mekas, who was then writing a monthly movie review for a little magazine called *Intro Bulletin*, went in to see Jerry Tallmer, the *Voice*'s associate editor, and asked why the paper didn't have a regular film column. Tallmer said, "Nobody wants to write it. Why don't you?" Mekas's first column appeared in the next issue.

From the outset, his column was called "Movie Journal," and a journal is what it has most closely resembled—opinionated and not infrequently didactic. The Mekas column has delighted some readers, infuriated others, and drawn more mail—most of it unfavorable—than any other department in the *Voice*. Readers have attacked Mekas's "flabbergastingly irresponsible reviews," his "truly monumental vulgarity," his "new depths of pretentiousness." One of them accused him of never liking "ANY movie that cost over $6.37 to produce." Maya Deren, now a close friend, wrote in to say that "even when Mekas is wrong he is wrong about the right things and for the right reasons." For the first year or so, Mekas tried to deal with Hollywood films and foreign films as well as the $6.37 avant-garde, but this was clearly impossible; accordingly, in 1960, he prevailed on Tallmer to hire Andrew Sarris, a young contributor to *Film Culture*, who eventually took over the reviewing of the commercial films, while Mekas turned all his own energy and attention to what he was now calling the New American Cinema. As it happened, two recent independent films had given Mekas great hope for the future. John Cassavetes' *Shadows*, shot in New York in 1958 for $15,000, with much of its action and dialogue improvised by Cassavetes and the actors, seemed to Mekas a real breakthrough into a new area of narrative film-making. The second film was entirely different—a plotless, absurd, often hilarious spoof that was the first cinematic realization of the Beat spirit. Called *Pull My Daisy*, it was made in the spring of 1959 by a friend of Jack Kerouac's named Alfred Leslie and a Swiss photographer named Robert Frank. Its action, such as it is, takes place in Leslie's loft, and the cast consists of Leslie's and Kerouac's friends—Allen Ginsberg, Gregory Corso, David Amram,

Peter Orlovsky, Larry Rivers, Richard Bellamy, and the professional actress Delphine Seyrig, who would be seen to somewhat better advantage two years later in Alain Resnais's *Last Year at Marienbad.* In 1959, *Film Culture*'s first annual Independent Film Award went to *Shadows*, and in 1960 its second went to *Pull My Daisy.* The latter film, Mekas wrote in the *Voice*, pointed new directions—"new ways out of the frozen officialdom and midcentury senility of our arts, toward new themes, a new sensibility."

In the summer of 1960, having scraped together enough money to buy some out-of-date film stock, Mekas and de Laurot themselves began work on a feature-length film, from a script by Mekas, called *Guns of the Trees.* Mekas described the film as an "attempt to portray the inside of a generation, its subtle feelings, thoughts, and attitudes." There is no plot to speak of. The generation is summarized by two urban couples, one of them white, middle class, and weighed down by thoughts of suicide (played by Adolfas Mekas and Frances Stillman, Jonas's girl friend at the time), the other black, poor, and better adjusted (played by Ben Carruthers, the star of *Shadows*, and Argus Juillard, Carruthers' girl friend). A good many scenes take place on the bleak outskirts of the city, and there is a lot of wordless staring into space. At intervals, the sound track is taken over by Allen Ginsberg reading his own poems. The film lasts an hour and a quarter, and it is pretty heavy going.

Its somewhat sepulchral tone may be due in part to the ordeal involved in making it. The Mekas brothers, who had moved from Orchard Street to West 109th Street and then downtown again, to East Thirteenth Street, were living during this period on about thirty cents a day. They subsisted on rice, tea, and lard, plus an occasional potato stolen from the local Safeway market. Relief arrived of the most unexpected sort—tinned pâté, caviar, truffles, boar's tongue, and the like. A fellow Lithuanian named George Maciunas, who had gone into the fancy-food importing business, was passing on his samples. But cash was desperately short. Every spare penny went into buying film. Sheldon Rochlin, the cameraman, by agreeing to cut his hair got his father to buy a $500 participation. The equipment kept breaking down, and the film-makers kept being evicted by irate property owners just as they were about to shoot a scene.

"It's unbelievable what we went through," Adolfas has recalled. "We were arrested three times for filming without a permit." Jonas himself was never happy about the finished film. He regretted having made de Laurot its assistant director, because de Laurot's ideas

turned out to be entirely opposed to his. De Laurot wanted to direct the actors at every turn, while Mekas sought to draw from them the spontaneous "truth" of their own reactions. Many scenes were never shot, because they would have cost too much. "It's very clear by now, the whole film is a failure," Mekas wrote in his diary during the final editing, in April 1961. *Guns of the Trees* nevertheless won the first prize at the Second International Free Cinema Festival at Porretta Terme, Italy, in 1962, edging out other entries from sixteen countries (among them François Truffaut's *Jules and Jim*), and it was shown commercially here and abroad.

For Mekas and the twenty or thirty other independent film-makers in New York at this time, the big problem was distribution. Most of them had had their films shown and distributed in the past by Cinema 16, the society formed in 1947 by Amos and Marcia Vogel. Cinema 16 handled a wide variety of films—educational, political, foreign, avant-garde—which were shown at weekly screenings in a succession of theaters and were also available for rent. For years, it had been virtually the only outlet for the avant-garde film-maker. Vogel exercised his own aesthetic judgment as to which avant-garde films he would handle, though, and the independents—nearly all of whom were (and still are) both chronically broke and unshakably convinced of their talent—tended to chafe at this. In 1961, Vogel's decision not to screen a film by Stan Brakhage called *Anticipation of the Night* brought on a crisis. Although Cinema 16 had shown practically all of Brakhage's previous films, *Anticipation of the Night*—an attempt to visualize the world as it might look through the eyes of a newborn baby—struck Vogel as an artistic failure. He did accept it for distribution through Cinema 16's rental service, but he declined to inflict what he considered bad art on an audience, and soon afterward, largely as a result of this refusal, Mekas and a number of his colleagues decided to form their own distribution agency. This was the beginning of the Film-Makers' Cooperative, which was formally established early in 1962.

Looking back on the schism, Vogel thinks that Mekas simply used the Brakhage issue as a means to his own ends. "I had known Jonas for years," Vogel said. "My wife always used to let him in free to Cinema 16 screenings, because he had no money and was so obviously in love with film. But there are really two Jonases—one very dedicated, the other a Machiavellian maneuverer, a history rewriter, an attempted pope. He has two passions: film and power. His greatest talent is to make people—some people—believe that he is what he is

not." Cinema 16 went out of business in 1963, partly because of television and rising business costs and partly, one can assume, because of the Film-Makers' Cooperative. Vogel went on to become cofounder (with Richard Roud) and director of the New York Film Festival, but relations between him and Mekas have been rather strained for some time.

The basic policy of the Film-Makers' Cooperative was that no film would be rejected, for any reason. While Cinema 16 had been oriented at least partway toward its audience, the coop intended to serve no one but the film-maker. Anybody who had ever made a film could send it in and have it listed in the cooperative's catalogue, for rental at a fee set by the film-maker. The arrangement was nonexclusive: no contracts were involved, and film-makers were encouraged to seek out additional means of distribution as well. The rental income went directly to the film-maker, minus 25 per cent taken out to help pay the cooperative's operating costs. The cooperative distributed films to art theaters, film societies, universities, and other outlets, and started regular weekly screenings of cooperative members' films at the Charles Theatre, at Twelfth Street and Avenue B, around the corner from the Mekas apartment. Although decisions were nominally in the hands of a seven-man board of directors, the galvanizing figure and principal architect of all these activities was Mekas, who spent most of his time at the cooperative's small, cluttered, fourth-floor office at 414 Park Avenue South. By then, he had quit his job at the Graphic studios (where he had risen from messenger boy to darkroom technician), and was getting along on his $10-per-column salary at *The Village Voice*, plus $18 a week for two days' work at an offset-printing studio. Neither then nor later did he get any salary from the Film-Makers' Cooperative, which was chronically short of cash anyway.

The cooperative's first catalogue listed twenty-seven film-makers in various categories, and fifty-six films, covering almost every aspect of the avant-garde cinema, that were available for rental. Some were quite literally "home movies," made by amateurs who had little more to offer than their own unfocused egos. The cooperative refused on principle to provide any sort of guidance for its customers, who were thus obliged to rely on brief and often fanciful catalogue descriptions sent in with each film by its maker. At the Charles Theatre, devotees grew accustomed to sitting through two hours of relative misery for every ten minutes of filmic revelation. Mekas's rigidly nonselective policy alienated more than a few viewers, but Mekas, who sometimes appeared to like everything he saw, remained unshakably convinced

that only in such an uncritical climate could the tender shoots of the new film art find sustenance. Cinema was learning to talk a new language, as he never tired of informing his readers in the *Voice*, and these early babblings were a necessary part of the process. "Even the mistakes, the out-of-focus shots, the shaky shots, the unsure steps, the hesitant movements, the overexposed and underexposed bits are part of the vocabulary," he wrote. "The doors to the spontaneous are opening; the foul air of stale and respectable professionalism is oozing out."

Before the cooperative was a year old, however, some of its more established members had started to drift away. These erosions were offset to some extent by the success of Adolfas Mekas's film *Hallelujah the Hills,* a spirited feature-length comedy that both Mekas brothers worked on through much of 1963. Directed by Adolfas from his own script, and filmed by Ed Emshwiller, the acknowledged technical genius of the independent-film movement, *Hallelujah* was described by the London film journal *Sight & Sound* as "one of the most completely American films ever made," and its anarchic humor and youthful high spirits pleased many American critics as well. Although *Hallelujah the Hills* earned back most of the $25,000 it cost to make, investors were not falling over each other in a rush to

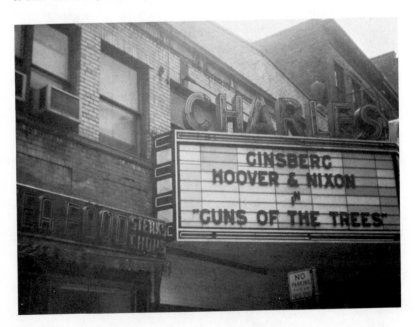

back independent films by the Mekas brothers or anyone else, and the costs of advertising, promotion, and commercial distribution were far in excess of what the Film-Makers' Cooperative could afford; Mekas frequently had to dig into his own meager funds to square things. Quite clearly, the "new wave" of American feature films that Mekas and others had prophesied was not gathering much momentum, and this realization led to one of the major turning points in Mekas's career. From now on, Mekas decided, he would devote himself more and more exclusively to the true "underground" (Stan Van-DerBeek had coined the term in 1959)—to the defiantly noncommercial cinema of the extreme avant-garde.

At this point in the early 1960s, a new group of underground film-makers was doing its best to subvert the still emergent sexual revolution. As Mekas had noted with disapproval in his early *Film Culture* essay, homosexual themes had permeated the films of Gregory Markopoulos, Kenneth Anger, and other members of the second avant-garde. By 1960, however, several young New York film-makers were turning out pictures that were far more "deviant" than anything seen before, in a chaotic style that often parodied the most exotic Grade B Hollywood features of the 1940s—in particular, the films of the stupefying Maria Montez. Ken Jacobs, one of the originators of the new style, has said that he was inspired mainly by a film that the Surrealist artist Joseph Cornell had made in 1939 by cutting most of the footage out of a studio romance set somewhere east of Suez; in Cornell's truncated version, the heroine is forever shrinking in terror or nervously waiting for something to happen. Mekas himself found money to print a film by Jack Smith, a remarkable young man from Columbus, Ohio, who starred in many underground films of the period. Smith's film, his first to be released, was the forty-five-minute opus *Flaming Creatures*. It was shot on out-of-date stock, on the roof of an abandoned building in the East Village, for a total cost of about $300, and it soon managed to derange a surprising number of senses, cinematic and otherwise. To the tune of scratchy recordings of "Amapola" and other pseudo-Latin rhythms, fantastically draped beings, male and female (although one is often unsure which is which), commingle in settings of Spanish and Arabian décor (the two great exotic styles of Maria Montez features), parade their genitalia before the camera, and eventually indulge in a ridiculous orgy that seems to coincide with an earthquake. After seeing the film at a private screening, Mekas, the man who had once denounced "the

conspiracy of homosexuality," reported to his *Voice* readers that *Flaming Creatures* was a great film, "a most luxurious outpouring of imagination, of imagery, of poetry, of movie artistry—comparable only to the work of the greatest, like von Sternberg."

Mekas was not kidding. *Flaming Creatures* and others in this genre —Ken Jacobs' and Bob Fleischner's *Blonde Cobra*, Ron Rice's *The Queen of Sheba Meets the Atom Man*—struck him as the forerunners of a cinema revolution more far-reaching than anything that had gone before: "a turn from the New York realist school . . . toward a cinema of disengagement and new freedom." Invoking Baudelaire and Rimbaud, he described the world of these films as "a world of flowers of evil, of illuminations, of torn and tortured flesh; a poetry which is at once beautiful and terrible, good and evil, delicate and dirty." Mekas believed that these films must be seen, and he was ready to take the risk of showing them. He was ready, in fact, for a *cause celébre*.

The opportunity soon arose. The Third International Experimental Film Competition at Knokke-le-Zoute, Belgium a sort of avant-garde festival, had invited Mekas to be one of its judges. Mekas went over in December 1963, accompanied by P. Adams Sitney and Barbara Rubin, an intensely militant young woman whom Mekas had hired to work at the cooperative and who had recently shot a film, *Christmas on Earth*, that exceeded even *Flaming Creatures* in sexual explicitness. They took along a selection of underground films to show at the festival, including Anger's *Scorpio Rising*, Markopoulos's *Twice a Man*, Rice's *Chumlum*, Brakhage's *Dog Star Man* and *Window Water Baby Moving*, Breer's *Pat's Birthday*, and Smith's *Flaming Creatures*. The other judges drew the line at *Flaming Creatures*, declaring it unfit for public screening in the festival theater. Mekas withdrew from the jury in angry protest, and some of the American filmmakers demanded (unsuccessfully) to have their films withdrawn as well. Mekas and his associates remained in Knokke-le-Zoute, however, and gave a private screening of *Flaming Creatures* in their hotel suite, where it was seen by Jean-Luc Godard, Agnes Varda, Roman Polanski, and other leading European *cinéastes*. The case had hit the European papers by this time, and interest in the film was building up. On the last day of the festival, Mekas and Rubin invaded the projection booth, overwhelmed the projectionist, and started to show *Flaming Creatures*. Theater personnel quickly cut off their power source and sought to eject them. At this point, the Belgian minister of justice appeared onstage to calm the audience, and Rubin, having secured an alternate power line, started to project the film on his face.

179

The current was again cut off, and in the darkness and confusion the Belgians regained control of the projection booth.

Sitney took the underground films on a tour of European cities after that, while Mekas returned home to arrange for the New York premiere of *Flaming Creatures*. Since 1960 Mekas had been arranging irregular screenings of underground films at various movie theaters in and around Greenwich Village. Nobody had yet suggested that these films ought to be licensed, as commercial films were, but a contagion of censorship had recently begun to manifest itself—some people thought it had to do with the expected influx of visitors to the 1964 New York World's Fair—and a number of theaters and coffeehouses had been closed down. Although Mekas tried to circumvent the problem by listing the exhibitor of *Flaming Creatures* as the Love-and-Kisses-to-Censors Film Society and charging twenty-five cents for a membership card in lieu of admission, he fully expected trouble. Actually, *Flaming Creatures* ran for three successive Mondays at the Gramercy Arts Theatre early in 1964 without incident. But then, on February 15, the police came and issued a summons to the theater owner, who immediately terminated all underground-film screenings there. Mekas transferred his operations to the New Bowery Theatre, on St. Marks Place, where *Flaming Creatures* was shown on the night of March 3—shown for thirty minutes, that is, at which point the police rose up and arrested everybody in sight and confiscated the film and all the projection equipment they could lay their hands on. Mekas and the others spent the night in jail, and were released on bail the next afternoon. A week later Mekas was arrested again, for showing Jean Genet's homosexual film *Un Chant d'Amour* at the tiny Writers' Stage, on East Fourth Street, and spent another night in jail. The Genet case was later dropped on a technicality, after letters in support of the film and of Mekas had been written by Jean-Paul Sartre, Simone de Beauvoir, Christiane Rochefort, and other European intellectuals, but Mekas drew a six-month suspended sentence for *Flaming Creatures*. The case was appealed all the way to the Supreme Court, which voted by a narrow margin not to hear it. One of the justices recorded in favor of hearing it was Abe Fortas, and his vote was subsequently interpreted by his political enemies as signifying that he was in favor of dirty movies.

There is no doubt but that the Mekas arrest and the floods of attendant publicity created a new situation for the independent filmmaker. The public, which had been largely oblivious of the underground's existence, assumed that "underground" was synonymous with dirty pictures, and this naturally irked a lot of avant-garde film-

makers. Also, a lot of them complained bitterly that Mekas was pushing Jack Smith and a few others and neglecting the rest. Mekas had no leisure for private quarrels. In addition to fighting the *Flaming Creatures* case through the courts, inveighing against censorship in the *Voice* and elsewhere ("Works of art are above obscenity and pornography"), dealing with distributors and would-be underground impresarios, overseeing the cooperative, putting out *Film Culture,* financing the exposition of underground films that P. Adams Sitney and Barbara Rubin were taking around Europe (and trying to make peace between Sitney and Rubin, who were at cross-purposes much of the time), finding money for destitute film-makers like Jack Smith and Ron Rice, and looking for another theater to show films in, he was trying in spare moments to make his own films. A few days before the *Flaming Creatures* arrest, Mekas had filmed the Living Theatre production of Kenneth Brown's play *The Brig*, a powerful indictment of Marine brutality; he was so strongly impressed by the play that he decided to film it as a series of real, rather than simulated, events, and he was so successful in this that the film won the documentary award at the 1965 Venice Film Festival. He made several other short films in 1964, but he had time to edit few of them. Carrying his Bolex around with him everywhere, he shot whatever struck his fancy—friends' weddings, the circus, Tiny Tim, sunrise over the city, Salvador Dali shampooing an automobile, Timothy Leary in his Millbrook retreat. At some point during the early 1960s it had occurred to him that what he was really doing was writing a diary with his camera. "One of my big problems, though, was that when I looked at the footage later and saw a tree or a snowstorm or something like that, there was nothing left of what it had meant to me when I filmed it," he has said. "In reality, I was looking at that tree or snowstorm with all the memories that I brought to it, but my memories and attitudes were not recorded." It was at this stage that Mekas began to evolve his personal film style, with its quick cutting between images, short bursts of speeded-up action, jerky camera movements, superimpositions made by winding the film back and exposing it again, and single-frame shots. His intention was "to break down the image into single frames, into the smallest film note, and then to restructure that image, that tree, and to introduce myself into it by means of pace, rhythm, colors—to introduce my own state of being indirectly." And he wanted to do all this "in the camera"—not later, in the editing process.

The crackdown on unlicensed film showings in the spring of 1964 drove the underground temporarily underground in fact as well as in name. For the next few months, the Film-Makers' Cooperative office on Park Avenue South was the meeting place of embattled film-makers, who came there to discuss strategy, to fight among themselves, to screen their work, and sometimes to eat and sleep— although the cooperative's paid secretary, Leslie Trumbull, frowned on that. Trumbull was working valiantly to bring some order and efficiency into the coop's business affairs, which no one else had been able to do. His first act on being hired, in 1964, was to rule the long sofa in the office out of bounds for sleeping, thereby discouraging itinerant film-makers, homeless poets, and hangers-on of all kinds from using the room as a crash pad. (He also decreed that the coop would no longer spend money that it did not have—a blow to some film-makers but rather a boon to Mekas, who had been in the habit of making up deficits out of his own pocket.) During the post-crackdown period, though, Mekas himself frequently bedded down under the film-cutting table in the office, too weary or too busy to go home. Funds were shorter than ever, with nothing coming in from New York screenings. In spite of such hardships, the period was an exceptionally productive one for independent film-makers. Shortly before the *Flaming Creatures* bust, Mekas had introduced the public to the extraordinary films of George and Mike Kuchar, teen-age prodigies from the Bronx, whose Loews-haunted adolescence gave birth to such extravaganzas as *I Was a Teen Age Rumpot* and *Hold Me While I'm Naked.* Bruce Baillie and several other West Coast film-makers sent their work to the cooperative office, and so did Harry Smith, a somewhat legendary older figure. The most sensational discovery of the period, though, was Andy Warhol, who started in the summer of 1963 to make films—or antifilms, as some people called them. *Kiss*, primarily a series of close-ups of the film-maker Naomi Levine kissing various companions; *Sleep*, a six-hour film of a man sleeping; *Haircut*, thirty-three minutes of a man having his hair cut; *Eat*, forty-five minutes of artist Robert Indiana eating a mushroom; and other flowerings of the early Warhol cinema were shown first by Mekas at the Gramercy Arts Theatre, where they excited a good deal of strenuous controversy. Warhol's static, deliberately boring films, his habit of turning the camera on someone and letting it run, seemed like a slap in the face to film-makers like Brakhage and Markopoulos—a crude attack on the whole idea that cinema could be used to portray the inner consciousness. Mekas nonetheless proclaimed him a genius.

"I think that Andy Warhol is the most revolutionary of all film-makers working today," he wrote in the *Voice*. "He is opening to filmmakers a completely new and inexhaustible field of cinema reality. . . . What to some still looks like actionless nonsense, with the shift of our consciousness which is taking place will become an endless variety and an endless excitement." Ready, as always, to help a fellow film-maker, Mekas served as cameraman on *Empire*, Warhol's eight-hour character study of the Empire State Building, which was shot in one long sequence in July 1964. "If all people could sit and watch the Empire State Building for eight hours and meditate upon it," Mekas told his readers, "there would be no more wars, no hate, no terror—there would be happiness regained upon earth." It was the sort of column that drew a lot of mail.

Those who saw a good deal of Mekas then often wondered how he could maintain his unflagging enthusiasm. He continued to live like an anchorite, on one meal a day, and he wore the same corduroy suit the year round. Film-makers badgered him incessantly for funds, assuming that his income from lectures, writings, and film rentals was considerably larger than their own, but Mekas's yearly earnings from all sources never exceeded $1000. The truth is that not even his friends knew him terribly well. In that society of straining and perturbed talents, of self-conscious *poètes maudits* and initiates of the drug culture, Mekas's apparent lack of competitive ego and his refusal to take himself too seriously made it easy for the others to take him for granted. His generosity was unfailing. Jack Smith's *Normal Love*, Barbara Rubin's *Christmas on Earth*, Ron Rice's *The Queen of Sheba Meets the Atom Man*, and several of Gregory Markopoulos's films were shot with Mekas's Bolex. "I owe everything to Jonas," Barbara Rubin has said. "He started me making films. He gave me film, which he couldn't really afford for himself. He lent me his camera—everything. And I guess none of us gave him back enough—we didn't recognize his humanity." Unlike Adolfas, who married an American girl in 1965 and withdrew somewhat from the activities of the underground to make more or less conventional film comedies, Jonas Mekas showed no interest in setting up a ménage. He is attracted to women—Adolfas once said he couldn't remember a time when his brother was not in love, although "it could be just a pair of eyes seen on a moving train"—but after Adolfas's marriage Jonas lived alone. "He is a balanced person," according to Barbara Rubin, "even though he does not lead a balanced life. He has devoted himself *absolutely* to cinema. I think his being European makes a dif-

ference. He was always more intellectual, more concentrated, less chaotic than the rest of us. Jonas was always the one who held things together."

Mekas admits to being a fanatic in many ways, but, unlike most fanatics, he has never been too rigid to bend with the wind and alter his strategy. For years, he dreamed the European intellectual's dream of using art to change society. He marched against the Vietnam war, and made films that set out to expose the corruption of bourgeois society. Then, around 1964, his outlook underwent a change. As he put it, "Instead of marching and shouting against things I didn't like, I decided to try to construct something new, outside the system." Forcing the legal issue of censorship with *Flaming Creatures* had done no real good, he now felt—"the laws will change only when people change, and underground cinema will not get anything from going to the public." What independent film-makers really needed was an opportunity to show their films unmolested by censors, nervous theater owners, or the profit motive, and from 1964 on Mekas directed most of his energy toward this end. The result was the Film-Makers' Cinémathèque, which is what Mekas and his friends decided to call the changing programs of new films that they screened—usually once a week and often at midnight—in various movie theaters around town.

"One of the great things about Jonas," Andrew Sarris once remarked, "is that he has never succumbed to the sin of despair." It would have been relatively easy to do so many times in the next four years, during which the Film-Makers' Cinémathèque (named in homage to Henri Langlois's film theater and library in Paris) lost money at one temporary house after another. It opened at the New Yorker Theatre, at Broadway and West Eighty-eighth Street, in November 1964; moved a month later to the Maidman, on West Forty-second Street; then to the City Hall Cinema, at 170 Nassau Street; then to the Astor Place Playhouse, on Lafayette Street; and then to the 41st Street Theatre, near Sixth Avenue, where it settled down for a relatively long stay of eighteen months. There was no more trouble with the police—word of the sexual revolution was spreading fast—but attendance at the screenings was rarely large enough to cover the costs. Mekas estimated that the deficits ranged between $400 and $1000 a month, which he had to make up somehow. He spent a lot of his time on the telephone trying to raise money. The foundations seemed loath to make grants to the underground cinema—though Mekas learned in 1966, to his annoyance, that someone had received a Rockefeller

grant to write a book *about* underground film-makers. In spite of increasing publicity, in spite of the fact that Madison Avenue advertising agencies regularly rented coop films and incorporated their techniques into television commercials (collage animation, single-frame cutting to cram a dozen different images into a few seconds of air time), in spite of the 1960s' taste for avant-gardism in general, there was never enough money for what Mekas called "free" cinema, and many free *cinéastes* remained more or less destitute. The perpetual dissensions and feuds among the film-makers added to Mekas's problems, and a good deal of the unrest centered on Andy Warhol. His early, static films had given way to movies with scripts—improbable and highly impromptu scripts, to be sure—and with performers, who were in many cases the same people who had earlier appeared in the films of Jack Smith and Ken Jacobs. Jack Smith himself became one of the Warhol stars, along with Naomi Levine, Taylor Mead, Francis Francine, and "Mario Montez" (who appeared in *Flaming Creatures* as "Dolores Flores," the Spanish dancer). But if Warhol can be said to have appropriated the mock-Hollywood, camp style of Smith, Jacobs, and Rice, he used it for different and more disconcerting

WITH ANDY WARHOL
(Ugo Mulas)

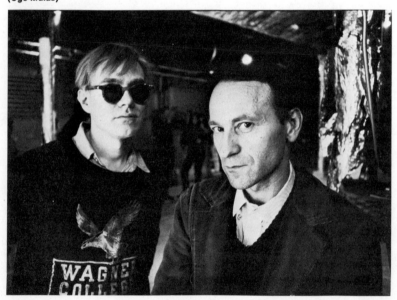

ends. *Flaming Creatures* looks curiously innocent today—a spoof of "forbidden" eroticism and a parody of pornography, rather than the real thing. The famous Warhol "stare," on the other hand—the unblinking camera's voyeuristic eye, which draws from his narcissistic nonactors the sort of personal revelations that one does not expect to see on the screen or anywhere else—is by no means innocent, and is sometimes pretty scary. Warhol's instant fame and his reputation for turning out a film a week piqued a number of film-makers. Very few of them questioned his importance, however, and even those doubts evaporated when *The Chelsea Girls* opened, in September 1966, at the 41st Street Theatre.

Asked once why *The Chelsea Girls* was a work of art, Warhol replied, with characteristic insouciance, "Well, first of all, it was made by an artist, and, second, that would come out as art." More verbal enthusiasts saw it as "quite possibly the first masterpiece from a generation that has learned to handle the medium of film as casually as an artist used to handle paint" (Brian O'Doherty), and as "a tragic film," full of "classical grandeur" and "the terror and hardness" of our age (Jonas Mekas). *The Chelsea Girls* consists of twelve separate episodes that were said to take place in different rooms of the Chelsea Hotel. References to specific rooms were deleted when it was pointed out that the hotel might well sue—an understandable reaction in view of the depicted goings on, which include simulated drug-taking, homosexual and lesbian behavior, and a climactic hysterical fit of aggression on the part of a man who claims to be the pope. Largely because of the remarkable screen presence of Warhol's freakish performers, who are seen mostly in extreme close-ups that eliminate the background entirely (one critic has detected a resemblance here to Caravaggio's portraits), the film has an intermittently gripping fascination that makes its running time of more than three hours almost bearable. (It would have run twice a long if Warhol had not decided to screen the episodes two at a time, side by side on a split screen.) The film is neither pornographic nor, by current standards, particularly racy, and its appeal to the general public remains something of a mystery. Following its initial run at the 41st Street Theatre, it moved into a commercial theater uptown and became, as *Variety* would say, the underground cinema's first boffo smash.

The success of *The Chelsea Girls* gave great impetus to certain ideas that Mekas and others had never quite relinquished. Earlier that year, Mekas, Shirley Clarke, and Lionel Rogosin had established a

separate branch of the Film-Makers' Cooperative, to distribute films, like *The Chelsea Girls*, which they thought might appeal to a wider public than the coop's regular customers. The Film-Makers' Distribution Center, as they called it, set up shop in the cooperative's office, raised some money, and embarked on a campaign to establish a network of small art theaters in different cities which would book feature-length films by Markopoulos, Warhol, Robert Downey, Adolfas Mekas, Storm DeHirsch, and several others, in addition to the three initiators. For a time, it looked as though the underground might be going to surface with a notable splash. Cooperative rentals were booming, as more and more film departments were established at universities and colleges in all parts of the country, and the contributions to film art of Mekas and his colleagues were receiving increasing recognition. (The Philadelphia College of Art honored Mekas in June 1966 for his "devotion, passion, and selfless dedication to the rediscovery of the newest art.") In September, the fourth annual New York Film Festival gave official and substantial recognition to the underground with a Special Events series devoted to independent film-making. The Film-Makers' Distribution Center hired additional office workers just to handle the bookings of *The Chelsea Girls*.

But then, as sometimes happens in such cases, Warhol decided that he could do better distributing his own films. He withdrew them from the center, and the center reverted almost immediately from a money-making to a money-losing operation. What with the costs of promotion and distribution already contracted for in several cities, moreover, the losses were considerably higher than those Mekas was used to coping with. Mekas and Shirley Clarke put all the income from their own films into the center, and spent more and more of their time in a frantic search for outside support. Elia Kazan cosigned a $6000 bank loan for them, and Otto Preminger gave the center $5000. Ironically, though, the general relaxation of censorship that had come about since the *Flaming Creatures* scandals (and which many people attributed in part to the impassioned anticensorship battles of Mekas and a few others) now seemed to be working against the film underground. Several theaters that had agreed to book the center's films had subsequently become outlets for the "sexploitation" movies that were starting to flood the market. (Some theater owners thought they were getting such movies when they booked underground film art, which led to cruel surprises on all sides.) The freer moral climate of the middle and late 1960s had also opened the way to nudity, explicit sex, and relaxed language in the commercial

cinema, some of whose flashier young directors borrowed copiously from the underground's technical and conceptual bag of tricks. (Hand-held camera work, such as that which marked the foxhunt scenes of Tony Richardson's *Tom Jones*, was becoming all the rage.) The commercial cinema was increasingly innovative, while the underground seemed to have lost energy and direction. Around the Film-Makers' Cooperative office, moreover, there were several members who disapproved of spending money on ventures that stained the purity of noncommercial cinema, and who tended to think that any fund-raising efforts should be directed toward the realization of their own projects. Stan Brakhage, who had quit the coop and then thought better of it, told Shirley Clarke that she was nothing more than a commercial film-maker. Brakhage spoke bitterly against the center, and by the end of 1967 Mekas himself was beginning to doubt the wisdom of the enterprise.

In the midst of all these uncertainties, moreover, Mekas was forced to close down the cinémathèque at the 41st Street Theatre, because increased rentals had made the screenings unprofitable. He had by no means given up the idea of the cinémathèque, however—perhaps in a smaller version. What with the distribution "sharks" moving their skin flicks into the art-film houses, Mekas estimated that the average audience for true underground film art in the foreseeable future would be from thirty to fifty people per screening. As it happened, George Maciunas, Mekas's Lithuanian friend, had recently founded what he called the Fluxhouse Cooperative, whose aim was to provide low-cost housing for artists in the area south of Houston Street now referred to as SoHo. With a $20,000 grant from a foundation, Maciunas had bought an old loft building at 80 Wooster Street and was in the process of renovating it. Mekas got together enough money to put down a deposit on the ground floor and basement of 80 Wooster Street, and in the summer of 1967 he and several other film-makers threw themselves into the herculean job of turning the ground floor into a small theater. They had, as usual, no money to start with, and although they did most of the work themselves, the bills mounted alarmingly. "I am on guerrilla warfare now," Mekas wrote in his diary. He spent his days scrounging for small sums—"anything goes, almost skirmish tactics, dollar by dollar." This was the year that he and Sitney saw the two roses on the sidewalk and enlisted the aid of Saint Theresa of Avila, and, by one miracle or another, the new cinémathèque managed to open to the public that December. The following spring, its accumulated debts were paid off in full with the

help of a timely $40,000 grant from the Ford Foundation—the first foundation money Mekas ever received.

The cinémathèque was open, but it was operating without a license from the New York City Department of Buildings. Mekas had applied for one, and he now found himself in a labyrinth familiar to New York property owners. A series of building inspectors arrived, followed by a police captain. "They all indicated that they would appreciate a few bucks," Mekas wrote in his journal. "I said no, so they laughed and wrote out another summons." As a result, the new theater never did get its license, and the screenings there ended six months after they had begun. The cinémathèque became a vagabond once more—there were screenings at the Methodist Church on West Fourth Street, at the Bleecker Street Cinema, at the Elgin, at the Gotham Art, at the Jewish Museum on Tuesday evenings, and, for one uneasy month, at the Gallery of Modern Art—the last an arrangement that Mekas abruptly terminated because, as he explained in a letter to the gallery, attempts had been made to censor some of the films, the $2 admission charge was too high for "serious film students," and "the building itself, the tradition of bad art in the galleries, exudes a very stifling and bad atmosphere not suitable for presentation of any living art." It was a bleak period, all things considered. The Film-Makers' Distribution Center kept sinking deeper and deeper into debt, and Mekas was afraid that its debts might eventually overwhelm the cooperative as well. Shirley Clarke and a few others argued that if the center could hold out just a little longer it would show a profit. But Mekas thought otherwise, and in the spring of 1970, with a city marshal threatening to auction off both the center's and the coop's property to settle a judgment by a theater owner who had not been paid, he closed it down. When the center went out of business, its debts totaled close to $80,000. Mekas made himself personally and legally responsible for the entire sum, this being the only way he could insure that the coop would not sink as well. "So now I have to eat this soup, and it doesn't taste like it's really good cooking," he wrote in a memo mailed to all the cooperative's members. "It stinks, in fact. I wish you a good summer."

By means of arduous negotiation, Mekas was able to get his creditors to reduce their claims from $80,000 to about $40,000, which he agreed to pay off in monthly installments. Somehow, during all the confusions of 1968, he had managed to edit twenty hours of his own film footage into the three hours of *Diaries, Notes, and Sketches*, which earned him nearly $7000—most of it from a single showing on German television. Every cent went to reduce the debt, as did his fees

from lectures and writings. He managed to bring down the amount still owed to about $8000, and his refusal to complain, or even to discuss what was still a decidedly lonely effort, added considerably to his reputation for saintliness.

The Film-Makers' Distribution Center had failed and the cinématheque was fading, but, astonishingly enough, money had become available for another Mekas project—a film "academy," dedicated to showing, in repertory, the highest achievements of avant-garde film, from the pioneer experiments of the Lumières and Méliès, through the masterworks of Griffith, Eisenstein, Pudovkin, Dreyer, and Bresson, up to the "film poems" of Brakhage, Kenneth Anger, Michael Snow, and others. Mekas had started thinking about it in 1967, and in 1968 the Film Art Fund—set up by Mekas's old friend and fellow film-maker Jerome Hill and by Allan Masur, a lawyer with a special interest in the arts—came into being for the primary purpose of financing "the first film museum exclusively devoted to the film as an art," to be known as Anthology Film Archives. The Film Art Fund worked out a contract for anthology to operate as an independent film library and theater within Joseph Papp's Public Theatre, on Lafayette Street, in the old Astor Library building. The Fund also

LEFT TO RIGHT:
P. ADAMS SITNEY, JONAS MEKAS, PETER KUBELKA
AT THE ANTHOLOGY CINEMA

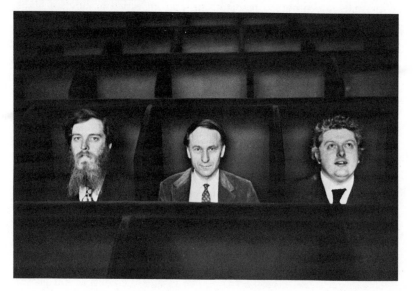

raised $360,000 for the construction of anthology's theater, a ninety-seat temple of cinematic art, designed by the Austrian film-maker Peter Kubelka, which opened in December 1970. Kubelka, who is also a curator of the Österreichisches Filmmuseum, in Vienna, had wanted for years to construct a theater that would eliminate every distraction to the eye and ear and permit total concentration on the screen. He came close to achieving this goal at anthology, where each seat was a kind of isolated viewing booth, with blinders on each side and a canopy overhead, and where the black walls and ceiling, black carpets, black velvet upholstery, and complete absence of lighting save what is reflected from the screen made it necessary for the faithful to reach their seats by a process of grope and stumble.*

Although many found the viewing experience at anthology novel and pleasant, there was considerable criticism of Kubelka's black box. Comedy fell flat there, it was said, because there was so little sense of shared laughter. Amos Vogel called it "authoritarian cinema," which forced the viewer to sit, look, and listen in a Kubelka-prescribed manner. Other critics suggested that the theater was designed specifically for one film—Kubelka's own *Arnulf Rainer*, a six-and-a-half-minute imageless, visually and aurally stentorian hymn to cinema's four basic elements of light, darkness, sound, and silence. To arrive one minute late for one of anthology's three daily screenings was to be denied entrance by Mrs. Eugenia Mitchell, the polite but adamant ticket taker; Kubelka himself once blocked a particularly insistent latecomer by resorting to judo, in which he holds a black belt. Criticism was also directed against anthology's policy of showing foreign films without subtitles (which distract the eye), and, of course, nearly everybody had some complaint about the selection of films. Most of the complaints were directed at Mekas, as usual, although his was only one voice of five on the selection committee, whose original members (six then) were Mekas, Brakhage, Kubelka, Sitney, the West Coast film-maker James Broughton, and the critic Ken Kelman. The committee deliberated for two years on the stocking of the anthology, and for a time—until Brakhage resigned, and a simple majority vote was substituted for unanimous rulings—it looked as though it could never agree on anything. The list eventually ran to about three hundred films, which were shown in a repeating cycle that took about six weeks to complete, so that anyone who wanted to absorb what the committee considered "the heights of the

* In 1974 the anthology theater and offices were relocated to 80 Wooster Street. The new theater is less austere, more casual.

art of cinema" from 1899 to 1971 could do so in a couple of months of assiduous viewing. Although the list was weighted rather heavily toward the various avant-garde movements, with a great deal of Brakhage, Markopoulos, Anger, and other current heroes, it did include such early Hollywood classics as Griffith's *Intolerance* and Chaplin's *The Gold Rush*, together with representative samplings of the great Russian, European, and Japanese films. The total absence of films by Godard, Truffaut, Antonioni, Fellini, Hawks, Hitchcock, and other much-admired contemporary narrative-film directors greatly annoyed some critics, and the failure to include such independents as Shirley Clarke, Ed Emshwiller, and even Stan VanDerBeck, the man who gave the underground cinema its name, greatly miffed some film-makers. No clear guidelines existed in the matter of film comedies, many of which seemed to consist of treacly stories with a few great comic moments. The fact that there were so few contemporary narrative films reflected the committee's feeling that narrative film-making was the area most heavily compromised by the taint of commercialism. In their desire to avoid current fashions, Mekas said, "we felt it was better to underinclude than to overinclude."

It struck some of his colleagues as ironic that Mekas, who was often criticized in the past for his "permissiveness" in showing any film by any film-maker, should be running such a rigorously selective archive. Mekas worried about this himself. He wanted to revive the defunct cinémathèque by devoting a period of several days between each anthology repertory cycle to the showing of new films, and he tried hard to raise money for this purpose. In general, though, he felt that the need for his cinémathèque was no longer as pressing as it used to be. New York now had the Millennium Film Workshop and Film Forum, which regularly screened new work by independent spirits, and both the Whitney Museum and the Museum of Modern Art had begun programs devoted to the low-budget avant-garde. (Willard Van Dyke, director of the film department at the Modern, has said that MOMA's Tuesday-afternoon "Cineprobe" was "really a response to the activities of Jonas at his various cinémathèques.") "Part of the early battle has been won," Mekas said. "Films are more readily accepted as an art form on a formal basis. What's happened during the last ten years is that a whole new range of possibilities in cinema has opened up, and this, I think, is one of the main achievements of the so-called underground."

When Anthology Film Archives opened its doors, in December 1970,

Mekas said that he would give two years of his life to getting it start-
ed, after which he would withdraw to work on his own films. His
friends had heard him say this often enough in the past, and nobody
really believed he would do anything of the sort. Mekas never seemed
to shed responsibilities; he simply compartmentalized them. In his
cluttered office adjoining the anthology theater and in his dark, Spar-
tan room at the Chelsea Hotel, bookshelves and desks divided the
space into separate areas for his separate jobs—anthology business,
Film Culture, "Movie Journal," and so on. He looked at dozens of
new films each week and ministered to the ever-critical needs of in-
dependent film-makers, who trooped in and out of the anthology of-
fice at all hours. Occasionally, he asked himself why the hell he didn't
just quit and concentrate on making his own films.

"I'm not too clear about it even yet," he once said in a reflective
mood. "Maybe I did what I did—accomplished what I accomplished
—only because of my indecision among a number of things. Maybe

JONAS MEKAS
(Judy Tomkins)

that's part of my character. I always think, Oh, I'm wasting my time. These last months, I am thinking that very much. And my films are sitting there in the hotel—hours and hours of footage waiting to be edited. But I will come to them sooner or later—some week when I do nothing else. There will be two other volumes of my film diaries, the first one taking in the period of the fifties and sixties—Brooklyn and Orchard Street, Barbara Rubin and Allen Ginsberg and all those people, the Women Strike for Peace, all those early protest marches. I have much footage on that. The second volume will go from 1969 to the present, whenever that happens to be."

In Lithuania, Mekas is considered one of the most important living poets. His collected poems (four volumes in all) were published in his homeland for the first time in 1971, and quickly sold out. He is not a prolific poet—he may think about a poem for a year or more before he writes it down—and he feels he could never write poetry in any language except Lithuanian. But it seems likely that the qualities that distinguish him as a poet also mark his film-making, with its more or less international language. His *Diaries, Notes, and Sketches*, in fact, may be one of the most authentically poetic films ever made, as well as one of the most personal. Barbara Rubin has called the film "a summary of everybody's trip in that whole period," and, in a sense, it can be seen as a marvelously inclusive home movie of the underground-film movement. The film-makers who were Mekas's friends are there, along with Allen Ginsberg, Timothy Leary, John Lennon and Yoko Ono, and dozens of others whose lives Mekas has touched. And the New York that they inhabited is there, too, with its dingy lofts and streets and cafeterias, its peace marches and Hare Krishna singers, and its great escape hatch of Central Park. But the medium through which we see these people and scenes is the camera eye that has become, after ten years of practice and experiment, a living extension of Mekas's unique sensibility. Each shot, each motion of the camera, each sound on the sound track (snatches of Chopin, street noises, Mekas narrating) is suffused with the presence of an *"auteur"* whom we come to know more intimately, perhaps, during the film's three hours than anyone has ever known him in person, and whose company wears extremely well. Up to then, Mekas had been known principally for his untiring efforts on behalf of other film artists. It would be a fine irony if his own *Diaries, Notes, and Sketches* should turn out to be, as some people already proclaim, the supreme achievement of the New American Cinema.

Discussing the film one day in 1973, Mekas conceded that its point

of view was deeply and sometimes unwittingly personal. Time and again throughout the film, for example, we see New York under a blanket of snow. "I thought I was shooting New York as it is," Mekas said, "but when I looked at the film I realized that my New York was a fantasy—that it does not really have so much snow. I was shooting my memories. Winter memories are very special to me. At home, everybody worked outside in the summer, but in the winter we all sat together in rooms, and so the memories of my childhood are very much of the winters. In my *Diaries*, this city of steel and concrete becomes like a Walden, with trees and birds, the seasons very noticeable. What my *Diaries* contain is maybe what I would like New York to be."

After a pause, he added, "And, you know, during the period when I was shooting the *Diaries* I felt very much that New York was my city. On my way back to New York from somewhere else, I felt that I was coming home—that my real roots were here. But now I'm not so sure any more. I feel now that I haven't found my real roots—that I have no place. I keep looking ahead and wondering."

VIDEO VISIONARY

The video-art movement, which has been in high gear for more than three years now, can have come as a surprise to practically no one. Most of the people who are trying to turn the cathode-ray tube into an art medium belong to the under-thirty, or TV, generation—which means, according to current estimates, that each of them has spent, on the average, about 15,000 hours watching television. Television has been their landscape, in a way, and it would appear inevitable that they should want to make use of it. Until quite recently, the huge costs of working with television equipment made it all but impossible for anyone outside the commercial-television studios to tap into the medium, but with the marketing, in the mid-1960s, of relatively inexpensive, portable videotape recorders the territory suddenly opened up, and the artists, who had been toeing the line in anticipation, lit out for the new electronic frontier.

More than a dozen New York art galleries handle "personal" videotapes by artists. Leo Castelli's downtown gallery, at 420 West Broadway, which, in 1974, merged its video and film operations with the Sonnabend Gallery, in the same building, shows and distributes videotapes by twenty-four artists, while Howard Wise, who gave up his Fifty-seventh Street gallery in 1970 to concentrate on helping video art get started, handles the distribution of work by thirty-eight more, through his Electronic Arts Intermix. Artists' videotapes, most of which are available on cassettes that can be viewed on special monitor-receivers equipped for the purpose, are leased, as a rule, to museums and to university and college art departments, but requests also come in from high schools and community groups throughout the country, and there are even a few early-bird private collectors who buy them outright. Publications with names like *Radical Software* have sprung up, devoted to the "alternative TV" movement. The Museum of Modern Art's Open Circuits conference on video art in January 1974 drew participants from as far away as Argentina and Japan, and both the Modern and the Whitney museums now include

videotapes in their over-all program. Concurrently with the action in galleries and museums, moreover, three of the most active public-television stations in the country—WGBH, in Boston; KQED, in San Francisco; and WNET, in New York—have established experimental workshops where artists are invited to work with the complex and sophisticated hardware of broadcast television. The results might startle regular viewers of the *Lawrence Welk Show*, but they have met with generally encouraging reactions from the critics, and funding for the workshops—largely by the Rockefeller Foundation—seems reasonably well assured. In the wings, meanwhile, lies the glittering and often delayed promise of cable television, or CATV: the promise of as many as sixty new channels, with hundreds of thousands of viewing hours to be filled somehow—a vast empty canvas not yet smeared and scumbled over by the Sponsor. As far back as 1965 Nam June Paik saw it as a "historical necessity" that "someday artists will work with capacitors, resistors, and semiconductors as they work today with brushes, violins, and junk."

Nam June Paik is slightly embarrassed about being known as the George Washington of video art. A smallish, rather self-effacing Korean whose English is still, after some ten years in this country, so nearly impervious to the definite and indefinite articles that it is hard to understand him on first, or even second, meeting, shunned the spotlight at the Museum of Modern Art's Open Circuits conference, which took its title from a statement he had published in 1966. When Paik, with nervously oscillating eyebrows and a woollen stomach warmer, came up to the front of the room to speak, he praised other artists in the movement and then showed portions of his videotape *Global Groove*. No doctrinal statements, no manifestoes, no fuss. It is a fact, however, that Paik began thinking about video as an art form back in 1959, when he mentioned it in a letter to John Cage, and that his 1963 exhibition at the Galerie Parnass, in Wuppertal, Germany, was the first show of video art anywhere. This was several years before the advent of lightweight video equipment, but in those days Paik was not thinking in terms of cameras or recorders; he was thinking solely in terms of the image on the home screen. He went in through the back of the set and played around with that image, changing voltages and cycles, warping and distorting the picture, and reintroducing a lot of the technical flaws that television engineers had spent years trying to eliminate. "It was Paik who saw that the way the signal is created on the monitor presented all sorts of opportunities for new images," David Loxton, the director of WNET's Televi-

sion Laboratory, said recently. "That vision obviously made everyone stop and think. You could really make TV just by manipulating signals electronically, without all this insane two-thousand-dollars-a-minute business of studio production."

Many of the gallery artists who work in video are not interested in signal manipulation at all—they use the equipment simply to record activities, processes, or environments in much the same way that a movie camera would. The range of possibilities for signal manipulation is virtually limitless, however, thanks in part to an electronic device called the videosynthesizer, which Paik and Shuya Abe, a Japanese collaborator, designed and built, and signal manipulation is one of the areas that make video an infinitely more flexible medium than cinema. In the hands of Paik, Ron Hays, Ed Emshwiller, and other practitioners, the synthesizer can produce a ceaseless kaleidoscope of shapes and colors on the screen—shapes and colors unlike anything anyone has ever seen before. It can superimpose as many as seven different images; cause the features of announcers and other unsuspecting subjects to vibrate, melt, change color, and spread laterally; and generally turn the familiar screen into an electronic canvas for an artist whose brush consists of light. Watching television is not the same experience as watching a movie. Instead of seeing light reflected from a screen, the video viewer looks directly into the light source, and that is why the colors in color television are so luminous. "Film is chemicals; TV is electronics," Paik points out. "There are something like four million phosphor dots on a twenty-one-inch color television screen every second; it is just like Seurat—you mix them in your eye. In film, you take from reality; in TV, you produce reality—real electronic color."

Psychological differences exist as well. As Marshall McLuhan has pointed out, a new medium usually begins by imitating the content of the medium that preceded it: the first automobiles looked like horse-drawn broughams; the first motion pictures were filmed stage plays. For more than thirty years, most of the dramatic entertainment on television has been little more than shrunken cinema, movies squeezed down to the dimensions and the commercially dictated time structures of the home screen, and this is one reason that even the movies made for television seem so drained of life and so blatantly artificial. The cinematic model simply won't work on the tube. But as art in our time becomes more and more a question of information, of dealing with our incredible public reality, the validity of television as an art medium grows increasingly evident. "The big difference be-

tween film and video is that you need darkness for film and you have to stop other activities," Paik has observed, "but with video you can do everything and still watch—it's a continuation of your life."

The nature of the medium and the fact that videotape, which can be erased and reused, is a great deal cheaper to work with than film have lured film-makers as well as artists to experiment with it. Shirley Clarke, who used to make film documentaries (the 1967 *Portrait of Jason*, for instance, about a black male prostitute), presides over a studio for experimental video. Ed Emshwiller, considered the finest technician among the so-called underground group of film-makers, has been working mostly in television of late. Although it has become modish for art critics to state that the video movement has yet to produce anything resembling a major work of art, the television reviewers have responded enthusiastically to Emshwiller's work on WNET and to Paik's *Global Groove*—a high-velocity collage of images ranging from Japanese Pepsi-Cola commercials, through tap dancers, to views of the Living Theatre performing *Paradise Now*, most of which are subjected to surreal distortions and overlaid by the light-painting techniques of the Paik-Abe videosynthesizer.

Paik himself is using the videosynthesizer less and less. He is pleased that others are using it, and he says, typically, that they do it much better than he does. Paik has always been far more interested in processes than in results, and as an artist-in-residence at WNET's Television Laboratory and a consultant on television to the Rockefeller Foundation, he is concerned with a great many different processes, not all of which even involve television. But video remains the basis of his wide-ranging and somewhat visionary cast of thought. "I believe in timing," he has said. "Somehow, you have to be at a certain point at a certain time. You have to 'meet the time,' as they say in Chinese history. I start in 1960, first time television sets become cheap, become secondhand, like junk. I buy thirteen secondhand sets in 1962. I didn't have any preconceived idea. Nobody had put two frequencies into one place, so I just do that, horizontal and vertical, and this absolutely new thing comes out. I make mistake after mistake, and it comes out positive. That is story of my whole life."

One explanation for Paik's success as a video pioneer may be that he came to television by way of music. Visual artists—painters and sculptors—are accustomed to filling up space; they do not always understand how to use time, as a great many of their "performance pieces" in recent years have made painfully evident. Paik was trained

as a musician, however, and, no matter what else may be said of his performance pieces and his videotapes, hardly anyone finds them tedious. "My experimental TV is not always interesting but not always uninteresting," he observed on the occasion of his 1963 show in Wuppertal. It was, he went on, "like nature, which is beautiful not because it changes beautifully but simply because it changes."

Paik's musical education, though it was thorough, took place largely on the sly. In Korea, he has explained, professional artists and musicians have no status at all. "We have expression 'man of letters,' same as here, and if a man of letters writes music or does painting, that's okay. But professional musician is nothing." Paik's family, which was middle class and periodically well-to-do, would not have looked with favor on his musical studies, but the family did not learn about them until it was too late. "We are really one of the most corrupted families in Korea," says Paik, who was born in Seoul in 1932. "My grandfather made first modern factory there—textiles. Then, in Depression, we became very poor. Later, we have two steel factories in North Korea, but in 1945 they become 'people's factories.' It was all luck and unluck. Sometimes I felt I was on wrong side, because I had such radical thoughts. In 1950 we were on refugee train and bombing started. We get out and I really don't know which side I am on. Then I thought, Well—enlightenment!—I will just look at everything from now on like baseball. You know, nothing serious. I became quite cynical." Paik and his family did manage to escape the country in 1950, and, because of South Korea's stringent military-conscription law, he could technically be arrested as a draft dodger if he ever returned.

The family went first to Hong Kong, where Paik's father dabbled in the ginseng-root business, and then to Tokyo. Paik, the youngest of five children, entered the University of Tokyo, took courses in philosophy and history and aesthetics, secretly studied Western music (only one course in Oriental music was being taught), and graduated in 1956 with a degree in aesthetics. Paik's two older brothers were businessmen by then, but their father allowed Paik to go off to Germany, ostensibly to work for his doctorate in philosophy: "He liked the idea that one son gets Ph.D." Graduate work at the University of Munich and the Conservatory in Freiburg gave him a thorough grounding in music history and theory and in piano technique, although, as Paik tells it, he was so shy as a student that he never even considered the possibility of performing in public. "I was always very serious, straight-A student, but so timid that when I played in front

of my teacher, Chopin or Bach, my tempo would go up and down, up and down."

What interested Paik far more than Chopin or Bach even then was the music of the twentieth century. As a high-school student in Seoul, he had tried for three years to find any recording of Arnold Schön-berg's works, and finally found "Verklärte Nacht," which he had read about in *Time*. He also managed, through great diligence, to find a recording of Stravinsky's "Firebird" ("I will never forget the red label, with Stokowski conducting Philadelphia Orchestra") but not of "The Rite of Spring." "Then, when I got to Tokyo, I heard on radio some music with girl weeping, and I said, 'Oh, must be Schön-berg.' It was *Pierrot Lunaire*, first time I hear it. Such a big event for me."

Germany in the 1950s was a center of the newest developments in music, most of which had to do with electronic means of composition. Karlheinz Stockhausen, György Ligeti, Mauricio Kagel, and other avant-garde composers were working at the Studio for Electronic Music, which had been established by Radio Cologne, and one of Paik's teachers at the Conservatory in Freiburg, Wolfgang Fortner, strongly urged him to go there. He took Fortner's advice and enrolled at the University of Cologne, but for the first year there he was too shy to approach any of the other young composers. He was writing music, but not confidently. In Munich, he had composed a string quartet, which, he says, "started out Bartok, became Schönberg, and ended Webern." While at Freiburg, he wrote a composition based on a ninth-century Korean poem, in which he included certain tape-recorded "collage" elements, such as water sounds, a baby's bab-bling, and snatches of Tchaikovsky. Later he edged further into the electronic field with taped compositions of himself chanting or shout-ing. And at about this juncture, in 1958, he met John Cage—the event that he considers the turning point in his life.

Cage, the irrepressible American avant-gardist, whom Schönberg once described as "not a composer but an inventor of genius," had decided by then that electronic music was "dead as a doornail." Cage had noticed that the audiences at concerts of all-electronic music in-variably went to sleep. He believed that the healthier tendencies in all the arts then were moving in the direction of theater, and he made sure that his own compositions gave audiences something to look at as well as listen to; most of these visual activities were dictated, like his music, by chance operations, and the results were often hilarious. Paik was still living in Tokyo when he first heard about Cage, and

shortly afterward he had been both astounded and pleased to hear Professor Yoshio Nomura, who taught music history at the University of Tokyo, and whose special area was the Gregorian chant, name Cage's "String Quartet in Four Parts" among the ten best musical works of the twentieth century.

When Cage came to Darmstadt on a concert and lecture tour in 1958, Paik took in the performance and later went to call on the composer at his hotel. He was rather shocked to find Cage washing his shirts. It seemed to Paik that someone with Cage's attitude toward music should not waste any time on details of personal appearance; nor did Paik approve of the fact that Cage wore a dark-blue suit and a necktie when he performed. They got along well enough in spite of this, however, and discovered that they were both engrossed just then in Mallarmé's writings on chance. Paik asked Cage whether he meant to be funny when he did things like blowing whistles or rattling egg-beaters onstage. Cage replied that he did not set out deliberately to be funny—for example, the whistles in the collage piece called "Music Walk" had simply been a means of making sounds while his hands were occupied in making other sounds—but that if something turned out to be funny in performance, as the whistles had, then he could accept that without difficulty. In general, he said, he preferred laughter to tears.

For Paik, all this was hugely liberating. Cage, who is not always comforted by the work of people he has inspired, tends now to belittle his influence on Paik. "I don't believe in this business of people influencing other people," he said recently. "Maybe Nam June's meeting me made it possible for him to go on and do the things he was going to do sooner or later anyway, but only because it was already in him to do them. The fact is that he took my ideas into areas where I would never have gone." In the pieces that Paik began to compose after 1958, there was often an element of violence, which was entirely foreign to anything in Cage. Paik, the timid student who could not conceive of playing the piano in public, now found it within his power to compose and perform a work called "Hommage à John Cage," in which he caused an upright piano to tip over and fall on the stage with a crash. (Stockhausen, watching from the front row, leaped up and started to lift it back up again, until he was dissuaded by Paik; they have been close friends ever since.) In "One for Violin," Paik stood facing the audience, holding by the neck a violin with both hands, which he raised slowly—so slowly that the movement was all but imperceptible; when the violin was above his head, he would bring

it down (fortissimo) on a table in front of him, smashing it to smith-
ereens. He performed these and other pieces in small galleries around
Cologne and in the atelier of Mary Bauermeister, a painter friend,
and later in museums and concert halls in Oslo, Copenhagen, and
Stockholm. Paik also performed works by Cage and others, and he
was enormously encouraged when a German music critic referred to
him in print as "the world's most famous bad pianist."

In 1960, when Cage returned to Europe for a series of lectures and
performances, Paik was ready with a new piece, entitled "Étude for
Pianoforte." Cage recalls its first performance vividly. "It is hard to
describe why his performances are so terrifying," he said not long
ago. "You get the feeling very clearly that anything can happen, even
physically dangerous things." In the "Étude for Pianoforte," whose
premiere was in Mary Bauermeister's studio, Paik played some Cho-
pin on the piano, broke off, weeping, and got up and threw himself
upon the innards of another, eviscerated piano that lay scattered
about the floor, then picked up a wickedly long pair of scissors and
leaped down to where Cage, the pianist David Tudor, and Karlheinz
Stockhausen were sitting, in the front row. He removed Cage's suit
jacket and started to slash away at his shirt with the scissors. Later he
explained that he had intended to cut off the shirttail but when he saw
that Cage was not wearing an undershirt he took pity on him and
decided instead to cut off his necktie at the knot. After doing so, he
poured a bottle of shampoo over Cage's head and also over Tudor's.
(As Stockhausen edged nervously away, Paik said, "Not for you!")
When the bottle was empty and both Cage and Tudor were fully
lathered, Paik forced his way through the crowded room to the door
and ran out. Everyone sat as though stunned, Cage recalls, for
several minutes. Finally, the telephone rang; it was Paik, calling to
say that the concert was over.

Performances of this sort, with their clear echoes of the Dadaist
manifestations of the 1920s, had a good deal in common with the
events called "happenings" which were going on in New York about
this same time in small galleries and artists' lofts. The happenings
were in one sense an outgrowth of the process-oriented, gestural Ac-
tion painting of Jackson Pollock and other artists of the New York
School, and the most prominent "happeners" were visual artists, such
as Claes Oldenburg, Jim Dine, Red Grooms, Robert Whitman, and
Allan Kaprow (who coined the term "happening"). It was generally
acknowledged, however, that the first true happening had been a col-
laborative event organized by John Cage and Merce Cunningham,

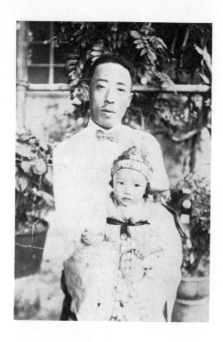

NAM JUNE PAIK AND FATHER.

PAIK AND SPIRITUAL FATHER,
JOHN CAGE, WHOSE NECKTIE
PAIK HAS JUST CUT OFF
IN PERFORMANCE
(Klaus Barisch)

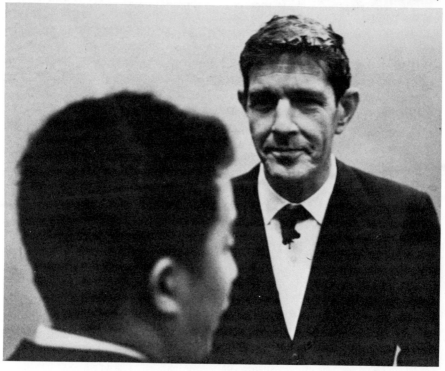

the choreographer, at Black Mountain College in 1952, and Cage's influence on the whole phenomenon was strong and pervasive. A number of young New York musicians, dancers, and artists, many of whom had attended Cage's classes in experimental music at the New School (as had Kaprow himself), had also become interested in doing performance pieces that could be described as Action music, but they lacked the gallery facilities of the better-known artists and had a hard time finding performance space. Then, in 1961, George Maciunas took up their cause. Maciunas, a Lithuanian-born graphic designer who seemed to have a hand in any number of money-losing operations, was then a part owner of a Madison Avenue art gallery called the AG Gallery, and early that year he sponsored there a series of about a dozen events by Dick Higgins, Richard Maxfield, Jackson MacLow, La Monte Young, and other friends of his. Maciunas and MacLow also took over the design and printing of a publication called *An Anthology*, edited by the composer La Monte Young, which included "scripts" for happening-type events by twenty-five contributors; among them was Nam June Paik, whose European performances Maciunas had heard about.

When the AG Gallery folded, in the summer of 1961, Maciunas went to Europe with the idea of founding a periodical devoted to what he considered the rapidly changing directions in all the arts. The periodical was to be called *Fluxus* (for work "in flux"), but it never got off the ground. Instead, Maciunas organized a series of Fluxus Festivals around Europe—in Wiesbaden, Copenhagen, Paris, Düsseldorf, Stockholm, Nice, and London—with a fluctuating troupe that usually included George Brecht, Ben Vautier, Tomas Schmit, Bob Watts, Emmett Williams, and various others who, along with Paik, Dick Higgins, and Higgins's wife, Alison Knowles, formed the core of the Fluxus group. Fluxus events tended to be more Dada in spirit than happenings, which were primarily visual. La Monte Young's "Composition, 1960, #7" called for a singer and an accompanist to sound the same two notes (B and F sharp) continuously for one hour. Wolf Vostell, a round-faced giant from Cologne, did a piece in which he hammered toys to pieces, tried to erase pages of a magazine, broke light bulbs against a piece of glass, and then threw cake at the broken bulbs. Higgins's "Danger Music No. 3" had Alison Knowles shave Higgins's head and fling political pamphlets at the audience. The aesthetic behind all this was somewhat elusive. George Brecht tried to explain it at one point by stating that Fluxus was against the exclusiveness and elitism of art. Anything can be art and anyone can do it,

Brecht wrote, and "therefore, art-amusement must be simple, amusing, unpretentious, concerned with insignificances, require no skill or countless rehearsals, have no commodity or institutional value." It could be said that Brecht was speaking only for himself, inasmuch as the Fluxus people denied that they were part of a movement, and even that they had similar ideas and goals, but the antiart, neo-Dada bias of the members was never in much doubt.

Paik's performances differed from those of the other Fluxus people in that they were hardly ever boring, intentionally or otherwise. Everything that he did onstage was done with an excruciating and highly theatrical intensity, and there was often that sense of physical danger which had frightened Cage. Allan Kaprow described Paik as a "cultural terrorist," and Higgins went so far as to criticize his "joy in the perverse." Paik hammered nails into pianos, or attacked them with a carpenter's plane. ("People have idea that piano is very expensive, very sacred," he explained. "I was not thinking about destruction at all.") He crawled underneath the instrument and licked the dust from the pedals. He also composed works that would now qualify as Conceptual art, including a score for a symphony "to last one million years," and a long series of correspondence events that involved mailing pennies to people in various parts of the world. His return address at this point was the University for Avant-Garde Hinduism, which he had founded, and of which he was the sole member. ("I like Hinduism," Paik once said. "Is not so restricted as other religions, and they like sex, too.") Most people had trouble understanding him. He spoke five languages besides Korean, all of them badly. Something that nobody knew was that he had a studio on the outskirts of Cologne, where he and an engineer friend spent endless hours taking apart and rewiring thirteen secondhand black-and-white television sets.

Television pictures are produced by a flow of electrons moving in straight lines across the phosphor-coated surface of a cathode-ray tube. Paik and his friend interfered with this flow of electrons in a variety of ways. They altered the horizontal input to make the image stretch laterally across the screen. They used sound waves to warp the image, and they reversed the black and white controls to make negative images. Odd, distorted shapes floated unfixed through fields of electronic static. Paik hooked up one set to a microphone so that when you talked into the mike the image would jump around on the screen. It was all quite complicated electronically—nothing as simple

as the blurring or tumbling effects that you get inadvertently by fiddling with the horizontal and vertical controls. Paik learned television circuitry backward and forward. "I still did not consider myself a visual artist," he has said of that period. "But I knew there was something to be done in television and nobody else was doing it, so I said why not make it my job?" If it had not been for television, Paik said, he might still be breaking up pianos.

Paik's thirteen doctored television sets were presented to the public in the spring of 1963, at the Galerie Parnass, in Wuppertal. Nobody bought one; Paik had suspended the head of a freshly slaughtered ox over the door to the gallery, and that attracted more attention than the electronics. Soon afterward, Paik closed his Cologne studio and went back to Tokyo. He wanted to experiment with color television, which was not available in Europe then. In Tokyo, he met a man named Hideo Uchida—an electronics wizard, who was interested in using FM radio to test for extrasensory perception. Uchida introduced Paik to Shuya Abe, a young Japanese electronics engineer, and Abe soon became Paik's principal collaborator. Together they interfered with electron flows in color sets, and Paik discovered, to his delight, that it was impossible to control the results, because each set worked a little differently. A true disciple of Cage, Paik did not want to make anything that would be a mere reflection of his own personality. What he was after was indeterminacy—the image created by chance—and he found that the behavior of electrons in a color television set was truly indeterminate. Paik and Abe also built an electronically controlled bisexual six-foot robot that walked, talked, moved its arms, and excreted white beans. In his spare moments, Paik tried to learn something about Oriental music and Oriental religion, neither of which had interested him at all until he met Cage. He spent three days in a Zen monastery near Kamakura, where he was beaten repeatedly by the head monk. "There were twenty or thirty people there, all sitting facing walls," Paik recalls. "In charge was monk with a long stick. We were not supposed to move, even if a mosquito bit. Every so often, monk would hit somebody with his stick, usually me. Why me? It made big noise but didn't really hurt. Anyway, that was slightly unhappy three days."

Paik was planning to return to Germany after his year in Tokyo, but he decided to spend six months in the United States first. America had held no interest for him before; he had once been offered a scholarship to Dartmouth, but Germany seemed to be the place for new music, and, besides, as he put it, "I knew that Dartmouth was

not Yale." In 1964, though, he wanted to investigate what had struck him, from afar, as the curious "flatness" of American culture. He arrived in New York City in June, and the noise and the summer heat astonished him. "New York was as ugly as Düsseldorf," he said, "and as dirty as Paris." He was met by Dick Higgins, who took him to stay at the Broadway Central (the hotel that collapsed in 1973), where the carpet in his room was so filthy that he had to cover it with newspapers before he could sleep. Paik hated New York at first. He hated the dirt, and he also hated the glamour of the uptown art galleries and the spirit of commercialism that seemed to dominate the whole art scene. Even the New York artists seemed standoffish to him. "The key to Fluxus was that artists were killing individual egos," Paik has said. "At least, that was how I interpreted it. But in New York artists have very big egos. I was never really antiart, but I was antiego. Postindustrial society will be a kind of egoless society is what I think. Many people now are giving up acquisitiveness in terms of money and material comfort; next stage is to give up acquisitiveness in fame. Of course, Fluxus people, including myself, are vain and *do* have ego, I know that. Is very, very hard."

Within two months of his arrival Paik made his presence felt in a typically disturbing fashion. As the centerpiece of a festival of avantgarde music at Judson Hall the festival's organizer, a twenty-four-year-old cellist named Charlotte Moorman, had scheduled five performances of Karlheinz Stockhausen's "Originale"—a theater event in which Paik had appeared prominently when it was done in Europe. Stockhausen had told Miss Moorman that she could do the piece only on the condition that Nam June Paik's part was played by Nam June Paik, and Miss Moorman, who had never heard of Paik and was told he was in Europe, was wondering how to reach him there when Paik called her. He had arrived a few days before, had heard about the production, and would be happy to re-create his role and assist in the rehearsals. Paik's role consisted of covering his head with shaving cream and rice, slowly unrolling a long Chinese scroll, plunging his head into a pail of water, screaming, and playing the piano; for the New York production he added his electronic robot, which had come over with him from Tokyo, and which walked about the stage, waving its left arm, twirling its left breast, and playing a tape recording of President John F. Kennedy's 1961 Inaugural Address. On the fourth night, just as Paik was starting his performance, three well-dressed young men rose from the front row of the audience, came up onstage, handcuffed Paik to a metal scaffolding there, and

then disappeared out the back of the set. The audience thought that it was part of the performance. Paik made plaintive sounds, and Miss Moorman, terrified, called the police. Told by their producer that they were breaking a number of municipal ordinances (for one thing, the cast included a live chimpanzee without a leash), she called the police station back to tell the police not to bother coming, but they were already on their way. They arrived a few minutes later, freed Paik, found the perpetrators, whom nobody in the cast had ever seen before, and asked whether Paik wanted to press charges. Paik said no. A good many people in the audience thought that all this was probably part of the show, too.

The meeting between Paik and Miss Moorman was auspicious for both parties. Although they have never been romantically involved with one another—Miss Moorman is happily married, and Paik now lives with a gifted Japanese video artist named Shigeko Kubota—virtually all of Paik's performance pieces since 1964 have been written for Miss Moorman, whose indefatigable dedication to his work and to the work of other advanced composers once led Edgard Varese to refer to her as "the Jeanne d'Arc of New Music." In her service to the new, Miss Moorman has traveled rather a long distance from her musical origins, in Little Rock, Arkansas, where she began studying the cello at the age of ten. She took her bachelor's degree in music at Centenary College, in Shreveport; went on to get her master's at the University of Texas; and proceeded to Juilliard, in New York, where she studied with Leonard Rose. She spent the preceding summer at Ivan Galamian's Meadowmount School of Music, near Elizabethtown, New York, considered the best in the world for string players. After she left Juilliard, she became a regular member of the American Symphony Orchestra, under Leopold Stokowski, and also of the Boccherini Players, a chamber-music group. To gain concert experience, Miss Moorman also performed as a soloist with any number of lesser symphonic groups, and in 1961, during one such concert, in darkest New Jersey, while Miss Moorman was performing the Kabalevsky Cello Concerto for the thirty-fifth time in public, she caught herself wondering whether she had locked the door to her apartment and turned off the gas stove. This led her to wonder, in turn, whether a career in traditional music was precisely what she wanted.

About this time, Miss Moorman and Yoko Ono, who had just left Sarah Lawrence College, moved into an apartment together on West End Avenue. Both of them had recently been separated from their first husbands—in Miss Moorman's case, a double-bass player who

had been her college sweetheart in Texas. Yoko Ono was the daughter of a wealthy Tokyo banking family. She and her estranged husband, a Japanese music student named Toshi Ichiyanagi, had been thoroughly involved with the musical avant-garde in New York, and it was not long before Miss Moorman found herself becoming thoroughly involved with it, too. A year before, Miss Moorman had managed to arrange for the Town Hall debut of the young Japanese violinist Kenji Kobayashi, a friend of Yoko's; she had done this by persuading an impresario named Norman Seaman to sponsor the event and then going around to Isamu Noguchi and other well-known Japanese Americans and persuading them to put up the money. In the fall of 1961 Miss Moorman got Seaman to sponsor a rather different sort of concert, by Yoko and her friends—a group of musicians, poets, and dancers that included La Monte Young, Philip Corner, Joseph Byrd, Jackson Mac Low, Yvonne Rainer, Jonas Mekas, Ay-o, and George Brecht. Seated on a toilet on the stage at Carnegie Recital Hall that evening, with her back to the audience, and making "non-cello sounds" on her cello, as the score indicated, Miss Moorman again had cause to wonder whether her long musical education was being properly applied. But she felt that the event was interesting somehow, and she did not think about the gas stove while she was performing. She went on to perform in other avant-garde events, and then, in 1963, without realizing what she was getting into, she put her formidable energy and persuasiveness to work organizing a one-week festival of new music, which the steely-nerved Norman Seaman again agreed to sponsor, at Judson Hall. This was the start of what has ever since been an annual New York Festival of the Avant-Garde.

The 1963 festival was all music—or what was so described in avant-garde circles—by Cage, La Monte Young, Morton Feldman, Frederic Rzewski, and others. The dividing line between music and other forms was under heavy assault, however, and when Miss Moorman put the second festival together, in August and September of 1964, she was only too happy to broaden its scope. Stockhausen's "Originale," the main feature of that series, was more "happening" than music, and the annual avant-garde festival has since become a catchall, accommodating just about every far-out activity that anyone involved can think up. Some people feel that Miss Moorman has found her true vocation as the organizer of these events. According to Cage, who usually vows not to take part in the festival but then succumbs to Miss Moorman's relentless urging, "Charlotte's real talent

is for publicity." Miss Moorman herself takes great pride in the festival, but she believes that her work as Paik's leading interpreter is of equal importance.

Paik made Miss Moorman a star, in a sense, and she made possible a long-postponed desire of Paik's—to bring sex to music. "Sex has been a main theme in art and literature," Paik reasoned. "Why not in music? Why should music be fifty years behind? In Cologne, I had idea for a concert where 'Moonlight' Sonata is played by woman nude. I thought it would be very beautiful to do this in Germany. But I couldn't find anyone to do it. Piano players are very middle class, it seems. In my 'Etude for Pianoforte,' I wanted to have girl who would take off many pairs of panties. I even tried to get prostitutes, but none of them would agree." Miss Moorman had some difficulty at first with Paik's ideas, but she got over it. Soon after their meeting, he composed his "Cello Sonata No. 1 for Adults Only," which Miss Moorman performed at the New School in January 1965. In this work, Miss Moorman, a rather small girl with a full figure and a totally serious manner of performing, starts out fully gowned and plays a few measures of the Prelude to Bach's Third Cello Suite; she stops, removes an article of clothing, and resumes playing, stops again, removes something else, and continues alternately playing and removing until she is down to nothing at all. Paik's next composition for her was "Variations on a Theme by Saint-Saëns," which had its premiere at the third avant-garde festival. In this one, Miss Moorman plays the first half of Saint-Saëns's "The Swan," gets up and submerges herself in an oil drum filled with water, then returns dripping wet to finish the piece. Sometimes she performs the "Variations" in an evening gown, and sometimes she wears nothing but a covering of clear plastic. Miss Moorman said recently that she enjoys performing this piece, because she is a Scorpio and her sign is water. Paik says she invariably plays much better after her immersion. Both Paik and Miss Moorman claim that the piece is not meant to seem comic, although Paik, who laughs a lot, is inclined to laugh when discussing it. "In Korea, being artist is bad enough," Paik has said. "To be comedian is even worse."

Paik and Miss Moorman took their repertoire abroad in the summer of 1965, and presented it to variously appreciative audiences in Reykjavík, Paris, Cologne, Frankfurt, Aachen, Berlin, and Florence. The excitable Florentines rioted when Miss Moorman made her entrance in clear plastic, and the police had to be called to restore order. At the Galerie Parnass, in Wuppertal, scene of his pioneer

1963 video show, Paik and Miss Moorman teamed with Joseph Beuys, Bazon Broc, Tomas Schmit, Wolf Vostell, and other European artists in a marathon event called *24 Stunden,* which lasted twenty-four hours. In Berlin, they came close to being arrested for performing Paik's *Robot Opera* in front of the Brandenburg Gate. In the opera, Miss Moorman sits on the back of a crouching artist (any artist will do) and plays the cello while another artist lies on the ground at her feet with the cello's ferrule held in his mouth and Paik's robot marches to and fro. The armed guards near the Berlin Wall had not been warned ahead of time, and rifles were cocked in nervous anticipation. Miss Moorman also performed works by Cage and by Yoko Ono (one of the crowd-pleasers was Yoko Ono's "Cut Piece," in which members of the audience are invited to come up and cut sections out of Miss Moorman's dress with a pair of scissors), and she and Paik took part in a variety of events in and around Cologne. The tour was a great success, from their point of view. "The Germans love Charlotte," Paik said afterward. "They think she is what American girl ought to be."

Paik and Miss Moorman returned to New York in time for Miss Moorman to put together the 1965 annual Festival of the Avant-Garde, which was also the last to be held in Judson Hall. The management there became upset over Allan Kaprow's "Push-Pull" event, which enjoined the audience to go out and search in trash bins and vacant lots for discarded objects with which to furnish two empty rooms onstage. Once again the police appeared, largely out of curiosity to see what was going on, but the Judson Hall management did not get into the spirit of the thing.

When Paik was not composing or performing, he invoked the muse of television. He had brought over from Tokyo a number of large secondhand television sets, with which he experimented continually at a studio he had settled into, on Canal Street. Visitors to the studio, over whose entrance Dick Higgins had posted a sign reading "I AM NOT VERY ELOQUENT," had to crawl over and through a maze of exposed electrical wires, tubes, and discontinuous circuitry to find Paik. At home, he usually had on a pair of rubber boots, which were supposed to prevent his electrocution. He had also taken to wearing a woollen scarf around his middle, even in warm weather, to ward off stomach pains that several doctors had been unable to diagnose. There was no furniture to speak of. Three old RCA black-and-white sets, pushed together and covered with a mattress, served as his bed.

Paik had found that he could get magnificent distortions of television pictures by using magnets and degaussing coils (devices employed in the earliest television sets to *correct* for natural magnetic distortion). "Every night, ten million people were watching the same Johnny Carson," he recalls. "Only I was watching a different one." He experimented with video feedback, in which the camera is pointed at the receiver picking up that camera's signal and goes slightly crazy, producing unpredictable and more or less uncontrollable imagery. In 1966 he discovered the "dancing-wave pattern," a graceful, wavelike, looping image produced on a color television screen by modulating three audio input signals. Paik's electrical engineering was not exactly elegant, but it seemed to work. Many of his connections were achieved with Scotch Tape. "For me," he once said, "Scotch Tape is *tao*."

Paik's television experiments did not pass unnoticed. He had exhibited his manipulated television sets at the New School in January 1965—along with his "Sonata for Adults Only" and other works. One critic said the sets reminded him of upset stomachs in commercials, but others were more impressed. Porter McCray, the director of the Asian Cultural Program of the JDR Third Fund, was impressed enough to recommend a $6000 grant to further Paik's television experiments, and Cage and Merce Cunningham invited him to project his television imagery as part of the stage set for their *Variations V*, which was performed that summer at Lincoln Center. In the fall of 1965 the Galeria Bonino, Ltd., on West Fifty-seventh Street, gave Paik a one-man show, largely on the recommendation of his Cologne friend Mary Bauermeister, who was then living in New York. The roomful of doctored television sets drew exceptionally large crowds for three weeks; it also drew a relatively kindly review by *The New York Times* art critic, John Canaday, who said the show "has unquestioned fascination and a probable potential for expansion."

A month before the Bonino show, moreover, Paik personally ushered in the new era of alternative, or underground, television. As early as 1961, in Cologne, he had spent a good deal of time and money trying to construct a portable, lightweight television camera and videotape recorder, but without success. "I was very naïve," Paik recalls. "I thought the first man to own videotape recorder could become best painter of the age." In Tokyo, two years later, he had learned that Sony was developing just the sort of equipment he had in mind. He had kept himself posted on all the latest industry advances, and the day Sony's first reasonably portable video camera-recorder reached the Liberty Music Shop, in New York—it was October 4,

1965—Paik bought it, using the unspent portion of the grant from the JDR Third Fund. Within moments, he had begun videotaping Pope Paul's arrival at St. Patrick's Cathedral, and a number of other scenes around town, which he showed that same evening to a regular Monday-night gathering of vanguard artists and film-makers at the Café à Go-Go, in Greenwich Village.

Paik was feeling a lot better about New York. The exclusiveness of the artists, which had bothered him so much at first, he now saw as a necessary defense against the "information overload" to which everyone was constantly subjected. "I began to understand New York from the New York point of view, and I felt more at home. It's funny —coming to Istanbul once from Germany, I say to myself, 'Ah, is beginning of Asia.' And then when I go back to Tokyo in 1963 I say, 'Is beginning of America.' That kind of chaotic energy—you know?" Paik's own energy was unflagging. He toured Europe again with Miss Moorman in 1966, and they performed a gondola version of the Saint-Saëns piece in Venice, with Miss Moorman descending into the Grand Canal and subsequently being rushed to the hospital for a typhoid shot, which they had somehow overlooked. Paik helped out faithfully with all aspects of most of the yearly avant-garde festivals —the 1966 festival took place in Central Park, and subsequent sites have included a Staten Island ferryboat, the 69th Regiment Armory, Grand Central Terminal, and Shea Stadium. In 1967 he figured prominently in two important group shows of kinetic-and-light art at the Howard Wise Gallery. If not yet wholly egoless, he was always willing to assist others and to participate in group efforts.

The only time anyone has ever seen Paik seriously depressed was in February 1967, when the police stopped the performance of his new *Opera Sextronique*. Paik had been a little nervous about doing this piece in New York. He and Miss Moorman had performed it without incident in Aachen the preceding July, and then in January at the Philadelphia College of Art, but New York was at that time in the grip of one of its rare public-morality seizures, and the police were abnormally alert to vice. *Opera Sextronique* has four "arias," or acts. In the first, Miss Moorman, wearing a bikini consisting of small electric light bulbs, plays the cello on a darkened stage; in the second, she wears a topless evening gown, plays the cello, and puts on and takes off a succession of grotesque masks; the third aria has her nude from the waist down and clothed in a football uniform and helmet above; in the fourth, she is totally nude, playing, in lieu of her cello, a large, upright aerial bomb. The New York performance, at the Film-Maker's Cinématheque, on West Forty-first Street, was interrupted

by a police squadron at the end of the second (topless) aria, and Miss Moorman and Paik were carted off to jail. Miss Moorman retains a vivid memory of Paik sitting for his police photograph with a number hung around his neck and saying mournfully, "Oh, Charlotte, I never think it come to this."

Later that night, in jail, Paik remembers, he felt very calm—"like the last scene in Stendhal's *Rouge et Noir*, when Julien Sorel is so much at peace," he says. "I thought that when I got kicked out of United States I would be hero in Germany. I was happy things were ending here—all this complicated life. Well, we were released on parole next day, and a guy called from San Francisco offering us five thousand dollars to do our 'act' in a night club. We had many offers like that." They accepted none of the offers, and Paik was hard pressed to raise money for their defense. His lawyer was Ernst Rosenberger, who had represented Lenny Bruce and other prominent performers. When the case came to court, in April 1967, Rosenberger had no difficulty persuading the court that under no law could a composer of music be arrested for obscenity, but Miss Moorman was less fortunate. Although the flower of New York's avant-garde came to testify on her behalf—and in spite of the fact that nudity was rapidly

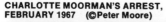

CHARLOTTE MOORMAN'S ARREST,
FEBRUARY 1967 (©Peter Moore)

becoming the obligatory scene in the New York theater—she was convicted on a charge of indecent exposure and given a suspended sentence.

The conviction, according to Miss Moorman, caused her grandmother in Little Rock to suffer a heart attack, and ended her own career with the American Symphony and as a musician for television commercials, which had until then been her main means of support. Lucrative offers to repeat the "act" in Las Vegas and elsewhere only made her feel worse about it all. Paik, too, was at a low ebb. He had been receiving small amounts of money from his family in Tokyo, but now they ceased to arrive; the family, he says, "had just lost another fortune." He owed a rather large bill to Consolidated Edison, which he couldn't pay, and he was having visa problems. It was with some relief, then, that he accepted a post as artist-in-residence at the State University of New York at Stony Brook, Long Island. Allan Kaprow, who was trying to establish a sort of avant-garde institute at Stony Brook with funds from the Rockefeller Foundation, had been instrumental in getting the assistant director of the Foundation's arts program, Howard Klein, to visit Paik's studio, and Klein and his boss, Norman Lloyd, had subsequently arranged a one-year appointment to Stony Brook for Paik. Nobody bothered him there, so he spent his time doing video experiments and writing a long report on the uses of television in the "instant global university" of the future. One of his recommendations was that television stop being exclusively nationalistic. "You simply cannot escape Camus or Sartre in a bookstore," he wrote. "But do you remember seeing a production of French TV recently?" Paik has followed his own advice—his recent *Global Groove* contains excerpts from French, German, Japanese, Austrian, and African television—and he feels strongly that if we were to see more examples of Asian television we might not misunderstand the Asian mind as disastrously as we have done in the past. Paik's report went unnoticed at Stony Brook, but it has been reprinted many times since he left there, and is looked upon within the alternative-video movement as a prophetic document.

The Rockefeller Foundation (which has no connection with the JDR Third Fund) has shown a surprising interest in experimental television. While its grants to public television have been small compared to the Ford Foundation's, Rockefeller Foundation money supports the experimental workshops at San Francisco's KQED, Boston's WGBH, and New York's WNET, all three of which cater primarily to artists working in video. From the artists' point of view, the best of

these workshops was until recently the one at WGBH, largely because of a young producer-director there named Fred Barzyk. As Barzyk saw it, television had begun to develop its unique properties in one field only—the spot-commercial message, which compresses huge quantities of information into a few seconds; in its regular programing, television was still imitating the motion picture. In 1964 Barzyk was able to persuade the management at WGBH to let him play around with his own and other people's ideas for opening things up a bit, and one of the early results was *What's Happening, Mr. Silver?*—a youth-oriented, technically innovative weekly program whose host, a British-born and unpredictable man named David Silver, once conducted an on-camera interview with a young woman while they both reclined on a large bed. The fast cuts and visual juxtapositions in *What's Happening, Mr. Silver?* reminded some viewers of the vintage output of the late Ernie Kovacs, who is now considered a sort of pioneer in the effort to shake video loose from its moorings in cinema. Barzyk wanted to go a lot further along these lines, and in 1968, when the recently established Public Broadcast Laboratory (set up by the Ford Foundation to improve the level of noncommercial-television programing) asked him to work with a selected group of artists, each of whom would be invited to come and make videotapes in the WGBH studio, he readily agreed. The project had been conceived originally by two young women, Patricia Marx (now Patricia Ellsberg) and Ann Gresser (now Ann Sherry), who brought the idea to PBL, selected the artists to work on it, and put together with Barzyk the resulting half-hour show, which was aired in 1969. The first national showing of video art on the home screen, it had contributions by Aldo Tambellini, Thomas Tadlock, Allan Kaprow, James Seawright, Otto Piene, and Paik. Paik's segment, the concluding one on the program, lasted seven minutes and was called "Electronic Opera No. 1." While an offscreen pianist played Beethoven's "Moonlight" Sonata and an offscreen Paik periodically advised viewers to close one eye or both eyes ("This is audience-participation TV"), the screen showed double and triple images of a nude go-go girl, President Nixon's face stretching puttylike as he talked about "the brilliant manager of my campaign for the Presidency," three hirsute hippies mugging for the camera, and the dancing-wave pattern looping and rolling and changing color. At the end, Paik's laconic voice was again heard, telling the viewers, "Please follow instructions. Turn off your television set."

The people at WGBH were a little surprised by the go-go dancer, but everyone there was delighted with Paik. Barzyk, of course, was

DOCTORED TV: FROM PAIK'S "ELECTRONIC OPERA NO. 1" (Mary Lucier)

naturally sympathetic to Paik's ideas about "low-fidelity TV": instead of trying always to reproduce images as accurately as possible, Paik said, one could also work to produce original television images that nobody had ever seen before. Barzyk and Michael Rice, the station's vice-president and program manager, were eager to have Paik return and work at the studio, so when Paik went to them soon afterward and said he needed $10,000 to build a videosynthesizer Barzyk and his associates got it for him. Nobody—not even Barzyk—understood clearly what it was that Paik had in mind. Paik wanted to make a machine that would let him create television images directly—without involving hordes of technicians and batteries of costly equipment. He had drawn up a rough proposal that unfolded to a length of about fifteen feet, but it made little sense to the WGBH engineers. "Nobody could really tell whether the thing would work or not—partly because nobody really understood Paik's English very well then," Barzyk recalls. "But Nam June breeds a certain kind of energy and strength. You just can't deny Nam June."

Paik spent the next year at the WGBH studios, in Cambridge, working with Shuya Abe, whom he had managed to bring to this country. Paik gives Abe full credit for the engineering of the Paik-Abe videosynthesizer: "Without him I could never have done it." It was, and is, a somewhat ramshackle mechanism ("Is sloppy machine, like me," Paik explains), which is continually being added to and improved by Paik and others. (Paik and Abe have made five models all told, one of which is at WNET's Studio 46, in New York.) What it does is to take the images relayed by black-and-white or color video cameras, sound-signal generators, and other video sources and convert them into an infinite number of color patterns and configurations. It is manually operated by means of a console with knobs, switches, and dials to control the various inputs and the changes that take place in the resulting images. With practice, one can often produce the particular images and configurations one wants, but it is also possible to let the machine generate images randomly, and Paik, who prefers process to results, and who likes to be surprised, is usually inclined to let it take that course. The videosynthesizer can be used by itself to create live programing or videotapes, and it can also be used to transmogrify prerecorded material in ways that are measureless to man.

Actually, the Paik-Abe videosynthesizer is not the only one around, or even necessarily the first—Stephen Beck, in California, and Eric Siegel, in New York, each made a similar device at about the same

time—but the Paik-Abe model was the first to be used for broadcast television. In the summer of 1970 Paik used it to produce a four-hour live show for WGBH called *Video Commune*, whose sound track was the entire recorded *oeuvre* of the Beatles, and whose imagery was provided by Paik, David Atwood, their studio associates, and a large number of perfect strangers whom Paik invited in off the street to play with the controls or to have their features melted or stretched on camera. The program was broadcast over the UHF band, rather than the stronger VHF band, and at one point the visual pyrotechnics succeeded in blowing out a transmitter. Viewer response to the program was so favorable that WGBH repeated it in an edited, one-hour version, as a New Year's Eve present to its viewers.

The video-art movement was visibly gathering steam by 1970. Dozens of artists had started to work in the medium, several universities had established courses in video, and art galleries and museums were duly taking notice. Howard Wise, the dealer, whose interest was shifting from kinetic-and-light art to art by video, had put on an extremely influential group show in the spring of 1969 called "TV as a Creative Medium," with works by twelve artists. Paik's main contribution to this show was "TV Bra for Living Sculpture," a contraption consisting of two three-inch television sets that were worn in lieu of upper clothing by the dauntless Miss Moorman and were wired to Miss Moorman's cello so that her playing generated images on the tiny screens. Paik announced that this was an attempt on his part to "humanize electronics." Miss Moorman, who believes that it is Paik's greatest work, said recently that when she performs in the TV Bra it is "a great, great feeling—so pure and romantic."

The following year, Paik and Miss Moorman demonstrated the TV Bra and Paik displayed other works, old and new, at the Vision and Television exhibition at the Rose Art Museum of Brandeis University —an exhibition that was heavily attended by students and dogs. "Television operates on a very high sound cycle, and that cycle is very attractive to dogs," Paik explained afterward. "We had nearly a hundred TV sets in the museum, and every morning many, many dogs would come." On the last day of the Brandeis show, a representative of the New York State Council on the Arts dropped in and asked Russell Connor, the museum's assistant director and the man responsible for the exhibition, to come to New York for an interview, which led to Connor's becoming the State Council's expert on grants to television artists. Paik sensed that this was a turning point in the

development of video art. The following September he went to spend the year at the California Institute of the Arts, teaching video techniques in a program run by his old friend Allan Kaprow (who had given up the East Coast for the West); somewhat to Kaprow's distress, Paik decided to leave Cal Arts at the end of the spring semester and return to New York. "I say to Allan, 'Look, every artist has once in their life their time. You had your time with happenings. Next year is video time—I have to be in New York.' "

As it turned out, Paik divided his time in 1971 between New York and Boston. Soon after his four-hour *Video Commune* show at WGBH, he and seven other artists had been commissioned by the Boston Symphony to provide visual accompaniment for a television program of symphonic highlights. Once again Paik's sequence came last on the program, and offered a fairly vivid contrast with the lyrical, predominantly abstract imagery of the other artists. He chose to work with the Boston Symphony's recording of the Beethoven Piano Concerto No. 4 in G Major, and his visual imagery for it included quick cuts of a bust of Beethoven being punched by a man's fist and of a piano (a toy piano shown in close-up, so it filled the screen) catching fire and burning to a crisp. The Boston Symphony was said to be far from pleased.

Paik spent a large part of 1971 working at WGBH on an ambitious hour-long videotape called *A Tribute to John Cage*, to mark the composer's sixtieth birthday, which was coming up the following year. Then early in 1972, when WNET reorganized its experimental workshop as the Television Laboratory and asked video artists to come in on a regular basis, Paik was among the first to be invited. He had a lot to do with the way the Laboratory was set up under its director, David Loxton. He contributed a steady flow of ideas and suggestions, and his *Selling of New York* was the first TV Lab project to be broadcast over WNET. Paik had started this opus with the notion that he wanted to show some of the good things about New York—of which he had become so fond by now that he no longer thought of leaving—but it did not work out quite that way. The program opens with a shot of Miss Moorman in the TV Bra, and then keeps cutting rapidly back and forth between Japanese television commercials and views of a television set on which a commentator (Russell Connor) is reciting facts about New York. The television-within-a-television turns up near a bathtub in which a girl is taking a bath; on a night table beside a bed in which a couple are simultaneously trying to make love and to turn the television off; in a deserted living room

where, while Connor is announcing that "the New York police force is now larger than the Army of Denmark," a burglar comes in, yanks out the cord, and steals the set. When the program was shown over WNET, in 1973, several viewers called to ask why their sets were suddenly bringing in Japanese TV; others just wanted to know what the hell was going on.

Paik's admirers at WGBH and WNET look on him as an absurdly comic and wholly engaging personality, an inventive genius, and an amazingly successful promoter of his own ideas. "Nam June is the world's best hustler," Loxton has said. "A lot of the time, I feel he knows a lot more clearly what he wants to say than he lets on—it's as though he decided not to let the bureaucracy understand him too clearly or they'd step in and louse things up." What his friends at the studios may not have fully grasped is Paik's continuing commitment to the antisystem, antiformal energies of his Fluxus period. Paik is really undermining the commercial structure of television, according to the art critic Douglas Davis, who is also a video artist. "The TV people think of him as an entertainer, but his humor is tougher than that." Paik's videotapes, up to and including *Global Groove* and the recently shown *Suite (212)*, a series of three- to eight-minute vignettes of different aspects of New York City, done in collaboration with video artist Jud Yalkut and others, are characterized by an ironic wit that is fairly glacial at times, and by all sorts of subversive assaults on familiar patterns of television viewing.

It is the same sort of comedy that pervades his Action music and his performances with Miss Moorman. Miss Moorman has admitted that she feels a little depersonalized when she is performing Paik's compositions. "Sometimes I feel Paik doesn't really think of me as Charlotte Moorman," she once said reflectively. "He looks on me as a work of his." This doesn't upset her, because she has absolute faith in Paik's artistic talent. She is extremely proud of the fact that Paik's "TV Cello," a vaguely cellolike construction of three television sets with a string down the middle, on which she uses a regulation bow to produce not cello sounds but "TV Cello sounds," is "the first real innovation in cello design since 1600." She is equally proud of the fact that when she underwent surgery three years ago and could not perform in her regular fashion for several weeks, Paik constructed a "TV Bed" out of eight television sets fastened together, on which she was able to play her cello while lying down. The totally unsmiling concentration and dedication that Miss Moorman brings to her performances with TV Bras, TV Cellos, and TV Beds—the fact that she

obviously does not see anything funny in what she is doing—contribute quite a bit to the over-all effect.

So far, Paik is one of the few video artists who have managed to bridge the gap between the gallery-sponsored, limited-distribution, "fine art" videotapes and the broadcast-oriented work of the television workshops. He has continued to show his doctored television sets and his videotapes at the Galeria Bonino. Though the gallery has yet to sell a Paik TV set, one was stolen from his latest show there, in the winter of 1974, and his "TV Buddha," an authentic and rather fine eighteenth-century Japanese Buddha figure that sits contemplating its own image in a closed-circuit television set, could easily find a buyer if Paik were willing to sell it, but he isn't. Paik's delicate, calligraphic ink drawings, which look like television screens after the picture has been lost because of technical difficulties, are being snapped up by European and American dealers, however; his videotapes are in great demand around the country; and a retrospective exhibition of his work—the hallmark of an artist's having arrived—was presented at the Everson Museum, in Syracuse, in 1973.

The "fine art" video people tend to feel that Paik, for all his importance as a pioneer, is not really a very serious artist. A great deal of the video art that is to be seen in galleries is almost unbelievably boring—endless repetitions of simple actions such as a hand trying to grab a falling object, or the artist lying on the floor of his studio and talking to himself. Paik's videotapes, by contrast, are often dismissed (or appreciated) as mere entertainment. Paik understands this, and is not bothered by it. "I have a theory about American avant-garde art," he said once. "Serious avant-garde art here is always in opposition to American mass culture. In a way, mass culture conditions serious art. For instance, why is it that only in America such intensely boring music has been produced? And films? Because Hollywood is doing too good a job, I think. Popular culture is setting the rules, so you have to define what you do against what they are doing. We want to make more crude if they are perfect, we want to make more boring if they are exciting—you know? Of course, Oriental music is boring, too. But Oriental boring music is wet, moist—very spiritual. American is very dry, like baseball. American boring music is not at all spiritual. La Monte Young tries his best to dig in Oriental aesthetic, but the more he tries to be Oriental the more he becomes American, in the good sense. Another thing—Oriental music was always for the aristocrat, was always rich man's thing. Now America has reached stage where most people are aristocrats. Much richer than Europeans,

anyway. Americans need not be entertained every second, because they are so rich. They think art can be kind of extension of parties. My first concert at New School here really crowded like hell. I couldn't do anything. People were just talking together, there was no still moment. I thought it was big mistake, big failure, but afterward people say it was very big success *because* so many people there, including notables. America has in a way this very rich attitude that makes boring, long music possible. But I'm not writing boring music that much. The reason is that I come from very poor country and I am poor. I have to entertain people every second.''

Paik himself feels that video art still has a long way to go before its potential emerges. What is taking place is a widespread exploration of the medium by various groups—visual artists, film-makers,

MOORMAN AND TV CELLO
(Carl Samrock)

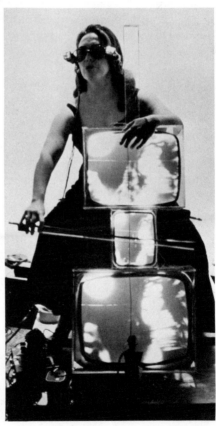

MOORMAN AND TV BRA
(©Peter Moore)

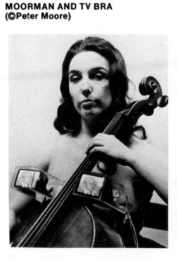

dancers, musicians—each of which approaches it from a different point of view and often with quite different expectations and a quite different goal. Each group tends to feel, of course, that its approach is the only valid one. This situations reminds Paik of an ancient Chinese story about a monkey who thought he was dancing on the top of the world only to find that he was dancing on the Buddha's palm.

"Everyone is trying to define what video is," Paik has observed. "Art critics struggle with that a lot. But I think best thing is not to try to define video. In New York, every art movement is destined to die in five years, but I would like to save video from such quick obsolescence. It is more than fad."

In the future, Paik is convinced, all art will have as its prime function the movement of information. In his view, the artist must become a "humanizing agent" within the vast and proliferating network of information technology, and he still thinks that the best way for this to happen is for the artist to give up his self-serving ego, to become more like the anonymous cathedral builders of the Middle

NAM JUNE PAIK (Carl Samrock)

Ages. Although Paik's theories about the future of art and of video technology are sometimes dismissed as so much visionary claptrap, his theorizing is based on a solid intellectual groundwork. A voracious reader of technical data, he is also well informed about contemporary thinking in many different fields, and his studio on Mercer Street, in SoHo, is adrift in scientific papers, television-industry studies and reports, clippings from American, European, and Japanese newspapers and magazines, and books of all kinds—not to mention television sets in various stages of decomposition or reconstitution. When he wants to cite a fact or a statistic, he can go instantly to the proper stack of papers and dig it out (often causing the stack to subside laterally across the floor). Paik says that by 1985 the picture telephone will be in use throughout the world, in color; by making most travel for business reasons unnecessary, it will contribute substantially to solving the energy crisis. (He has proposed topless answering services for understimulated executives.) The videotape cassette, which is already here, will make possible Paik's "global university"—a place where vast quantities of up-to-date information on every conceivable subject can be stored, with computers to provide instant retrieval, so that a student of any age can pursue his own education at his own pace.

Even more far-reaching effects on society, Paik believes, will result from the development of cable television. "It will definitely come," he said recently. "Rand Corporation thinks cable is very good for long-range investment. Nobody really making money in cable now, but cable lobby in Washington is *very* strong—they snap up congressmen like nothing." In a recent report to the Rockefeller Foundation, which has retained him as a consultant on communications, he pointed out that in the late 1940s and early 1950s, when the Federal Communications Commission was offering relatively inexpensive licenses for television stations on the strong VHF band, the intellectual and academic communities looked the other way; consequently, nearly all the licenses went to commercial interests. With the advent of cable television, he went on, approximately sixty new channels have become available for programing, and, because of the superiority of cable transmission, the signal on each of these is at least as strong as the signal on VHF. Will the intellectuals continue to ignore this powerful resource? Paik would like to see at least one new cable channel in each community set aside for work by video artists. Other channels could be reserved for municipal or community affairs, for children's programing, for theater or music or dance. There could even be all-

Mozart stations, as Paik once suggested, or all-Beethoven, or all-Cage. But unless somebody acted rather quickly, he warned, history would repeat itself and the licenses would go once again to the commercial interests—the polluters of the videosphere. "I wish all our consultants could be as productive as he is," Howard Klein said a short time ago. "With all his whimsicality, Paik can go straight to the essentials of complicated matters with great logic and force."

Paik, of course, has had his problems in dealing with the establishment. "Only reason I survived this long at WNET is I had underground outlet," he conceded recently. "I have a lot of frustration to work within system A *lot* of frustration. So when I get mad at them I don't fight—I yield to them, and then go and do some stupid thing in small place which satisfies me so that I can work with them again. Underground outlet is my safety valve. I like being world's most famous bad pianist. But I also like to do NET because it is important, is where I can maybe influence society."

After a moment's reflection, Paik went on, "We are now at stage of ancient Egypt with hieroglyphics. Until recently, TV equipment is so expensive that only the priests can use it. And there is *constant* effort made by networks and by TV unions to keep production costs high. That is classical way of monopoly capital—you know? I want to find ways to cut costs so it can be opened up to others—many others. Now we have color portapak—costs three thousand dollar in Tokyo, six thousand here, but will come down. And with use of computers cost of editing videotape will become much cheaper. Problem is not really socialism or capitalism but technology, you know—how we manage that. For instance, technological forecasting, future-research —I am very interested in that. They *need* us artists, to make that sort of information available to public. Even *New York Times* will not print Rand Corporation Report, because it is so boring. Like McLuhan say, we are antenna for changing society. But not only antenna— we also have output capacity, capacity to humanize technology. My job is to see how establishment is working and to look for little holes where I can get my fingers in and tear away walls. And also, try not to get too corrupt."

TIME TO THINK

Fifteen minutes before the curtain goes up at the Brooklyn Academy of Music, the cast assembles on the stage—144 people, who join hands and stand quietly in a circle, feeling the energy build. On the other side of the curtain, at the front of the stage, Queen Victoria (Cynthia Lubar), wearing a diamond tiara, faces the incoming audience in a white gown with a red sash, her arm resting on a marble column at stage left. Precisely at seven-twenty, the Queen begins a strange, disjointed monologue, which she seems to be enunciating in at least four different voices. ("You see, what I did was to revamp the pineal movements into wholescore glandular recollections. Arctimes besought the wholar universe perenially abiding. . . .") Tonight's is the fourth and final performance of *The Life and Times of Joseph Stalin*, Robert Wilson's twelve-hour, seven-act play, which the program calls an "opera," and which will run continuously, with six intermissions, until seven o'clock in the morning.

Cindy Lubar's speech can be heard backstage, where the cast in its circle waits quietly. The circle parts, and Wilson enters, leading a fourteen-year-old boy, Christopher Knowles, by the hand. Wilson is very tall (six feet four) and a trifle awkward, as though, at the age of thirty, he had not quite grown used to his height. He has on a double-breasted gray suit, a white top hat, and white gloves, and is wearing a Stalin mustache. After studying his shoes for a few moments, he looks rapidly around the circle and speaks in a low voice. "Please be careful," he says. "I wish everybody would try tonight to be a little more reserved. Some of you have been playing to the audience, and they've been responding, but that's not really what . . ." His voice trails off. "And don't forget to listen, listen, every moment, to everything that's happening." Another pause. "Okay, let's have a good show."

The cast disperses backstage. The man and woman playing the Prince and Princess step out in front of the curtain, stand for a moment in the white spotlight, then descend into the aisle and go to

their box at stage right. Wilson comes out slowly, drawing Christopher Knowles behind him. They stand in front of the curtain, neither one looking at the other, and begin a dialogue:

WILSON: Emily what?

KNOWLES: Emily likes the TV.

WILSON: Because?

KNOWLES: Because Emily watches the TV.

WILSON *(sharply)*: Because?

KNOWLES: Because Emily likes the—

WILSON: *What?*

KNOWLES: —the TV. Because Emily likes the TV. Because Emily watches the TV . . .

The audience's laughter is uneasy. Although the dialogue sounds as precisely timed as an ancient vaudeville routine, the boy is not an actor; he is a beautiful child who has suffered brain damage. He and Wilson move to stage left, toward Queen Victoria. Wilson breaks off the dialogue, turns to the audience, and declaims in a piercing voice, "Ladies and gentle . . . men! *The Life . . . and Times . . . of . . . Joseph . . . Stalin!*" At the word "Joseph," the curtain goes up.

Sheryl Sutton, who plays the Byrdwoman in *Stalin*, once said that she liked performing in Wilson's plays because it gave her so much time to think. Wilson would like his audiences to feel the same freedom. "One of the things I never liked in the theater of the 1960s, when I first came to New York, was that there was never any time to think," he explains. "Everything was so speeded up. It was never natural, and there was no element of choice—you had to see what the playwright and the actors wanted you to see. It seemed important to me for the audience to have a more interesting experience than that." Over the last few years Wilson has certainly provided audiences with experiences unlike any others they have had in the theater, and the reactions to his work have become fairly predictable. A sizable number of those who came to *The Life and Times of Joseph Stalin* left after the first act, offended by the apparent absence of narrative, the repetitiousness, and the slow movement, and, perhaps, by the dawning recognition that they were being invited to think—or at least to fall into a trancelike state of mind in which the imagination could run free. Others stuck it out for several hours, beguiled by the sets, the costumes, the lighting, the music, and all the extraordinary events, personages, and spectacles with which Wilson fills his stage. A third

group—and in Brooklyn a surprisingly large one each night—settled without much difficulty into the dreamlike atmosphere of the work and stayed the entire twelve hours, dozing off here and there, reviving themselves with coffee and crêpes served in the lobby during intermissions, and, no doubt, going home at seven in the morning with interpretations as mixed and multifarious as the long night's activities onstage.

The Life and Times of Joseph Stalin is—or, rather, was, for it will probably never again be seen in exactly the same form—a sort of retrospective of Robert Wilson's stage work up to that point. Since then, he has gone on to do a new work called A Letter for Queen Victoria—a mere three-hour curtain raiser—which had its premiere at the Spoleto Festival in June 1974, subsequently toured Italy and France, and ran for nearly a month at the ANTA Theatre in New York in the spring of 1975. Although A Letter for Queen Victoria was considerably more verbal than Wilson's previous work, it was no more susceptible to rational interpretation. All Wilson's plays come out of his own inner imagery, or that of people who are close to him, and they must be experienced rather than understood. The first four acts of The Life and Times of Joseph Stalin drew their basic material from Wilson's first three major productions: The King of Spain, which was presented at the Anderson Theatre in New York for two nights in January 1969; The Life and Times of Sigmund Freud, which had two runs of two performances apiece at the Brooklyn Academy later that year; and Deafman Glance, which was seen first at the University of Iowa in 1970, then at the Brooklyn Academy (the customary two performances) in 1971, and subsequently in France, Italy, and Holland. Much of the material in Acts VI and VII was developed originally for "KA MOUNTAIN AND GUARDenia TERRACE," Wilson's offering at the 1972 Festival of Arts in Shiraz, Iran, where it ran continuously, to the amazement of Islam, for seven days and seven nights. All these elements were redesigned and restructured for the Stalin play, though, and much of the material was entirely new.

Wilson and his core group of about twenty-five close associates, who go under the name of the Byrd Hoffman School of Byrds, began to work intensively on the twelve-hour Stalin play about two months before the premiere in Brooklyn. Early rehearsals took place in a loft building on Spring Street, in lower Manhattan, which serves as headquarters of the Byrd Hoffman Foundation, a nonprofit organization, and as living quarters for Wilson, the dancer-choreographer Andrew de Groat, and a fluctuating number of Byrds. Notices were placed in

The Village Voice and elsewhere asking for volunteers ("No Previous Theatre Experience Necessary—Looking for Alexander Graham Bell and Wilhelm Reich"). None of the eventual performers were professionals. They ranged in age from Duncan and Diana Curtis's seven-month-old son, Devin, to Wilson's eighty-seven-year-old grandmother, Alma Hamilton, who came all the way from Waco, Texas, to see the play and found herself cast in rather prominent roles in four of its seven acts. Among the other players were suburban housewives, students, artists, musicians, a live boa constrictor, and five children from the New York Public School for the Deaf. A columnist for the Staten Island *Register* came around one day to interview Wilson and was recruited to appear in the second act; his wife was also recruited, for a bigger role. In the first three performances, the part of Sigmund Freud was played by Michel Sondak, a designer and woodworker whom Wilson happened to see passing through Grand Central Station one day in 1969. Somewhat alarmed at being told that he resembled Dr. Freud and that Wilson wanted him to act in a play called *The Life and Times of Sigmund Freud*, Mr. Sondak walked quickly away. Wilson gave chase and cornered him in a cafeteria. Again Mr. Sondak demurred, but he gave Wilson his telephone number in Far

ROBERT WILSON (Martin Bough)

Rockaway, and Wilson went out there the following week and got him to agree. Mr. Sondak apparently enjoyed the experience, for he accepted Wilson's invitation to repeat his performance in *Stalin*. He was unable to come to the fourth performance, however, and his part that night was played by Jerome Robbins.

The Byrd Hoffman School is not a repertory group like the Living Theatre, whose members live a form of communal life. According to George Ashley, the *Stalin* company manager and one of the play's more active performers, it is more like an extended family. "We're very close sometimes, when a production is in the works, but then most of us want to get away and be on our own," he says. Some of the members have homes and families, and some who have been active in the past have moved on to other things. There is about the group, nevertheless, a definite sense of cohesion and shared experience. As the opening date of *Stalin* drew closer, the Spring Street loft became increasingly crowded, and life there got daily more hectic. As the cast grew, rehearsals had to be moved out of the loft—first to the La Mama Third Street Workshop, in the East Village, then to Jerome Robbins' American Theatre Laboratory, on West Nineteenth Street. And, of course, there was the matter of money. The Byrd Hoffman Foundation receives grants from the National Endowment for the Arts, the New York State Council on the Arts, and other public and private donors. In the case of *Stalin*, the cost of all the scenery and most of the costumes—major items in any Wilson production—was being donated by the Gulbenkian Foundation, in Lisbon. Under the arrangement that Wilson had with Harvey Lichtenstein, the Brooklyn Academy's director, the Byrd Hoffman Foundation was responsible for its own production costs (sets, costumes, props, and fees to professionals like Fred Kolouch, the set designer, and Laura Lowrie, the lighting director), while the Academy would assume the costs of backstage construction and of the stagehands' salaries, and contribute a modest outlay for promotion. Altogether, the total budget was about $120,000—a fifth of what it would cost to mount a medium-sized Broadway musical.

Wilson's main concern was that he might not get an audience. In Copenhagen, where *Stalin* had had its premiere in 1974, there had been one night when the actors discovered, shortly before 1:00 A.M., that they were playing to a totally empty house. Advance sales at the Academy were not encouraging. "Do you think it's the title?" Wilson would ask. "Are people put off by Stalin?" In interviews, he usually explained that the twelve-hour play was centered on a single incident

—the death of Stalin's first wife. This, he said, had brought about a fundamental change in Stalin's career, and it also marked a fundamental change in the direction of the play; the death occurred in the fourth act—at the play's epicenter—and everything led to it or away from it. Wilson also admitted readily that he knew very little about Stalin—next to nothing, in fact. On other occasions, he would say that the play was really about our own life and times, over which historical figures such as Stalin, Freud, and Queen Victoria still exerted a powerful influence. At one point, his play had carried the alternate title *The Life and Times of Dave Clark*, mainly because the Gulbenkian Foundation had indicated that in Portugal there would be a problem about donating funds to anything with "Stalin" in the title. Dave Clark was an obscure Canadian criminal whom Wilson had heard about. Two weeks before the opening, Wilson confided to a friend that he could just as well have based the play on Clark, and that "all those stories and associations" with Stalin probably weren't necessary. Wilson can be disconcertingly diffident about his work. A perfectionist who is constantly and intensely absorbed by the minutest details of costume and lighting and stage movement, he is bored and annoyed by people who want to know what it all means. "Why do reporters always ask such dumb-dumb questions?" he asked a reporter from the *New York Post*, who printed his query in her story the next day.

Act I: The Beach

On a bare stage covered with fine sand to a depth of several inches, the Byrdwoman—Sheryl Sutton, wearing a long-sleeved, high-neck, ankle-length black Victorian dress, and holding a stuffed raven in her right hand—sits motionless in a chair. A man in red shorts and a red undershirt is seen from time to time running across the rear of the stage against a backdrop of blue sky and clouds. The sound of gulls comes faintly from somewhere in the distance. Gradually, other figures appear. Two girls and a boy, nude to the waist and wearing baggy trousers, perform a series of slow movements. A child daubs red paint on the back of the boy, then sits down to play in the sand (which is actually vermiculite, a powdery mixture that looks like sand but weighs much less and can be quickly rolled up in a ground cloth during the intermission). A tall man in striped pajamas (Wilson), with a stuffed bird on his left shoulder, hops backward across the stage. A soldiers' chorus advances from the wings, making a guttural roaring sound and gesticulating (five of the soldiers are deaf children). Queen

Victoria comes out and makes the same gestures and sounds, which cause the soldiers to disperse and go off, saying "Okay." A giant fake turtle crawls across, taking twenty minutes to do so. A man enters carrying a live five-foot snake; he hands the snake to a follower, grasps a rope, and is pulled aloft out of sight. There is also a sort of "Greek chorus," whose heads poke up through holes in the stage apron and whose comments on the action reveal rather little, on the whole. Most of them repeat only the words "Click," "Collect," and "Collecting," while the most prominent chorister, an Iranian girl with thick dark hair and a liquid voice, speaks entirely in Parsi. And throughout this act and the two acts that follow it a straight chair suspended from the ceiling on a wire descends by invisible degrees.

Toward the end of Act I, which lasts a little more than an hour, events reach a climax of sorts. Sigmund Freud and his daughter, Anna, walk on, following the path of the turtle. A figure identified as Heavyman, in a padded white suit, does an extraordinary whirling dance, raising clouds of golden vermiculite dust. Soon after this, the lights dim and, to the music of "The Blue Danube," sixty Southern mammies—in blackface, wearing long red skirts, gray blouses, white aprons, and pillows front and rear—do the famous Wilson mammy dance. It is hard to believe, at this particular moment in history, that anyone but Wilson would have thought of putting sixty black mammies on the stage. Even those who dislike his work, though, are inclined to concede that the mammy dance is very funny. It is also, for unfathomable reasons that go beyond the aesthetics of lighting and costuming and choreography, almost unbelievably beautiful. The scene, in fact, has led some of Wilson's more implacably vanguard critics to accuse him of becoming a mere crowd-pleaser.

When the mammies have waltzed off, the Byrdwoman is left alone onstage. She has been sitting without moving for more than an hour, now and then making a soft sound like a foghorn. The audience, watching her, grows very still. She stands up, so slowly that the movement is virtually imperceptible. She moves forward to a little square table at the front of the stage and—slowly, slowly—places on it a small green statuette that she has been holding, unseen, in her left hand. Slowly, she raises her eyes to the audience, which has maintained total silence. The curtain comes down.

Entr'acte

Following each act of *The Life and Times of Joseph Stalin,* an activity of some sort takes place on the forestage. As the audience drifts in

from the first intermission, Queen Victoria—Cindy Lubar—is sitting in a carriage that moves from left to right in front of a painted backdrop of a Victorian town house, whose windows, one by one, appear to burst into flames. A man stands at the one window that does not burn, looking through a quizzing glass. While a backstage pianist plays an insipid little English music-hall ditty called "The Moth and the Flame," the Queen, who now is dressed in funereal black, gives voice to extraordinary sounds: rich, operatic contralto notes that suddenly break into shrill screams, which, in turn, become frenzied yappings suggesting a dog whose tail has been caught in a screen door. (Sitting at his vast lighting board in the wings, the head electrician murmurs, "Hit it, Cindy! I'm going to give that kid a pitch pipe for Christmas.") After an interval of silence, her strangled cries erupt into new paroxysms of shrieking. It sounds like several people, but Cindy Lubar is alone on the stage.

Again the laughter is a trifle uneasy. At times, Cindy's screaming sounds out of control. But Cindy, who had a frightening breakdown in Paris a year or so ago, is in complete command of her vocal resources. A dark-haired, round-faced girl who bears a rather striking resemblance to Queen Victoria as a young woman, she is one of the company's most arresting performers. She started coming to Robert Wilson's classes in body movement and body awareness at the Byrd Hoffman School in 1969, when she was fifteen. Her parents were then in the process of separating. Cindy hated school, and lived for Saturdays, when she would come in from White Plains to attend Wilson's classes. "When I was in school, I always felt I wanted to learn how to think," she has said. "I wanted to go to college and study philosophy." Instead, in her first year at a small college in Florida she dropped out to be in the Iowa production of *Deafman Glance*, and she never went back. She has found that she can do a great deal of thinking onstage when she performs in Wilson's plays, and that the images in the plays seem to relate in all sorts of ways to her own life. This is a matter of concentration, she says, not just daydreaming. Lately, she has begun to write, and some of her stream-of-consciousness texts (the "pineal movements" speech in Act I, for example) are being used in the play. Like many in the group, she has no interest in performing or writing for anyone except Wilson. Cindy believes that her bizarre vocal abilities grew out of Wilson's body-movement and body-awareness classes. "I don't know anything more about it than that," she has said. "I don't know how it came about, or what it means, or anything." The same is true of her writings,

which seem to be generated more or less automatically, and which she understands no better than anyone else. She has read and reread the diaries that Queen Victoria wrote between the ages of thirteen and eighteen, but the Queen's mature character does not particularly interest her.

In a final explosion of shrieking, the Queen's carriage exits at stage right.

Act II—The Victorian Drawing Room

Some of the images that appear in Wilson's plays go far back into his childhood. The Byrdwoman, for example, has been with him for as long as he can remember. ("I just know that a very long time ago I had this image of a woman on a beach in a black Victorian dress.") The King of Spain can be dated more precisely. Wilson remembers his second-grade teacher in Waco asking the class what each one wanted to be when grown up; there were the usual replies—nurse, fireman, housewife—until she got to Wilson, who said, "The King of Spain." The teacher noted this on his next report card, with the suggestion that this child had problems.

The drawing room of Act II (the act is based on Wilson's 1969 *The King of Spain*) was once described by Wilson as an old, musty room in which a number of odd and dissimilar characters come together without actually meeting. From time to time, pianist Alan Lloyd plays snatches of Bach, Scarlatti, Couperin, and his own compositions. Through a floor-to-ceiling gap in the rear wall of the stage we can see back to the beach landscape of Act I, where the red runner flashes by at irregular intervals. Act I was an act of passage, with figures continually moving into and out of the playing space. Act II is an act of accumulation—the characters enter and remain onstage, although they remain, for the most part, oblivious of one another. Three gentlemen come in singly. Stalin's first wife moves about restlessly. A small boy in knee pants and suspenders stands on a low stool. A middle-aged woman in a black leotard crawls in on all fours. Another woman holds a boot and talks in Italian. A third describes the landscape in Iowa. A walrus saunters in, fanning himself with a pink fan. Wilson's grandmother comes forward and tells a story about how she was nearly burned to death at the age of five down in Mississippi; her story concluded, she raises her arms and delivers five extended, reverberant, and surprisingly melodic screams. Freud appears with Anna, and they have a meeting with Joseph Stalin (the

only social event of the act). As the two men shake hands, Stalin says "Hmm." The act lasts about an hour and a half. At the end, the players move offstage in procession, leaving only Wilson's grandmother and the King of Spain, who has been sitting out of sight in a high-backed chair facing the rear of the stage. Now the King of Spain sings a little dirge and rises slowly from his chair. He is grotesque, beastlike. He comes forward, raising his huge and misshapen puppet head to confront the audience just as the curtain falls.

Until the original production of *The King of Spain*, in 1969, Robert Wilson was not really sure where he was going. Born and brought up in Waco, the son of a moderately successful lawyer, he was on the verge of graduating from the University of Texas with a degree in business administration when he decided that he wanted to study architecture instead, and came East to enter Pratt Institute, in New York. He did get his architectural degree from Pratt, in 1965, but by then he was spending most of his spare time painting. During this period he supported himself mainly by teaching classes in body movement and body awareness, using methods he had learned some years before while working with brain-damaged children in Texas. "I worked with a very amazing woman out there," Wilson has recalled. "It was just after I got out of high school. She was a dancer. She had worked out a series of exercises intended to activate brain cells in brain-damaged children—exercises based on the primary states of physical activity. The theory was that if we don't master these primary movements in infancy we won't be prepared for more complex movements later on. I worked with her for nine months, teaching very simple things like turning the head to the right and to the left, looking at the right hand and then the left hand, and so forth."

When Wilson came to New York, he found that his ability to work with handicapped or deprived children was much in demand. He was even invited to lecture at Harvard. He became a consultant to the New York City Board of Education and the Department of Welfare, and later was appointed a special instructor in the public schools, working with disturbed children. He also put together a class in movement for neighborhood children in the Bedford-Stuyvesant section of Brooklyn, where he lived at first. After he graduated from Pratt, his activities in this field continued to expand. He worked with the aged and the terminally ill at Goldwater Memorial Hospital, on Welfare Island; with private-school children in New Jersey and with public-school children in Harlem; with suburban housewives and

older people at the Summit Art Center, in New Jersey. All his work involved getting people to discover, or rediscover, their own particular "vocabulary of movement." Although he had had no formal training as either a dancer or a therapist, Wilson had an extraordinary capacity for establishing contact with people, for getting past their habitual defenses, and for creating a group atmosphere that was free of tensions or competitiveness.

Robyn Anderson, a young University of Connecticut graduate who was working at Goldwater Memorial Hospital when Wilson came there, and who now dances and acts in his plays (she is Anna Freud), remembers how amazed she was by Wilson's ability to get through to aged patients who had not spoken to anyone for months or years. "He could persuade them to listen to the sound of the heat in the pipes, or to watch the plants grow in the solarium," she recalls. He even organized a "dance" piece for iron-lung patients. He built a construction that hung from the ceiling, with dangling strings that a patient could hold in his mouth and pull, to control the lighting and the movement.

In his classes, Wilson's teaching was almost entirely intuitive and nonverbal. Robyn Anderson well remembers the first workshops she attended at the Spring Street loft: "For a while, I had no idea what he was driving at. People would come and spend half an hour or an hour just walking from one end of the loft to the other. He would tell us to walk toward a particular point in space and then to walk away, still being aware of that point. Sometimes, only one or two people would show up, sometimes as many as twenty. Once, I was the only person who came. Bob was sitting in a chair. He sat there absolutely still for twenty minutes or more. I began to feel uneasy, and even a little frightened—what sort of an ego trip was he on? But then he started slowly—very slowly—to get up, taking maybe fifteen minutes to do it. And suddenly I saw all sorts of things. It was like the complete evolution of man going on there. He was communicating *dozens* of things with his body."

Wilson's parents were not very enthusiastic about the way his career was developing. His father, who had always wanted him to be a lawyer, was somewhat impressed when, in 1961, an art gallery in Dallas gave Wilson a show, and sold every picture, but by this time Wilson had virtually abandoned painting for theater. "The real reason I stopped painting was that the images in my head were so much richer than what I could get on the canvas," he said once. Theater was by

no means a new interest for Wilson, although, being a nonreader, he had little or no knowledge of theater history. (The one book he cites as having had an important effect on his thinking is John Cage's *Silence*.) Starting when he was twelve, he had written and put on dozens of plays in the family's garage in Waco; he had run a children's-theater workshop sponsored by the University of Texas; he had designed the sets and costumes for several Off-Off-Broadway plays, including the giant puppets for the original production of Jean-Claude van Itallie's *America Hurrah*. Wilson's early theater pieces in New York were all based on nonverbal, bodily communication in some form, and thus came closer to avant-garde dance than to most forms of theater. He put on a number of somewhat minimal works, and then, in 1968, at the loft on Spring Street, *Byrdwoman*, in which people bounced on boards, leaned against wires, and otherwise disported themselves in an environment resembling a chicken coop. This was followed by *Alley Cats*, which featured Wilson, the dancer Meredith Monk, and forty other performers in long fur coats, and which was presented at the Loeb Student Center at NYU. Some of the visual elements of these apprentice works, such as people in long fur coats and people leaning against wires, have continued to turn up in his subsequent works.

About this time, Wilson also made contact with Jerome Robbins. Robbins had recently established his American Theatre Laboratory, an experimental project, financed by a grant from the National Endowment for the Arts, to explore new ideas and directions in theater. He invited Wilson to join the group as a designer, and then, after finding out about his work with children, asked him to lead a class at the lab in body movement. Robbins later helped with the expenses of *Alley Cats*, and has remained, ever since, one of Wilson's closest friends and most enthusiastic supporters. When Wilson first came to Robbins's lab, the group there was working with elements of Japanese No drama. The exaggerated slow movement that later characterized Robbins's ballet *Watermill* has sometimes been attributed to the influence of Wilson, but what seems more likely is that the two men were approaching, from different directions, similar theatrical ideas.

In the late 1960s Wilson's ideas became more ambitious. Having spent the summer of 1966 working with the architect Paolo Soleri in Arizona, he felt the urge to build something outdoors—something big. Through a former classmate at Pratt, he got a commission from the Grailville School, in Loveland, Ohio, to build a $1200 "environment-theatre-sculpture" of telephone poles. He used 576 poles in all, of various lengths, and sank them in a wheat field, so that the square

"sculpture" started at two and a half feet and rose to fourteen and a half feet. The wheat farmers were puzzled, but the structure, called *Poles*, has since been used as a site for weddings and other festive gatherings, and, Wilson says, "it will probably be there for a long time."

Wilson had also been thinking that it might be nice to put together a large-scale theater piece, using as performers some of the people from his various body-movement classes. He had no difficulty finding volunteers of all ages for what became *The King of Spain*. The real problem was finding money and a theater. He had financed *Byrd-woman* mainly by writing checks on nonexistent bank balances; the checks bounced, but by then he had what he needed and could pay the money back out of ticket sales. *The King of Spain* was too big for such tactics. He needed a large theater for the set he had in mind. Near the end of the play, moreover, Wilson wanted a cat to walk across the front of the stage—a cat so immense that only its legs would be visible. Jerome Robbins, who was helping to finance the production, was dubious about the cat legs. They would require a specially constructed track above the stage, and a system of pulleys, and at least eight people backstage to work the apparatus; the whole thing would be hugely expensive. "About two weeks later," Robbins recalls, "I asked Bob how the big cat was coming. He said, 'I've got the fur.' He'd gone out and bought forty yards of imitation fur, with the idea that you had to start somewhere. One of the inspiring things about Bob is his complete trust in his own images. The cat legs were built."

For $400 (which represented every cent he had), Wilson was able to rent, for two nights, the Anderson Theatre—big, old, and musty; just right for the atmosphere Wilson had in mind—on Second Avenue at Fourth Street, and the cat legs were installed, after a couple of near-accidents. However, the cat-leg assembly fell to pieces in Paris during the Byrds's last European tour, and it was not used in *The Life and Times of Joseph Stalin*. It would have cost too much to rebuild. Everyone regretted the loss, especially George Ashley. "That was such a fine effect," he said sadly. "The gigantic cat walking through the drawing room, and nobody paying any attention."

Entr'acte

A cowboy climbs out of one of the holes in the stage apron carrying a guitar. He sits with his legs in the hole, strums, and sings "I'm Thinking Tonight of My Blue Eyes." Wilson appears at stage right

and echoes him with loud squawking sounds. They are old buddies, these two, classmates at Pratt. Duncan Curtis, the cowboy, whose father is the head of George School, in Newtown, Pennsylvania, lives now, with his wife and baby, in British Columbia in a cabin he built himself on some wilderness land that the Byrd Hoffman Foundation acquired in 1972. Wilson and some of the others spend time up there in the summers, working on new material, building things, reading, writing, cooking, and meditating, but Duncan and Diana Curtis live there the year around. They like the isolation. The place is fifty miles from the nearest town.

Wilson's original idea for this entr'acte was to have Dan Stern, another friend, stand in one of the holes and talk to the audience about his work with very young children. Dr. Stern, whom Wilson met through Jerome Robbins, is an experimental psychiatrist at the New York State Psychiatric Institute, and his work has had a profound effect on Wilson's thinking. Dr. Stern's films of babies and their mothers, shown in extreme slow motion, disclose a world of gestural communication that is not visible otherwise. To take an example that Wilson refers to again and again: A baby cries, and the mother reaches to pick it up; what we see with our eyes is the large movement, the tender gesture—but when the film is shown in slow or stop motion, frame by frame, we can see that the mother's initial reaction, in almost every case, is to make a *lunge* toward the child, and that the child's reaction is to recoil, in what looks very much like terror. "So many different *things* are going on," Wilson says. "And the baby is picking them up. I'd like to deal with some of these things in the theater, if that's possible. I guess what I'm really interested in is communication." Dr. Stern wanted to accept Wilson's invitation to be in the play (his name is even listed in the program), but he could not spare the time. He is extremely interested in Wilson's work. "Mothers and children play all sorts of exaggerated verbal-visual games," he has said. "It's like a sort of dance that precedes speech, with specific action and reaction going on all the time. In some ways, it's remarkably like what Bob is doing in the theater—the way he works with people. In fact, when I see what he's doing, sometimes I wonder why I'm doing what I do."

Act III—The Cave

Those in the audience who have seen *The Life and Times of Sigmund Freud* tell their friends to be sure and stay for Act III—the

animal act. The setting is a dark, shadowy cave. An old woman (Wilson's grandmother) in a tattered, multicolored garment lights an oil lamp, and in the flickering light we begin to make out familiar shapes. The King of Spain sits on a pile of straw, with the Byrdwoman at his side. Near them lies a great ox. Gradually, other animals appear from the shadows and lie down in the straw: lion, black bear, ape, turtle, polar bear, walrus, fox, ostrich. The costumes have all been made by various Byrds; the movements are wonderfully feral. Alan Lloyd's score, which he plays on a piano in the wings, is quiet, repetitive, ritualistic. The old woman sits on a stool near the cave mouth. In the bright daylight outside the cave, young men and women, nude to the waist, crawl back and forth with animal grace, slowly stretching their muscles and nuzzling one another. A heavy vertical bar falls suddenly into place at one side of the cave mouth. After a time, those outside the cave begin to stand erect—awkwardly at first, and then more naturally. Another heavy bar falls into place. The animals inside the cave quietly shift their positions. The small boy in knee pants and suspenders enters the cave, lies down, and goes to sleep.

Outside, the now fully erect creatures move about more quickly; soon they will start to run back and forth across the entrance, uttering shrill cries. Black-clad people from another time move past the cave mouth in a slow procession—priest, aristocrat, *grande dame*, executioner—the costumes stiff and elaborate, some with long trains dragging behind. Three ladies in white dance. The procession continues. Every few minutes, another bar hurtles down in front of the entrance, separating the cave's inhabitants from those outside. At the end, the entrance is closed; the cave is a cage. The men and women in the daylight slowly gather around the cave mouth, put on masks, and look through the bars; it is a scene out of Goya. And now Sigmund Freud comes out of the shadows, walks slowly to the center of the cave, and sits in the chair that since the beginning of the play has been descending imperceptibly on a wire from the flies, and has just at this moment touched the floor. Nothing moves for several minutes. The boy in knee pants begins to cry. On his thirteenth cry, Anna Freud runs in behind Freud and makes a dramatic gesture above his head, and as she does so a pane of glass falls and shatters on the stage. Curtain.

Interpretations come almost too readily. Primitive innocence and decadent civilization. Man cut off from his animal nature (while

Freud looks on). Plato's cave and the shadows of images. When *The Life and Times of Sigmund Freud* was presented at the Brooklyn Academy in 1969, Richard Foreman, an avant-garde dramaturge of Wilson's generation, described this act in *The Village Voice* (the first serious critical piece on Wilson's work, and a perceptive one) as a "20th-century Nativity scene," and called the play "one of the major stage works of the decade." Tonight, the spectators respond to it enthusiastically. There is a crescendo of applause, laced with loud "Bravoes." There is also a rush for the Lepercq Space, on the second floor, where dinner is being served. It is after ten-thirty, and the fourth act, as many in the audience are aware, will run more than two hours.

In his dressing room backstage, which he shares with Andy de Groat, Wilson is uncertain about tonight's performance. It seems to him to be going almost too smoothly; there are not enough "scratches," as he calls them—flaws and snags that require adjusted reactions on the part of the performers. Also, he is annoyed with Richie Gallo, who has managed to make at least one appearance in every act, although Wilson has told him he can appear only three times all evening. Richie Gallo is another former classmate of Wilson's at Pratt. He lives with his mother in Brooklyn and practices his probably unique form of "corporeal art," which mostly involves making unscheduled appearances in public places, such as the expensive-dress department at Henri Bendel's on Fifty-seventh Street, masked and wearing one of his skintight black-leather-and-chains outfits, and just standing there for a while, as the customers slink away. He has a great wardrobe—white outfits and green ones, a wide-mesh black fishnet, a flaming-red job with yards and yards of trailing red chiffon. In the past, Wilson has tried to keep him out of his productions, but this seems to be impossible. Clive Barnes, in his generally admiring *Times* review of *Stalin*, wrote that the play had some elements of camp, which bothered Wilson no end; Wilson doesn't think his work is camp, and he suspects that Barnes was referring to Richie Gallo. Tonight, when Gallo made an unscheduled entrance in the second act wearing the black fishnet, Wilson stood in the wings and practically shouted, "Richie, damn you, get off!"

Francine Felgeirolles, on the other hand, is behaving fairly well tonight. Francine, the French girl who plays Stalin's first wife, hammed outrageously in the earlier performances, playing broadly to the audience, drawing laughs, and rather successfully dispelling the atmosphere that the other actors were trying to create. Wilson has hesitated to speak to her about it, because Francine is so unstable. She has a

THE CAVE SCENE FROM
THE LIFE AND TIMES OF SIGMUND FREUD
(Martin Bough)

history of mental illness—in fact, Francine was a patient in a mental hospital when she attended her first Wilson workshop, in Paris, in 1972. Her response to the workshop was so remarkable that Wilson asked her to perform with the group at the Opéra-Comique, which she did, much to the amazement of her doctors. At Wilson's invitation, she came to New York to be in *Stalin*. There were one or two unnerving scenes after her arrival, and once she was on the verge of returning to Paris, but a day later she appeared at the Spring Street loft and announced that she was no longer schizophrenic. Wilson doesn't want to do anything to undermine her fragile self-confidence.

"I don't know," Wilson said after the second-night performance. "Sometimes I think it's okay what she does onstage. It's such a contradiction of my work, but maybe it's good to contradict yourself. Also, in her particular situation this is such a big thing for her. If she can get through these four performances, maybe that's more important than anything else." But he did speak to her before this night's performance. "I screwed up all my courage and told her she was doing too much—that she should be more restrained," he said afterward. "She seemed to accept it. She really is a remarkable performer."

Robyn Anderson and others are often surprised by Wilson's odd mixture of diffidence and authority, gentleness and power. "There's something almost Svengali-like in the way he draws from people all sorts of things they never knew were there," Robyn said one day. "He makes impossible demands on everyone, and yet the atmosphere he creates is one of great freedom. Of course, by the time we get to the actual performance stage everyone is a little crazy and freaked out from sheer exhaustion."

Entr'acte

This is the opening scene—the murder scene—of *Deafman Glance*, and it is a good deal more than an entr'acte. It has sometimes lasted as long as an hour, depending on how Sheryl Sutton plays it. Sheryl, the Byrdwoman—still in her long black Victorian dress—starts the scene standing with her back to the audience, facing a painted drop that suggests a massive stone wall. Behind her, on a raised platform built out over the stage apron, a young black boy sits on a stool, reading, while his younger sister sleeps. Both the children wear white nightgowns. At Sheryl's right is a small table on which are placed a half-filled bottle of milk, a glass, a pair of black gloves, and a knife.

THE MURDER SCENE FROM *DEAFMAN GLANCE*
(Martin Bough)

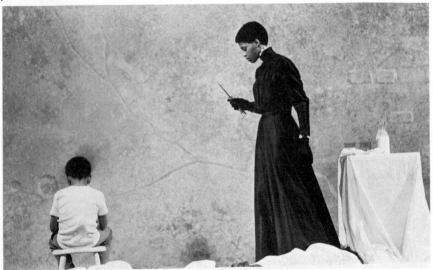

Sheryl stands absolutely immobile, waiting, until the intermission audience is seated and silent.

Sheryl Sutton's theatrical presence is phenomenal. No one else in the group, except perhaps Wilson, has it to such an intense degree. This arrestingly beautiful black girl—born in New Orleans, raised in Chicago, an undergraduate at the University of Iowa when Wilson found her there in 1970—can hold an audience in complete silence without appearing to do anything whatever. "I do so little," she marveled one evening, backstage. "The Byrdwoman is not really a character, and I don't try to make her one. Maybe it's the absence of details that makes her so mysterious." Sheryl has played only one other important role in her brief theatrical career—Medea, in a student production at the University of Iowa. For Sheryl, the murder has three parts, each with its own particular tempo: drawing on the gloves (medium slow), pouring the milk and giving it to the children (quick), and the killings themselves (very slow). The tempo with which she turns away from the backdrop and puts on the long black gloves determines the tempos of the two other parts, and no two performances are ever quite the same. In *Stalin*, the murder scene took about twenty minutes the first night, fifteen the last. It is a ritual—a slow and undeviating series of movements that Sheryl has come to think of as a kind of dance. She draws on the gloves. She pours the milk and carries it to the reading boy, who drinks; she returns the glass to the table and takes up the knife; she crosses again to the boy, and slowly —her absolute concentration making of the act one clear line—slides the blade into his body and gently cradles him as he falls forward to the floor. The same sequence is repeated with the girl. Then, as Sheryl wipes the knife for the second time and returns it to the table, the boy in knee pants and suspenders comes on from stage left and cries out. He cries again and again, perhaps forty times, while Sheryl walks slowly to where he is standing. She covers his eyes with her black-gloved hand. Her hand moves downward to his mouth, and the cry is cut off.

Sheryl herself has no clear idea what the murders signify, or why their effect is so stunning. "Maybe that's why I'm still here," she has said. "I'm still trying to find out what it is that Bob does."

Act IV—The Forest

Deafman Glance is Wilson's most widely acclaimed theater work. In its three-and-a-half-hour version of 1971, it was the sensation of the

World Theatre Festival in Nancy, France; subsequently it played in Amsterdam and Rome, where it was enthusiastically received, and in Paris, where the majority of its forty performances were sold out well in advance. Eugene Ionesco announced that Robert Wilson "has gone farther than Beckett," and *Le Monde*'s theater critic wrote that *Le Regard du Sourd* was "clearly a revolution of the plastic arts that one sees only once or twice in a generation." The Byrd Hoffman Foundation could no doubt mount an extended and successful production of this play alone, but Wilson, of course has no intention of doing that.

For *Stalin*, the *Deafman* material has been pared down to a little more than two hours. Several of the characters have become Stalin figures, and the two women at a banquet table downstage right are now Stalin's first and second wives; because of this, they cannot appear simultaneously. Both wives die violently onstage. Wife No. 2 (Scotty Snyder) shoots herself toward the end of the act. The death of Wife No. 1 (Francine Felgeirolles) takes place at the exact midpoint of the entire play's action; she leaves the banquet table and wanders downstage to the murder platform (from which the bodies of the slain black children have been removed), there to perish in slow agony—it has been said that she was poisoned on Stalin's orders—while two Stalin figures in white uniforms (Wilson and Cindy Lubar) sit stolidly in white armchairs and watch. Wilson-Stalin then sings a love song— Al Jolson style, with maximum bathos—over her bier. According to Wilson-author, this scene is the key to the play—the single event that irrevocably altered Stalin's life ("He's supposed to have said he loved her"), and changed the course of history. Here it serves as a turning point in the twelve-hour cycle.

Wilson's multilayered, architectural stagecraft approaches its richest and most complex effects in Act IV. Nearly a hundred characters move through a stage space that seems to stretch back almost to infinity, through seven successive, horizontal playing zones ("tracks," Wilson calls them), in each of which various activities take place singly or simultaneously. The activity in one zone is continually juxtaposed with the activities in other zones, and the eye must move constantly to take it all in. Wilson has cheerfully dug down into the centuries-old bag of theatrical tricks and come up with whatever he needed—scrims, flats, all kinds of special lighting, traps in the floor, backdrops that rise and backdrops that descend, a wooden house that catches fire and sinks to ashes, even a palm tree that grows several feet as the act progresses. From time to time, this tremendous visual

collage suggests a painting—a Magritte, perhaps, or one of the dreams of the Douanier Rousseau—but a painting that changes as we look at it.

The act begins with a gathering of women in long white gowns (each one carrying on her arm a white bird) sitting in white chairs in the forest and listening to a white-clad mammy play the "Moonlight" Sonata on a piano. As it gradually progresses, more and more elements are added. A giant green frog (Duncan Curtis) squats at the head of the banquet table downstage right, drinking Martinis served him by a red-headed waiter and occasionally scribbling notes to his dinner guests, who include a Stalin with one hugely enlarged eye (George Ashley) and, in turn, Stalin's two wives. At stage left, semi-nude people build a wooden bin on the backs of four large turtles. Fish people move slowly across the stage with a finlike motion. A goat-woman appears at the window of the little house, speaking in a strange tongue. Behind the house, figures move through the trees—an old man following an ox, a green-headed dwarf, a woman carrying a child (seven-month-old Devin Curtis, who evidently never cries), men and women holding large squares of glass that catch and reflect the stage lights, a violinist, Ivan the Terrible, the King of Spain. Behind them all, the red runner crosses and recrosses, and behind him a pyramid is rising; near the end of the act a luminous eye will appear at its apex. The moon rises, moves across the sky, and sets. Characters speak, sometimes intelligibly. Music is heard—Beethoven, Buxtehude, original compositions by several Byrd composers. The pope appears, and inexplicably falls dead. The dinner guests having departed or died, the frog, who has not moved from his crouched position for almost two hours, makes a prodigious leap onto the banquet table, landing on a concealed trampoline-like mechanism that catapults him ten feet across the stage; three more leaps effect his exit. A beautiful young couple dance, nude, to the music of Fauré's Requiem; they lead a procession of women in white into the forest and down into the earth, descending through trap doors. Smoke or fog drifts through the forest, and a tribe of black apes moves out from the trees. Marie Antoinette and George Washington enter, resplendent in eighteenth-century court costumes, their hands and faces painted silver; Marie Antoinette's parasol is aflame. And watching it all from a bench on the stage—a bench that slowly rises on invisible wires after the death of Stalin's first wife, so that for the second hour he is looking down from the height of the treetops—is the boy in knee pants and suspenders, the boy who saw the Byrdwoman murder her children, the

boy who has appeared in all the preceding acts. The boy played
originally by Raymond Andrews.

Wilson met Raymond Andrews by chance one evening in 1968,
when he was arriving to teach at the Summit Art Center. Raymond
had just thrown a rock through a church window, and, as Wilson
later discovered, he had been in trouble with the police on several

other recent occasions. He was eleven then, a deaf-mute black boy
from Alabama who had come North a few months before to live with
a foster family in Summit. He had never attended school. Using sig-
nals and gestures, Wilson induced the boy to come to the class at the
Summit Art Center. Raymond was pretty disruptive at first, but he
came to the class every week from then on, and soon Wilson began

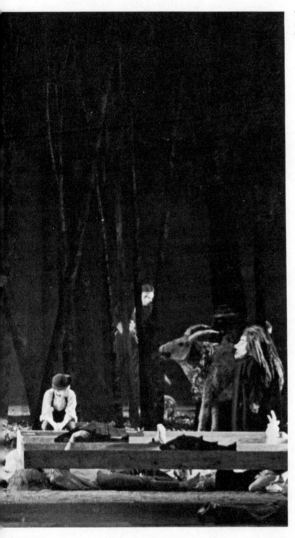

THE FOREST,
DEAFMAN GLANCE
(Martin Bough)

taking him to his other classes as well. Raymond was wonderful with younger children, encouraging them to get rid of their self-consciousness and to move around more freely. He was also highly intelligent, and he had a visual memory that enabled him to imitate any step or movement after seeing it once—later, in their rehearsals, Raymond was often more acute than Wilson at correcting tiny details of movement or design. His deafness was no problem after a while. Performing as the lead mammy in *The Life and Times of Sigmund Freud*, Raymond would stop his movement the instant the piano stopped playing—he could feel the vibrations through the floor. Wilson also got him started painting and drawing, and the results were wildly imaginative. "A lot of the material in *Deafman* came from Raymond," Wilson has said. "Raymond was the deaf man. The play was really based on a series of images around Raymond, on Raymond's drawings, and on my thinking about him." The boy's foster parents gave their permission for Raymond to go out to the University of Iowa with Wilson in 1970, when Wilson was invited to give a workshop there at the Center for New Performing Arts. The workshop sessions became rehearsals for the first version of *Deafman Glance*, during which Raymond was never offstage.

A number of people in the present group joined it originally at the University of Iowa. Sheryl Sutton and Mel Andringa, the stage manager of *Stalin*, were both students there, as was Bobbi Krasner (Marie Antoinette). Sue Sheehy was working as a cook-cashier at Henry's Beef-n-Burger, near the campus. Wilson and John d'Arcangelo, the stage manager of *Deafman*, came into the diner and asked if she would like to be in a play, and after thinking about it overnight she agreed. They gave two performances of *Deafman* at the university, and filmed a third. Several Iowa students came East the next year to be in the Brooklyn Academy production, and then went on the European tour that spring. So did Raymond Andrews. George Ashley and another member of the group took turns tutoring him in his schoolwork. (He was attending school regularly by this time.) He learned how to ride the Métro, and traveled all around Paris by himself, having a fine time. Toward the latter part of June, though, Raymond wanted to go home; Wilson had promised to send him to camp that summer, and the camp session had already started.

"At first, I said he couldn't leave—that he was the star of the show and we needed him," Wilson recalls. "Then I said okay, but that it was his responsibility to find and train his own replacement. The play was up to ten hours by then, with the addition of the *Freud* material, so there was a lot to teach. Raymond suggested a young Nigerian girl

who was in the cast, and I realized that she would be very good for the part. So Raymond taught it to her. And the night she went on, he did a very beautiful thing. He dressed in the white costume of the Prince—he had always wanted to see the play from out front, and the Prince and Princess sit in a box the whole time. Then, at the beginning of the fourth act, when the Nigerian girl was sitting on a bench on the stage, Raymond left the box, went backstage, changed his clothes, and came out onstage bringing her the black hat that she was supposed to wear but had forgotten. He gave her the hat, bowed to her, bowed to the audience, danced around her, and left the stage."

Raymond has not performed with Wilson since then. In *Stalin,* Raymond's role was played by Julia Busto, a slim young Argentine girl whom Wilson considers one of the most gifted members of the group.

Entr'acte

After Act IV, the audience thins out. It is close to two o'clock in the morning, and most of those who do not plan to stay through to the end have gone home. The remainder—some four hundred souls on this frozen winter night—have a sense of solidarity verging on camaraderie. Neighbors nod to one another as they come back after the intermission. They stretch their legs over the empty seats in front. On the platform over the stage apron, a *tableau vivant* has Helen Keller, Anne Sullivan, and Alexander Graham Bell holding hands, oblivious of a ringing telephone. They are engaged in wireless communication.

In a dressing room backstage, Scotty Snyder and Mary Peer are drinking coffee and eating homemade cake. Mrs. Snyder lives with her husband, a retired Air Force colonel, in Summit, and until a mutual friend brought Wilson to a party at their house one afternoon in 1968, she used to spend most of her free time painting and making sculpture; her work has been exhibited at the Newark Museum and elsewhere. At the party, she happened to mention that the Summit Art Center needed somebody to teach a children's art class on Saturdays. Wilson proposed himself, Mrs. Snyder arranged it, and the children's class (which turned out to be a class in body movement) soon expanded to include adults. Mrs. Snyder, Mrs. Peer, and quite a few others from Summit have been performing in Wilson's plays ever since. Mrs. Snyder plays Stalin's second wife, among other parts. A calm, monumental woman who speaks in the flat and unhurried accents of the Midwest (she was born in Iowa), she leads two very distinct lives. "My husband says I was an artist before I joined the

circus," she observes. "He comes to the plays and to the parties in the loft, but he's not a Byrd. He tends to be a little resentful when I come home from a tour exhausted or sick. He's concerned, but he's a little resentful, too."

Mary Peer plays the lady in a black leotard who crawls onstage in Act II (among other parts), and she is famous in the group for never getting anywhere on time. She and Wilson had a row about this during rehearsals for *Stalin*, as a result of which she did not appear on opening night, but they made it up in time for the three remaining performances. "I don't know what I would have done if it hadn't been for Bob," she says. "I remember one of those early classes of his at the Art Center—he turned the lights down very low and put a record on, and said just do anything you feel like doing. What a wonderful thing! I found myself just sort of tilting, very gradually, down to the floor and going into a somersault. It was the most natural thing in the world. I guess that was about the happiest time of my life, talking to all those different people and learning how to move." Mrs. Peer's husband was a well-to-do lawyer. He died some years ago, and she lives alone in Summit, in a big house by a pond.

Alma Hamilton, Wilson's grandmother, looks in at the dressing-room door, and is invited to come and sit down. She reminisces a bit about Bob. "He was such an interesting child," she says. "I used to take him on all kinds of trips with me, and when he was ten years old he was as good company as any adult." Mrs. Hamilton has always loved to travel. Her husband died many years ago, and until quite recently she used to go around by herself on long-distance buses; she has visited every state in the Union and a number of foreign countries. "They used to say my middle name was Goin'," she says, "because I was always goin' somewhere." Now she travels with her grandson and the Byrd Hoffman School. In 1974 she went with them to Copenhagen, where she made her theatrical debut. "When Bob wants you to do something," she explains, "you just can't get around him." Before the opening in Copenhagen, Wilson asked her whether she thought she could scream onstage. "I said no, but then he sort of demonstrated what he meant, and I tried it. I was just *amazed* at what came out. Who'd have thought my voice could fill a whole theater?"

Act V—The Temple

A French critic coined the term "silent opera" to describe Wilson's theater. Others have often suggested that his work is really closer to

dance than to anything else—a view to which Wilson himself inclines. Act V is all dance—a free-form, self-taught kind of dancing that grew out of Wilson's body-movement classes and out of the hours and hours of free dancing in the Spring Street loft. Andy de Groat has carried this technique (or nontechnique) further than anyone else, and Act V is Andy's act. Wilson has tried hard to stay out of its direction, and he has almost succeeded.

A compact, small-boned young man with close-cropped dark hair, Andy de Groat was going to art school in the daytime and working nights as house manager of the Bleecker Street Cinema when Wilson did a performance there with Kenneth King and others in 1967. They became friends immediately. The following year Andy performed in *Byrdwoman* and *Alley Cats*, and found his interest shifting, as Wilson's had, from painting to theater. Aside from a few months' work in California with the choreographer Ann Halprin, he has had no formal dance training. "All my dancing is connected with Bob's work," he has said. "I've got something from watching Merce Cunningham and Kenneth King and a few others, but basically it's just from working with Bob and on my own."

Andy de Groat can do things that astonish professional dancers. He can spin for long periods without getting dizzy, turning so rapidly that his body becomes a blur; he can also change direction in mid-spin, apparently without coming to a stop. His five-minute spin as Heavyman in Act I, where he wears three ape suits under his white costume to pad it out, always evokes applause; during a performance in Paris, he spun continuously for an hour. He knew nothing about whirling dervishes or Sufi mystics when he started doing this, but recently he said that for him spinning "concerns the mind state between waking and sleeping, life and dream, the conscious and the unconscious." He is phenomenally agile, quick, and sure in his movements, and his stage presence is very clear and strong.

Until the production of *Deafman Glance*, Wilson's theater was largely static—a succession of tableaux and very slow movements. The group used dancing only to warm up during rehearsals—to free the body and to get rid of tensions. Since *Deafman*, though, dancing has become much more important. Every Thursday evening at the loft, and before each rehearsal when a play is being prepared, the group dances to records for an hour or more—each person dancing separately, with varying degrees of concentration. Wilson himself has been evolving a kind of movement that looks almost spastic in its stumbling lurches and off-balance recoveries. "I hate it," he said

sheepishly after rehearsal one day. "If I were in the audience, I wouldn't want to watch anything like that. But I can't seem to stop doing it." His angular, big-footed movements are arresting onstage, and others in the group have obviously been influenced by them. Many more have been influenced by Andy de Groat's spinning, and spins of one sort or another are the basis of much free dancing at the loft. Scotty Snyder, who is rather large, spins slowly and thoughtfully, seldom varying her tempo. Kit Cation (in her twenties) spins very fast, with metronomic precision. Ritty Burchfield and Robyn Anderson and Liz Pasquale and Julia Busto have all developed individual variations of spinning—movements of the arms and the head and the upper body—that seem expressive of their different natures.

This is the raw material that Andy de Groat has used and shaped in his choreography for Act V. The broad patterns have been intricately planned and endlessly rehearsed. Igor Demjen's repetitive, Balinese-sounding music, the nearly constant spinning movement of the dancers in their white dresses, and the set itself, which resembles a crypt in an Egyptian pyramid, all tend to suggest some sort of Eastern ritual or temple dance. And yet the dancers themselves seem loose and free, and each moves in a different idiom.

"Maybe the most important thing we've done is to put across this sense of individual vocabularies of movement," Wilson said reflectively one day, over a sandwich in a restaurant across the street from the loft. "I keep thinking about Isadora Duncan—that thing she said about teaching the children in her school not to imitate her movements but to develop the movements that were natural to each one. Isadora was so far ahead of her time—we still haven't caught up with her. Ideally, I guess, what we'd like to do onstage is to present ourselves. Each one presenting himself individually, and at the same time trying to be aware as much as possible of what's happening as a whole group. Not trying to design it or anything—just trying to be aware of it."

There were a lot of problems with Act V in rehearsal. Wilson wanted to leave the direction entirely up to Andy, but was nervous about the way the act seemed to be shaping up. He felt that the stage was getting too crowded. He also thought that several members of the group were not dancing well—that they seemed "jammed up" in their movement and lacking in concentration. "When you come offstage, even for a moment, don't make contact with anybody in the wings," he told them at the end of one unsatisfactory rehearsal. "The main thing is to keep your concentration. You've got to be able to see with

255

your body, in all directions, and to be aware of everything else that's happening onstage." It was hard for Wilson not to get involved in the details. But every time he made a criticism or a suggestion, Wilson worried afterward that he was undercutting Andy's authority or Andy's confidence. Andy never seemed in the least upset by this. "Everything here comes out of Bob or through Bob," he said cheerfully one afternoon. "What I'm mainly interested in is that people dance well."

While the dancers weave their patterns onstage in Act V, Stalin sits at stage right in an upright rectangular glass box, occasionally speaking into a microphone. For the first part of the act, the Stalin is Wilson. After a time, he is replaced by George Ashley. Ashley has dug up an authentic essay of Stalin's on dialectical and historical materialism, which he reads with deliberation, first in its normal word order and then backward. (Ashley claims that it makes as good sense either way.) He also reads two Emily Dickinson poems, which he chose because they seemed to have some bearing on the life of Stalin. "Bob told me he wanted a Stalin who was dignified, pedantic, infantile, and Chaplinesque," Ashley confided to another member of the cast. "It's clearly impossible, but I do my best."

Entr'acte

Sue Sheehy, her blond hair in curlers, appears in front of the house curtain pushing a heavily laden shopping cart. As she crosses, she tells the audience a story—a true story about an incident in the office of the United Jewish Appeal, where Sue does secretarial work five days a week. It is not a very interesting story, but that doesn't much matter. Watching Sue cross the stage at three-thirty in the morning is not without interest.

There is not the slightest doubt in Sue's mind that she would still be working at Henry's Beef-n-Burger in Iowa City if Robert Wilson and John d'Arcangelo had not come in and spoken to her. There was something about this good-natured, heavy girl that interested them —"the direct way she shows you just exactly what she's feeling at that moment" is how Wilson once put it. As a girl born and raised in New Sharon, Iowa, Sue had her moments of doubt, but once she had performed in *Deafman Glance* at the university, and Wilson had praised her performance and suggested that she come East to be in the play, the decision was not difficult. "It was really amazing how Bob could get what he wanted," Sue wrote in an autobiographical ac-

count of the experience. "He conveys faith and trust. You didn't, and I still don't question what he asks you to do." At any rate, Sue bought a round-trip bus ticket and came to New York that winter. Never having been to a major city before, she was somewhat apprehensive, but Wilson and Mel Andringa met her at the Port Authority Bus Terminal (they had dressed up in ape suits for the occasion), and a week later she cashed in her return ticket. In the summer of 1973 she went back to Iowa for the first time in almost three years. It was a mistake, she found. New York is her home now; she even likes the subway. She has played many different roles in Wilson's plays, and, in addition, she has become the company's wardrobe mistress. She has been to Paris and Copenhagen and Venice, and she has talked with a princess in Iran. "People ask me what we're doing—what it means," she said last winter. "I say, 'I can't possibly tell you.' But I like doing it—this is what I want to do."

Act VI—The Victorian Bedroom

The program says, "Some elements of music, movement and libretto in this act were first seen in 'KA MOUNTAIN AND GUARDenia TERRACE: A Story About a Family and Some People Changing,' presented at the Festival of Arts, Shiraz-Persepolis, Iran, in 1972."

Fifteen members of the Byrd Hoffman School went to France with Robert Wilson in the spring of 1972 to conduct a theater workshop that was sponsored jointly by Jean-Louis Barrault's Théâtre des Nations and Michel Guy's Festival d'Automne. The material developed at the workshop would be presented at the Shiraz Festival, to which they had been invited by the Iranian government. They spent six weeks in a lovely thirteenth-century abbey at Royaumont, about an hour from Paris, living and working with professional French actors and dancers whom Wilson had selected through a series of auditions. Alone or in small groups, they wrote plays, made dances, painted and constructed sets. In June the Wilson group dispersed to various parts of Europe, prior to reassembling in Iran. Wilson, Andy de Groat, Ann Wilson (a painter, Willard Gallery; no relation), and Kit Cation went to Crete, where Wilson's European agent and friend, Ninon Tallon Karlweis, had offered to let them use her house. After a week of relaxation, they were on the point of leaving for Iran when a customs officer at the airport in Heraklion found a small parcel of hashish in Wilson's coat pocket. The next five weeks were a nightmare for everyone concerned. Wilson was arrested on the spot,

searched (they found nothing more), and imprisoned without bail. For the next few days Andy de Groat and George Ashley, who was in Shiraz with the rest of the company, spent most of their time on the telephone to Paris and New York, where influential friends were trying to find the right strings to pull. A local lawyer who had been engaged to represent Wilson told them that the best he could hope for was a trial in six months and a one-year jail sentence, and that it could be much worse. After five weeks, and against the lawyer's advice, Andy again applied for bail, and, to everyone's surprise, it was granted—with the stern warning that under no circumstances was Wilson to leave Greece. Wilson and the others flew immediately to Athens, took the first non-Greek flight they could find, and held their breath until they landed in Istanbul. He has since heard that he has been amnestied by the new Greek government, but he does not intend to visit the country again for some time.

In Shiraz, meanwhile, Ashley had kept the company going as best he could. Nearly everyone had been hospitalized at least once for dehydration—the temperature got up to about 120° every day—and the festival authorities, in Wilson's absence, were extremely chary with funds. Although a month had been lost, Wilson managed to pull together the Royaumont material and to generate enough new material for *Overture*, a one-hour play presented in the garden of a famous house in Shiraz, and for "KA MOUNTAIN AND GUARDenia TERRACE," which lasted, in the land of Scheherazade, for seven days and seven nights. "KA MOUNTAIN" began ("opened" hardly seems the word) at midnight on September 2 in Shiraz, at the foot of a hill called Haft-tan, or Seven Bodies, in reference to the graves of seven Sufi poets buried there. Each day thereafter the performers moved to an area higher on the mountain, reaching the summit for the seventh and last day's performance. In the intervals between the main passages, there were continuous activities on a platform near the foot of the mountain. A detailed program showed what was happening every day, and where, and for how long.

What *was* happening? Dozens of individual plays, dances, pantomimes, and tableaux that had been developed by various members of the company—the program listed seventeen directors and nine authors and a cast of seventy-nine (the majority of whom were students at Pahlavi University in Shiraz). The first night's audience included the flower of Iranian society, in mink stoles and precipitous high heels. Within an hour, the elite had departed (they evidently were expecting a traditional opera), and their places were taken by students,

who came equipped for the chilly night air with blankets, foodstuffs, and stimulants. There was an audience of some kind in attendance for a good part of the 168-hour performance, except during the torrid hours between noon and 3:00 p.m. Life is a good deal slower in Iran than it is in New York, and the play's length caused little public outrage. "There were times, though, when nobody was watching us," Wilson recalls. "At three in the afternoon, with the sun overhead, everybody except us was home sleeping. It made me wonder about the difference between living and performing. 'KA MOUNTAIN' in some ways was like a documentation of what we're like—we were the family and the people changing. I think it's a piece I could work on for the rest of my life."

Several members of the group went through crises of one sort or another during or soon after "KA MOUNTAIN." Scotty Snyder contracted typhoid and pneumonia, and spent two weeks in a hospital in Shiraz. George Ashley and Anna-Lisa Larsdotter stayed with her while the others went on to Paris, where they had been invited to give a performance at the Festival d'Automne, and where Cindy Lubar—a tower of strength all through the Shiraz experience—began to show some alarming symptoms. Normally a quiet and rather withdrawn girl, Cindy became very aggressive during the Paris rehearsals, ordering others around in a loud voice and repeating words compulsively. She could not sit still for a moment. One day, she came to rehearsal in a bright-red dress and silver shoes, with her dark hair bleached white-blond. The next morning, she showed up with her head shaved. Wilson and the others were in a quandary. They thought that if they took her to a doctor she would be institutionalized, and those in the group who had had experience with mental institutions thought anything would be preferable to that. Wilson finally got through to her. He told her to take a week off and sleep, which is what she did.

Cindy talks freely about the experience now. "I felt as though too many things were happening in my mind at the same time," she said last winter. "It was interesting, but I was scared, too, because it was so out of control. I'm terrifically grateful that I was with the group, because otherwise I know I would have gone to a mental hospital, and I might still be there. People like Bob and Ann Wilson made me feel it was all right, what was happening to me."

Cindy, it seems, was then able to put what had happened to her into *Ouverture*, a twenty-four-hour Wilson opus at the Opéra-Comique that became, in effect, Cindy's play. "She was onstage nearly the whole time," Mel Andringa recalls. "Sometimes she slept on-

stage. For hours at a time, she would do those queer, broken vocalizations of hers, and you never knew when she might go out of control completely. It was painful to watch, but absolutely compelling. At the end, she took off her coat—she was nude underneath—knelt down, and started to wash her hands and arms in a pool of water that was onstage. The lighting was exceptionally beautiful just then. It was incredibly moving—you felt as though she had come through it and out the other side."

The Theatre of Madness has its historical antecedents, including the Marquis de Sade's Charenton productions and the influential writings of Antonin Artaud. Wilson's willingness to incorporate individual breakdowns into his theater pieces—to allow for the occurrence of breakdowns, if not actually to provoke them—may represent a further step in this direction, and a step that raises some fairly disturbing questions. When asked about it recently, Wilson said that Cindy's breakdown, Francine Felgeirolles's instability, and the fact that others in the group often seemed to be close to the edge mentally or emotionally concerned him a great deal, but that it also seemed important to him to explore the kinds of communication that such states opened up. People like Francine and Christopher Knowles, he said, were acutely sensitive to all forms of nonverbal communication, and they seemed to respond in a good way to being placed in a theatrical situation or environment. Theater itself, Wilson said, was a kind of organized insanity. Jerome Robbins has put the matter in much the same way: "Bob is attracted, somewhat, to what the rest of us would consider the misfits of this world. He sees in them the exceptional. This is part of his caring. Theater is all a little crazy anyway. After all, what could be madder than a lot of people in ballet shoes dancing on their toes? We're apt to say the new thing is the maddest, because we're not used to it, but maybe his work is saner than anything else around. One of Bob's great contributions is another way of looking at the question 'What is theater?' What he does is make you think about the whole question. And I firmly believe that his contribution will be as great as that of any theater man in America."

The madness in Act VI, at any rate, is not very upsetting. There are twelve beds onstage, and twelve sleepers in white nightgowns and white mobcaps, and an old man with a staff who laboriously counts to ten, and, behind him, an octagonal, mirrored room through which various characters make stealthy entrances and exits. The sleepers get up every so often and search with lanterns for an invisible "thief." Queen Victoria appears, to announce that "conflict in the created

world is not what it seems," but Stalin is nowhere in sight. The act goes on rather too long, and, coming at the time it does—between three-thirty and four-fifteen in the morning—and considering the imagery, it provides an almost irresistible invitation to nap. Nobody leaves the theater at this hour. Wintry gusts can be heard buffeting the Academy walls, and there are few taxis at 4:00 a.m. The bedroom setting and the lighting are eminently restful. One dozes. One wakes briefly to see Sheryl Sutton, in a white satin suit, doing a music-hall turn. One dozes again. The dream continues.

Entr'acte

The raised platform is a black lake ringed with icebergs. Kit Cation plays the flute at stage right. Julia Busto, wearing a man's dark suit and a fedora, dances among the icebergs. (She will remain on the platform throughout Act VII, turning continuously in slow, smooth circles, never varying her tempo.)

Behind the house curtain, the cast again forms a circle, hands linked. Wilson, who had posted a notice backstage an hour before ("Circle of hands before Act VII—everyone"), stands in the center. He thanks them all for their work and says he thinks the play is going well tonight. Act VII, he says, is the most difficult act of all—the one that has given the most trouble in rehearsal. "I've been worried about people holding back in this act," he says. "But maybe all the trouble we've had in rehearsal came from my trying to make it into something it isn't. Maybe Cindy and the others are right to hold back. There's a point of saturation for the audience. Well, okay. Let's have a good show."

Act VII—The Planet

Ostriches fill the stage. Thirty-two of them, turning and bowing and strutting stiff-legged in a stately ostrich ballet—choreography by Mel Andringa and Andy de Groat, music by Alan Lloyd. The costumes are marvels. Although the bare legs are clearly human, the large feathered bodies and the towering necks and beaks and the queer hopping movements create an uncanny illusion. Their dance is a counterpart to the dance of the sixty mammies in Act I—one of many correspondences. Act I ties up with Act VII, Act II with Act VI, Act III with Act V, while Act IV stands alone at the center. Now, as in Act I, the stage is covered with sand (which the ostriches kick up),

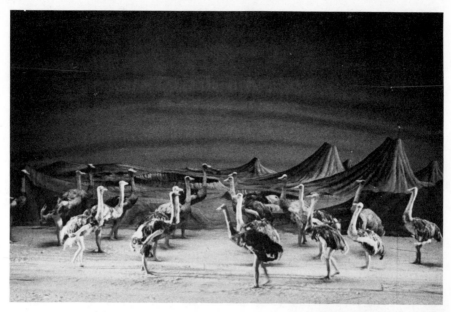

THE OSTRICH BALLET, ACT VII OF
THE LIFE AND TIMES OF JOSEPH STALIN
(Carl Paler)

and most of the characters who appeared in the first act will reappear in the last.

The new element in Act VII—the element that has made it, for Wilson, more difficult and more interesting than the other acts—is language. Once the ostriches have made their exit, the act is peopled by characters who actually recite lines, though rarely to one another. This is a new direction in Wilson's work, which in the past has been largely nonverbal. To a certain extent, of course, language has been an element in all six of the previous acts, what with Stalin explaining dialectical materialism and Queen Victoria holding forth on pineal movements and a chorus whose members talk Parsi or say "click" and "collect." In Act VII, however, language becomes the central element, although not in precisely the same sense as the language in a Neil Simon play.

Until Wilson was seventeen, he had a severe speech impediment. "I had great difficulty getting anything out," he said once. "But just as I was graduating from high school I met this amazing person—the dancer who was working with brain-damaged children in Texas. She said, 'Oh, you can speak.' I don't even think it was what she said as much as the way she said it. Within three months I was making lots of progress. Part of it was just slowing down. I learned to speak very,

very slowly. I entered a radio speaking contest, and spoke very slowly over the air—it became funny, and then it became theatrical, a sort of projected image. It was a very important time for me, like a dam bursting."

The use of language in *The Life and Times of Joseph Stalin* seems to be another kind of breakthrough for Wilson, and it will be interesting to see how this develops in his future work. At the moment, language is something he uses as another theatrical material, like movement or light; the sense of the words is of minor importance. Listening to the sounds that Raymond Andrews and Cindy Lubar made in his classes started Wilson thinking about the relation between sound and movement, and this, in turn, led to some odd experiments. In 1971 Wilson gave a "press conference" in Yugoslavia in which he simply repeated the word "dinosaur" over and over, for twelve hours, while cutting an onion the whole time. "Students and other people would come up and ask why I kept saying 'dinosaur dinosaur dinosaur,' and after a while I'd feel as though I had answered their question. I suppose the idea is that we already know the answers to most of our questions. I wasn't sure whether or not I was actually *saying* other words, but I knew I was *hearing* other words, like 'disaster' and 'soaring.' It's very curious. Anyway, the object of a lot of the work we're doing with movement is to break movements down into very small units. Like Balinese dancers, who have something like a hundred and seventy-five eye movements alone. The question becomes 'Can we break down the phrasing of sounds in the same way, and work with that?' You notice in the *Stalin* script we say 'okay' a lot. 'Okay. Okay. Okay. Okay. Okay. Okay.' Sometimes I feel that the emotions can shift more rapidly when we do this than when we talk as we ordinarily do. We also say 'Hmm' a lot. It's amazing how often people do that in conversation. It communicates something about all sorts of other things that are happening besides the words. Also, it's international—it's understood in Paris or Copenhagen or anywhere. We were invited to do a radio program on WBAI—a five-hour program, from midnight to 5:00 a.m. It didn't work out too well. My idea was to do the program in three parts. The first part would be a group of us saying 'Hmm' in all sorts of different ways; in the second part we'd say 'Okay'; and in the third part we'd say 'There.' 'There. There. There. There. There.' I thought it would be nice if some truck driver turned on the radio late at night and got a bunch of people going 'Hmm' or 'There.' But the program manager wasn't too happy, and she kept asking questions that weren't very in-

teresting. Why do people ask such uninteresting questions? My grandmother is close to ninety, and she's never once asked me what the play means or why people are going around in it without their clothes on. Most of the important things never get communicated in words anyway."

The backdrop for Act VII is a landscape on the moon, or some less familiar planet. The red runner passes in the deepest zone, and Julia Busto turns and turns on the downstage platform. A pair of tourists appear, outlandishly garbed; the man takes a photograph of a hole. Smoke comes from the hole, and then Sheryl Sutton, reciting a speech from *Medea*. Stagehands drag in a platform bearing four people: a man who holds a quizzing glass to his eye and intones cosmic news reports, a woman who reads from a book, a man with a tree on his head, and Queen Victoria, who paces restlessly back and forth. Their voices sometimes combine and overlap, sometimes fall silent. The man with the tree on his head is Stefan Brecht, who writes on theater (his wife, Mary, designed the costumes for this play, among others); he was also the red-haired waiter in Act IV, and the old man who counts to ten in Act VI. Stefan is the son of Bertolt Brecht, who almost certainly would not have approved of Robert Wilson. Stefan reads from a Ford Foundation report, from the Book of Job, from *Gestes et Opinions du Docteur Faustroll*, by Alfred Jarry. Other familiar figures come and go: Freud and Anna, Ivan the Terrible, the dancing Heavyman. Wilhelm Reich is dragged offstage by two vigilantes shouting "Communist!" A man in a long fur coat comes on carrying two large blocks of ice. Slides of a closing door are projected. High up in the darkened sky, a shape like a spiral nebula glows luminously, outlining the figures of a bride and groom. The bride appears to be strangling the groom, but without violence. A winged horse flies across the sky. The lights come up onstage, the nebula fades out, and another cycle of action begins.

There are about four hundred people left in the audience, some of them asleep. "Sometimes people go to sleep and see things that aren't there," Wilson says. "When you have a group of people together for twelve hours or twenty-four hours, all sorts of things happen. The brain begins to operate on a slower frequency. Ideally, in our work, someone in the audience might reach a point of consciousness where he is on the same frequency as one of the performers—where he receives communications directly."

Time passes. The man with the melting blocks of ice says, "It

won't be long now." Ann Wilson, the woman reading the book on the platform, recites a speech that Wilson wrote in 1969—a sort of prologue to *The Life and Times of Sigmund Freud*. She has a lovely, strong voice, and she reads it beautifully:

> And now in saying something, something introductory to get something settled or someone adjusted there is going on and getting started. ON WITH THE SHOW! as they used to say in the days that I like to remember when people used to waltz. And when they square danced. And when they sat in drawing rooms and played pianos gently to themselves. Then it all changed. Someone got an idea. Things were never the—no, no I won't say it but, then I see in the same pictures and in the flood of encoding the detail the voices of beasts the power coming over the walls through the memory as they do slicing the onion the man into (his) particulars and appear- as they do on the trail of a voice singing a void arresting a beach dissolving through his ears of the cave.

"It won't be long now," says the Iceman.

In the distant sky, where the nebula glows, the city of Moscow is in flames. A ragged mob in thick military overcoats thunder across the stage. They are stopped with a gesture by Stalin—a slim Stalin (Sheryl Sutton this time) in military green. A telephone rings onstage. Stalin answers it ("This is Joseph Stalin"), and expresses mild surprise that an aide will not speak up for a friend who is about to be shot. Stalin climbs a flight of stairs and stands looking down on the motionless crowd. A bassoon sounds. Violin and flute take up on the accompaniment, and the crowd starts to hum a Baroque chorale by the seventeenth-century German composer Johann Pachelbel. Slowly, very slowly, at six-fifty in the morning, the curtain comes down. Everybody is onstage when it comes up again—144 people plus a few stagehands, who have been pulled there by Wilson and others. The applause sounds tremendous. The cast is applauding back, and then suddenly, in some excess of unspent energy, the cast is jumping up and down on the stage, applauding and jumping and raising a great cloud of golden dust as the curtain comes down for the last time.

INDEX